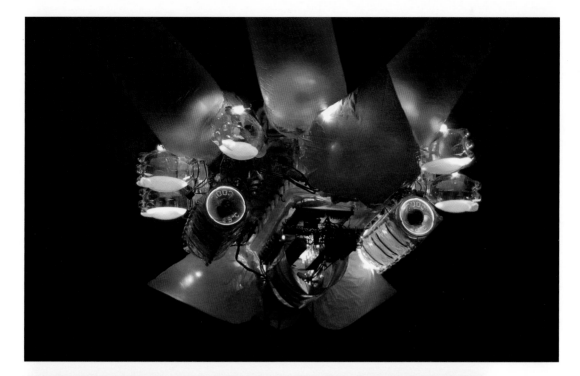

Analyzing Art
and Aesthetics

Edited by Anne Collins Goodyear and Margaret A. Weitekamp

artefacts
STUDIES IN THE HISTORY OF
SCIENCE AND TECHNOLOGY

volume 9

Managing Editor
Martin Collins, Smithsonian Institution

Series Editors
Robert Bud, Science Museum, London
Bernard Finn, Smithsonian Institution
Helmuth Trischler, Deutsches Museum

Smithsonian Institution
Scholarly Press

Washington, D.C.
2013

The series "Artefacts: Studies in the History of Science and Technology" was established in 1996 under joint sponsorship by the Deutsches Museum (Munich), the Science Museum (London), and the Smithsonian Institution (Washington, DC). Subsequent sponsoring museums include: Canada Science and Technology Museum; Istituto e Museo Nazionale di Storia della Scienza; Medicinsk Museion Kobenhavns Universitet; MIT Museum; Musée des Arts et Métiers; Museum Boerhaave; Národní Technické Museum, Prague; National Museums of Scotland; Norsk Teknisk Museum; Országos Mıszaki Múzeum Tanulmánytára (Hungarian Museum for S&T); Technisches Museum Wien; Tekniska Museet–Stockholm; The Bakken; Whipple Museum of the History of Science.

Published by SMITHSONIAN INSTITUTION SCHOLARLY PRESS
P.O. Box 37012, MRC 957
Washington, D.C. 20013-7012
www.scholarlypress.si.edu

Front cover image: Figure 5 of Huang, Chapter 8.
Title page image: Figure 4 of Huang, Chapter 8.
Back cover images (Clockwise from top): Figure 1 of Ott, Chapter 1; Figure 4 of Goodyear, Chapter 16; and Figure 2 of Weitekamp, Chapter 6

Library of Congress Cataloging-in-Publication Data:

Analyzing Art and Aesthetics / Edited by Anne Goodyear and Margaret A. Weitekamp.
 pages cm. — (Artefacts: studies in the history of science and technology ; volume 9)
 Includes bibliographical references and index.
 ISBN 978-1-935623-13-7 (alk. paper)
 1. Art and science. 2. Art and technology. 3. Aesthetics. I. Goodyear, Anne Collins, editor of compilation.
II. Weitekamp, Margaret A., 1971– editor of compilation.
 N72.S3A49 2013
 701'.05--dc23

 2012035696

ISBN: 978-1-935623-13-7

Printed in the United States of America

∞™ The paper used in this publication meets the minimum requirements of the American National Standard for Permanence of Paper for Printed Library Materials Z39.48–1992.

Contents

Series Preface by Martin Collins v

Foreword by G. Wayne Clough vi

Acknowledgments ix

Introduction x

Models as Aesthetic Objects

Section Introduction 1

CHAPTER 1 Using Science to Parse the Body:
Some Artful Methods for Learning Medicine by Katherine Ott 2

CHAPTER 2 The Disappearing Model:
Harvard's Glass Flowers and the Perils of Trompe l'Oeil by Ellery Foutch 18

CHAPTER 3 "A Track Across What Is Now a Desert":
A. H. Munsell's Quest for a System of Color by Erin McLeary 40

CHAPTER 4 Models: Assembled Realities in Architecture and
Engineering by Dirk Bühler 56

Aesthetics of Technology

Section Introduction 75

CHAPTER 5 *Karsh: Image Maker:*
Bringing Artifacts to an Art Show by Bryan Dewalt 76

CHAPTER 6 Softening the Orbiter:
The Space Shuttle as Plaything and Icon by Margaret A. Weitekamp 88

CHAPTER 7 The Kilmer Complex: Artificial-Tree Cellular Towers and
Landscape Aesthetics by Bernard Mergen 104

CHAPTER 8 Form Over Function? Technology, Aesthetics, and
Identity at the National Museum of Scotland by Alison Taubman 122

CHAPTER 9 *Split + Splice:* An Experiment in Scholarly Methodology
and Exhibition Making by Martha Fleming 132

Artists Interpret Science and Technology

Section Introduction 143

CHAPTER 10 Mercurial Pigments and the Alchemy of
 John Singleton Copley's *Watson and the Shark* by David Bjelajac 144

CHAPTER 11 C. A. A. Dellschau:
 An Outsider Artist and the Dream of Flight by Tom D. Crouch 168

CHAPTER 12 African Cultural Astronomy and the Arts:
 A Preliminary Enquiry by Christine Mullen Kreamer 186

CHAPTER 13 The Mathematical Paintings of Crockett Johnson, 1965–1975:
 An Amateur and His Sources by Peggy Aldrich Kidwell 198

CHAPTER 14 Art in the Context of a Science Institution: A Case Study of the
 Cultural Programs of the National Academy of Sciences by J. D. Talasek 212

CHAPTER 15 Retaking the Universe:
 Art and Appropriated Astronomical Artifacts by Elizabeth A. Kessler 222

CHAPTER 16 The Medium as Message in Contemporary Portraiture
 by Anne Collins Goodyear 240

Collaboration in Action: Three Perspectives on the Smithsonian Artist Research Fellowship Program

CHAPTER 17 Contemporary Art Informed by Science:
 The Smithsonian Artist Research Fellowship by Jane Milosch 260

CHAPTER 18 The Influence and Inspiration from Taking Part in the
 Smithsonian's Artist Research Fellowship Program by Shih Chieh Huang 268

CHAPTER 19 Light at the Museum by Lynne R. Parenti 278

 About the Contributors 281

 Index 285

Series Preface

Science and technology have been defining elements of the modern era. They have entered into our lives in large and small ways—through broad understandings of the universe and in the tools and objects that make up the texture of everyday life. They have been preeminent activities for organizing expertise and specialized knowledge, defining power and progress, and in shaping the development of nations and our relations with others across the planet. In 1996, the Smithsonian Institution, the London Science Museum, and the Deutsches Museum formed Artefacts to emphasize the distinctive role that museums—through their collection, display, and, especially, study of objects—can play in understanding this rich and significant history.

Artefacts has two primary aims: to take seriously the material aspects of science and technology through understanding the creation and use of objects historically and to link this research agenda to the exhibition and educational activities of the world community of museums concerned with the intimate connections among material culture, the history of science and technology, and the transnational. The effort gradually has gained footing: Artefacts holds an annual conference and has expanded its formal organization to include fourteen cosponsors (listed on this volume's copyright page). This expanded community, composed primarily of European and North American museums, provides opportunity for more robust professional conversation and, broadens the range of local and national historical experiences of science and technology represented in Artefacts. Not least, Artefacts has created a fruitful interplay between scholarly research and museum practice. Aided by its Advisory Editorial Board, it publishes this book series, which, in conjunction with annual meetings, has helped stimulate a broader turn toward material-based research in scholarship and its use in museum collecting and exhibitions.

The Artefacts community believes that historical objects of science and technology can and should play a major role in helping the public understand science and technology: the ingenuity associated with these activities, their conceptual underpinnings, their social roles, and their local and global connotations. We welcome other museums and academic partners to join our effort.

Martin Collins

National Air and Space Museum, Smithsonian Institution
Series Managing Editor

Foreword

As the Secretary of the Smithsonian Institution, I have the good fortune to experience many incredible moments. None was more impressive than seeing the Space Shuttle *Discovery* put down wheels a few feet away from where I was standing on the tarmac of Dulles International Airport in Virginia in April of 2012, a short distance away from its new home at the National Air and Space Museum's Steven F. Udvar-Hazy Center. It was breathtaking to witness the landing of this iconic symbol of determination, courage, and ingenuity. As a former engineer, I had always considered the shuttles from a design, science, and technology perspective. Upon seeing it in person, however, I realized that, despite *Discovery's* worn and scorched exterior, it is also a work of art; its 39 trips to space gave us earthbound mortals a tantalizing glimpse of the beauty of the cosmos. Now that millions will get a chance to see *Discovery* up close as I did, everyone will be able to experience that same sense of wonder and curiosity and look at spaceflight from a whole new perspective.

Many artists have tried to capture the infinite grandeur of space with paint, clay, film, and other media. More than 4,700 of these efforts comprise the Smithsonian National Air and Space Museum art collection. Works by diverse artists such as Alexander Calder, Nam June Paik, Robert Rauschenberg, and Norman Rockwell can be found here. But artist Alan Bean had a distinct advantage over the other artists in our collection: he was able to get a first-person view of outer space. As an Apollo astronaut, Bean translated his impressions of the lunar landscape and space exploration into acrylic paintings that conveyed the buoyancy of walking on the moon.

Now, with high-powered telescopes ever more capable of producing awe-inspiring images, photography of phenomena such as neutron stars, quasars, galaxies, and black holes can evince wonder just as the most gifted and creative painters do. The Smithsonian Astronomical Observatory operates the Chandra X-ray Center in conjunction with NASA. The Chandra X-ray Observatory can take breathtaking astronomical pictures, thousands of which were compiled and distributed as part of "From Earth to the Universe," an award-winning project of education and outreach which spanned over 500 exhibits in nearly 70 countries. These pictures can spark scientific curiosity that will last a lifetime, inspiring people of all ages to want to unlock the mysteries of the universe.

The Smithsonian offers many opportunities for people to examine exhibitions and objects that highlight the intersections between art and science, aesthetics and technology, and form and function. You can see these intersections for yourself at one of our sites outside of Washington DC, such as the Udvar-Hazy Center, or at any of many Smithsonian museums and art galleries

on the National Mall and beyond, as well as at the National Zoo. Between the Smithsonian Arts and Industries building and the National Air and Space Museum stands the Hirshhorn Museum and Sculpture Garden, opened in 1974. In the spring of 2012, Doug Aitken's installation piece *Song 1* projected a film onto the Hirshhorn's façade at night, accompanied by multiple versions of the timeless song "I Only Have Eyes for You." It transformed the solid into the ethereal, as the massive concrete ring became a fluid, kinetic spectacle that literally stopped traffic every night it was on display.

Another intersection between art and science can be found at the National Museum of Natural History, where scientists work to document and classify the estimated 50,000 plant species that have yet to be officially named. Our own botanical artists work alongside researchers, creating drawings and paintings that can document the rich diversity of plant life. They can also recreate extraordinary details of these plants to reveal new biological insights into various new species of plants. Our collection of botanical art consists of over 10,000 scientific illustrations and paintings, valuable resources that can help conservation efforts and deepen understanding and appreciation of these species.

Within our museums, examples abound of the Institution's continuing work bridging art and science. At the Smithsonian American Art Museum, the recent exhibition *The Great American Hall of Wonders* explored the prevalent nineteenth-century American belief that U.S. citizens shared a particular talent for innovation and invention. The exhibition combined objects and paintings depicting American creations, including clocks, guns, and railroads, with representations of the natural resources that drove progress in that era (including Niagara Falls, the buffalo, and giant sequoia trees). Patent models, blueprints, and engineering diagrams rounded out the exhibition. All the objects explored how inventiveness and scientific discovery are captured and portrayed through art.

And consider our National Museum of Natural History display, *X-Ray Vision: Fish Inside Out*. This collection of strikingly detailed black-and-white images of marine life was created using digital x-ray technology and was based on Smithsonian research of the evolutionary development of fish. Using digital x-rays allows researchers to examine in great detail the changes in fish fins, spines, teeth, and other structures and to make hypotheses about how these animals have evolved over time. But the images are not just scientifically important. As anyone who had the chance to visit X-Ray Vision can attest, they are also quite beautiful in their monochromatic detail.

At the Smithsonian, we see a great value in using *things*—objects and artifacts, paintings, models, and three-dimensional representations—as sites of inquiry and public engagement. It is easy to be inspired by a work of modern art or an artifact from a scientific expedition, and often these objects pique museum visitors' interests, prompting them to ask insightful questions and delve more deeply into complex topics. Objects that represent the intersections of art and science, such as the woolen hyperbolic coral reef project mentioned in this volume's introduction, can increase the ability for people to interact with us. They can also help dissolve the artificial

borders between "museum work" that happens behind the scenes and the creative inquiry that happens every day in the public areas of our museums.

One of our most popular exhibitions in the summer of 2012 was *The Art of Video Games* at the Smithsonian American Art Museum. This was a perfect example of how science and technology unleash human creativity, allowing people to build fully realized worlds that can tap the rich potential of interactive, emotional storytelling. The medium increasingly uses the tools of technology to apply aesthetics, music, and character in a way that immerses participants; video games continue to evolve as an art form.

All of the examples in this volume created something new by bringing together art, aesthetics, design, science, and technology in surprising ways. That is because the wellspring of creativity flows through all of these disciplines. Steve Jobs said as much in 1995 in an interview he recorded for the Smithsonian Oral and Video Histories project. He noted that "there's actually very little distinction between an artist and a scientist or engineer of the highest caliber."[1] This overlap has been present throughout history. Einstein, who was a violinist, said, "If I were not a physicist, I would probably be a musician. I often think in music. I live my daydreams in music."[2] Leonardo da Vinci was the epitome of the Renaissance man, a genius in art, design, science, and mathematics. And as far back as 13,500 years ago, Paleoindian peoples intuitively understood this connection, as the stone Clovis points they created to use as weapons demonstrate artistic beauty, functional design, and scientific thinking.

The Smithsonian is dedicated to bringing creative minds together from different disciplines, including our vast array of experts all across the institution and our many partners outside of it. By tapping into the unexpected connections that result from differing perspectives, we want to initiate innovation and start an ongoing dialogue with learners of all ages. We hope that this impressive collection of essays will spur insights into your own research and motivate you to look to other disciplines for collaboration and inspiration.

G. Wayne Clough
Secretary of the Smithsonian Institution

Notes

1. National Museum of American History, Smithsonian Institution Oral and Video Histories, Steve Jobs, http://americanhistory. si.edu/collections/comphist/sj1.html (accessed May 9, 2012).

2. "What Life Means to Einstein: An Interview by George Sylvester Viereck," *The Saturday Evening Post*, October 26, 1929: 113.

Acknowledgments

Projects as complex as this edited volume are extraordinarily rewarding—and leave deep debts of gratitude to all those who helped us to see it to completion.

First, many thanks to the talented authors whose contributions testify to the time, effort, and thoughtfulness they brought to this project, repeatedly and with good humor. Thank you also to the founders of the Artefacts meetings (Bernard "Barney" Finn of the Smithsonian's National Museum of American History, Robert Bud from the Science Museum in London, and Helmuth Trischler of the Deutsches Museum) for creating these annual gatherings that serve as rigorous investigations into the material culture of science and technology. Thanks also to Barney and to Martin Collins for organizing the 2008 meeting that inspired this volume.

Martin, our esteemed colleague and Artefacts series editor, also earns our gratitude for the opportunity to take on this challenging and rewarding project. Thank you for your support, encouragement, and friendship. Ginger Strader at the Smithsonian Institution Scholarly Press guided this project with clarity and generosity; Deborah Stultz joined her in seeing it through to its conclusion.

The many complexities of assembling text, images, and permissions, with all of the attendant details, from nineteen different authors (including these editors) were made easier by the dedication and organizational finesse of Sara Ickow, Ellen Castrone, and Michael Maizels, three highly capable interns at the National Portrait Gallery.

Anne thanks, as always, her family and, most especially, her husband, Frank, as well as her colleagues at the National Portrait Gallery, particularly Wendy Wick Reaves and Amy Baskette, for their support and encouragement.

Margaret is thankful to her colleagues and family for their support throughout this project.

Anne Collins Goodyear
National Portrait Gallery

Margaret A. Weitekamp
National Air and Space Museum

Introduction

Inspired by the thirteenth annual Artefacts meeting, held in Washington, DC, in October 2008, *Analyzing Art and Aesthetics* investigates the materiality of science and technology, focusing on art and aesthetics. During the two-day meeting, the conference presentations raised fascinating questions. How have artists responded to developments in science and/or technology in their own times or from the past? Moreover, how have art forms as diverse as glassblowing, sculpture, drawing, and painting responded to discourse and achievement in the arenas of science and technology or inspired innovation and discovery in these fields?

Rather than limiting the discussion to art alone, the conference organizers also invited participants to consider aesthetics, a field originally conceived as the philosophy of beauty but reframed in recent years to include the scholarly consideration of sensory responses to cultural objects. When considered as aesthetic objects, how do scientific instruments or technological innovations reflect and embody culturally grounded assessments about appearance, feel, and use? And when these objects become museum artifacts, what aesthetic factors affect their exhibition? For all of these questions, the participating scholars looked for answers in the material objects themselves. By doing so, the conference—and this volume—reconsidered how science, technology, art, and aesthetics influence one another.

Given the opportunity to develop this volume, we asked the authors to delve further into these cross-disciplinary questions, with particular consideration of the centrality of material culture. In addition to scholars who participated in the conference, we invited submissions from people who had not been present at the original conference but whose work engaged the volume's projected themes strongly. The three-part consideration of the Smithsonian Artist Research Fellowship program from the perspectives of an artist, a scientist, and the program's former coordinator was one such addition. The resulting submissions fell rather naturally into three categories: models as aesthetic objects, the aesthetics of technology, and artists interpreting science and technology. All three sections include both topical analyses and exhibit overviews.

The resulting compilation, international in scope, takes seriously both academic and museum practices, bringing to light critical relationships in the work of a diverse range of professionals and intellectuals. It draws not only from art, art history, museum studies, and the history of science and technology but also from other social sciences and humanities fields. This variety reflects the multiple methodologies employed in the study of material culture. Yet the result is a set of papers that speak to each other around a central set of questions. In contributors and topics, this edited collection reflects the diversity that characterizes Artefacts, an international scholarly

collaboration that combines the intellectual frameworks of academic study with the practical considerations of museum work.

Museums provide a rich site for collaborations between the arts and sciences. The examples featured in this volume represent only a small part of the burgeoning interest in combining art, science, and technology. For example, in 2010 and 2011 the Smithsonian National Museum of Natural History participated in The Hyperbolic Crochet Coral Reef, a collective project creating artistic renderings of coral reefs using crochet. Working with Margaret and Christine Wertheim of the Institute for Figuring (IFF), the museum organized volunteer crocheters to produce a textile coral reef. In addition to the inherent visual appeal, the project illustrated complex geometry—and material culture.[1] The ruffled edges of corals are defined by hyperbolas. For centuries, mathematicians struggled to model hyperbolic planes in three-dimensional space, until Cornell mathematician Daina Taimina solved the problem by crocheting the shapes using yarn. The solution was material. According to Margaret Wertheim, the Hyperbolic Coral Reef project illustrated "the importance and value of embodied knowledge." Rather than relying on symbolic knowledge representations (words, equations, or codes, for example), models like the textile coral reef allowed complex ideas, such as hyperbolic geometry, to be grasped, both literally and figuratively.[2]

As we investigated the materiality of science and technology, the category of models presented itself as a special case, integrating many of this volume's themes into one particular kind of objects (and thus featured in their own section). Moreover, these analyses of models also laid out the foundations for material culture analysis in a way that set the tone for the entire volume. As this first section of the volume demonstrates, models serve many functions. They can be miniature versions of large-scale objects that cannot easily be comprehended (or that no longer exist) or durable examples of things that are fragile or perishable. Models can be physical representations of three-dimensional structures (either biological, architectural, or otherwise). Or they can be industrial tools, providing constants against which variable or changing materials can be compared and categorized. They can stand alone as art works. Or they can be practical representations. In their very definition, as material versions of another object, models elicit fundamental questions for material culture scholarship.

Likewise, the material culture studies that follow illustrate the connections between science, technology, art, and aesthetics. The scholars featured here investigate the culturally grounded judgments of taste that guide the development of cell phone towers disguised as trees or that underlie the transformation of space shuttle orbiters into toys. In unpacking the question of how artists have responded to contemporary science and technology, the authors represented here explore what it means for a contemporary artist to develop animated sculpture mimicking deep-sea fish or for an eighteenth-century painter to have fashioned a complex allegory inspired by a shark attack. How does that relate to an outsider artist filling sketchbooks with drawings of fantastical flying machines, inspired by early dreams of flight? How have scientific developments driven artists to reimagine both star fields and their own identities? Interspersed with these essays

are case studies addressing the development of exhibitions. What questions must be considered when exhibiting an artist's cameras, the tools of modern biomedicine—or the industries that built a nation? How do artistic representations illustrate a culture's understanding of its cosmology? Can institutions foster interplay between science and the arts?

Charged with preserving artifact collections for posterity, museums enable visitors to learn by encountering objects. In recent years, museums have employed new techniques to reach visitors with different learning styles—and new expectations for interactivity—using touch, interactive displays, and other immersive strategies. The display and production of art can provide valuable lessons for exhibition designers and curators. Thus, the study of intersections between aesthetics and the material culture of science and technology has critical implications in the context of the museum.

Juxtaposing art and aesthetics with science and technology also has broader practical application. Recently, education reformers have begun adding an *A* for art to the commonly used education acronym of STEM (which stands for science, technology, engineering, and mathematics, four areas of study that have been singled out to be fostered through renewed attention and funding), now rendering it "STEAM." The connections this volume suggests between art, science, and technology could provide some ideas for classroom- or museum-based education planning in support of those efforts.[3]

As a collection of essays, a sourcebook for graduate or undergraduate seminars, and a resource for museum professionals, *Analyzing Art and Aesthetics* not only provides a framework for thinking about the topics addressed in these pages but also offers lessons with a much broader application. We hope that these essays will help museum studies students think about how to exhibit scientific and technological artifacts, art historians to rethink the ramifications of science and technology for the development of visual culture, and historians of science and technology to reconsider the aesthetic dimensions of the material they study. Above all, we hope that these essays, drawn from a broad range of disciplines, will demonstrate the benefit of interdisciplinary study for reinterpreting the rich material culture we occupy.

Notes

1. Institute for Figuring, http://www.theiff.org/ (accessed April 24, 2012). Smithsonian National Museum of Natural History, "The Hyperbolic Crochet Coral Reef," http://www.mnh.si.edu/exhibits/hreef/ (accessed April 24, 2012).

2. Daina Taimini with D. W. Henderson, "Crocheting the Hyperbolic Plane," *Mathematical Intelligencer* 23, no. 2 (2001): 17–28. Also Daina Taimina, *Crocheting Adventures with Hyperbolic Planes* (London: AK Peters, 2009); TED, "Margaret Wertheim on the Beautiful Math of Coral," filmed February 2009, posted April 2009, http://www.ted.com/talks/view/id/519 (accessed April 24, 2012).

3. See, for example, Learning Worlds Institute, "The Art of Science Learning," http://www.artofsciencelearning.org (accessed April 24, 2012); Harvey P. White, (SHW)2 Enterprises, "STEAM: Science, Technology, Engineering, Art, Mathematics," http://steam-notstem.com (accessed April 24, 2012).

Models as Aesthetic Objects

Human knowledge is always analogical and metaphoric. But what does it mean to see something in terms of something else?

Exploring models used to account for or "explain" science and technology, all mediated by aesthetic and stylistic considerations, can serve as a primer in material culture analysis. Models alternately manipulate scale, defy fragility, or systemize the natural or built environment. What are the expectations and conventions caught up with these—frequently sculptural—endeavors designed to shed light on a specific body of knowledge that can only be studied through some analogous material (or virtual) artifact? To what degree can methodologies developed in the fields of art history, architectural history, and the history of technology elucidate the intellectual paradigms caught up in the structures of these analogical objects? And how do models bring objective insight to fields, such as the study of color, that might seem subjective in nature or to materials, such as plants and flesh, that can be too delicate and changeable to promote ongoing, systematic study?

This section incorporates detailed studies of models produced from the late nineteenth century to the present and used to study topics as diverse as architecture, botany, pathology, and color. Katherine Ott, Ellery Foutch, Erin McLeary, and Dirk Bühler examine models themselves and how models—often created to be objective archetypes—can take on different meanings as they are collected by museums.

These essays demonstrate that the museum environment can reveal assumptions, often invisible, embedded in the construction of prototypes for the study of something else. Together they ask us, when surveying such mediating instruments, what does it mean to construct, as Ott argues, "an aesthetics of truthfulness"?

Using Science to Parse the Body
Some Artful Methods for Learning Medicine

Katherine Ott

Curator

Smithsonian Institution
National Museum of American History
Washington, D.C.

Introduction

Medicine, like all professions that rely upon craft knowledge, encompasses a range of graphic and three-dimensional materials. Medical teaching and practice depend upon both technique and theory from science, mathematics, and engineering as well as on the subjective judgments of the practitioner. Likewise, medical practitioners have employed many different methods for conveying information about anatomy, physiology, pathology, diagnosis, and treatment. Three-dimensional models made of wax, papier-mâché, or plastic as well as drawings, woodcuts, stereographs and photographs, working facsimiles, and digital images have all been used in different eras, with varying success. All of these strategies dissect the body in order for the viewer to see the bigger picture. Medical knowledge is then built up from the pieces. Consequently, the artfulness in rendering the pieces influences what becomes known and what remains unstudied or hidden.

The three artifacts that are the subject of this chapter bridge art, aesthetics, and science in order to teach elemental aspects of medicine, expressing both objective theory and subjective interpretation. These three, from the medical sciences collection of the National Museum of American History, were selected because their artistry is immediately obvious, yet each elaborates a different aspect of the relationship between art and science. They illustrate ways in which medicine relies upon representation and demonstrate the importance of culture and aesthetics in guiding the creation of medical knowledge. Each of the objects, drawn from different medical

specialties, frames a different approach to representation. S. I. Rainforth's stereographic set of skin diseases (1910), W. A. Fisher's schematic eye (1920), and an acupuncture model (1990s) are aesthetically complicated and materially rich. These objects are attempts by technicians to work out nature's codes and mysteries through techniques of pictorial representation—to render nature with accuracy. As teaching models, they are used both as literal truth and as material metaphor. They give form to the imagination. All three were created for internalist purposes, intended for a relatively small group of users who required advanced knowledge. But they also have other lives, as part of the market culture of their eras, and now "live" again within museum collections.

Models as Objects

To begin, it is important to acknowledge that these artifacts have been extracted from their appointed course by being repurposed for a museum collection. This removal separates them from other examples of similar artifacts and attaches uniqueness to these particular objects. The separation elevates them among their peers. Following Igor Kopytoff's useful analytical method of examining the life cycle of commodities, these artifacts have undergone successive phases or stages of social transformation, from raw material to design, manufacture, marketing, and exchange and, finally, removal from the marketplace. The objects under examination here have reached an end to their circulation in the marketplace. In Kopytoff's terminology, they are "enclaved."[1] This stage of their existence not only separates them from others of their type, it also separates them from their earlier existence. Their museum isolation has made them precious and has rendered them immune to commercial valuation.

The finality bestowed by the museum facilitates analysis of other aspects of these artifacts' meaning. For example, the artifacts express political positions grounded in their particular systems of medicine. Although they share the general category of health, an obvious difference between Asian and allopathic, biotechnical systems exists. Mediation of this divide is embodied in the acupuncture model through using western numbering conventions on the treatment sites. The allopathic politics of the skin stereographs are evident in the medical language that accompanies the images.

The politics of these "collected" artifacts underscore specific aesthetics of the human body. Their existence within the field of medicine places them outside of the traditional domain of art. The art historian James Elkins has spent much effort in drawing attention to such examples of graphic art in fresh ways, especially in a fine essay on art that is not usually considered art.[2] Elkins rightly points out that in the visual arts, only a tiny portion comprises the fine arts of drawing and painting. The vast visual expanse is made up of what he calls "nonart" images. These are images intended to convey information, such as graphs, schemata, and technical drawings, that is, whatever fine art does not include. One of his explanations as to why these nonart images do not usually receive the kind of attention that typifies traditional art history is that they are not sufficiently unfettered in their expressiveness. They are bound by the technical constraints of the

subject they portray. As illustrated here, analysis of nonart images sometimes generates different kinds of information and interpretation as well.

Another relevant method for interpreting these three artifacts is that of the long and rich history of attempts to translate what is encountered in nature into graphic or material form. Numerous art historians have written about how artists worked out nature's codes and mysteries through techniques of pictorial representation.[3] From the fifteenth to seventeenth centuries, painters such as Masaccio, Van Eyck, Vermeer, and others tried to capture nature on paper and canvas, to conquer reality through graphic imitation. Likewise, the great Vesalius recorded his observations from the anatomy theatre. In the late nineteenth century, Impressionist painters such as Monet, Cezanne, and Morisot played with light and optics to challenge conventional pictorial perspective. These artists undertook empirical investigations of the natural world and related their findings through their art. The artifacts of this chapter may have been created many generations later, but pedagogically, they attempt to do the same thing: render nature with accuracy.

Politics and aesthetics combine in the material form of scientific teaching models. These particular models are for teaching what is known, not for research or creating new knowledge. Models have been used for centuries to demonstrate theories, as prototypes; to give form to the imagination, as part of the research process; or to teach. They can be mass produced commercially, such as phrenological heads, or a one-off, such as patent models. Models are commonly produced where it is important to illustrate relationships that words cannot capture. Models also vividly illustrate that science is not only a form of theoretical knowledge but also a form of practice. Science operates in the realms of the representational and tangible.[4]

The stereograph set, schematic eye, and acupuncture model demonstrate the primary role of objectivity in science as well as the critical need for medicine to be scientific. Each artifact is a statement of objectivity. The stereographic skin clinic conveys the objectivity of the photograph—the aesthetics of truthfulness. Viewers of photographs in this era assumed that such images depicted reality and truth, without editorializing by the artist.[5] The schematic eye presents the objectivity of the mechanical device—the aesthetics of neutrality. Instruments held particular authority as unbiased mediators between true nature and fallible human judgment. Beginning with the stethoscope in 1817, instruments of precision became the hallmark of scientific medicine.[6] The acupuncture figure illustrates the objectivity of the mass-produced product—the aesthetics of standardization. In this case, objectivity resides in the authority of the marketplace. Widespread agreement about the form and design of the model indicated by its acceptance in the marketplace becomes the common wisdom.

The assertion of objectivity through scientific artifacts such as these also makes them important aids in the struggle for professionalization within medicine. Tools such as these, of use only to the trained practitioner, serve as proof of expertise in the same way a framed diploma on the wall indicates ownership of specialized knowledge and authority.[7]

Last, models complicate ways of thinking about embodiment. Because medicine relies upon examination and therapeutic manipulation of the human body, models are also significant

examples of counterembodiment. Whereas practitioners must translate the particular embod-
iment of the patient, the maker or user of models need never come in contact with another
human. Learning from models insulates the student from the intricacies of a person's physicality
and life experiences. This aspect of scientific models places them squarely in the middle of de-
bates over the last twenty-five years, as scholars have reacted to poststructuralism's abstract the-
orizing. As a result, scholars are searching for methods to restore a sense of the lived experience
in their analysis and to regain scholarship as more than abstracted theory and mental gymnastic.
Poststructuralist writers theorize the body by extracting it from its sensory and material pres-
ence.[8] So what about models? Models serve as physical examples of sensory, embodied states,
through which the scientist/physician/maker attempts to create an analog for some aspect of
embodiment. Yet to be useful, models must achieve a level of neutrality as an incarnate demon-
stration as well.

Rainforth's Skin Clinic

Selden Irwin Rainforth is a tantalizing yet enigmatic historical figure. He was born in 1879 in
Hamilton, Ohio. His father was an actor who got his start on the stage in Denver and Central
City, Colorado, with the Selden Irwin Company. Back in Cincinnati, Rainforth senior became the
general manager of the Grand Opera House in 1889. Young Rainforth went to the University of
Cincinnati, received his medical degree from Johns Hopkins University in 1903, and practiced
medicine in New York City from about 1908 until 1929, when he moved to Florida. He disap-
peared from the public record until 1960, when at age eighty-one he took his own life.

Other than diploma dates and obituaries, the only tangible record of Rainforth's life is the
stereograph set in the medical science collections at the National Museum of American History,
made in 1910 (Figure 1). The daughter of a prominent Washington, DC, physician (Marvin A.
Custis) donated the set to the museum along with seventy-one other medical artifacts in 1957.
The set includes 132 half-tone litho print cards, each with an image on the front and an extended
legend (that is, detailed information) on the back, including a description of symptoms, diagno-
sis, and treatment (Figure 2). Rainforth notes on the box that the texts were intended as clinical
lectures. Each set comes in a box with a stereo viewer. There is no information available about
the Medical Art Publishing Company that manufactured it, other than it was located in Brooklyn,
New York. It may have been Rainforth's creation solely for marketing his stereograph sets. The
stereoscope is an H. C. White viewer.

The set is significant for several reasons. There are only a few other stereograph sets related
to medicine. The *Edinburgh Atlas of Anatomy,* an Underwood-Keystone product, was published
beginning around 1900 until 1950. The *Stereoscopic Atlas of Neuro-Anatomy* was published in
1947. Dermatological atlases in book form were common, with large, beautiful lithographed im-
ages. Such atlases were the main means of distributing knowledge of skin disorders, besides
through medical journal articles. Accordingly, Rainforth's skin clinic is subtitled "An Atlas of dis-
eases of the skin . . . " Dermatology was still a new and relatively unorganized specialty in 1910,

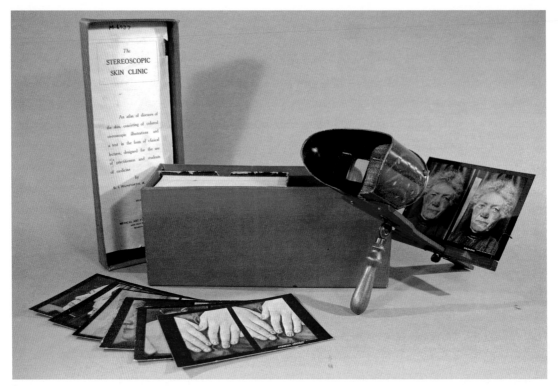

1.

Rainforth viewer and skin cards. Rainforth's stereographs document skin diseases in 3-D. The rear of the cards contains descriptions of symptoms and treatment. From the Division of Medical Sciences, National Museum of American History, Smithsonian Institution, Washington, D.C.

having slowly diversified out of syphilology over the course of the previous century. In Philadelphia, there had been a short-lived dermatology journal that used photography extensively, but there was not a large enough readership to sustain it.[9] So Rainforth was plowing new ground both in medicine and in dermatology.

Rainforth took a bold step in using the commercial stereograph format for doctors. Stereographs were just peaking in popularity in 1910. He probably began taking images and writing the legends a year or more before then.[10] His attempt at making the body three-dimensional is unique. Perhaps his father Harry, the showman, had planted the seed of theatricality in him. He likely would have played with a stereograph as a child, as stereographs had been introduced in the 1860s. Stereo viewers were most often for educational purposes, such as armchair travel, with legends on the back.

The identity of the patients depicted in the images is unknown, as is who took the pictures. There is also no record of the active dates for sales of the skin clinic or who bought it or how it was actually used.[11] It is likely, however, that those who viewed Rainforth's stereoscopes were prompted with views of famous people, the pyramids of Egypt, and vistas of Yosemite. The skin patients in 3-D were no doubt equally serious, exotic, and fascinating to dermatology students. Whoever took them had to have been deeply committed to the work and not motivated by fame or remuneration. Creating such stereographic cards would have required hours of work with

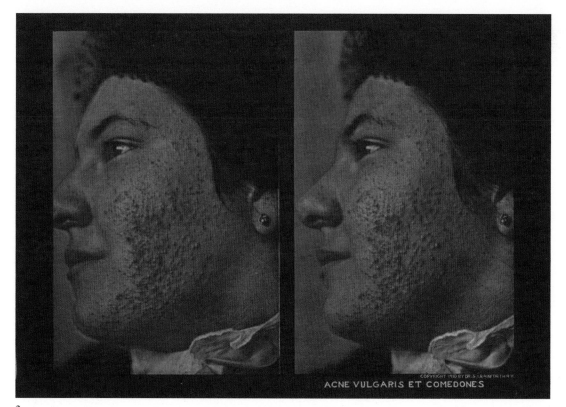

ACNE VULGARIS ET COMEDONES

2.
Rainforth stereograph. Only the affected part of the body is depicted. This abstracts the disease and helps to distance the viewer from the person depicted. From the Division of Medical Sciences, National Museum of American History, Smithsonian Institution, Washington, D.C.

a 5 × 7 camera (the cards state that the original was 5 × 7) and great expense. Further, the images are beautiful in color, composition, and effect. They were created through passion, not for profit.

The bodies and parts of bodies depicted are not intended to be those of individuals. They are depictions of pathology. Consequently, the entry point for comprehending them in their own time is that of perceiving universalized disease. The stereographs of patients are not portraits of individual and social beings. However, the maker intended them to be seen and understood in the spirit of portraiture and adapted corresponding visual cues of the time. For example, the sitter poses for head and shoulder views, centered within the field. Unlike other portraits, the subjects of these portraits are not desirous of establishing a relationship with the viewer. The men and women with erupting rashes do not wish to connect or communicate about themselves with others. They are not individuals with life stories, nor are these portraits intended to confer dignity and posterity upon the subjects.[12] As portraits, they are types, cases, and anonymous disease statements. The aesthetics of Rainforth's work—through the frame, pose, context, and captioning—serve to decontextualize the sitters and turn them into "patients." Rainforth the doctor erased the sitters subjective history and biographical context and converted their interesting humanness into interesting disease. Although they wear street clothes, they are "cases."

Barthes writes that photographs assert the existence of the thing shown.[13] Photographs produce truth in that they are indisputable evidence that their contents once existed. This aspect of photographs makes them ideal as carriers of medical information. Medicine, in its search for truth, finds the perfect expression in images of patients. Their "patientness" clearly illustrates the medical model of disability as well. They are patients first and people second. Their primary identity is their illness, and their illness requires fixing, treatment, or eradication. One of the casualties resulting from the strength of the medical model in this era is a holistic approach to people with a disability or illness.

Schematic Eye

The schematic eye illustrates somewhat different themes in the fields of art and science (Figure 3). Made by William Albert Fisher, it is one example from among several methods for practicing how to use an ophthalmoscope that circulated at the turn of the twentieth century. Born in Indiana in 1859, Fisher was a Midwesterner all of his life. He received his medical degree from the University of Michigan in 1885 and taught and practiced ophthalmology for many years in Chicago. He specialized in cataract surgery and traveled to India several times to study the technique there. In Chicago, Fisher was influential in the medical community, having been president of the Chicago Ophthalmological Society (1910–11), a fellow of the American College of Surgeons, and

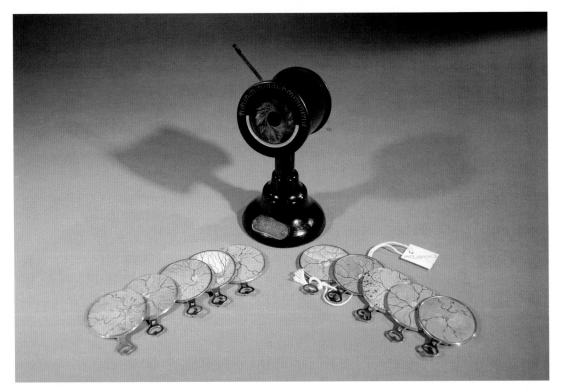

3.
Schematic eye. The cast-iron base has a barrel with an iris shutter that accommodates the colored discs with representations of various conditions of the fundus. It is used with an ophthalmoscope. From the Division of Medical Sciences, National Museum of American History, Smithsonian Institution, Washington, D.C.

a founder of the Chicago Ear, Eye, Nose and Throat College and hospital. He died in Chicago in 1944.[14]

The device illustrates how provenance and biography can become enmeshed. Fisher created his device around 1907.[15] It was, perhaps, the most popular schematic eye in the United States, being the most common one that turns up in trade catalogs and the one usually mentioned in ophthalmic textbooks. The example in the National Museum of American History's collections dates from about 1920, based on comparison with printed illustrations of it. The Fisher schematic eye was marketed at least until 1937. Fisher wrote a textbook about how to use it, and the fourth and final edition was published in that year. Alice S. Cleveland is credited as the artist who drew the twenty-four discs. She signed each one along the rim. Nothing else is known about her. She may have been a relative or friend. She may have been an art institute graduate who made a living illustrating and coloring cards, texts, and other paper goods. The device was distributed by McIntire, Magee and Brown; Riggs Optical; and later by Bausch and Lomb. Distinctions among maker, owner, and seller yield little about this particular object's life cycle; provenance is reduced to biography. The National Museum of American History's example was purchased in 1993 at a New York auction where the device had ended up as part of the commercial offerings of a numismatics seller.

The discs are representations of the fundus (the back of the eye) as it is seen with an ophthalmoscope. Each depicts a particular condition, such as detached retina, neuroretinitis, and rupture of the choroid. Fisher purposely printed the discs with a screen to achieve a stippling effect (they appear blurred to the naked eye) so that when viewed through the magnifying lens of the ophthalmoscope, the image was more realistic.[16] The crystal in the front of the barrel is a +13 diopter from a trial lens set. The barrel itself telescopes to simulate a near- or far-sighted eye. In his textbook about using the device, Fisher notes that "a practical schematic eye can be made by any carpenter."[17] The student uses the device to improve her or his skill with an ophthalmoscope, an instrument used to examine the interior of the eye. Fisher also suggests that students master control of the light beam, the most difficult part of the maneuver, by directing it through the narrow opening in a spool of thread as practice. The ophthalmoscope, over fifty years old when Fisher made his device, was a part of basic office instrumentation for general practitioners in the early twentieth century. A thermometer, stethoscope, otoscope, and ophthalmoscope could be found in many offices.[18] Although most physicians received training in medical school in the use of instruments, practitioners long out of school needed instruction when new or redesigned instruments appeared on the market. Furthermore, Fisher explained the reason for his device and accompanying textbook was that instruction in the use of the ophthalmoscope was seldom or badly given.[19]

The discs, similar to the skin stereographs, graphically rhyme with each other. They go together, each a variant of the other. They constitute a minicollection of their own. As with all collections, whether of shot glasses or T-shirts, they illustrate the principle of sameness in difference. This is the principle that fuels the desire of collectors as they build their collections. In

assembling a collection, with the compiler as the originator, the images build upon each other, creating a sense of unity in diversity.[20]

The discs also create an economical abstraction. They reduce the large subject of the human body to a simple element, the fundus, and communicate the subject as a "case." The stand that supports the device is an attempt to reintegrate the part into a larger whole. The stand, as a metaphoric optic nerve connecting the eye to the rest of the body, provides a modicum of setting. The discs fragment the body even more than the skin stereographs, capturing the extent to which specialization had become routine. Although there were not nearly as many medical subspecialties in the early twentieth century as there are now, in Fisher's time, specialization was no longer controversial. So much knowledge existed about the body that no one physician could stay current in it all. Specialists had begun to claim sovereignty over various physiological parts and systems. Mastery of the discs equals mastery of specialized knowledge.

The discs are also artistic curiosities. They are like exploded drawings, depicting the bits and shards after the body is dissected. Exploded drawings are meant to show how the thing exploded fits together. These discs show the scraps or shrapnel left from opening multiple orbits for study. As with exploded drawings, only an artist can create them, not a photographer, and as with shrapnel, only a physician can relate them to the body. Because they are meant to represent the generic eye in different states, they require imagination and flexibility not possible with a camera. Because they are drawn from life and interpreted from the experience of examining numerous eyes, these objects could not have been rendered photographically.[21]

Acupuncture Models

We turn now to yet another mode of representation of the body for teaching purposes. The acupuncture model presents a different set of aesthetic choices, having to do with vantage point and translation across cultures. The plastic female figure has the acupuncture points and meridians marked with both Chinese words and Arabic numerals, the blending of East and West (Figure 4). The dual-identification system was created to make it easier for Westerners to learn the techniques. In Chinese medicine, the acupuncture points have illustrative names, such as "conception vessel," "palace of toil," and "central treasury," making it difficult for those who are culturally illiterate. The nature of points, expressed eloquently in their names, is important to understanding needle combination and placement. The complexity of the names and their meanings and the location of the points, meridian, and channels necessitate years of study.

Acupuncture originated in China and dates to at least 200 BC. It was introduced into Europe in the eighteenth century and was reported in American medical literature in the mid-1800s. The popularity of acupuncture in the United States outside of Asian communities dates from the 1970s, after journalist James Reston was successfully treated for an illness while he accompanied Richard Nixon to China.[22]

Mastery of acupuncture relies upon models and charts. A figure cast in bronze in 1443, currently in the collections of the State Hermitage Museum in St. Petersburg, Russia, has 654

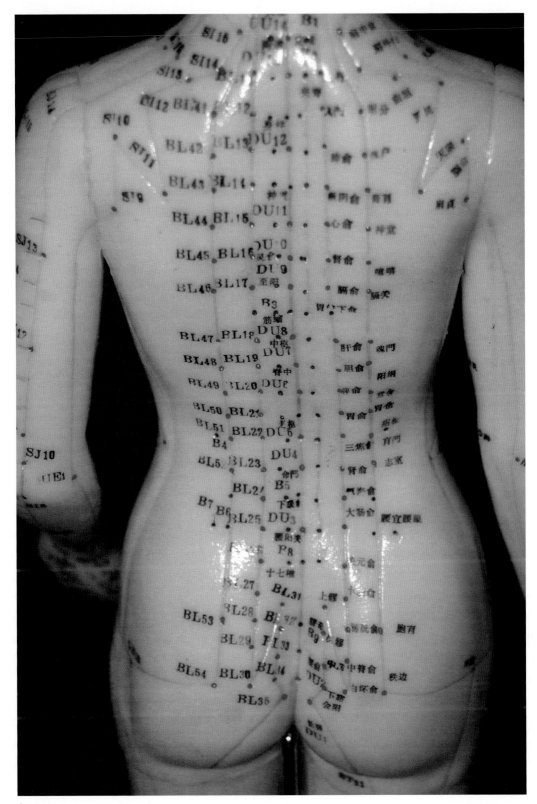

4.
Acupuncture figure, rear torso view. This plastic figure of a generic human body is mass produced and includes markings for the points and meridians in Chinese letters and as numerals. From the Division of Medical Sciences, National Museum of American History, Smithsonian Institution, Washington, D.C.

points with 352 names. The advent of a numerical system, although making the teaching and learning easier, results in both a different training and orientation to the points and an altered relationship to the body. In addition, the sequential numbering misleads the casual viewer into the false assumption of a hierarchical or chronological order. However, Western science requires eliminating or reducing subjectivity wherever possible. The World Health Organization released a standard acupuncture nomenclature in 1991, noting that it is important to put the method of treatment on a firm scientific basis in order to investigate its claims to efficacy. Consequently, the use of numbers is both instrumental for scientific replication and testing and symbolic of allopathic acceptance through evacuating "native" associations. In 1996, the Food and Drug Administration removed acupuncture needles from the list of experimental devices, and treatments have since become a mainstay in integrative medicine.

Asian practitioners used models for teaching acupuncture as early as the seventh century. Used for student examinations, the models were made of wood and covered in wax to conceal the points. They were also made of bronze. In the West, models for teaching about the human body have a long history. European models were usually for teaching anatomy. Ivory examples date from the early seventeenth century.[23] Crafted from many different materials and varied in design and purpose, the aspect that all models have in common is that they reflect the creative efforts of the imagination in parsing the body into a manageable entity. That is, such models draw attention to some aspect of the whole and demonstrate where the piece fits.

Although the fitting of body parts to the whole is fundamental to acupuncture practice, the points and their names also represent place and history. The acupuncture model is a figurative container for the cultural viscera of the patient's body, essential for diagnosis and treatment. The names, before they were turned into numbers for Western practitioners, explain the context, implications, relationships, and purposes of each point. Each is a specific and richly articulated location—a geographic place on the body that is fixed in culture. The acupuncture model is a cultural map of the cumulative knowledge about things that have happened in the past to human bodies. The Western Apache people have an analogous way of understanding location that helps to elucidate the cultural work of the model. Places such as "Water Lies with Mud in an Open Container" or "Snake's Water" demonstrate how historical events unfold in a specific place and continue to animate the place and anchor it in Apache comprehension.[24] The name contains an account of how the place came to be known and its significance in the identity of a group of people.

In the Western biomedical system of medicine, using narrative as data is a problem. It opens the door to subjectivity and rubs against the precision of science. Another example of this discomfort with narrative subjectivity is found in the history of recording patient information. Physicians gradually replaced prose accounts in their case records with charts, printed templates, graphs, and information mediated by technology.[25] For Western practitioners, replacing the prose names of points with numbers not only makes them easier to remember but also translates the unscientific, subjective information into neutral science, just as substituting a temperature graph

for a verbal description of a fever is more exact. The Rainforth images work in this way as well, turning unmanageable humans into compliant, organized patients.[26]

In addition, the inked points act as both openings into the body and marks upon its surface. Each dot locates an opening, the technical purpose of the model. Some early models actually had holes plugged with wax that exuded liquid when pierced in the proper spot. As marks upon the surface, the dots are merely ink decoration, tattooing the plastic exterior. But as the core data, they are paramount. The dyed spots reference the portals to the interior channels where the healing takes place. The points make no sense individually and are unimportant in and of themselves. Their power rests upon the hidden interior substance they target.

Unlike the schematic eye and the skin stereographs, the acupuncture model is of the entire human body, placing the points in full, not partial, context. This gives the model a decidedly unscientific, doll-like or toy impression. Another way to understand the shift in perspective that takes places with the acupuncture model is to think of the overall model as a classic view from above, similar to the popular bird's-eye views of villages that enclosed and ordered the inhabited terrain of late nineteenth and early twentieth-century life, except with the focal length of the human body.[27] To extend the analysis a bit further, if the acupuncture model is the bird's-eye view, establishing boundaries and portraying consensus, the schematic eye and the acupuncture points are the city street view, capturing the emblematic commerce of the body.

Conclusion

In addition to the functions described above, all three objects share a theatrical function. They perform medical competency, supported by technical knowledge and training. They dramatize the patient, with a physician maestro as both creator and audience. The physician guides the composition, content, shape, color, and highlighted features in producing a commercial consumer product for other physician practitioners. Certainly, all three of these artifacts are for internalist purposes, for a relatively small group of users. In advance of their use, specific knowledge and expertise is necessary in order to employ them for the intended purpose.

However, the models also have other lives and relationships that are revealed through examining their components. Stereographs are a mass cultural form, hugely popular and widely collected by all kinds of people. Science is a familiar theme in the work of many artists. A number of artists have anatomical training or use medical imagery in their work, mixing science into the art rather than art into the science as with these models. The acupuncture model is sold in catalogs for Asian cultural products, available to anyone with a charge card, a type of medical tourism that is peculiar to market economies. Artifacts are ideology in material and visual form. They are symbols of desire and carriers of tension and need. Certain objects carry repressed, unconscious desire. These three artifacts express deeper desires for health, knowledge, power over the mysteries of the physical body, or integration into a fraternity of healers.[28]

The models also illustrate attributes of modernity through their material existence. They make information available to a broad group, the sharing of privileged knowledge (democratizing)

for purchase (consumerism), and are part of modernity's explosion of imagery. The schematic eye with its cast-iron base and hand-painted paper discs and the stereographs straddle the transition between artisan products, with designs closely wedded to materials, and mass-marketed products, with designs unleashed by new materials and processes. The fact that they were both marketed through commercial medical trade catalogs anchors them in modern economies of exchange. Furthermore, they are examples of what Foucault long ago pointed to as disciplining the wildness of culture (although he was writing about the seventeenth and eighteenth centuries): how teaching about medicine and bodies resulted in the standardizing of examination and normalizing of judgment.[29]

There is yet another way to understand what can be gained through close analysis of artifacts illuminated by considering two dimensions of the relationship between people and objects.[30] The human dynamic with objects can move from action to contemplation, facilitating deeper knowledge or insight. The motion can also move from self to others, affecting connections with other beings. These three objects immensely complicate that relational movement. They enact the dimension of action to contemplation by providing the raw material for knowledge processing. At the same time, they also dwell along the dimension of self to others by moving from the particular to the general, the part to the whole, through acquisition of the bits of knowledge that build professional expertise. This contradictory existence might be a universal characteristic of heuristic objects, those meant for instruction and application. Certainly, it is at the very heart of models.

Acknowledgments

I wish to acknowledge the research assistance of Ellen Castrone, my intern, who did much of the digging related to these artifacts as well as the photography of them. Intern Sophia Zuluaga also contributed to the photography.

Notes

1. Anthropologists have done the significant work on analyzing objects in this way. A good place to start is Arjun Appadurai, ed., *The Social Life of Things: Commodities in Cultural Perspective* (Cambridge: Cambridge University Press, 1986); see especially Igor Kopytoff's essay, "The Cultural Biography of Things," 64–91.

2. James Elkins, "Art History and Images That Are Not Art," *The Art Bulletin* 77 (December 1995): 553–71.

3. For example, see, Thomas Kaufman, *The Mastery of Nature* (Princeton, NJ: Princeton University Press, 1993).

4. For more on science and 3-D modeling, see the volume edited by Soraya de Chadarevian and Nick Hopwood, *Models: The Third Dimension of Science* (Stanford, CA: Stanford University Press, 2004). For the use of theoretical models in fields such as economics and business, see Mary Morgan and Margaret Morrison, eds., *Models as Mediators* (Cambridge: Cambridge University Press, 1999).

5. For more on photography as a conveyor of truth, see John Tagg, *The Burden of Representation* (Amherst: University of Massachusetts Press, 1988); Allan Sekula, "The Body and the Archive," in *The Contest of Meaning: Critical Histories of Photography*, ed. Richard Bolton (Cambridge, MA: The MIT Press, 1989), 343–389; Lorraine Datson and Peter Gallison, "The Image of Objectivity," *Representations* 40, Fall 1992:82–128.

6. A contemporary explanation of this can be found in S. Weir Mitchell, *The Early History of Instrumental Precision in Medicine* (New Haven, CT.: Tuttle, Morehouse, and Taylor, 1892); see also Stanley Reiser, *Medicine and the Reign of Technology* (Cambridge: Cambridge University Press, 1978).

7. For more on the development of medicine as a profession, see John S. Haller Jr., *American Medicine in Transition, 1840–1910* (Urbana: University of Illinois Press, 1981).

8. For discussion of this as it relates to material culture, see P. M. Graves, ed., *Matter, Materiality and Modern Culture* (London: Routledge, 2000); see also Charles Jencks, ed., *The Post-Modern Reader* (New York: St Martin's Press, 1992); Pierre Bourdieu,

Acts of Resistance: Against the New Myths of Our Time (Cambridge: Polity Press, 1998); Perry Anderson, *The Origins of Post-modernity* (London: Verso, 1998).

9. *Journal of Cutaneous and Venereal Diseases*, begun in 1883. Medical moulage would have been familiar to Rainforth and other physicians of the time and may have been a motivation for the stereographs. The heyday of wax models of disease, especially of the skin and body surface, was the 1880s–1950s. Medical moulage eventually lost out to photography as a heuristic medium. For more on medical moulage, see Thomas Schnalke, *Diseases in Wax: The History of Medical Moulage* (Berlin: Quintessence Publishing, 1996).

10. William Darrah, *The World of Stereographs* (Gettysburg, PA: W. C. Darrah, 1977); Paul Wing, *Stereographs: The First One Hundred Years* (Nashua, NH: Transition Publishing, 1996).

11. Little has been written about Rainforth or his stereographs. One of the few printed pieces is an interview with an artist who admired Rainforth's work: Warren Dotz, "Dr. Rainforth's Dermatologic Stereoview," *American Journal of Dermatology* 5 (October 7, 1985): 447–53.

12. See W. J. T. Mitchell, *What do Pictures Want? The Lives and Loves of Images* (Chicago: University of Chicago Press, 2005).

13. Roland Barthes, *Camera Lucida*, trans. Richard Howard (New York: Hill and Wang, 1981).

14. This biographical information was supplied by staff at the American College of Surgeons and the Chicago Ophthalmologic Society. See also Fisher's obituary in the *Chicago Daily Tribune*, August 2 1944, and his entry in Albert Marquis, ed., *The Book of Chicagoans: A Biographical Dictionary of Leading Living Men of the City of Chicago* (Chicago: A. N. Marquis & Co., 1911).

15. W. A. Fisher, "New Schematic Eye," *Ophthalmic Record; a Monthly Review of the Progress of Ophthalmology* 16 (1907): 6.

16. W. A. Fisher, *Ophthalmoscopy, Retinoscopy and Refraction* (Philadelphia: F. A. Davis, 1927), 26.

17. Fisher, *Ophthalmoscopy*, 21.

18. Daniel Cathell, *The Physician Himself and What He Should Add to His Scientific Acquirements* (Baltimore: Cushings and Bailey, 1882).

19. Fisher, *Ophthalmoscopy*, 5, 15.

20. For more on collection building in this sense, see Brenda Danet and Tamar Katriel, "No Two Alike: Play and Aesthetics in Collecting," *Play and Culture* 2 (1989): 253–77; Russell Belk, *Collecting in a Consumer Society* (New York: Routledge, 1995); Werner Munsterberger, *Collecting: An Unruly Passion: Psychological Perspectives* (Princeton, NJ: Princeton University Press, 1994); Jean Baudrillard, "The System of Collecting," in *The Cultures of Collecting*, ed. John Elsner and Roger Cardinal (Cambridge, MA: Harvard University Press, 1994), 7–24.

21. Note that the ability to sketch was relatively common among doctors, as with engineers and inventors. Physicians' casebooks often have visual renderings of symptoms, treatments, and outcomes. Drawing skill is no longer as evident today, however, having been replaced by Web archives and digital images and, before that, printed forms with body templates upon which the physician marked the location of disease or intervention.

22. For the history of acupuncture, see Charles Leslie, ed., *Asian Medical Systems* (Berkeley: University of California Press, 1976); Paul Unschuld, *Chinese Medicine* (Brookline, MA.: Paradigm Publishing, 1999); Joseph Needham, *Science and Civilization in China*, vol. 6, part 6, *Medicine* (Cambridge: Cambridge University Press, 2000).

23. See C. J. S. Thompson, "Anatomical Manikins," *Journal of Anatomy* 59 (1925): 442–45; K. F. Russell, "Ivory Anatomical Manikins," *Medical History* 16 (1972): 131–42; Thomas Haviland and Lawrence Parish, "A Brief Account of the Use of Wax Models in the Study of Medicine," *The Journal of the History of Medicine and Allied Sciences* 25 (1970): 52–75.

24. For more on the importance of place and analysis of the relationships between place and the cultural identity of objects and people, see anthropologist Keith Basso's book on the Western Apache: *Wisdom Sits in Places* (Albuquerque: University of New Mexico Press, 1996).

25. For more on the transition of patient records, see Joel D. Howell, *Technology in the Hospital: Transforming Patient Care in the Early Twentieth Century* (Baltimore: Johns Hopkins University Press, 1995).

26. For more on photography as an important tool for scientific medicine, see Rachelle Dermer, "Photographic Objectivity and the Construction of the Medical Subject in the United States" (PhD diss., Boston University, 2002).

27. For the history of bird's-eye views, see Peter Hales, *Silver Cities: The Photography of American Urbanization* (Philadelphia: Temple University Press, 1984).

28. For more on this aspect of artifacts, see Karl Marx's classic explanation: "The Fetishism of Commodities and the Secret Thereof," in *Capital: A Critical Analysis of Capitalist Production* (London: Swan, Sonnenschein & Co., Ltd., 1904), 41–55.

29. See Michel Foucault, *Discipline and Punish: The Birth of the Prison* (New York: Vintage, 1979); *Madness and Civilization: A History of Insanity in the Age of Reason* (New York: Vintage, 1973).

30. For more on these aspects of understanding, see Mihaly Csikszentmihalyi and Eugene Roehberg-Halton, *The Meaning of Things* (Cambridge: Cambridge University Press, 1982), 112.

Bibiliography

Anderson, Perry. *The Origins of Postmodernity*. London: Verso, 1998.

Appadurai, Arjun. "Introduction: Commodities and the Politics of Value." In *The Social Life of Things: Commodities in Cultural Perspective*, edited by Arjun Appadurai, 3–63. Cambridge: Cambridge University Press, 1986.

Barthes, Roland. *Camera Lucida*. Translated by Richard Howard. New York: Hill and Wang, 1982.

Basso, Keith. *Wisdom Sits in Places.* Albuquerque: University of New Mexico Press, 1996.

Baudrillard, Jean. "The System of Collecting." In *The Cultures of Collecting,* edited by John Elsner and Roger Cardinal, 7–24. Cambridge, MA: Harvard University Press, 1994.

Belk, Russell. *Collecting in a Consumer Society.* New York: Routledge, 1995.

Bourdieu, Pierre. *Acts of Resistence: Against the Myths of Our Time.* Cambridge: Polity Press, 1998.

Cathell, Daniel. *The Physician Himself and What He Should Add to His Scientific Acquirements.* Baltimore: Cushings and Bailey, 1882.

Csikszentmihalyi, Mihaly, and Eugene Roehberg-Halton. *The Meaning of Things.* Cambridge: Cambridge University Press, 1982.

Danet, Brenda, and Tamar Katriel. "No Two Alike: Play and Aesthetics in Collecting." *Play and Culture* 2 (1989): 253–77.

Darrah, William. *The World of Stereographs.* Gettysburg, PA: W. C. Darrah, 1977.

Datson, Lorraine. "The Image of Objectivity." *Representations,* Fall 1992:82–128.

de Chadarevian, Sonya, and Nick Hopwood, eds. *Models: The Third Dimension of Science.* Stanford, CA: Stanford University Press, 2004.

Dermer, Rachelle. "Photographic Objectivity and the Construction of the Medical Subject in the United States." PhD diss., Boston University, 2002.

Dotz, Warren. "Dr. Rainforth's Dematologic Stereoview." *American Journal of Dermatology* 5 (October 7, 1985): 447–53.

Elkins, James. "Art History and Images That Are Not Art." *The Art Bulletin* 77 (1995): 553–71.

Fisher, W. A. "New Schematic Eye." *Ophthalmic Record: A Monthly Review of the Progress of Ophthalmology* 16 (1907).

———. *Ophthalmoscopy, Retinoscopy and Refraction.* Philadelphia: F. A. Davis, 1927.

Foucault, Michel. *Discipline and Punish: The Birth of the Prison.* New York: Vintage, 1979.

———. *Madness and Civilization: A History of Insanity in the Age of Reason.* New York : Vintage, 1973.

Graves, P. M., ed. *Matter, Materiality and Modern Culture.* London: Routledge, 2000.

Hales, Peter. *Silver Cities: The Photography of American Urbanization.* Philadelphia: Temple University Press, 1984.

Haller, John S., Jr. *American Medicine in Transition, 1840–1910.* Urbana: University of Illinois Press, 1981.

Haviland, Thomas, and Lawrence Parish. "A Brief Account of the Use of Wax Models in the Study of Medicine." *The Journal of the History of Medicine and Allied Sciences* 25 (1970): 52–75.

Howell, Joel D. *Technology in the Hospital: Transforming Patient Care in the Early Twentieth Century.* Baltimore: Johns Hopkins University Press, 1995.

Jencks, Charles, ed. *The Post-Modern Reader.* New York: St. Martin's Press, 1992.

Kaufman, Thomas. *The Mastery of Nature.* Princeton, NJ: Princeton University Press, 1993.

Kopytoff, Igor. "The Cultural Biography of Things." In *The Social Life of Things: Commodities in Cultural Perspective,* edited by Arjun Appadurai, 64–91. Cambridge: Cambridge University Press, 1986.

Leslie, Charles, ed. *Asian Medical Systems.* Berkeley: University of California Press, 1976.

Marquis, Albert. "Dr. W.A. Fisher." In *The Book of Chicagoans: A Biographical Dictionary of Leading Men of the City of Chicago,* 236. Chicago: A. N. Marquis & Co., 1911.

Marx, Karl. "The Fetishism of Commodities and the Secret Thereof." In *Capital: A Critical Analysis of Capitalist Production,* 41–55. London: Swan, Sonnenschein & Co., 1904.

Mitchell, S. Weir. *The Early History of Instrumental Precision in Medicine.* New Haven, CT: Tuttle, Morehouse, and Taylor, 1892.

Mitchell, W. J. T. *What Do Pictures Want? The Lives and Loves of Images.* Chicago: University of Chicago Press, 2005.

Morgan, Mary, and Margaret Morrison, eds. *Models as Mediators.* Cambridge: Cambridge University Press, 1999.

Munsterberger, Werner. *Collecting: An Unruly Passion: Psychological Perspectives.* Princeton, NJ: Princeton University Press, 1994.

Needham, Joseph. *Science and Civilization in China.* Volume 6, Part 6. *Medicine.* Cambridge: Cambridge University Press, 2000.

Reiser, Stanley. *Medicine and the Reign of Technology.* Cambridge: Cambridge University Press, 1978.

Russell, K. F. "Ivory Anatomical Manikins." *Medical History* 16 (1972): 131–42.

Schnalke, Thomas. *Diseases in Wax: The History of Medical Moulage.* Berlin: Quintessence Publishing, 1996.

Sekula, Allan. "The Body in the Archive." In *The Contest of Meaning: Critical Histories of Photography,* 343–386, edited by Richard Bolton. Cambridge, MA: The MIT Press, 1989.

Tagg, John. *The Burden of Representation.* Amherst: University of Massachusetts Press, 1988.

Thompson, C. J. S. "Anatomical Manikins." *Journal of Anatomy* 59 (1925): 442–45.

Unschuld, Paul. *Chinese Medicine.* Brookline, MA: Paradigm Publishing, 1999.

Wing, Paul. *Stereographs: The First One Hundred Years.* Nashua, NH: Transition Publishing, 1996.

CHAPTER 2

The Disappearing Model
Harvard's Glass Flowers
and the Perils of Trompe l'Oeil

Ellery Foutch
A.W. Mellon Postdoctoral Fellow

University of Wisconsin-Madison
Madison, Wisconsin

The Glass Flowers in Harvard's Museum of Natural History have long blurred the boundaries between science and art; they are commonly promoted as "an artistic marvel in the field of science and a scientific marvel in the field of art."[1] These models have delighted viewers with their deceptive exactitude since they were first made by German glassmakers Leopold (1822–1895) and Rudolf (1857–1939) Blaschka. Beyond pedagogical tools, the Glass Flowers became a popular tourist phenomenon and have been memorialized in poems, photographs, and artistic tributes, some of which continue to blur the line between the models' status as illusionistic representations and actual flowers. Yet the very illusionism that made the Glass Flowers such a popular attraction in the first century of their existence has also led to a manner of disappearance of the models, a denial of their materiality as unique, handmade objects painstakingly fashioned from glass, wire, and pigments. The Glass Flowers resist being read in terms of composition or form, in part because they are so convincing at posing as the plants themselves. The accuracy and successful execution of the models have made them almost impenetrable to critique or analysis. Yet the models can and should be analyzed as small-scale, polychrome glass sculptures that are themselves a mediated representation of the plant world, molded by human hands: the products of dozens of aesthetic and logistical decisions.[2]

Specimens versus Models, Natural versus Artificial: The History of Harvard's Botanical Museum

Harvard's Museum of Vegetable Products was founded in 1858 when botanist Asa Gray collected and organized plant specimens such as wood samples, cones, nuts, and seed pods, some of which had been given as duplicates from the British Royal Botanic Gardens at Kew (Figure 1).[3] Although these specimens and the dried, pressed plants and type specimens of herbaria were the accepted materials used for botanical research, training, and museum display, they did not yield an eye-catching installation or give an accurate representation of a living plant. Within the realm of the natural history museum, these drab displays of faded pressed leaves or dusty drawers of pinecones were in disappointing contrast to the spectacular displays of taxidermy and articulated skeletons or the sparkling gems and minerals housed in the university's popular mineralogical cabinet. Living plants were not a pragmatic solution either: the limited greenhouse facilities were unable to produce the volume of plants needed for display or classroom use, and Harvard's Botanic Garden and Arnold Arboretum (given to the university in 1872) were inhospitable or in hibernation for large parts of the year during Cambridge's long winter. As botany professor George Lincoln Goodale lamented in one of his updates for Harvard's annual report, the academic year began "near the time of the early frosts, and ends in May. The whole period in which our Garden can furnish out-of-door flowers for our classes is very short."[4] The timing of the academic year calendar was almost fully incompatible with the study of botany from nature.

1.

Installation view featuring the original collections of the Harvard Botanical Museum assembled by Asa Gray, from the exhibition *Dodos, Trilobites, & Meteorites . . . Treasures of Nature and Science at Harvard*, Harvard Museum of Natural History, Cambridge, Massachusetts. Photograph by the author, August 2009.

Goodale was desperate to find specimens that could represent plants in all their complexity and exactitude yet would be impervious to the effects of time, not fading or wilting, not depreciating or becoming disfigured. As he contemplated the pedagogical models and plant specimens currently available, none seemed equal to the task. As Goodale mused,

> Flowers are perishable, and all preparations of flowers are more or less unsatisfactory. When dried they are distorted, when placed in alcohol they are robbed of their color, when depicted on canvas or paper they are necessarily more or less conventionalized . . . Flowers, when copied in wax, become like the cheerless elements of funereal wreaths; when given in papier-mâché, they are necessarily exaggerated and grotesque. What remains? In what material can plants and their magnified parts be rendered permanent?[5]

Flowers seemed incapable of representing themselves to viewers past a certain point, losing both color and form in alcohol or pressed specimens. Goodale objected to traditional tools of botanical illustration in two-dimensional representations of flowers as well as three-dimensional renderings in papier-mâché and wax, despite the fact that several botanical museums, including the influential Kew Gardens, had embraced wax models to represent plants, especially rarely blooming species like orchids, amassing a large collection of wax models through the 1850s and 1860s.[6] Yet to Goodale, wax models seemed too evocative of funeral arrangements, decidedly nonscientific and emotionally loaded. Goodale's complaint indicates that, rather than the scientific precedents of wax models, he associated wax fruits and flowers with handmade memorials and the fancywork projects popularly embraced by women in this period, indicators of middle-class femininity and taste rather than intellectual rigor.[7]

Similarly, the papier-mâché models of Germans Robert and Reinhold Brendel and French modeler L. T. J. Auzoux were popular teaching tools for botany professors in the United States and around the world, and they were frequently exhibited at meetings of scientific societies, where viewers praised their sturdiness and the large scale that allowed classroom demonstrations of virtual dissections thanks to their removable parts.[8] These models distill flowers down to essential characteristics, eliminating distracting details in their straightforward representations of plants and their reproductive systems, but to Goodale, these simplifications were "exaggerated" and "grotesque."[9] Goodale found fault with what others saw as strengths.

Despite the established tradition of studying and teaching botany with artificial, constructed models rather than actual plants, Goodale remained dissatisfied with the existing options. In his letters and published writings, Goodale repeatedly voiced the desire for a teaching collection that would be both "permanent" and "perfect," a term he deployed to convey concepts of completeness or totality, exactitude or fidelity to nature, accuracy of representation, and an ultimate, final state that cannot be improved.[10] In search of this ideal, he contacted German glassworkers Leopold and Rudolf Blaschka, who were known worldwide for their detailed models of marine invertebrates.[11]

The story of Goodale's initial visit to the Blaschka studio, in search of perfect glass models of flowers, has been well established: inspired by the Blaschkas' detailed models of jellyfish,

octopuses, and sea anemones that were in Harvard's Museum of Comparative Zoology, Goodale embarked upon a mission to convince the Blaschkas to model flowering plants for his Botanical Museum, visiting their home and studio in a suburb of Dresden in the fall of 1886.[12] Despite the artists' initial resistance, Goodale persevered, and his advance payment of 200 marks secured an initial shipment of botanical models that arrived in the spring of 1887; their quality encouraged Goodale to seek a more extensive contract with the glass artists, whose lampworking techniques transformed bits of glass into shapes and textures that imitated plant forms nearly seamlessly.[13] Goodale also secured patronage for the work by suggesting that the collection become a memorial to Charles Eliot Ware, fulfilling the desire of Ware's widow and daughter for a donation in Ware's memory. By mid-April 1890, the Blaschkas had signed an exclusive, binding contract with Harvard, guaranteeing that they would dedicate all their working time in the coming ten years to botanical models for Harvard's collection and ending their production of marine models. Ultimately, the Glass Flowers became a life's labor and their last project; after Leopold's death in 1895, his son Rudolf continued to work alone on the models until his hands and eyes failed him, sending the final shipment in November of 1936.

The Success of the Glass Flowers

The glass models were declared a triumph, aesthetically, scientifically, and pedagogically, functioning not only as teaching aids but also as a popular tourist attraction. Only a few short years after their original commission, the models were drawing admiring crowds, both in Cambridge and at their display at Chicago's Columbian Exposition.[14] In the fall of 1893, the *New York Times* reported on the arrival of a new shipment of models, an event that

> always stimulates interest in the wonderful collection at the Agassiz Museum. Here for nearly two years the beautiful specimens of iridescent glass have attracted crowds to Cambridge. As one of the professors has remarked in private: "The Blaschka flowers are evidently the most attractive feature of the university. Visitors leave the library, gymnasium, and laboratory to get one more glimpse of those gorgeous tints."[15]

Meanwhile, at Harvard's world's fair display in Chicago, a reviewer noted the glass flowers were given "the place of honor. Many visitors [come] to gratify their curiosity in regard to these famous flowers alone; and even those whose scientific temper should be proof against any undue seduction of curiosity or aestheticism, often find it difficult to divert their attention to the . . . more prosaic cases of specimens in economic botany."[16] The Glass Flowers thus "seduced" nearly all who saw them, even those of "scientific temper," all of whom were entranced with the aesthetics of the models—the transformation of glass into petals, leaves, stamens, and grains of pollen. No longer was glass simply a transparent pane that admitted light but produced little other transformation of the objects or view beyond. Instead, the Blaschkas crafted glass into a variety of textures, colors, and shapes, creating opaque or translucent objects that subsumed their glassiness to the plant they imitated. Goodale boasted of the exhibit's popularity, informing the Wares, "A

gentleman told me . . . that he considered the case of flower-models the finest thing in the whole exposition, and that he had found the case frequently surrounded by a surprised and delighted crowd."[17] The popularity of the glass models with the general public, not just their reputation among scientists, continued to be a point of pride for the botany department. In the 1920s, newly appointed director of the Botanical Museum Oakes Ames proudly informed Rudolf Blaschka that the glass models brought over one hundred thousand visitors to Harvard per year.[18] The models continued to be one of the most popular tourist attractions for the university, and in Harvard's tercentenary celebrations of 1936, Ames estimated the visitors to the Botanical Museum at "over one thousand a day," ultimately resulting in about 225,000 visitors for the year.[19] Lest his patrons or the administration think this was due to the popularity of the natural history collections as a whole, Ames was quick to explain, "Our visitors come through the turn-stiles, and without a pause, go directly to the third floor [where the glass models were displayed] . . . [I]t looks like 'glass models, or bust.'"[20]

The Disappearing Models

Despite this early success, the models have in many ways fallen out of public consciousness. Whereas initial publicity focused upon the seemingly magical abilities of the Blaschkas as artists and artificers,[21] subsequent publications have insisted upon the scientific and pedagogical aspects of the models in what seems to be an attempt to justify their inclusion in a university setting. As such, the consistent emphasis is the accuracy of the models, their ability to stand in for and act as the plants themselves, rather than as mediated representations.[22] This slippage between representation and the real is evident in most official publications or photographs of the models, in which the Glass Flowers' status as *models* is completely elided, as though they were as transparent as the glass pane of an exhibition case.[23]

From its title, the 1940 publication *Glass Flowers from the Ware Collection* would seem to be a book about the Blaschkas' models.[24] In reality, though, after a brief five-page history of the models' commission and history, the majority of the text is devoted to explaining the mechanics of flower pollination by insects. The slim volume is illustrated with watercolors of the models from the Blaschkas' insect pollination series by Fritz Kredel, a book illustrator and printmaker (Figure 2).[25] Although watercolor illustrations were indeed used for other "documentary" visual records of the period, such as the illustrations of folk art and vernacular design for the Index of American Design, the employment of watercolor here is unsettling: do these mediated illustrations represent the models or their own scientific rendering of the process of pollination?[26] These difficulties are highlighted by the textual elisions throughout the book; there is no acknowledgement of the illustrations' status as representing models, rather than flowers and insects observed from nature. The book's captions explain what transpires between insects and flowers, assuming absolute transparency of the illustration. As with many Glass Flowers publications before and since, the text matter-of-factly equates the illustrations with the things themselves, denying the status of the images as representations. Yet, in fact, these illustrations are many times removed

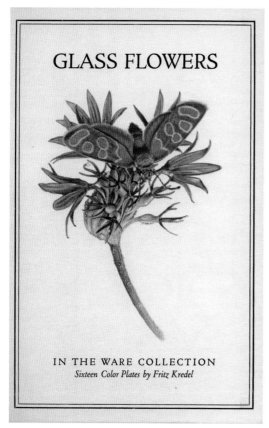

GLASS FLOWERS

IN THE WARE COLLECTION
Sixteen Color Plates by Fritz Kredel

2.
Cover of Fritz Kredel's *Glass Flowers from the Ware
Collection in the Botanical Museum of Harvard University:
Insect Pollination Series, with Sixteen Color Plates* (New
York: Harcourt, Brace and Co., 1940). Kredel's illustration
represents Rudolf Blaschka's model of *Centaurea cyanus*
(cornflower or bachelor's button), 1913 (Blaschka number
761, museum collection number 116).

from both the models and from actual flowers
and insects: they are mass-produced repro-
ductions of watercolors of the models that are
themselves based as much upon other book
illustrations as upon firsthand observation of
nature. This representational strategy not only
denies the constructed nature of the models—
their status as manmade objects—but also
erases the traces of human labor and con-
scious decision making involved in the time-
consuming process of both their creation and
Kredel's depiction of them.

In the 1980s, Harvard capitalized on ad-
vances in the reproduction of color photogra-
phy and produced another volume about the
Glass Flowers with photographs by Hillel
Burger, the chief photographer at the Peabody
Museum of Archaeology and Ethnology (Fig-
ure 3).[27] A brief note about the photographs
furnishes information about what makes and
models of camera, lenses, and film were used,
but otherwise, the photographs' inherent medi-
ation of the models is denied, much as Kredel's
watercolors were assumed to be transparent.[28]
Yet Burger's images radically crop the models,
focusing on certain details; his photographs are
often dramatically lit against dark backgrounds, selectively highlighting the translucency or vary-
ing textures of the models. Despite the fact that a few of Burger's close-ups reveal brush marks,
the occasional bit of stray dust, adhesive repairs, or accession numbers painted onto the models,
the text accompanying the plates ignores issues of representation and instead presents biological
information about the species represented. Any discussion of the models themselves is confined
to a brief introduction that outlines the history of the collection and the biographies of the cre-
ators and patrons. In none of the images are the dates of the model's production or accession in-
cluded, nor is it indicated if the models were joint productions by both Leopold and Rudolf or by
Rudolf alone. Burger's close-ups and cropping techniques also obscure the scale of the models.
Portrayed against dark backgrounds with little contextual information, it is nearly impossible to
discern if the models are life-size or themselves enlargements. Although the photographs reveal
details that visitors might be unable to see from the distance imposed by the museum's display
cases, they also obscure matters of scale and the glassworkers' framing decisions, for example,

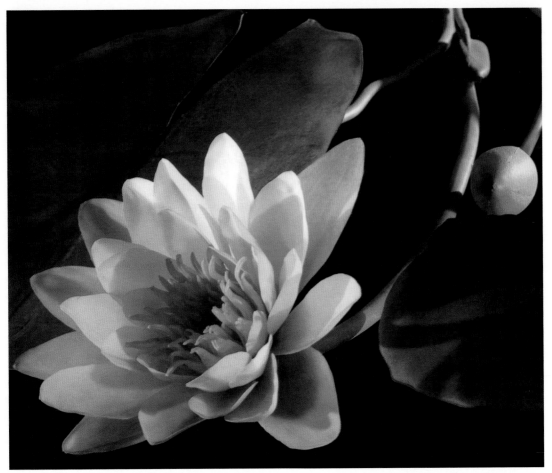

3.
Hillel Burger, "*Nymphaea odorata* Ait.," 1982. Photograph of model by Rudolf Blaschka, 1906 (Blaschka number 730, museum collection number 210). This photograph was used as the cover illustration for Richard Evans Schultes and William A. Davis, *The Glass Flowers at Harvard* (New York: E. P. Dutton, 1982) and also reprinted on page 40. Courtesy of The Archives of Rudolph and Leopold Blaschka and the Ware Collection of Blaschka Glass Models of Plants, Harvard University, Cambridge, Massachusetts.

when roots are included or omitted. Although Burger's photographs ostensibly function as documentation of museum collections, they radically alter the perception of these objects through manipulation of light, shadow, background, and framing devices.

With their cropping and dramatic lighting, Burger's photographs strikingly resemble the work of his contemporary Robert Mapplethorpe, whose close-ups and compositional choices defamiliarize plant life.[29] Yet whereas Mapplethorpe's photographs transform real flowers into sculptural forms, Burger's compositions have the opposite effect: the glass models metamorphose into real flowers. Whereas Mapplethorpe's representation of nature yields "art," a category inherently understood as a cultural construction that alters our perception of the object portrayed, Burger's photographs of scientific models, though compositionally similar to Mapplethorpe's, produce a "document," a category that is not usually subjected to further analysis despite the radical mediation of the models. I emphasize these points because they perpetuate the myth of

the transparency of the models; when the models are so consistently aligned with nature or the "real thing," the models (and their photographic representations) are not seriously considered as products of human labor or of particular social and cultural circumstances and contexts. These models are not "natural," but rather just as constructed as paintings or sculptures, with a complicated history of commission, collaboration, and international exchange, and they are worthy of close analysis.

Furthermore, Burger's photographs and their wide dissemination are troubling for the degree to which they frame the reception of the Glass Flowers for both the general public and scholars alike. Not only are these photographs featured in museum publications and postcards of the Glass Flowers, souvenirs that directly manipulate the visitors' memories and recalled experiences of the visit, but they are also furnished as the official photographs for publicity about the museum or press packets.[30] In this way the photographs not only affect what the public expects to see when they come to an exhibition of the Glass Flowers but also filter the journalist's or scholar's interpretations, which are often drawn from photographs that themselves frame and alter their subjects, thereby influencing the reception of the models.

Oddly, Burger's photographs of the models were added to the collections of the Harvard University Herbaria, a collections system usually limited to pressed specimens of actual plants. In a traditional herbarium, botanists would compare an unclassified specimen with a pressed, dried, and preserved specimen of an already known or identified plant, comparing and contrasting anatomical details and forms to determine the relationship of the plants. Yet in 1984, the herbarium proudly reported

> another unique aspect of the Herbarium is the inclusion of over 300 photographs of the economically useful species from Harvard's Ware Collection of Glass Models of Plants. This superb public exhibit . . . may be viewed as an adjunct herbarium in glass; it provides the scholar with 847 accurate three-dimensional species, including more than 2000 enlarged flower parts and cross sections.[31]

This passage indicates the assumed transparency of both the models themselves and the photographs of their forms. The botanists so trusted the models and their photographs, it would seem, that they were ready to stake plant classification and identification upon these images. This elision between the models as representations and as the real obscures the ideological shifts underlying the models' programs of commission and execution. Today's viewers must attempt to consider the models on their own terms, within the frame of Harvard's Botanical Museum and the project that the professors and glassworkers assigned to them and to one another.

Indeed, although Goodale and Ames emphasized the instructive and practical applications of the Glass Flowers, they also praised their aesthetic qualities, reminding viewers of their constructed nature. Tourists coming to admire the models had to be reminded of their original, educational intent; as an article noted, they "not only are considered artistic masterpieces but are used in class work by students of botany."[32] One naturalist remarked of the models' display at the

1893 Chicago World's Fair, "Nothing so *beautiful* exists in any other Museum of Natural History. After these, one cares little for the ordinary herbarium."[33] Another viewer of the Blaschka models commented on "the marvelous *beauty* and fidelity of the models by the Messrs. Blaschka . . . The results of the *artistic feeling* of these wonderful *artists* are simply beyond belief."[34] This emphasis upon artistic qualities was potentially at odds with the ostensible "scientific" purpose of the models. In struggling to articulate the glass models' hold on the popular imagination, one author cited the collection's appeal "to the delight in beauty not less than to the devotion to science; to the love for the poetical at least as much as to the leaning toward the practical."[35] Are the Glass Flowers somehow more "beautiful" than *real* flowers? Do we study their handcrafted forms longer than we would an actual plant? Does their masquerade of a petal's velvety softness, a pine needle's sharp edge, the dustiness of pollen grains make them more transparent or more opaque?

Yet as much as Harvard's botany department took pride in their aesthetically pleasing models, they were nonetheless anxious to convey their scientific accuracy. Rather than consciously constructed models or sculptures, the models were soon described as straightforward "copies," "facsimiles," or "reproductions" of the living plants, denying their inherent mediation.[36] Although acknowledgment of the Blaschkas' artistic license might seem to threaten the perceived accuracy of the models, Harvard has asserted since the beginning of the project the Blaschkas' knowledge and expertise of botany, not just of glassmaking.

In an 1894 article, Harvard botany professor Walter Deane reported examining the glass models under a magnifying lens, attempting to find any evidence of deviance from nature. As he related, "there is such rigid observance of the very minutest features . . . that we can be absolutely sure that every model is an exact copy of the fresh specimen which the artists had in hand."[37] Deane's observations of an Aster model shocked him in its thoroughness, as "every flower has its separate pattern, no two being exactly alike. They are not all cast in one mould."[38] This interest in and emphasis on the variations of nature highlights the Glass Flowers' difference from wax models on display in other museums, at once their strength and their potential weakness.

Whereas the Blaschka models were entirely handcrafted, a point that was emphasized in accounts that praised the artists' skill, other natural history museums were reluctant to divorce their displays from nature itself. One such example was seen at New York's American Museum of Natural History (AMNH), whose models were unveiled around 1906 and publicized as "reproductions [that] are all prepared direct from natural specimens, and, wherever possible, *the natural object itself has been preserved and utilized in the model.*"[39] Unlike the Blaschkas, who transformed rods and tubes of glass into plant forms by hand, AMNH modelers prioritized the use of actual plants or plant parts, emphasizing a physical link to the living form. AMNH's artificial foliage was created from plaster molds of living plant leaves, establishing an indexical link with an actual plant. Not only were these wax leaves affixed to the original branches of trees, but in constructing the model of a cactus, the plant's very spines were removed and reinserted into the wax form![40] The AMNH staff was very open about the processes of crafting their models, inviting visitors to view the model-making studio and publishing articles that outlined

the step-by-step procedures followed in making their models.[41] As seen in text and illustrations provided to demonstrate how the wax models were made, the model makers emphasized the indexical relationship between the model and a real plant, with molds made from actual leaves, giving the plants a closer relationship to nature. Yet this use of a mold denies one of the most natural traits, variation and variability; the leaves crafted by AMNH's process would indeed be, in Deane's words, "all cast in one mould." By praising the variation found in the Glass Flowers, Deane was highlighting an advantage Harvard's models had over competitors' models, even if they were further removed from the living plant itself: a representation of a plant, rather than a physical relationship to a real one. Writing of an especially complex model (of *Aralia spinosa*), Deane noted, "In this cluster, with its flowers so small that their structure can be seen only with a lens, [and] . . . buds . . . so minute as to be indistinguishable to the naked eye, I counted, of buds, blossoms and developing fruit, from 2,500 to 3,000. And yet every flower has its five petals, and five alternating stamens with long filaments."[42] Almost every later publication about the Glass Flowers cited these observations by Deane, seeming to assert that although viewers might not be able to see this astounding accuracy with their own, unaided eyes, an expert had provided them with the stamp of authority and authenticity. Their distance from nature was somehow to be seen as an even greater claim to truth.

The Glass Flowers Reconsidered

Although the life-size, full-scale models of plants in bloom are what are usually thought of as the Glass Flowers, the original exhibition design was more complex. Lorraine Daston has recently argued that the Glass Flowers are "epidermal," a representation of nature that is "all surface" and therefore unscientific, already out of date at the time of their creation.[43] But, in fact, each model was (and still is) displayed with several enlarged details: magnified cross sections of plant anatomy, enlarged details of the reproductive systems, and various representations of dissected details (Figure 4). The earliest correspondence about the commission included references to these "anatomical details," indicating that this was a priority from the project's inception.[44] To assist with the rendering of these microscopic cross sections and details, Goodale furnished the Blaschkas with a new microscope, a reversing prism, and a micrometer, gifts that also ensured more accurate models by eliminating Rudolf's need to mentally "flip" what he observed through the microscope and allowing him to measure the relative parts with precision.[45] This emphasis on analytical details and scientific equipment reveals how important the microscopic work was to the commission, although the models of magnified details are often skimmed over by viewers who are more enchanted by the life-size plant models, and these details are often eliminated from photographs or other illustrations of the models. In truth, there are many more models of details than those of full-size plants: out of approximately 4,300 models, only about 850 are life-sized.[46]

The juxtaposition of life-size plant models with a variety of details represented in a range of magnifications immediately puts the "deceptive" qualities of the flowers into question, subverting their illusionism and pointing to their status as models. It also highlights issues of scale and

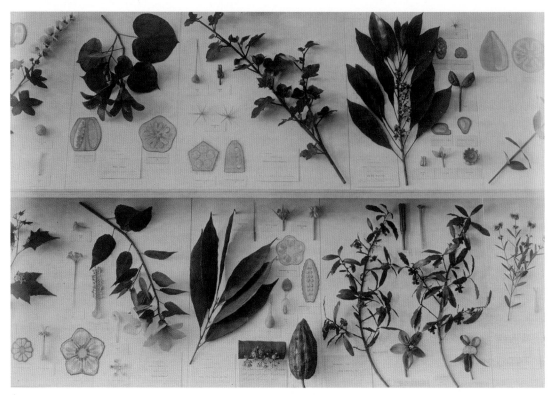

4.
Photograph by Dadman, "Cases 52a & 52b" (photograph 3014), circa 1931. Courtesy of The Archives of Rudolph and Leopold Blaschka and the Ware Collection of Blaschka Glass Models of Plants, Harvard University, Cambridge, Massachusetts.

an oscillation between three-dimensionality and the two-dimensional, monocular view imposed by a microscope. The monocular vision of microscope analysis yields a flat design, in contrast to the three-dimensionality of the full-scale model; the representations of cross sections are sliver thin. Here the medium of glass becomes almost self-reflexive, echoing the translucent and aqueous nature of a cross section, placed with a drop of water between glass slides, viewed through the magnifying lenses of a microscope, illuminated from beneath by the reflections from a mirror used to focus rays of light, processes that are all reliant upon glass and glass technology.[47] Their symmetrical, geometric patterns reassure the viewer of an underlying order of nature; it is not a bewildering, chaotic jumble, but rather a regular, rational microscopic world, as familiar as a thin slice of cucumber.

Whereas only one student at a time would be able to study forms under a microscope, these enlarged models allowed several students to view plant cells together, perhaps with the professor pointing out certain structures.[48] It also allowed the general public access to the microscopic realm of plant biology. After seeing the models exhibited for the first time on a private tour with Professor Goodale, Louis Agassiz's widow, Elizabeth, wrote to patron Mrs. Ware, congratulating her on the models' success as both aesthetic marvels and pedagogical tools, giving special emphasis to the models of dissected details:

Even more impressive than the exquisite beauty of these reproductions is their instructiveness . . . [The collection] gives you the key to so many of these hidden almost-invisible things in the structure of plants . . . [T]hey will be of infinite service in teaching,—indeed Dr. Goodale says he already finds they awaken a new & vivid interest in his classes . . . here you have before you the whole [plant] in such clear and legible characters that it seems to me a practical lesson in methods of study as well as in details of structure.[49]

To Agassiz and Goodale, these were models not only of plant structure but of the pedagogical process as well.

Yet not all viewers would have the benefit of a private tutorial from Professor Goodale, and in an attempt to educate and enlighten, the exhibition cases also included extensive text panels. In addition to standardized identification cards, smaller labels identify each enlargement or analytical detail; some models include longer, discursive, and descriptive texts as well. These cards provide an overwhelming amount of archaic information that is not especially informative to a nonspecialist viewer; they foreground the scientific Latin name of the plant and only occasionally list its common name, also providing the genus number and Latin family name, the growing season for the plant, and the regions in which it grows. Each individual detail also identifies what part of the anatomy or cross section it is and its degree of magnification. For an uninitiated viewer, the labels obfuscate as much as they enlighten, yet the text has an insistent presence, suggesting a vestigial memory of the origins in book illustration. These labels are akin to book captions.

Indeed, the conditions of the models' display—the intermingling of text, analytical details, full-scale model, and enlarged sections against a white ground— align the Glass Flowers with the traditions of two-dimensional botanical illustration and pedagogical wall charts. According to Gill Saunders, the naturalists Conrad Gesner and Fabio Colonna first included details of botanical anatomy in the sixteenth century, and the practice became widespread after the publication of Claude Aubriet's illustrations in *Institutiones Rei Herbariae* in 1700, with details of flowers, seeds, and fruits.[50] As the Linnaean classification system spread, artists became especially attentive to the reproductive structures of flowers, because these were the primary means of systematic classification. Although some botanical illustrators chose to depict plants in a natural setting or within a landscape environment (such as the illustrations for Robert John Thornton's *Temple of Flora*, 1799–1807), the convention has predominantly been to represent the flowers against a plain white ground. The Blaschkas, too, stated a preference for a plain ground, advocating either black or white supports for the models, an aesthetic choice that isolated the models and highlighted both their separation from the natural world's ecosystems and their perfect forms. As Rudolf wrote Miss Ware, "I think pure white sheets will do best as they bestow good light to the whole room. The models look best either on pure white or deep velvet-black."[51] In exhibitions the Blaschkas hosted in their studio before shipping the models to the United States, they displayed the models on white boards, with white tablecloths covering the table beneath.[52]

As in the consistent use of a white ground, both botanical illustrations and the Blaschka models also deploy scale for effect, representing specimens at life size. Yet the dimensions of the page sometimes require artists to create inventive compositions to fit a life-size representation of the plant within confines of a printed page: in the case of large species or those with tall vines, the artist often depicts a bending, curving specimen, or one whose flowers droop. Although the size allotted to each model is significantly larger than most books, the Blaschkas were also limited by spatial concerns; in their models of *Passiflora gracilis*, the crinkled passionflower, *Lapageria rosea*, the Chilean bellflower, and *Sicyos angulatus*, the star cucumber (Figure 5), for example,

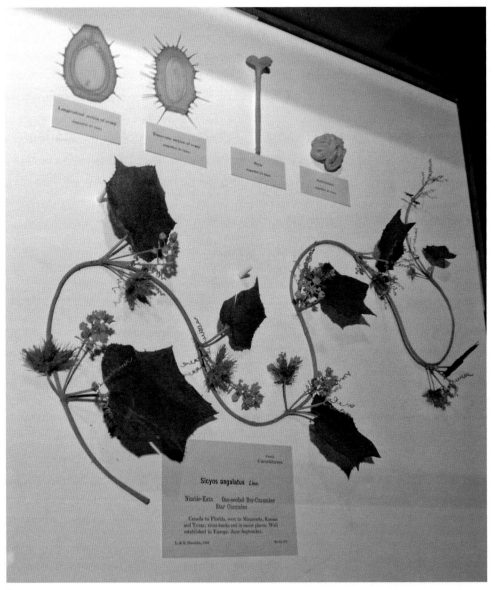

5.
Leopold and Rudolf Blaschka, model of *Sicyos angulatus* Linn. (also known as nimble Kate or star cucumber), 1892. The Ware Collection of Blaschka Glass Models of Plants, Harvard Museum of Natural History, Cambridge, Massachusetts. Photograph by the author.

the artists created a rhythmic undulating sine wave that conveyed the lengths the plant could grow to but nonetheless fit within the parameters of the exhibition case. Unlike artists creating illustrations for a page, however, the Blaschkas had the temptations and considerations of three-dimensional space to contend with. Although the models are certainly three-dimensional, the necessary supports and need to anchor the models to their backing sometimes caused them to deviate from reality; the banana model, for example, cannot expand evenly in all directions and radiates out only hemispherically in the 180° of range that its horizontal support allows, rather than the 360° expansion it would have in nature. Rudolf avoided this in his representation of a cactus, which he chose to represent as growing vertically from a separate base, painted and textured to imitate sandy, dusty soil. The delicate spines would not have been able to bear the weight of the model if he had represented it as he did most species, laying on its side, but the short height of the cactus plant could be contained within the standard case size even if displayed vertically.

Although many viewers today admit that their primary aim when observing the models is to find some evidence of their very glassiness, searching for cracks or breaks or seams, nineteenth- and early twentieth-century viewers instead embraced the illusory deception, celebrating that "the very flowers themselves seem to be lying before us. Here are . . . begonias and marigolds apparently just plucked in the garden, and buttercups . . . to all appearances fresh from the fields."[53] As a 1905 *New York Times* article explained,

> When one enters the exhibition hall on the third floor of the museum there is no sense of unreality such as with waxworks. Quite the contrary. If one did not know that the hundreds of blossoms in their cases were of glass, one would admire them as products of nature. They are so amazingly lifelike in shape and color that, as some visitors remark, they seem to smell.[54]

Yet certain clues reminded visitors of the materiality of the models they studied. Signs at regularly posted intervals warned viewers, "Vibrations have broken models. Please do not lean on the cases" and "Please keep hands off the cases."[55] The identifying label for each specimen also indicated the maker and year of creation, as mentioned previously. In case these signs were not sufficient, the museum also exhibited the packing materials to show how the flowers were transported to the museum from the studio in Germany (Figure 6).[56] As Franklin Baldwin Wiley recounted,

> Of the two examples of the packing that are exhibited, one, containing a spray of clematis with its dainty, green-white blossoms, has been left almost exactly as it was when opened,— 'To show,' as the card beside it reads, 'how the glass models are packed by the artists in Germany for transportation to America.' All the loose paper has been removed from the other box and placed in a good-sized pile at its head, thus allowing the visitor to see exactly how, 'for transportation,' to quote from the card, 'the glass models are packed in thin crushed paper, as shown in this specimen box.'[57]

Viewers were thus frequently reminded of the fragility of the models and their status as objects made of glass, despite their deceptive appearances. This display of packing crates emphasized

6.
Photograph by Dadman, "Main Exhibition Room" (photograph 3019), circa 1931. Courtesy of The Archives of Rudolph and Leopold Blaschka and the Ware Collection of Blaschka Glass Models of Plants, Harvard University, Cambridge, Massachusetts.

not only their delicacy but also the temporal and spatial dislocation of the glass models' production and the narrative of their distant manufacture in Germany. Photographs of the bucolic countryside of Hosterwitz along the Elbe and of the Blaschka house and studio reinforced the distance the models had traveled from their site of origin as well as the honorable-craftsman status of their creator, whose pastoral location suggested a closeness to nature not possible for city dwellers.[58]

Conclusion

Today, the packing boxes and tissue paper have been shelved. Wonder at how the fragile glass blooms arrived intact, packed in nothing more than tissue paper, cardboard, and straw, has been replaced by amazement at the deftness with which the Blaschkas wielded their crude tools, now rusty and impossibly rough in contrast to the delicacy of the Glass Flowers. A Plexiglas vitrine showcases the Blaschka's lampworking table and tools of their trade: rods and tubes of glass, a metal lamp, boxes of pigments, and jars of frit.[59] The primary atmosphere is one of wonder and disbelief, with visitors expressing shock that they are viewing objects made of *glass*—many echo the sentiments of a 1952 visitor to the collection who "spent half an hour inspecting the

University's world-famous collection of glass flowers, and then asked . . . 'These are very lovely, but where are the *glass* flowers?' "[60] Glass, usually prized for its translucency, has been transformed by the Blaschkas into any number of colors, textures, and shapes, ultimately disguising its own materiality and rendering itself nearly opaque to today's viewers.

The postcards sold in the Harvard Museum of Natural History's gift shop still primarily feature photographs by Hillel Burger, although they have been joined by those from the recent publication *The Rarest of the Rare: Stories Behind the Treasures at the Harvard Museum of Natural History*.[61] These photographs by Mark Sloan similarly reinterpret the museum's objects, selectively cropping, isolating, or recontextualizing the artifacts. The aestheticization of natural history museum objects and displays seems to be a growing trend, as witnessed in recent exhibitions and artistic collaborations; from the Brothers Quay's animation of objects from the Wellcome Institute, shown in a continuous loop in the museum galleries, to the popular calendar annually published by Philadelphia's Mütter Museum, objects from the history of science are increasingly seen through an aestheticizing lens.[62] Although the Blaschkas' models of marine invertebrates have not been as popular as the Glass Flowers, they have also been reinterpreted by contemporary photographers such as Heidi and Hans-Jürgen Koch. The Koches' photographs share the close cropping and dramatic lighting of Burger's depictions of the Blaschka botanical models; in some cases, it is unclear whether the color in the photographs is due to their lighting or is inherent to the models themselves.[63] As more and more science museums have invited artists to photograph or reinstall often-neglected objects from their collections, the resulting images are praised for endowing dusty artifacts with new life or for their potential to attract new audiences who embrace this sometimes "steampunk" aesthetic. In some ways, these projects seem akin to the aesthetics of institutional critique seen, for example, in Fred Wilson's landmark *Mining the Museum*, an exhibition staged with objects from the collections of the Maryland Historical Society.[64] Yet where Wilson's installation posed a critical intervention into the very practices of cultural memory and the formation of historical narratives, the spirit of these natural history projects often assumes a celebratory tone, emphasizing the collections' ability to inspire wonder and curiosity. Science and natural history museums seem to be returning to their roots, embracing the origins of the Wunderkammer and the joys of contemplation of the marvelous.[65] What impact will this have on the history of science or on the consideration of the objects themselves? Does the artists' mediation obscure our understanding of these artifacts, or does it open our eyes to new interpretations? Although the aestheticized views of scientific instruments, models, and tools may be seductive, we must remember the inherent mediations of representation and display and attend to the rich histories and contexts of scientific objects, analyzing these artifacts and their artful representations.

Acknowledgments

This essay stems from a chapter in my dissertation, which benefited from the guidance of Michael Leja, Karen Beckman, Wendy Bellion, and Gwendolyn DuBois Shaw. I am grateful to

many archivists, especially Lisa DeCesare (Botany Libraries, Harvard University), Nive Chatterjee (Rakow Research Library, Corning Museum of Glass), Tom Baione and Barbara Mathé (Library and Archives, American Museum of Natural History), Mark Nesbitt (Economic Botany Collection, Royal Botanic Gardens, Kew), and James Hatton (Archives, Natural History Museum, London). I also thank Margaret Weitekamp and Anne Collins Goodyear for their comments and suggestions and for including me in this volume.

Notes

1. Richard Evans Schultes and William A. Davis, *The Glass Flowers at Harvard* (New York: E. P. Dutton, 1982), 10.

2. My analysis of these models has been informed by the essays in *Sculpture and Photography: Envisioning the Third Dimension*, ed. Geraldine A. Johnson (New York: Oxford University Press, 1998), and *Models: The Third Dimension of Science*, ed. Soraya de Chadarevian and Nick Hopwood (Palo Alto, CA: Stanford University Press, 2004).

3. For more on the development of Harvard's Botanical Museum as well as its other natural history museums in this period, see Nancy Pick and Mark Sloan, "Natural History at Harvard," in *The Rarest of the Rare: Stories Behind the Treasures at the Harvard Museum of Natural History* (New York: HarperResource, 2004), 7–33; Botanical Museum Staff, "The Botanical Museum of Harvard University in Its 125th Year," special issue, *Botanical Museum Leaflets* 30, no. 1 (Winter 1984); Benjamin Lincoln Robinson, "Botany, 1889–1929," in *The Development of Harvard University Since the Inauguration of President Eliot*, ed. Samuel Eliot Morison (Cambridge, MA: Harvard University Press, 1930).

4. George Lincoln Goodale, "The Botanic Garden," in *Annual Reports of the President and Treasurer of Harvard College, 1884–85* (Cambridge, MA: Harvard University, 1886), 145.

5. George Lincoln Goodale, "The Blaschka Glass Flower Collection," *Harvard Graduates' Magazine* 2 (July 1893), 602–3.

6. Kew's extensive collection of wax orchids are housed in the Herbarium building and are thought to have been commissioned by Kew director Sir William Thiselton Dyer from Edith Delta Blackman, also related to the Mintorn family of wax modelers. For more on the models, see the Kew Library catalogue entry 2006/37, "The Edith Blackman Wax Orchid Collection." Gifts and purchases of models are recorded in the entry book of the Economic Library, Kew Economic Botany Collection Archives, Royal Botanic Gardens, Kew; see, for example, purchases of plant embryonic wax models from Friedrich Ziegler as entries 152 and 153 (October 7, 1861).

7. See Nancy Dunlap Bercaw, "Solid Objects/Mutable Meanings: Fancywork and the Construction of Bourgeois Culture, 1840–1880," *Winterthur Portfolio* 26, no. 4 (Winter 1991): 231–47; Ann B. Shteir, "'Fac-similes of Nature': Victorian Wax Flower Modelling," *Victorian Literature and Culture* 35 (2007): 649–61.

8. Goodale would have seen the Brendel models, if not previously, at the 1889 meeting of the Biological Section of the American Association for the Advancement of Science in Toronto, where he delivered a paper and where the models were prominently displayed; see "Botany in the American Association," *Botanical Gazette* 14, no. 10 (October 1889), 261. Brendel models were also praised in Clemmons Parrish, "Minutes of the Pharmaceutical Meetings," *American Journal of Pharmacy* 45 (February 1, 1873), 86.

9. For more on questions of inclusion or exclusion of details as well as scientific debates about depicting the general vs. the particular, see Lorraine Daston and Peter Galison, *Objectivity* (Cambridge, MA: MIT Press, 2007).

10. These emphases upon perfection and permanence are discussed at length in my dissertation, "Arresting Beauty: The Perfectionist Impulse of Peale's Butterflies, Heade's Hummingbirds, Blaschka's Flowers, and Sandow's Body" PhD diss., University of Pennsylvania, 2011.

11. For more on the Blaschka marine invertebrates, see "Proceedings of the Dublin Blaschka Conference," special issue, *Historical Biology* 20, no. 1 (March 2008); William Warmus, "The Blaschka Sea Creatures," *Glass* 83 (2001): 40–45; Henri Reiling, "The Blaschkas' Glass Animal Models: Illustrations of 19th Century Zoology," *Scientiarum Historia* 26 (2000): 131–43; Reiling, "The Blaschkas' Glass Animal Models: Origins of Design," *Journal of Glass Studies* 40 (1998): 105–126; David Whitehouse, "The Blaschka Animals," *Journal of the Glass Art Society* 44 (1991): 36–41.

12. See Goodale, "Blaschka Glass Flower Collection," 602–6.

13. The Blaschkas' lampworking technique is discussed in Rika Smith McNally and Nancy Buschini, "The Harvard Glass Flowers: Materials and Techniques," *Journal of the American Institute for Conservation* 32, no. 3 (1993): 231–40; Richard Evans Schultes, ed. "How Were the Glass Flowers Made? A Letter by Mary Lee Ware," *Botanical Museum Leaflets, Harvard University* 19, no. 6 (1961): 125–36. Lampworking, in contrast to glassblowing, is often used to make decorative items like beads or paperweights. For more on the art and craft of glasswork in this period, see Victor Arwas and Susan Newell, *The Art of Glass: Art Nouveau to Art Deco* (Windsor, UK: A. Papadakis, 1996).

14. Eventually, the models were also displayed at the 1895 Cotton States and International Exposition in Atlanta, the 1900 Exposition Universelle in Paris, and the 1904 Louisiana Purchase Exposition in St. Louis. For more on Harvard's exhibit in Chicago, see Edward Cummings, "The Harvard Exhibit at the World's Fair," *Harvard Graduates' Magazine* 2, no. 5 (September 1893): 50–63; J. C. [Arthur], "Botany at the World's Fair," *Botanical Gazette* 18, no. 9 (September 1893): 357–64; F. A. Bather, "Natural Science at the Chicago Exhibition," *Natural Science* 3 (November 1893): 336–43; E. C. Hovey, "Massachusetts at the World's Fair," *New England Magazine* 15, no. 6 (February 1894): 735–50.

15. "Harvard Blaschka Flowers," *New York Times*, October 30, 1893.

16. Cummings, "The Harvard Exhibit at the World's Fair," 57.

17. Goodale to Mary Lee Ware, 14 September 1893, The Archives of Rudolph and Leopold Blaschka and the Ware Collection of Blaschka Glass Models of Plants, Harvard University, Cambridge, MA (hereafter referred to as the Blaschka and Ware Archives Collection, Harvard).

18. Oakes Ames to Rudolf Blaschka, 25 February 1924, the Blaschka and Ware Archives Collection, Harvard.

19. Oakes Ames to Mary Lee Ware, 26 August 1936, the Blaschka and Ware Archives Collection, Harvard; E. L. Yordan, "Harvard's Unique Glass Flowers," New York Times, February 7, 1937.

20. Oakes Ames to Mary Lee Ware, 21 July 1936, the Blaschka and Ware Archives Collection, Harvard.

21. Lorraine Daston also discusses the mystification of the Blaschkas' work in her essay "The Glass Flowers," in Things That Talk: Object Lessons from Art and Science, ed. Lorraine Daston (New York: Zone Books, 2004), 222–54.

22. This is especially evident in Susan M. Rossi-Wilcox, "From Reference Specimen to Verisimilitude: The Blaschkas' Penchant for Botanical Accuracy," Historical Biology 20, no. 1 (March 2008): 11–18.

23. Geoffrey Swinney notes a similar "disappearance" at play in the Blaschkas' marine invertebrate models; see his article "Enchanted Invertebrates: Blaschka Models and Other Simulacra in National Museums Scotland," Historical Biology 20, no. 1 (March 2008), 44.

24. Fritz Kredel, Glass Flowers from the Ware Collection in the Botanical Museum of Harvard University: Insect Pollination Series, with Sixteen Color Plates (New York: Harcourt, Brace and Co., 1940).

25. Kredel was best known as a book illustrator and printmaker (specializing in woodcuts), and he was praised for his contributions to the three-volume Blumenbuch (Kredel and Rudolf Koch, Leipzig: Insel-Verlag, 1923–30). He also supplied the illustrations for Jean Hersey's The Woman's Day Book of Wildflowers (New York: Simon and Schuster, 1960); these illustrations are small, simplified line drawings that are supplemented with cursory touches of color. For more on Kredel's work, see Mathilde Kredel Brown et al., Fritz Kredel, 1900–1973: A Comprehensive List of Kredel's Work (New York: Grolier Club, 2000).

26. See Virginia Tuttle Clayton, Elizabeth Stillinger, Erika Doss, and Deborah Chotner, Drawing on America's Past: Folk Art, Modernism, and the Index of American Design (Washington, DC: National Gallery of Art, 2002). Gosia Rymsza-Pawlowska's presentation at the Southeastern American Studies Association (February 2009) and our subsequent discussions about changing conceptions of the "documentary" in the 1930s and 1940s have developed my understanding of this use of watercolor.

27. Schultes and Davis, Glass Flowers at Harvard. Burger's photographs accompany several catalogs of collections from Harvard's Peabody Museum.

28. Schultes and Davis, Glass Flowers at Harvard, 120.

29. For more on Mapplethorpe's flowers, see Mapplethorpe: The Complete Flowers (New York: teNeues, 2006); Pistils, with essay by John Ashbery (New York: Random House, 1996); Mapplethorpe, Flowers, with foreword by Patti Smith (Boston: Bulfinch Press, 1990); Janet Kardon, Robert Mapplethorpe: The Perfect Moment (Philadelphia: Institute of Contemporary Art, 1988).

30. For example, most of the official photographs for the Corning Museum of Glass's 1997 exhibition Botanical Wonders: The Story of the Harvard Glass Flowers were by Burger or were done in a similar style by the Corning Museum for continuity; these are viewable on their archived exhibition Web site (http://www.cmog.org/dynamic.aspx?id=7810, accessed January 9, 2012). These images were also used in publicity about the exhibition, including online and print articles. Burger's photographs are also used on the Harvard Museum of Natural History Web site and are included in their official Flickr photostream, which is also linked from their online press room, http://www.flickr.com/photos/harvardmuseumofnaturalhistory/ (accessed January 9, 2012). Furthermore, Burger's photographs are reproduced as the illustrations for most articles about the Glass Flowers, including in Lorraine Daston's critique (Things That Talk), a tactic that I believe influences interpretations of the models.

31. Botanical Museum Staff, "The Botanical Museum," 37.

32. Yordan, "Harvard's Unique Glass Flowers."

33. Emphasis mine. Bather, "Natural Science at the Chicago Exhibition," 342.

34. Emphasis mine. "Sketch of George Lincoln Goodale," Popular Science Monthly 39, no. 5 (September 1891), 694.

35. Franklin Baldwin Wiley, Flowers That Never Fade: An Account of the Ware Collection of Blaschka Glass Models in the Harvard University Museum (Boston: B. Whidden, 1897), 40.

36. For glass models as "copies" of nature, see Walter Deane, "The Ware Collection of Blaschka Glass Models of Flowers at Harvard," Botanical Gazette 19, no. 4 (1894), 147; "Harvard's 'Glass Flowers,'" New York Times, December 9, 1900; Sarah Ware Bassett, The Story of Glass (Philadelphia: The Penn Publishing Company, 1917), 137; "Sketch of George Lincoln Goodale," 694. For "facsimile," see John Ritchie Jr. "Science: The Ware Memorial," Boston Commonwealth July 27, 1895; Helen J. James, "The Ware Collection of Glass Flowers," Bulletin of The Garden Club of America 6 (September 1920): 41. For "reproduction," see "The Story of the Glass Flowers," Harvard Summer School News 1, no. 3 (July 12, 1935); "Harvard's Hundred Years of Botany," Nature 237, no. 5354 (June 9 1972): 316; Margaret Parke, "The Glass Flowers of Harvard's Botanical Museum," Endeavour 7, no. 3 (1983) 116; Susan Rossi-Wilcox and Stuart Lindsay, "Fragile Ferns: The Blaschka Models at Harvard University," Pteridologist 4, no. 3 (2004): 96.

37. Deane, "Ware Collection of Blaschka Glass Models,"147.

38. Deane, "Ware Collection of Blaschka Glass Models," 146.

39. Emphasis mine. "Museum News Notes," The American Museum Journal 6, no. 3 (July 1906): 128.

40. E. C. B. Fassett, Plant Forms in Wax, Guide Leaflet 34 (New York: American Museum of Natural History, 1911), 3, 24.

41. For an example of invitations to view the model-making studio, see "Museum News Notes," The American Museum Journal 7, no. 4 (April 1907): 62; for illustrated accounts of the model-making process, see Fassett, Plant Forms in Wax; Frederic A. Lucas, "The Story of Museum Groups, Part I" American Museum Journal 14, no. 1 (January 1914); Frederic A. Lucas, "The Story

of Museum Groups, Part II" *American Museum Journal* 14, no. 2 (February 1914); Laurence Vail Coleman, *Plants of Wax: How They Are Made in the American Museum of Natural History*, Guide Leaflet Series 54 (New York: American Museum of Natural History, 1928). These models are now lost, but photographs of the models were published in the above articles as well as in Mary Cynthia Dickerson, *Trees and Forestry: An Elementary Treatment of the Subject Based on the Jesup Collection of North American Woods in the American Museum of Natural History*, Guide Leaflet Series 32 (New York: American Museum of Natural History, 1910); J. W. Toumey, "Forestry and the Museum," *The American Museum Journal* 11, no. 2 (February 1911): 38–43.

42. Deane, "Ware Collection of Blaschka Glass Models," 147.

43. See Daston, "The Glass Flowers," 226.

44. See, for example, George Lincoln Goodale to Miss Mary Lee Ware, 15 November 1887, the Blaschka and Ware Archives Collection, Harvard. On Ware's interest in "very full illustration of analytical details," see G. L. Goodale to Leopold Blaschka, 20 October 1888, Blaschka Archives, Rakow Research Library, Corning Museum of Glass, Corning, NY (hereafter referred to as Blaschka Archives, Corning).

45. Goodale's concerns about the Blaschkas' outdated equipment had been expressed in a letter to Mrs. and Miss Ware, 21 June 1889, and a letter from Goodale to Mrs. Elizabeth Ware, 9 July 1889, both from the Blaschka and Ware Archives Collection, Harvard.

46. Susan M. Rossi-Wilcox and David Whitehouse, *Drawing Upon Nature: Studies for the Blaschkas' Glass Models* (Corning, NY: Corning Museum of Glass, 2007), 5. Early correspondence indicated that Goodale and the Blaschkas estimated that there would be twice as many analytical details as full-size models; see the handwritten contract of 10 July 1889 in the Blaschka and Ware Archives Collection, Harvard.

47. For more on glass and its importance in the nineteenth century, see Isobel Armstrong, *Victorian Glassworlds: Glass Culture and the Imagination, 1830–1880* (New York: Oxford University Press, 2008).

48. Another glass technology, lantern slides, allowed professors to demonstrate projected enlargements to a lecture hall of assembled students. For a discussion of the period fascination with the microscopic world, see "Adopting a Scientific Worldview," in Lynn Gamwell, *Exploring the Invisible: Art, Science, and the Spiritual* (Princeton, NJ: Princeton University Press, 2002), 33–55, and especially her discussion of "Invisible Life," 45–55; see also Corey Keller, ed., *Brought to Light: Photography and the Invisible, 1840–1900* (San Francisco: Museum of Modern Art, 2008).

49. Lizzie C. [Elizabeth Cary] Agassiz to Elizabeth Ware, 3 March 1890, the Blaschka and Ware Archives Collection, Harvard.

50. Gill Saunders, *Picturing Plants: An Analytical History of Botanical Illustration* (Berkeley: University of California Press, 1995), 88–89; see also Wilfrid Blunt, *The Art of Botanical Illustration: An Illustrated History* (New York: Dover Publications, 1994); Ella M. Foshay, *Reflections of Nature: Flowers in American Art* (New York: Alfred A. Knopf, 1984); Massimiamo Bucchi, "Images of Science in the Classroom: Wallcharts and Science Education 1850–1920," *British Journal for the History of Science* 31, no. 2 (1998): 161–84.

51. Rudolf Blaschka to Mary Lee Ware, 15 July 1900, the Blaschka and Ware Archives Collection, Harvard. The mounts were also discussed in correspondence from Mary Lee Ware to Rudolf Blaschka, 19 April 1903, Blaschka Archives, Corning.

52. This can be seen in archival photographs in the Blaschka Archives, Corning, box 11, in the folder "Rudolf Blaschka's 5 photographs of the glass models before they were sent to the Botanical museum-1890s."

53. [Franklin Baldwin Wiley], "Flowers That Fade Not: Exquisite Specimens in the Museum at Harvard," *Boston Evening Transcript*, May 1, 1893.

54. Yordan, "Harvard's Unique Glass Flowers," 147.

55. See Dadman, "Glass Flowers Displays," 1931, from the Blaschka and Ware Archives Collection, Harvard, photographs 3015 ("View in Main Exhibition Room") and 3018 ("View in Hallway 3rd floor"); both are viewable online through Hollis, the Harvard library catalog (http://discovery.lib.harvard.edu).

56. Visible in Dadman, photograph 3019, the Blaschka and Ware Archives Collection, Harvard.

57. Wiley, *Flowers That Never Fade*, 35; also described in Harvard Memorial Society, *Official Guide to Harvard University* (Cambridge, MA: Harvard University Press, 1907), 108.

58. Lorraine Daston has also emphasized the importance of the craft status of the glass flowers and the value of the handmade in contrast to industrialization and mass production; see "The Glass Flowers," in *Things That Talk*.

59. The design of the lampworking table is discussed in Susan M. Rossi-Wilcox, Henri Reiling, and Philip Bisaga, "The Blaschkas' Lampworking Tables," *Journal of Glass Studies* 45 (2003): 167–76.

60. "Gardener in Glass," *Harvard Alumni Bulletin* 54, February 9, 1952: 387.

61. Pick and Sloan, *The Rarest of the Rare*.

62. For the aestheticization of the Wellcome Collection, see, for example, Peter Blegvad et al., *The Phantom Museum and Henry Wellcome's Collection of Medical Curiosities* (London: Profile, 2003); Brothers Quay, *Phantom Museum: Random Forays into the Vaults of Sir Henry Wellcome's Medical Collection* (New York: Zeitgeist Films, 2006). For examples of photographs of the Mütter Museum collections, see Gretchen Worden, *Mütter Museum of the College of Physicians of Philadelphia* (New York: Blast Books, 2002). For a discussion of the extended collaboration between artists and the College of Physicians collections, see Nora L. Jones, "The Mütter Museum: The Body as Spectacle, Specimen, and Art" (PhD diss., Temple University, 2002), especially chap. 6.

63. Heidi Koch and Hans-Jürgen Koch, *Blaschka: Gläserne Geschöpfe des Meeres* (Munich: Dölling und Galitz, 2007).

64. Fred Wilson and Lisa G. Corrin, *Mining the Museum: An Installation* (New York: New Press, 1994).

65. This was especially evident in the 2008 Deutsches Museum (Munich) exhibition *Wunderkammer Museum*, which featured photograms by Floris Neusüss and Renate Heyne of objects from the museum's permanent collection. Mark Sloan, the primary photographer for Harvard's *Rarest of the Rare* publication, also provided the photographs for *Dear Mr. Ripley: A Compendium of Curioddities from the Believe It or Not! Archives* (Boston: Little, Brown, 1993), emphasizing the "spectacular" approach.

Chapter 2

Bibliography

American Museum of Natural History. Photograph archives. New York, New York.

The Archives of Rudolph and Leopold Blaschka and the Ware Collection of Blaschka Glass Models of Plants. Harvard University, Cambridge, MA.

Armstrong, Isobel. *Victorian Glassworlds: Glass Culture and the Imagination, 1830–1880.* New York: Oxford University Press, 2008.

Arthur, J. C. "Botany at the World's Fair." *Botanical Gazette* 18, no. 9 (September 1893): 357–64.

Arwas, Victor, and Susan Newell. *The Art of Glass: Art Nouveau to Art Deco.* Windsor, UK: A. Papadakis, 1996.

Bassett, Sarah Ware. *The Story of Glass.* Philadelphia: The Penn Publishing Company, 1917.

Bather, F. A. "Natural Science at the Chicago Exhibition," *Natural Science* 3 (November 1893): 336–43.

Bercaw, Nancy Dunlap. "Solid Objects/Mutable Meanings: Fancywork and the Construction of Bourgeois Culture, 1840–1880." *Winterthur Portfolio* 26, no. 4 (Winter 1991): 231–47.

Blaschka Archives. Rakow Research Library, Corning Museum of Glass, Corning, NY.

Blegvad, Peter, A. S. Byatt, Helen Cleary, Tobias Hill, Hari Kunzru, and Gaby Wood. *The Phantom Museum and Henry Wellcome's Collection of Medical Curiosities.* London: Profile, 2003.

Blunt, Wilfrid. *The Art of Botanical Illustration: An Illustrated History.* New York: Dover Publications, 1994. Originally published 1950, 4th ed., by Collins.

Botanical Museum Staff. "The Botanical Museum of Harvard University in Its 125th Year." Special issue, *Botanical Museum Leaflets* 30, no. 1 (Winter 1984).

"Botany in the American Association." *Botanical Gazette* 14, no. 10 (October 1889): 261.

Brothers Quay. *Phantom Museum: Random Forays into the Vaults of Sir Henry Wellcome's Medical Collection.* New York: Zeitgeist Films, 2006.

Brown, Mathilde Kredel, Judith K. Brown, Gay Walker, Hermann Zapf, and Ronald Salter. *Fritz Kredel, 1900–1973: A Comprehensive List of Kredel's Work.* New York: Grolier Club, 2000.

Bucchi, Massimiamo. "Images of Science in the Classroom: Wallcharts and Science Education 1850–1920." *British Journal for the History of Science* 31, no. 2 (1998): 161–84.

Clayton, Virginia Tuttle, Elizabeth Stillinger, Erika Doss, and Deborah Chotner. *Drawing on America's Past: Folk Art, Modernism, and the Index of American Design.* Washington, DC: National Gallery of Art, 2002.

Coleman, Laurence Vail. *Plants of Wax: How They Are Made in the American Museum of Natural History.* Guide Leaflet Series 54. New York: American Museum of Natural History, 1928.

Cummings, Edward. "The Harvard Exhibit at the World's Fair." *Harvard Graduates' Magazine* 2, no. 5 (September 1893): 50–63.

Daston, Lorraine. "The Glass Flowers." In *Things That Talk: Object Lessons from Art and Science,* edited by Lorraine Daston, 222–54. New York: Zone Books, 2004.

Daston, Lorraine, and Peter Galison. *Objectivity.* Cambridge, MA: MIT Press, 2007.

Deane, Walter. "The Ware Collection of Blaschka Glass Models of Flowers at Harvard." *Botanical Gazette* 19, no. 4 (1894): 144–8.

de Chadarevian, Soraya, and Nick Hopwood, eds. *Models: The Third Dimension of Science.* Palo Alto, CA: Stanford University Press, 2004.

Dickerson, Mary Cynthia. *Trees and Forestry: An Elementary Treatment of the Subject Based on the Jesup Collection of North American Woods in the American Museum of Natural History.* Guide Leaflet Series 32. New York: American Museum of Natural History, 1910.

Fassett, E. C. B. *Plant Forms in Wax.* Guide Leaflet Series 34. New York: American Museum of Natural History, 1911.

Foshay, Ella M. *Reflections of Nature: Flowers in American Art.* New York: Alfred A. Knopf, 1984.

Foutch, E. "Arresting Beauty: The Perfectionist Impulse of Peale's Butterflies, Heade's Hummingbirds, Blaschka's Flowers, and Sandow's Body." PhD diss., University of Pennsylvania, 2011.

Gamwell, Lynn. *Exploring the Invisible: Art, Science, and the Spiritual.* Princeton, NJ: Princeton University Press, 2002.

"Gardener in Glass." *Harvard Alumni Bulletin* 54 (February 9, 1952): 387.

Goodale, George Lincoln. "The Botanic Garden." In *Annual Reports of the President and Treasurer of Harvard College, 1884–85.* Cambridge, MA: Harvard University, 1886.

———. "The Blaschka Glass Flower Collection." *Harvard Graduates' Magazine* 2 (July 1893): 602–6.

Harvard Memorial Society. *Official Guide to Harvard University.* Cambridge, MA: Harvard University Press, 1907.

"Harvard's Hundred Years of Botany." *Nature* 237, no. 5354 (June 9, 1972): 316.

Hovey, E. C. "Massachusetts at the World's Fair." *New England Magazine* 15, no. 6 (February 1894): 735–50.

James, Helen J. "The Ware Collection of Glass Flowers." *Bulletin of the Garden Club of America* 6 (September 1920): 41.

Johnson, Geraldine A., ed. *Sculpture and Photography: Envisioning the Third Dimension.* New York: Oxford University Press, 1998.

Jones, Nora L. "The Mütter Museum: The Body as Spectacle, Specimen, and Art." PhD diss., Temple University, 2002.

Kardon, Janet. *Robert Mapplethorpe: The Perfect Moment.* Philadelphia: Institute of Contemporary Art, 1988.

Keller, Corey, ed. *Brought to Light: Photography and the Invisible, 1840–1900.* San Francisco: Museum of Modern Art, 2008.

Kent, George H. *The Ware Collection of Blaschka Glass Flower Models: A Short Description of Their Makers and Their Making.* Cambridge, MA: George H. Kent, 1908.

Kew Economic Botany Collection Archives. Economic Library, Royal Botanic Gardens, Kew.

Koch, Heidi, and Hans-Jürgen Koch. *Blaschka: Gläserne Geschöpfe des Meeres.* Munich: Dölling und Galitz, 2007.

Kredel, Fritz. *Glass Flowers from the Ware Collection in the Botanical Museum of Harvard University: Insect Pollination Series, with Sixteen Color Plates.* New York: Harcourt, Brace and Co., 1940.

Kredel/Zapf. New York: The Cooper Union Museum for the Arts of Decoration, 1951.

Lucas, Frederic A. "The Story of Museum Groups, Part I." *American Museum Journal* 14, no. 1 (January 1914).

———. "The Story of Museum Groups, Part II." *American Museum Journal* 14, no. 2 (February 1914).

Mapplethorpe: The Complete Flowers. New York: teNeues, 2006.

Mapplethorpe, Robert. *Pistils.* With essay by John Ashbery. New York: Random House, 1996.

———. *Flowers.* With foreword by Patti Smith. Boston: Bulfinch Press, 1990.

McNally, Rika Smith, and Nancy Buschini. "The Harvard Glass Flowers: Materials and Techniques." *Journal of the American Institute for Conservation* 32, no. 3 (1993): 231–40.

"Museum News Notes." *The American Museum Journal* 6, no. 3 (July 1906): 128.

"Museum News Notes." *The American Museum Journal* 7, no. 4 (April 1907): 62.

Natural History Museum. Photograph collection. PH/173, DF/141. Archives of the Natural History Museum, South Kensington.

Parke, Margaret. "The Glass Flowers of Harvard's Botanical Museum." *Endeavour* 7, no. 3 (1983): 116–22.

Parrish, Clemmons. "Minutes of the Pharmaceutical Meetings." *American Journal of Pharmacy* 45 (February 1, 1873): 86.

Pick, Nancy, and Mark Sloan. *The Rarest of the Rare: Stories Behind the Treasures at the Harvard Museum of Natural History.* New York: HarperResource, 2004.

"Proceedings of the Dublin Blaschka Conference." Special issue, *Historical Biology* 20, no. 1 (March 2008).

Reiling, Henri. "The Blaschkas' Glass Animal Models: Origins of Design." *Journal of Glass Studies* 40 (1998): 105–26.

Reiling, Henri. "The Blaschkas' Glass Animal Models: Illustrations of 19th Century Zoology." *Scientiarum Historia* 26 (2000): 131–43.

Ritchie, John, Jr. "Science: The Ware Memorial." *Boston Commonwealth* July 27, 1895.

Robinson, Benjamin Lincoln. "Botany, 1889–1929." In *The Development of Harvard University Since the Inauguration of President Eliot,* edited by Samuel Eliot Morison. Cambridge, MA: Harvard University Press, 1930.

Rossi-Wilcox, Susan M. "From Reference Specimen to Verisimilitude: The Blaschkas' Penchant for Botanical Accuracy." *Historical Biology* 20, no. 1 (March 2008): 11–18.

Rossi-Wilcox, Susan, and Stuart Lindsay. "Fragile Ferns: The Blaschka Models at Harvard University." *Pteridologist* 4, no. 3 (2004): 92–96.

Rossi-Wilcox, Susan M., Henri Reiling, and Philip Bisaga. "The Blaschkas' Lampworking Tables." *Journal of Glass Studies* 45 (2003): 167–76.

Rossi-Wilcox, Susan M., and David Whitehouse. *Drawing Upon Nature: Studies for the Blaschkas' Glass Models.* Corning, NY: Corning Museum of Glass, 2007.

Saunders, Gill. *Picturing Plants: An Analytical History of Botanical Illustration.* Berkeley: University of California Press, 1995.

Schultes, Richard Evans, ed. "How Were the Glass Flowers Made? A Letter by Mary Lee Ware." *Botanical Museum Leaflets, Harvard University* 19, no. 6 (1961): 125–36.

Schultes, Richard Evans, and William A. Davis. *The Glass Flowers at Harvard.* New York: E. P. Dutton, 1982.

Shteir, Ann B. "'Fac-similies of Nature': Victorian Wax Flower Modelling." *Victorian Literature and Culture* 35 (2007): 649–61.

"Sketch of George Lincoln Goodale." *Popular Science Monthly* 39, no. 5 (September 1891): 691–94.

"The Story of the Glass Flowers." *Harvard Summer School News* 1, no. 3 (July 12, 1935).

Swinney, Geoffrey. "Enchanted Invertebrates: Blaschka Models and Other Simulacra in National Museums Scotland." *Historical Biology* 20, no. 1 (March 2008): 39–50.

Thornton, Robert John. *The Temple of Flora, or, Garden of the Botanist, Poet, Painter, and Philosopher.* London: Dr. Thornton, 1812.

Toumey, J. W. "Forestry and the Museum." *The American Museum Journal* 11, no. 2 (February 1911): 38–43.

Warmus, William. "The Blaschka Sea Creatures." *Glass* 83 (2001): 40–45.

Whitehouse, David. "The Blaschka Animals." *Journal of the Glass Art Society* 44 (1991): 36–41.

Wiley, Franklin Baldwin. *Flowers That Never Fade: An Account of the Ware Collection of Blaschka Glass Models in the Harvard University Museum.* Boston: B. Whidden, 1897.

Wilson, Fred, and Lisa G. Corrin. *Mining the Museum: An Installation.* New York: New Press, 1994.

Worden, Gretchen. *Mütter Museum of the College of Physicians of Philadelphia.* New York: Blast Books, 2002.

"A Track Across What Is Now a Desert"
A. H. Munsell's Quest for a System of Color

Erin McLeary
Independent Scholar
Philadelphia, Pennsylvania

In 1879, at the age of 21, the painter Albert H. Munsell became interested—deeply, passionately, obsessively—in color. Sparked by his reading of Ogden Rood's recent *Modern Chromatics*, an influential work on color theory, the young artist sought out inspirational quotes about color, devised a novel photometer to assist him in his study of color, and began a seemingly ceaseless round of visits to artists, color theorists, physiologists, printers, and teachers that would continue until his death in 1918. His efforts, documented in a diary filled with notes, quotes, and sketches (and tinged with a paranoid attitude about those he saw as competitors), were directed toward nothing less than creating a new taxonomy of color.[1]

This essay explores why the world of color was so chaotic in the early twentieth century and how color systematizers sought to create a new regime of order, clarity, and simplicity. At the turn of the twentieth century, when Munsell was developing the foundations for his system of color, a number of "color workers" of various backgrounds and pedigrees were tackling problems related to color's fundamental nature: that it cannot be satisfactorily described in words, that it is difficult to exactly reproduce, and that color is so often defined by the eye of the beholder. Although Munsell was not unique, his system, and the ways in which it was used throughout the twentieth century, illuminates a number of aspects of why many believed a new way of thinking about color was desirable and the ways in which artists and scientists struggled to make objective what the eye sees and the brain perceives. Although Munsell worked within a centuries-long tradition of

color analysis, his goals were also distinct from that of such thinkers as Newton and Goethe in that Munsell was less interested in the *essence* of color—he was not worried about determining the nature of color or settling the philosophical question of whether color was a physical or psychological phenomenon—and more interested in how color should be systematized in order to make it *useful*.[2]

To anyone working on the problem of color in the late nineteenth century, it was clear that to make color truly systematic, two problematic aspects of color needed to be resolved: the infinite spectrum must somehow be split into discrete and finite parts, and each of those parts needed its own, unique, meaningful name. The chaos inherent in the world of color in the late nineteenth and early twentieth centuries was most immediately identifiable by the chaos found in color names. The issue of what to call a particular color might at first seem to be simply a matter of taste or a problem for lexicographers and linguists. But for those who sought to make color objective, useful, and a scientific tool, as well as anyone who sought to manufacture a uniform product, color names were a particularly vexing problem. Late nineteenth-century usage was filled with examples of color names that were evocative, poetic, and utterly meaningless: elephant's breath, ashes of roses, invisible green, Isabella color, blackish white. Although in apparently common use around the turn of the twentieth century, these names' referents were often obscure and their meanings debatable. Isabella color, for example, a brownish yellow, takes its name from the Spanish princess Isabella, daughter of King Philip II, who allegedly wore the same undergarments without change from 1601 to 1604 because of a vow she had taken. (This color name is still used by dachshund enthusiasts to describe a particular rich tan coat color.) Invisible green is a very dark green, so called because when used on exterior ironwork it made the ironwork blend into the surrounding foliage and become "invisible." Once explained, these names make a certain sense, but others, such as ashes of roses (a gray-tinged pink on the mauve side of things) and elephant's breath (a light gray), remained more whimsical than specific. Even those who eschewed metaphor in coming up with color names still struggled to find meaningful terminology; florists, for instance, described their offerings with such mashed-together names as "pink violet" and "green pink."[3] And these names merely epitomized the problem inherent in using language to describe color; even such seemingly straightforward metaphors as "spinach green" are subject to interpretation. Throw into the mix such descriptors as "shade," "tint," "tone," "value," and "intensity," all loosely defined and used by laymen and artists alike, and confusion over color only intensified. This lack of a uniform relationship between a color and its name had a destabilizing effect on a variety of turn of the century enterprises, ranging from fashion to natural history. "Every student of botany, ornithology, or entomology, has found the lack of any well-defined standard or credited nomenclature of color a prolific source of trial and perplexity," grumped botanist and Smith College professor J. H. Pillsbury in the pages of *Science* in 1892, continuing on to lament that since color was so intimate a part of so many enterprises, there was no single channel for reform. The lack of a clear path forward was clear to readers of *Science*, as Pillsbury, who promoted a system that used school supplies manufacturer Milton Bradley's line of colored papers, bickered off and

on with Columbia University physicist William Hallock, who offered a competing system based on painters' pigments.[4] So although many observers agreed upon the problem (a lack of standardization that led to sloppy thinking and impeded science) and the general nature of the solution (standardization), consensus on the nature of that standardization was difficult to achieve.

It was within this milieu of calls for reform and competing proposals that Munsell began his investigations into systemization. Munsell foresaw greatness for his system, taking to heart his friend Worthington Ford's assertion that "what atomic weights have done for chemistry this will do for color."[5] For Munsell, the rigor that atomic weights created in chemistry was needed in art as well, to bring about both order and an agreed-upon method for categorization and sorting.

Thus, the solution that Munsell proposed was two-pronged: develop rigorous standards for color and train the eye and the brain from an early age to approach color scientifically. Reforming the world of color by reforming the young was a shared tactic; among those who were actively working along similar lines were Bradley, a lithographer, board game pioneer, and kindergarten promoter, and Louis Prang, a fellow lithographer, printer, and art education promoter. Bradley and Prang concentrated their efforts on an entrepreneurial approach, marketing series of graded colored papers and crayon and paint sets to be used in the classroom. Munsell, on the other hand, approached the problem of color more systematically, working out the theoretical underpinnings of a scientific system upon which he built a philosophy of color education. (Munsell did eventually develop crayon and paint sets that used his terminology and pedagogical thinking to offset the expense of publishing the carefully calibrated color plates in his educational books.)[6]

In Munsell's system, color was rigorously organized along scientifically devised lines, in which individual colors were demarcated by codes that relied upon a uniform set of criteria. Like some other color systematizers, Munsell envisioned a theoretical color solid that allows for the expression of color's three fundamental qualities, which Munsell termed hue (red, blue, purple, etc.), value (luminosity, or where the particular shade of the hue falls on the spectrum from white to black), and chroma (essentially intensity, or how much gray is in the hue). Although Munsell did initially consider the problem of color names to be a matter of finding the name with the right evocative quality (for instance, proposing to a correspondent in 1900 that the best single word for yellow green was "lettuce"), as Munsell developed his system, he abandoned names, developing instead codes that expressed exactly where a given color fell in the color solid and related that color to all other colors. In this system, hue was written as an initial (R for red, for example) followed by a fraction with value as a numeral between one and nine on top and chroma as a numeral between one and nine as the denominator.[7] Such a system would "furnish a track across what is now a desert between practical and scientific color work," he asserted, and it would have widespread applicability. The many potential users, he noted in 1903, included "stores, printed and woven colored goods, dyers and chemists, architects, decorators, art industries, modistes, psychologists, scientists, educators, painters."[8] But Munsell, a teacher at the Massachusetts Normal Art School from 1881 until 1918, was primarily interested in the young.

Working out his stepped, comprehensive, uniform system provided Munsell with the tools he needed for rational, systematic education of children. In considering color, Munsell analogized from music: a sphere of artistic endeavor with a well-established, standardized nomenclature and, crucially for Munsell, a well-established system for training. It was also a sphere in which excellence was demanded of young people; as Munsell approvingly quoted his mentor Rood, "we tolerate daubs from young ladies—whose musical performances vie with professionals."[9] Children, Munsell lamented in his 1905 *Color Notation*, were being thrown into the world of color without guidance, preparation, or instruction in the fundamentals underlying what the eye sees. (For instance, red, blue, and yellow are not truly primary colors, they are simply the pigment colors that can be mixed to obtain other colors). Munsell advocated a careful training program based on drills of increasing difficulty, much as a budding pianist practices scales and chords before moving to actual pieces of music.

These drills made heavy use of some of the unique features of Munsell's color system. Color instruction, for Munsell, was based on inculcating a sense of the relationships among colors; as he noted in a lecture in 1904, "Without a system of identification it is useless to dogmatize about harmonious colors, for if the elements of such groups are in doubt, attempts to describe their combinations will end in confusion. Before the mind can intelligently unite such complex elements, it must separate and define them."[10] To ingrain in the student this sort of relational awareness, instruction thus started with the middle values, the shades of each hue that fell at the midpoint between white and black, shades that were by definition rather muted (Figure 1). This was a necessity, Munsell argued, not only for training the young artist's eye but for the very defense of civilization itself. "The gaudiest colors are found in the cheapest stores," Munsell exclaimed in a pamphlet published in 1907, whereas "in the homes of cultivation and refinement, one finds tempered color." But, he continued, allowing and even encouraging children to have access to bright, vivid colors has "been defended on physiological grounds, by the argument that a child needs strong sensations to produce a 'thrill.' If this is true, then why not give ammonia and whiskey to thrill the nose and throat? These excesses are barbarous, and another generation will resent such unintelligent methods. Brutal experiences do not cultivate fine distinctions."[11] The floridity of Munsell's prose was perhaps occasioned by the reaction he received, again and again, when he shared his instructional philosophy with teachers, who objected strenuously to Munsell's insistence that the muted middle values were the only colors children were to be allowed until considerable instruction had occurred. The reaction of three kindergarten teachers with whom Munsell met in 1906 was perhaps typical. To the teachers' objection that the Munsell colors were not bright enough and that in the classroom "we teach a color for its thrill—not for relation" (one teacher adding approvingly, "when I look at intense red, it thrills me"), Munsell crabbed in his diary that other strong sensations, such as "champagne—siren—stunning blow" were obviously unacceptable for children and that the nature of the thrill given by red was morbid, given its "association with fire—blood and danger."[12] Such responses from teachers seemed to merely prove to Munsell teachers' lack of considered judgment about the dangers of exposing untrained young minds to brilliant color and to

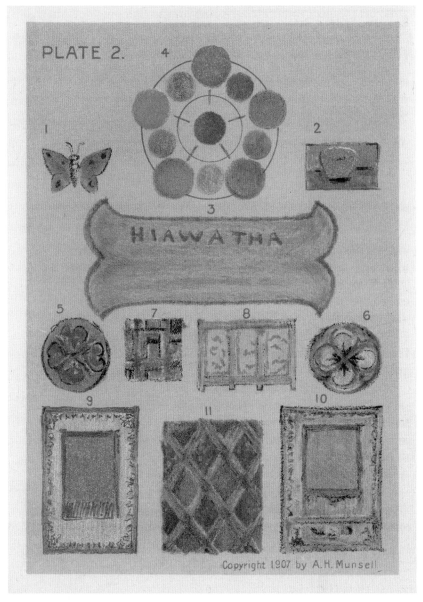

1.
Examples of acceptable children's artwork, done according to Munsell's drills. From A. H. Munsell, *A Color Notation: An Illustrated System Defining All Colors & Their Relations by Measured Scales of Hue, Value, and Chroma* (Boston: G. H. Ellis, 1913).

validate his own system of cautious and supervised education. "Our prime educator, the mother," he groused in support of his approach in his 1907 pamphlet, "does not hesitate to refuse the little one matches, scissors, candy, and fireworks, until years of discretion make their safe use a possibility."[13] For Munsell, bright colors in the hands of the inexperienced were figuratively explosive; one can only imagine his reaction to the preferred color palette for children seen today.[14]

Munsell devoted years to carefully developing and refining his system and educational philosophy, consulting physiologists, printers, teachers, and other color workers in an endless

process of improvement and promotion. Moving his system from thought to page was a particular challenge, for to move beyond the theory that described in black and white diagrams the ways in which hue, value, and chroma could vary, all the gradations in Munsell's system had to be recorded in color that would not fade or change. This was one of the main technical challenges faced by systematizers and a perpetual concern of color workers, requiring experimentation with a variety of pigments and substrates. For Munsell, it eventually required a full-time employee to create the colors and paint the color chips.[15]

Despite Munsell's passion for reform through education, when Munsell died in 1918, he left a company (the Munsell Color Company, which he founded in 1917 as his health began to decline) and heirs who, although passionate about color and the Munsell legacy, were less interested in color's civilizing influence on the young. His heirs soon rejected the aspects of Munsell's work that focused on color education, selling off the crayon and pedagogical aids business by 1923, and the young company embraced the technical side of his vision. In conjunction with the Bureau of Standards, the Munsell Color Company embarked on a series of technical reassessments and improvements of Munsell's work using newly developed instruments and standards. The colors used in Munsell's original *Atlas of the Munsell Color System* were subjected to spectrophotometric analysis, resulting in the compact and portable 1929 *Munsell Book of Color* (Figure 2). In conjunction with the Bureau of Standards the Munsell investigators worked with the International Committee

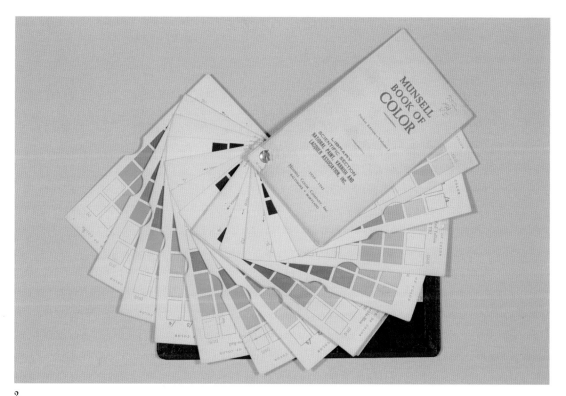

2.
The small, portable *Munsell Book of Color* (1929). Courtesy of Chemical Heritage Foundation Collections, Philadelphia, Pennsylvania. Photograph by Gregory Tobias.

on Illumination (sometimes known as CIE from its French initials) to establish illumination standards and a mathematical "standard observer" to replace the human observers who had compared hundreds of thousands of color chips to construct the early atlases.[16]

This flurry of technical activity was necessary for those who wanted to fully embrace color as a scientific tool because despite Munsell's careful systemization of color for pedagogical and artistic use, using color scientifically was still a fraught issue in the 1920s. This was not for lack of interest among scientists in using color as a scientific tool; botanists, entomologists, mycologists, ornithologists, soil scientists, chemists, and physicians, to name a few, routinely used color in their work and eagerly desired standardization.[17] Color had great appeal to such scientific workers as a proxy for more difficult types of analyses, as a quick method for determining some aspect of a substance's essential qualities, or as a method for categorizing items or differentiating among closely related items. Judging the quality of a substance—wine or maple syrup or blood or urine, for instance— by examining its color was an analytic technique with significant history by the early twentieth century. This sort of color analysis was at the heart of commercially important enterprises such as sugar grading and medically essential practices such as uroscopy. In the latter decades of the nineteenth century, the technique of color matching became more standardized, as colorimeters packaged with reference samples began to be used for such commercial, chemical, and medical analyses. Color matching was also the most widely used method in the late nineteenth and early twentieth centuries of measuring smoke discharged by factories, a terrible urban pollutant. In that case, smoke inspectors used what were called Ringelmann charts, cards printed with gradations of gray, and compared the shades on the card to the smoke emanating from a smokestack.[18]

However, dependent as it was on the human eye and human emotion, color matching remained distressingly unscientific. Minimizing the human element could eliminate some of this subjectivity, and to do this, early twentieth-century color workers created color charts (such as the Ringelmann charts), easy-to-use tools intended to help various types of scientific and medical workers quickly use color in lieu of more time-consuming or complex analytic tests. The user of a color chart needed only to glance at the substance under scrutiny and then at the color chart to conduct an analysis. Color charts developed in the early twentieth century for physicians and scientists promised simplicity of use and scientific accuracy, portability, uniformity, and universality.[19] Although Munsell had not developed his system for such a purpose, it did contain the two components necessary for scientific color matching: each color was clearly defined in relation to all other colors and was designated by a name free of ambiguity, whimsy, or poetry. When, after his death, the Munsell Color Company turned to more technical and scientific work, color matching charts were one of the company's main products. In other words while the Munsell Color Company was working on making its color charts more scientific through technical reassessment of its color schema, its color workers were also working to make science more colorful.

Much of this work was undertaken by Dorothy Nickerson, who started at the Munsell Color Company in 1919 as a secretary and became a central figure in the world of scientific color through her work at Munsell and the U.S. Department of Agriculture (USDA), which she joined

in 1927. Nickerson became involved in a host of problems at the intersection of science, industry, and color. Take cotton, for instance. Cotton comes in grades, described in the trade in the 1920s by a host of adjectives: creamy, bloomy, bright, gray, dull, spotted, tinged, stained. The grade of any particular crop of cotton could be the result of a number of factors, from when it was harvested to the whim of the grader, who relied on painstakingly prepared boxes of cotton samples showing examples of the different grades. Grade was related not only to price and desirability but also to how the raw cotton was then processed into a textile. Such sample boxes were not only difficult to assemble, as each must be identical, but were the basis for decisions with profound and cascading economic implications. That such decisions were made unscientifically, without rigor, by literally eyeballing it, was a source of great frustration for Nickerson and her colleagues. For what is the difference, really, between "gray" and "dull"? "Tinged" and "stained"?[20]

It was on these sorts of problems that Nickerson turned the objective eye of science, in the form of a disk colorimeter of her own design. Like many devices used by color workers in this period, her colorimeter used so-called Maxwell discs, colored circles with slits in them that could be overlapped in various proportions on a mechanism that spun. When the disks were spinning, the eye saw only one color, the combination of the two spinning disks. When that color matched the color of the sample being analyzed, the analyst using Nickerson's instrument measured the proportion of each disk that was visible and used a mathematical formula to convert the individual color notations and proportions into a single unique color code. Although time-consuming, it was reassuringly exact, a method that translated visual evidence into mathematical language by comparing a sample from the messy, variable natural world not to another sample from the messy world but to a color standard defined by science. To make these analyses as scientific as possible, Nickerson and her colleagues stressed the need to carefully control the physical environment in which the test was conducted, specifying, for instance, the location of the person conducting the analysis, the position of the disk colorimeter, and the sources of both artificial and natural light (Figure 3).[21]

Nickerson's scientific methodology could be applied to any number of products whose color was of economic and scientific interest, such as rice, honey, meat, grains, hay, or breads. As Nickerson noted in a USDA publication in 1929, proper color was a significant problem in agriculture, where color conveyed information about such widely disparate variables as protein content, diastatic activity, or monetary value. In the 1920s and 1930s the Munsell Color Company and the USDA made standards for soap colors; scales to measure detergent powder; scales to measure smoke deposits; and scales to be used in the commercial preparation, standardization, and grading of food products, including milk, butter, tuna fish, and potato chips. They also made scales for all sorts of canned foods (Nickerson noted in an overview of her career that canners were particularly concerned about standardizing the colors of tomato soup and mayonnaise) and meat-grading scales to be used in slaughterhouses.[22] With the Dairy Division of the USDA, Nickerson worked on color scales for chocolate and angel food cake—a reminder of how important color is to our experience of our mass-produced world. (Consumers would be startled and suspicious if a cake mix suddenly produced a cake noticeably different in color than a previous batch.) For the

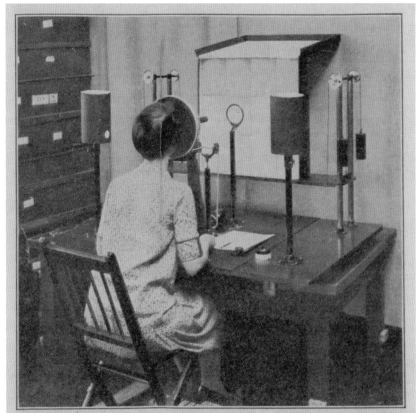

FIGURE 14.—Colorimeter developed for this work as it is set up for the measurement of cotton. The area within the black ring is measured at one time. Figure 15 shows the details of the apparatus

3.
A technician color grades cotton using a standardized setup, with lights, apparatus, and the technician's head all in their prescribed places. From Dorothy Nickerson, "A Method for Determining the Color of Agricultural Products," *USDA Technical Bulletin 154* (December 1929), Nickerson Papers, Acc. 2188, Item 197. Courtesy of the Hagley Museum and Library, Wilmington, Delaware.

Filene Department Stores, the Munsell Color Company in the 1920s created a color chart for the use of the fashion industry. All of these scales used the Munsell notation, the H V/C codes, which placed a particular color in an exact place in the color solid. These notations not only made the color easily identifiable and reproducible but also gave the entire enterprise the gloss of scientific accuracy.

Although these color charts brought a long-desired uniformity to a host of technical and commercial enterprises, these industrial, factory floor applications of color were also potentially deskilling, building into the chart itself what had once required a depth of experience, discernment, and a trained eye. Using color charts to grade meat or check mayonnaise required little training in either judgment or the use of instruments of quality control, as the charts themselves embodied instrumental data through the choice of colors included in the particular chart. (Nickerson and others did hold that the user of such charts should have his or her vision tested for color acuity, in essence converting the person into a calibrated instrument.)

However, other color charts were designed for those with great expertise. Of perhaps greater scientific importance was Nickerson's work on creating color scales for soil scientists, a field in which color was a proxy for all sorts of qualities that would otherwise have to be determined by laboratory testing, such as oxygenation and mineral and water content. Previous efforts to develop color scales for soil by other color workers had succumbed to the technical difficulties of actually handling the soil—one of nature's messier substances—but Nickerson and her collaborators developed a portable color scale that could be taken into the field, where soil could be analyzed in situ. Soil was also one of the few arenas in which the Munsell color workers yielded to the human impulse to name, to describe color using words. Yet even here Nickerson and her colleagues insisted on a scientific approach, using the social science method of surveying soil scientists to settle upon a set of carefully chosen descriptors with specifically defined adjectives to differentiate among them.[23] Nickerson also worked with other specialized groups, such as the American Horticultural Society and the American Orchid Society, to develop discipline-specific color charts. (The gardening columnist for the *New York Times* praised her American Horticultural Society color fan as "valuable to the horticultural public," given that it included both the popular names and numerical Munsell codes for colors.[24])

However, despite these trappings of science—the exactitude of the H V/C codes, the spectral data, the surveys, the international illumination standards, the mathematical "standard observer"—color work at midcentury remained a subjective enterprise. Using color charts to express something standard, unchanging, and uniform about the natural world still required the use of the decidedly nonstandard human eye and judgment. Color workers acknowledged these vagaries by calling for color perception tests for scientific workers who used color charts and tried to compensate for variation among humans by delineating fussy instructions and standard procedures for analysts to follow. For instance, soil analysts using the Munsell soil charts should ideally do their analysis in the field, with north light, on an overcast day, with a clod of soil that was freshly broken, dry but not dusty, then repeat their analysis with a lightly moistened but not shiny sample of soil, and so on.[25]

Perhaps a greater challenge to color standardization in scientific circles was the very reason why scientists in the late nineteenth century desired standardization. As J. H. Pillsbury noted in 1892, the colors and color terms found useful by one group of analysts, say, naturalists in the field, were not necessarily the colors another group, say, physicists in the laboratory, wanted to use. Indeed, a large number of scientists at midcentury looked at the Munsell colors and found them wanting as a measure of the natural world. In particular, biologists found the Munsell atlas unsuitable, its colors too vivid to describe feathers, fungi, and fur. In color workers' terms, the Munsell atlas lacked enough colors of low chroma. The special soil scale Nickerson developed was meant in part to meet these criticisms, but it too lacked necessary colors, as the Munsell company struggled to find pigments stable enough to be used in the color chips. Thus, at midcentury, many biologists preferred the color system developed by Smithsonian ornithologist Robert Ridgway, finding in Ridgway's 1912 system more of the colors they needed. In fact, the Division

of Geology and Geography subcommittee of the National Research Council had developed its original soil color scale in 1928 using Ridgway's system.

This partisan support notwithstanding, Ridgway's colors were problematic. Ridgway had developed his first color system (*A Nomenclature of Colors for Naturalists, and Compendium of Useful Knowledge for Ornithologists*) in 1886 as a way both to identify colors when working with specimens and to "determine exactly what name to apply to a particular tint."[26] Although this early work was embraced by some, the color chips lacked uniformity from volume to volume—a critical flaw—and some users from other fields in natural history resented the inclusion of ornithological data in the volume. Ridgway acknowledged these shortcomings, and spent the next two decades refining his *Color Standards*. Initial reviews were glowing.[27]

However, as botanists William Illman and D. H. Hamly noted in 1948, scientists soon realized that Ridgway's colors were "less useful in color description than it was originally hoped."[28] Most critically, Ridgway (or his printer) had not chosen the pigments he used for his color chips in *Color Standards* wisely: the chips faded, abraded, and darkened with the passage of time, creating significant variation among volumes.[29] Furthermore, although Ridgway's colors were more useful to certain scientists, his system was less "scientific": the colors were not stepped in equal increments like the Munsell colors, leaving a user of the Ridgway system no way to describe a color in between the colors Ridgway had included. Moreover, Ridgway used descriptive names for colors instead of codes (Figure 4).

More importantly—in ways that systematizers like the Munsell color workers found vexing—color helped define communities. As one historian has noted, despite the Ridgway color system's shortcomings, "Ridgway is used because Ridgway was used in the past."[30] Biologists liked the Ridgway colors, they were familiar with them, and the compact size of Ridgway's work was ideal for use in the field. Most critically, biological scientists found in Ridgway's pages the colors they saw in their specimens, and a 1949 international survey found that the Ridgway colors were the most widely used color system by biologists.[31] Ridgway included Isabella color, invisible green, dragon's blood, and elephant's breath in his system, but that may have just increased its appeal to its users. It was craft knowledge, something mastered through time and experience, something that required skill and judgment. The subjectivity of the system, its special place within biology, bound its users together.

A poignant illustration of the subjectivity of color is found in the Nickerson papers at the Hagley Museum and Library in Delaware. Carefully filed away, each tucked into its own protective sleeve, are a set of colored papers, heavy paint on thick cardstock. A note, dated September 4, 1975, is handwritten by Nickerson on the first protective sleeve, indicating that these are the Ridgway color sheets—*the* Ridgway color sheets, the reference sheets used in the production of the Ridgway atlases—given to her by A. B. Hoen of the Hoen lithographic and printing company of Baltimore, which had printed the atlases. Hoen told Nickerson "he was the last at the plant to understand their worth" and had given them to her for safekeeping.[32] No longer appreciated or understood by the printers, largely rejected by its former supporters, Ridgway's

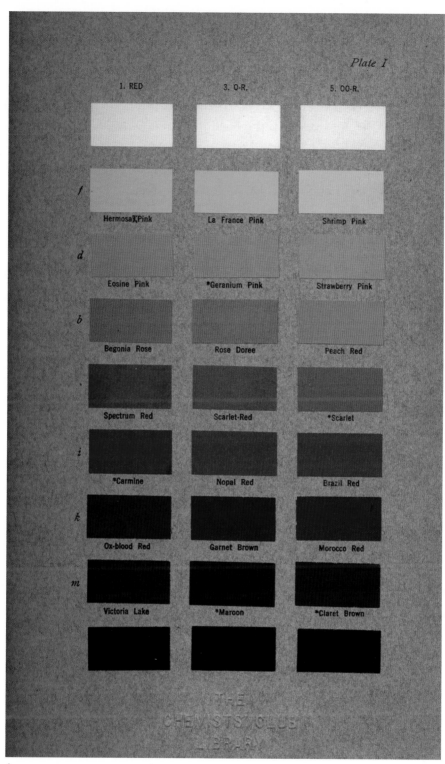

4.
La France pink (middle column, second from the top), oxblood red (left column, third from the bottom), and Victoria Lake (below oxblood red) were some of the idiosyncratic color names used in Ridgway's color standards. From Robert Ridgway, *Color Standards and Color Nomenclature* (Washington, D.C.: Robert Ridgway, 1912). Courtesy of the Othmer Library of Chemical History, Chemical Heritage Foundation, Philadelphia, Pennsylvania.

color standards now exist safely hidden away from any light that might disturb or distort their unique colors.

The Munsell color system, on the other hand, found application over the course of the twentieth century in an astonishingly wide variety of enterprises that use color as an analytic tool, from archeology to wetlands analysis to quantifying skin and hair color in forensic pathology to judging whether fast food French fries are cooked properly.[33] Munsell's moralizing about color's effect on the young and the need to train children in color as systematically as in music has long since disappeared from discussions about color. But his color system itself, reassuringly exact, backed up by instrumental data, and utterly devoid of poetry, perseveres.

Acknowledgments

I thank Jennifer Landry of the Chemical Heritage Foundation for encouraging me to pursue my fascination with the Munsell color charts, the audience at the 2008 Artefacts conference, where this paper was originally presented, for their helpful comments, and the editors and anonymous reviewers of this volume for their constructive feedback.

Notes

1. A typescript of Munsell's diary has been made available on the Web site of the Munsell Color Science Laboratory, Rochester Institute of Technology, http://www.cis.rit.edu/research/mcsl2/online/munselldiaries.php, last accessed November 13, 2010. At the time of this writing, the Web site was undergoing a substantial reorganization, and Munsell-related content was being moved to http://www.cis.rit.edu/research/mcsl/node/512. All citations to Munsell's diary in this essay cite both the name assigned to the diary section by the Color Science Laboratory, the page of the original typescript, and the date of Munsell's entry. A secondary source closely based on Munsell's diaries is Dorothy Nickerson, "History of the Munsell Color System," *Color Engineering* 7, no. 5 (September–October 1969): 42–51. For an overview of Munsell's career, see Edward R. Landa, "Albert H. Munsell: A Sense of Color at the Interface of Art and Science," *Soil Science* 169, no. 2 (February 2004): 83–89; and Landa and Mark D. Fairchild, "Charting Color from the Eye of the Beholder," *American Scientist* 93 (September–October 2005): 436–43.

2. There is an extensive literature on how various analysts and artists have sought to understand color, some of it highly technical. A starting point, which this author did not have access to during the preparation of this essay, is Regina Lee Blaszczyk, *The Color Revolution* (Cambridge, MA: MIT Press, 2012).

3. Munsell mentions some of these names in various diary entries and others in his published work. See also J. H. Pillsbury's complaints about color names in "A New Color Scheme," *Science* 19, no. 473 (February 26, 1892): 114. Both elephant's breath and ashes of roses have recently made comebacks in the offerings of an upscale paint company. A recently published starting point for the meanings of historical color names is Deb Salisbury, *Elephant's Breath and London Smoke* (Neustadt, ON, Canada: Five Rivers Chapmanry), 2009.

4. Pillsbury, "A New Color Scheme," 114. See also Milton Bradley, "The Color Question Again," *Science* 19, no. 477 (March 25, 1892): 175–76. Hallock's system was adopted as the basis for entries on color standards in Funk and Wagnall's *Standard Dictionary*; W. Hallock and R. Gordon, "Color Standards," *Science* 6, no. 136 (August 6, 1897): 214–15. For a brief discussion of Hallock's work, see Hilaire Hiler, "Some Associative Aspects of Color," *The Journal of Aesthetics and Art Criticism* 4, no. 4 (June, 1946): 209.

5. Worthington Ford, quoted in Munsell diary volume A3, p. 42, December 5, 1900.

6. Munsell diary volume A8, p. 159, June 15, 1902.

7. A. H. Munsell, *A Color Notation: A Measured Color System Based on the Three Qualities, Hue, Values and Chroma with Illustrative Models, Charts and a Course of Study Arranged for Teachers* (Boston: Geo. H. Ellis, 1905). The system that J. H. Pillsbury developed with Milton Bradley also used Maxwell discs to assign codes to specific colors, but these codes were not incorporated into a larger theoretical approach to color or color education. For Munsell's earlier endorsement of "lettuce," see Munsell diary volume A1, p. 15, April 2, 1900.

8. "Track across desert," Munsell quoting his friend Professor [Amos] Dolbear, Munsell diary volume A8, p. 144, April 8, 1902; "modistes," Munsell diary volume A7, p. 135, December 28, 1903.

9. Munsell diary volume A4, p. 63, May 17, 1901.

10. The preface to the 1904 lecture series is reproduced in the typescript of Munsell's diary, volume A4, p. 165.

11. Munsell, *A New Color System*, a pamphlet reprinted from the *Proceedings of the Joint Report*, 1907. A copy of this pamphlet can be found in the Inter-Society Color Council Records, Series V: Dorothy Nickerson Papers, box 197, Hagley Museum and Library, Wilmington, DE (hereafter Nickerson Papers).

12. Munsell diary volume A11, p. 205, October 31, 1906. Munsell faced opposition to his ideas about middle values from a variety of sources, recording an argument, for instance, with a correspondent in 1901 over his rather brownish middle yellow, which his correspondent objected was "not the accepted type." Munsell diary volume A4, p. 67, May 27, 1901.

13. Munsell, *A New Color System*.

14. Munsell's conservatism about color was echoed in his own artistic output, primarily muted seascapes and landscapes. In his color diary and published works on color systematization Munsell does not comment on contemporary artistic movements that explored the primacy of color, such as Fauvism.

15. A. H. Munsell, "A Pigment Color System and Notation," *American Journal of Psychology* 23 (1912): 236–44. Nickerson, in "History of the Munsell Color System," identified this employee as Ferdinand A. Carlson, noting that he worked full-time from 1912 to 1940 (with the exception of 1938–39, when the company struggled to employ him). Munsell documented a number of discussions with printers about the difficulties of color reproduction in his diary.

16. For a detailed account of these investigations and the Munsell researchers' collaboration with the Bureau of Standards (which began with A. H. Munsell in 1912), see Dorothy Nickerson, "History of the Munsell Color System and Its Scientific Application," *Journal of the Optical Society of America* 30, no. 12 (December 1940): 575–86.

17. See, for instance, P. L. Ricker, "A New Color Guide," *Mycologia* 2, no. 1 (January 1910): 37–38; and William Leon Dawson, "A Practical System of Color Designation: A Partial Critique of Ridgway's *Color Standards and Nomenclature*," *The Condor* 15, no. 6 (November–December 1913): 212–14.

18. See the discussion of color matching in Deborah Jean Warner, "How Sweet It Is: Sugar, Science, and the State," *Annals of Science* 64, no. 2 (April 2007): 147–70. On colorimeters, see Warner, "The DuBoscq Colorimeter," *Bulletin of the Scientific Instrument Society* 88 (2006): 68–70. On Ringelmann smoke charts, see Frank Uekoetter, "The Strange Career of the Ringelmann Smoke Chart," *Environmental Monitoring and Assessment* 106, no. 1 (2005): 11–26.

19. A wonderful example of a set of color charts developed for physicians' use can be found in the Nickerson Papers; see Henry Emerson Wethergill, *Universal Color Measuring Book* (Phoenixville, PA, 1929). Wethergill included iris colors, urine and feces colors, blood colors, and postmortem blood colors, among other color charts, in a slim, pocket-sized (man's jacket) sturdy booklet. Nickerson Papers, box 197.

20. "Tinged": Dorothy Nickerson, "Color Measurement and Its Application to the Grading of Agricultural Products," *USDA Miscellaneous Publication 580* (1946). A copy of this publication can be found in the Nickerson Papers, box 197. Nickerson's work is documented in a series of technical publications that were published as pamphlets or booklets by the U.S. Department of Agriculture (such as the 1929 bulletin "A Method for Determining the Color of Agricultural Products," *USDA Technical Bulletin 154*) or in technical journals. For more of her work on cotton, for instance, see "Color Measurements of Standards for Grades of Cotton," *Textile Research Journal* 16 (September 1946): 441–49, which recounts how her research on cotton color standards began in 1927.

21. Nickerson, along with colleagues, continued to elaborate this instrument and methodology over the course of several decades. See Dorothy Nickerson, Richard S. Hunter, and Marshall G. Powell, "New Automatic Colorimeter for Cotton," *Journal of the Optical Society of America* 40 (1950): 446–449

22. Nickerson, "History of the Munsell Color System" (1969): 48. A hand-painted meat-grading scale can be found in the Nickerson Papers, box 197.

23. T. D. Rice and James Thorp, "Preliminary Color Standards and Color Names for Soils," *USDA Miscellaneous Publication 425* (September 1941). A copy of this publication can be found in the Nickerson Papers, box 210. Robert L. Pendleton and Dorothy Nickerson, "Soil Colors and Special Munsell Soil Color Charts," *Soil Science* 71, no. 1 (January 1951): 35–43. For a fuller discussion of the needs of soil scientists and how this community adopted the Munsell system, see Landa, "Albert H. Munsell: A Sense of Color."

24. Joan Lee Faust, "Around the Garden," *New York Times*, November 17, 1957.

25. Pendleton and Nickerson, "Soil Colors," 40–41.

26. Robert Ridgway, *A Nomenclature of Color for Naturalists* (Boston: Little, Brown, 1886), 9.

27. Robert Ridgway, *Color Standards and Color Nomenclature* (Washington, D.C.: Robert Ridgway, 1912). There are numerous contemporary reviews of Ridgway's *Color Standards*. For discussions of some of the problems that emerged with use with the Ridgway atlases, see William Illman and D. H. Hamly, "A Report on Ridgway Color Standards," *Science* 107 (June 11, 1948): 626–28; John Zimmer, "More About Ridgway's *Color Standards and Color Nomenclature*," *Science* 108 (October 1, 1948): 356, defending Ridgway; and Hamly, "Robert Ridgway's Color Standards," *Science* 109 (June 17, 1949): 605–8, which provides an overview history of the Ridgway color standards as well as a specific comparison of the Ridgway and Munsell systems. A short exploration of Ridgway's work can be found in Elizabeth B. Davis, "Ridgway's *Color Standards*: A Classic in Biology," *Bios* 56, no. 3 (September 1985): 143–52. A full biography of Ridgway, which this author did not have access to during the preparation of this essay, is Daniel Lewis, *The Feathery Tribe: Robert Ridgway and the Modern Study of Birds* (New Haven, CT: Yale University Press, 2012). A thorough listing of color charts used by or developed for biologists can be found in Arthur O. Tucker, Michael J. Maciarello, and Sharon S. Tucker, "A Survey of Color Charts for Biological Descriptions," *Taxon* 40, no. 2 (May 1991): 201–14, who concluded by noting that "the ideal universal biological color chart still awaits publication."

28. Illman and Hamly, "A Report on Ridgway," 626.

29. Hamly, "Robert Ridgway's Color Standards," 606

30. Davis, "Ridgway's *Color Standards*," 150.

31. This survey is discussed by Hamly, "Robert Ridgway's Color Standards," 606–7.

32. Nickerson, memorandum September 4, 1975, handwritten on exterior of folder of Ridgway color standards. Nickerson Papers, box 197.

33. See, for instance, Munsell food grading charts such as the one at http://www.xrite.com/product_overview.aspx?ID=912 (accessed January 12, 2012), sold by the Michigan company X-Rite, which acquired the Munsell Color Company after a series of corporate twists and turns beginning in 1969, when the Munsell Foundation sold the Munsell Color Company to the Macbeth Color and Photometry Group of the Kollmorgen company.

Bibliography

Blaszczyk, Regina Lee. *The Color Revolution*. Cambridge, MA: MIT Press, 2012.

Bradley, Milton. "The Color Question Again." *Science* 19, no. 477 (March 25, 1892): 175–76.

Davis, Elizabeth B. "Ridgway's *Color Standards*: A Classic in Biology." *Bios* 56, no. 3 (September 1985): 143–52.

Dawson, William Leon. "A Practical System of Color Designation: A Partial Critique of Ridgway's *Color Standards and Nomenclature*," *The Condor* 15, no. 6 (November–December 1913): 212–14.

Hallock, W., and R. Gordon, "Color Standards." *Science* 6, no. 136 (August 6, 1897): 214–15.

Hamly, D. H. "Robert Ridgway's Color Standards." *Science* 109 (June 17, 1949): 605–8

Hiler, Hilaire. "Some Associative Aspects of Color." *The Journal of Aesthetics and Art Criticism* 4, no. 4 (June 1946): 203–17.

Illman, William, and D. H. Hamly. "A Report on Ridgway Color Standards." *Science* 107 (June 11, 1948): 626–28.

Inter-Society Color Council Records. Series V: Dorothy Nickerson Papers. Hagley Museum and Library, Wilmington, DE.

Landa, Edward R. "Albert H. Munsell: A Sense of Color at the Interface of Art and Science." *Soil Science* 169, no. 2 (February 2004): 83–89.

Landa, Edward R., and Mark D. Fairchild. "Charting Color from the Eye of the Beholder." *American Scientist* 93 (September–October 2005): 436–43.

Lewis, Daniel. *The Feathery Tribe: Robert Ridgway and the Modern Study of Birds*. New Haven, CT: Yale University Press, 2012.

Munsell, A. H. *A Color Notation: A Measured Color System Based on the Three Qualities, Hue, Values and Chroma with Illustrative Models, Charts and a Course of Study Arranged for Teachers*. Boston: Geo. H. Ellis, 1905.

———. "A New Color System," In Proceedings of the Joint Report of the Eastern Art Teachers, Eastern Manual Training Association, and Western Drawing and Manual Training Association, Cleveland, Ohio, pp. 56–71. Normal, Ill., William T. Bateman, 1908.

———. "A Pigment Color System and Notation." *American Journal of Psychology* 23 (1912): 236–44.

———. *Color Diary*. http://www.cis.rit.edu/research/mcsl2/online/munselldiaries.php (accessed January 12, 2012).

Nickerson, Dorothy. "A Method for Determining the Color of Agricultural Products." *USDA Technical Bulletin* 154 (December 1929).

———. "History of the Munsell Color System and Its Scientific Application." *Journal of the Optical Society of America* 30, no. 12 (December 1940): 575–86.

———. "Color Measurement and Its Application to the Grading of Agricultural Products." *USDA Miscellaneous Publication 580* (1946).

———. "Color Measurements of Standards for Grades of Cotton." *Textile Research Journal* 16 (September 1946): 441–49.

———. "History of the Munsell Color System." *Color Engineering* 7, no. 5 (September–October 1969): 42–51.

Nickerson, Dorothy, Richard S. Hunter, and Marshall G. Powell. "New Automatic Colorimeter for Cotton." *Journal of the Optical Society of America* 40 (1950): 446–446.

Pendleton, Robert L., and Dorothy Nickerson. "Soil Colors and Special Munsell Soil Color Charts." *Soil Science* 71, no. 1 (January 1951): 35–43.

Pillsbury, J. H. "A New Color Scheme." *Science* 19, no. 473 (February 26, 1892): 114.

Rice, T. D., and James Thorp. "Preliminary Color Standards and Color Names for Soils." *USDA Miscellaneous Publication 425* (September 1941).

Ricker, P. L. "A New Color Guide." *Mycologia* 2, no. 1 (January 1910): 37–38.

Ridgway, Robert. *A Nomenclature of Colors for Naturalists, and Compendium of Useful Knowledge for Ornithologists*. Boston: Little, Brown, 1886.

———. *Color Standards and Color Nomenclature*. Washington, DC: Robert Ridgway, 1912.

Salisbury, Deb. *Elephant's Breath and London Smoke*. Neustadt, ON, Canada: Five Rivers Chapmanry, 2009.

Tucker, Arthur O., Michael J. Maciarello, and Sharon S. Tucker. "A Survey of Color Charts for Biological Descriptions." *Taxon* 40, no. 2 (May 1991): 201–14.

Uekoetter, Frank. "The Strange Career of the Ringelmann Smoke Chart." *Environmental Monitoring and Assessment* 106, no. 1 (2005): 11–26.

Warner, Deborah Jean. "The DuBoscq Colorimeter." *Bulletin of the Scientific Instrument Society* 88 (2006): 68–70.

———. "How Sweet It Is: Sugar, Science, and the State." *Annals of Science* 64, no. 2 (April 2007): 147–70.

Wethergill, Henry Emerson. *Universal Color Measuring Book*. Phoenixville, PA, 1929.

Zimmer, John. "More About Ridgway's *Color Standards and Color Nomenclature*." *Science* 108 (October 1, 1948): 356.

CHAPTER 4

Models
Assembled Realities in Architecture and Engineering

Dirk Bühler
Senior Curator

Deutsches Museum
Munich, Germany

Introduction

The models of specific houses, exemplary bridges, and other outstanding architectural and engineering constructions represent a large part of the collections and exhibits on building history at the Deutsches Museum. By displaying these models, the Deutsches Museum aims to portray milestones in the history of construction and technology. The assembled realities of models are manifestations of a built reality outside the museum and placeholders for the "real" artifacts.

During the first decades after the foundation of the Deutsches Museum in 1903, only a few people could afford to travel around the world and study historically and culturally valuable buildings on site. Therefore, it was one of the tasks of the museum to allow visitors to appreciate these buildings as models. This is why the Deutsches Museum collected so many building and construction models from around the world in its first thirty years, including many valuable exhibits that now have historic value. This chapter presents three models of houses out of this collection and interprets them exemplarily in the context of their aesthetic significance for construction history: The model of the Kammerzell House in Strasbourg was built between 1880 and 1910 as a planning tool and represents today an eloquent example for a pictorial program on a medieval façade. The three models of Japanese houses have been utilized as an exotic attraction in the museum and represent still today a design model for

architects. The model of the public baths in Dessau was built in 1909 for public instruction in the museum and helps architects today in the restoration of the original building. A closer look at the models will contribute to a better understanding of the interrelations between art, science, and technology.

Even a superficial review of the literature on models reveals a fundamental problem when scholars of different academic disciplines try to define common characteristics within and between categories of models. Even if we limit our examination to the category of architectural and construction models, as proposed in this chapter, the task of defining the overarching properties remains difficult. But a first, pragmatic approach allows us to identify a common denominator: all models differ in scale and material from the reality they intend to represent.[1]

Architectural and construction models have existed since antiquity.[2] Their regular use, especially for the design process in architecture, only became widespread from the Renaissance onward.[3] These models, like the one Brunelleschi made for the cupola of Santa Maria del Fiore in Florence, have been produced either as a tool during the design process or for a more comprehensible presentation of building plans to the public. Models are often the first and best representation of an artistic or architectural idea. For a variety of reasons, these drafts often do not ever get realized, and for that reason, the models evidence the distillation of great, but otherwise unknown, designs. The fact that architectural models are still used in the "digitized" societies of our times attests to their convenience, benefits, and values. Models can represent archetypes for planned constructions and for reproductions of historical buildings; they can be imaginary presentations of the future and can serve as a means of explaining history, albeit, of course, very subjectively. Obviously, these models only represent a segment of the usually more complex reality outside the museum and are always embedded in their historical context. The way in which this partial reality is selected reflects not only the intentions but also the educational and social background of the modeler and follows an analytical interpretation of his or her ideas. In any case, they are what Herbert Stachowiak calls an "assembled reality" and are thus also subject to epistemological exploration.[4] Peter Galison has pointed out that a scientific approach to architecture and even more to its models involves the use of many different means of interpretation, signification, and meaning.[5] Manifesting particular layers of reality, models are also part of the material culture, and they are in many ways "things that talk."[6]

Beyond interpreting the design, meaning, history, and values of architectural models as "assembled realities," our analysis has to be focused on their aesthetic concepts since models develop their own aesthetic values independently from the originals on which they are based. The creator of a model submits his or her work also to his or her own imagination and transmits, beyond the established physical appearance of the object itself, his or her personal ideas, thoughts, and feelings. A personal vision of reality can constitute a profound incentive to a model builder and confers on him or her the status of an artist.

Collections of architectural models are, of course, expected to be found in museums of architecture and technical universities. Many cities also collect models of their own public buildings,

showing them occasionally in galleries. Most remarkable is the stock of model buildings in anthropological and cultural museums, which illustrate how people of the world live and dwell. The difference between the collections held in these museums, specialized in architecture, history, or anthropology, and the collection at the Deutsches Museum, examined in this contribution, results from the breadth of building and construction themes housed by the latter. The reason is the intention of the Deutsches Museum to represent a complete, if not encyclopedic, spectrum of scientific and technical fields and disciplines. These models do not represent just architectural or historical spaces (as architectural models usually do), but all additional constructive, material, and decorative details of a building. The construction of these models was nearly always accompanied by scientific research, with construction and research enhancing each other.[7] The scientific approach to construction models does not end with the completion of the model. Rather, it should ideally be a continuous process, drawing not only on history but also on the presence.

Because of a recent revalidation of the model stock in the Cité de l'architecture et du patrimoine in the Palais de Chaillot in Paris and the Technical University Munich, for instance, the discussion about the revalidation of models has been resumed with fresh academic interest.[8] Models are seen as examples and prototypes for the humanities, as simulations for natural scientific assumptions and phenomena, and as a random method for marketing, traffic, and financial planning and are thus also subject to theoretical research. Even architectural models experience new interpretations of their professional context when they are not used any more as design tools and become historical documents over the years. In the following section, I will focus on two overarching questions: First, what are the models made for? Second, what types of aesthetics do they express?

The Deutsches Museum is primarily known for its renowned hands-on exhibits, which serve as a means of technical education and as a source of artistic inspiration and scientific research. But its collection of dioramas and models is equally remarkable and designed to achieve the same aim. The tradition of creating dioramas and models as three-dimensional object lessons can be traced back to the communication concepts that were dominant in museum circles during the foundation period of the Deutsches Museum in the early twentieth century. Because of their long-lasting success, these instructive displays—now designed using present-day techniques— still form the backbone of the exhibition concepts. Many of these models are, even today, created in the museum's own workshops. There are about 10,000 such items on display in the Deutsches Museum, distributed throughout the various exhibitions and covering all classes and types of models.

Among these, the collection of architectural and construction models held by the Deutsches Museum represents a central part of the museum's holdings. The representative variety of the models included in this collection allows us to exemplify some of the main functions that models can have in a museum setting. A first category of model is designed to be used as a means of historical documentation and represents selective portraits of the past; frequently, these models were produced for a different purpose than the one they serve now and thus become documents

of their own history.[9] These model portrayals take on additional importance if the original they represent has been altered or even destroyed.

A second category of model is dedicated to the description of processes and procedures, documenting and representing technical methods of construction.[10] Manufacturing these kinds of models must be accompanied by scientific research. In particular, significant details have to be explored, defined, focused, and captured correctly in order to be transferred into a physical form. Models that display processes in action need a sense of the "right moment"; from the many steps that make up a process, the crucial moment must be ascertained in order to show the most descriptive and representative action. The design of this kind of model also obliges the researcher to pose new, more practical questions about the construction process, leading to a better understanding of the technical processes.

A curious type of model is dedicated to public instruction, for instance, the promotion of a healthier lifestyle, which was quite in vogue and necessary for public hygiene at the beginning of the past century.[11] These models are no longer explicable by their original intention; they lose their significance when the observer is already familiar with the attitudes promoted at the time in question. Hence, they modify their meaning and become documents not only of their own history, as signs and symbols, but also of the original object they represent. Another type of model is attributable to wanderlust in a time long before large-scale mobility became popular and possible for everyone; thus, models represented one of the only opportunities to see exotic forms of life and dwellings. In our times, models can document a lost past because many original buildings have disappeared.[12]

Construction models are a significant means of instruction during childhood, for schoolwork, and during apprenticeship and university studies, and thus, the Deutsches Museum maintains an exemplary selection.[13] Because children and students use these models for learning and training, they reflect the tastes and techniques of their time and therefore represent essential historical documents. This last category includes objects whose size suggests that they are models, but a detailed study reveals them to be original and unique works of art.[14] With their expressive power, meticulous workmanship, and creativity, these models are quite close to sculptural works of art

With regard to architectural models, three essential parts are fundamental and need to be assembled: the façade (or skin), the space, and the function of the building. From a large range of objects, I have selected three models for the actual presentation, each emphasizing one of these main assembly aspects. The skin will be the main issue for the study of the model of the Kammerzell House in Strasbourg, the aesthetics of space will be best exemplified by the models of Japanese houses, and the function of a building will be illuminated with an example of a public bathhouse in Dessau.

The main questions to be dealt with are what was the original purpose the model was built for, and what conclusions can we draw about the perceptions of the time? The subsequent steps in my interpretation concern the physical changes suffered by the model, and the changes in meanings and aesthetics. My final analysis asks what the model represents, both in an abstract

sense and in reality, what it stands for in present time, and, finally, what its significance is as part of the museum collection.

Façade: The Skin of Architecture

A visit to the Kammerzell House (Place de la Cathédrale 16), on the corner of Strasbourg's Cathedral Square, formerly the horse market, offers exceptional architectural and artistic delights.[15] A foretaste is provided by the model in the Deutsches Museum, a donation from the mayor of Strasbourg in the year 1912. It is one of the most beautiful exhibits in the collection of house models and reproduces the building in great detail at a scale of 1:50. This model (Figure 1), made of solid timber, represents a four-story timber-framed building with graceful wooden struts, leaded crown glass in the windows, and a steep folding roof, whose pointed gable in the original building faces Strasbourg Cathedral.[16] The two well-designed colored show façades are covered abundantly with wood carvings and paintings. The two rear sides that border the two outbuildings are not designed so carefully in the model, but they can be opened, so that inside the model the partition walls are visible. Lamps were mounted inside so that the front windows can be illuminated and their stained-glass windows are enabled to gleam.

The Kammerzell House is classified in construction history terms as an Upper German (formerly Alemannic) half-timbered house.[17] Within the context of other models of half-timbered houses in the museum's collection, this special model stands not only as an instructive example of this traditional German type of construction for the education of architects and carpenters (in times of historicism they should be enabled to build new and restore historic buildings in this style) but also as a political statement. This and other buildings in Strasbourg, the capital of the Alsace region of France, are part of the German building tradition. The act of showing this model in the Deutsches Museum indicates Alsace should consequently be considered a solid part of the German (and not the French) Empire: between the years 1871 and 1918, this was more than a demand.

The essential characteristics of the Upper German house are all shown in the model of the Kammerzell House as follows: the wall posts are placed at great distance and combined with continuous traverses. The oriels are salient only at bar width. Thanks to these characteristics, these half-timbered houses offer a clearly structured design.[18] The first floor, built of stone and raised slightly above street level, is another feature that fits into the typology of the Upper German half-timbered houses of Alsace. Some of these houses, especially those dating from the Renaissance, are decorated with wood carvings, but none in such an exuberant manner as this one.

The ground floor, with its Gothic stone vaulting, dates from 1467—as the inscription carved in stone above the entrance door tells us—and belonged to a clothier named Hans Jœrger. His workshop is first mentioned in records in 1427, which means that he must have been well established by that point, perhaps in an earlier building.[19] At the beginning of the sixteenth century, the house passed into the possession of the Staedel family, who occupied it until 1571, when they sold it to Martin Braun, who opened a cheese shop (Kæsebank) on the premises. His business

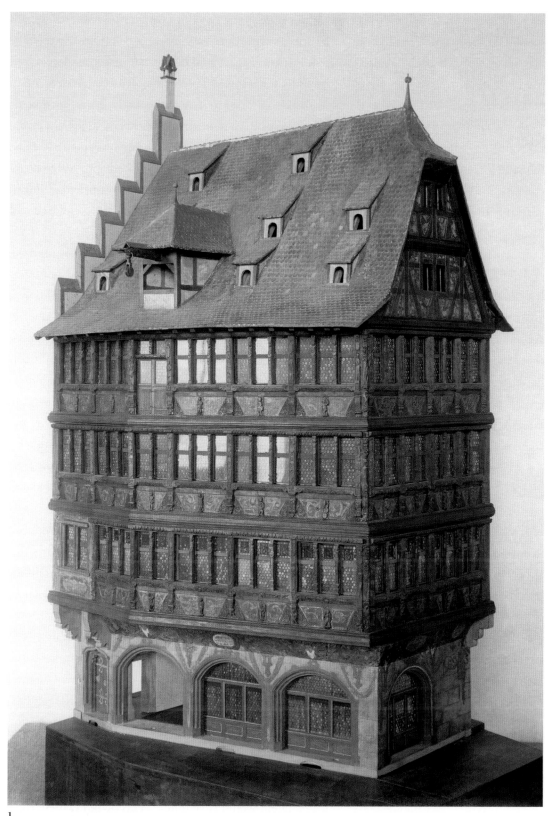

1.
The Kammerzell House in Strasbourg. Model scale 1:50. Picture Collection of the Deutsches Museum.

Assembled Realities in Architecture and Engineering

seemed to make a good profit because Braun added new stories to his house in 1589 and commissioned the magnificent half-timbered frames with their carvings and paintings. Because he had to pay tax for the privilege, we know quite precisely what Martin Braun's cheese shop looked like, with its sales tables in front of the ground floor windows, protruding between 3.5 and 7.5 ft. (1.06 and 2.26 m) into the street. When he decided in 1587 to rebuild the upper floors, documents were exchanged between the city and the owner.[20] They describe the negotiations about the allowances to cantilever new floors to the exterior and how the neighboring buildings had to be integrated into the architectural design. On May 18, 1588, he got the required approval to begin construction on his commercial building. The upper floors are laid out generously and linked vertically with a narrow spiral staircase in the rear part of the building. The pointed folding roof is also spacious and has a dormer housing a pulley.

The property remained in the possession of several of the major merchant families until the end of the nineteenth century without undergoing any physical changes. The present name dates back to the merchant Philippe-François Kammerzell from Würzburg, who bought the building in 1806. Following an auction in 1879, when the building already needed renovation, the Kammerzell House finally came into the possession of the city council of Strasbourg, who put it under the administration of the Œuvre Notre-Dame, the cathedral works and maintenance department, which still manages the building today. Under their direction the house was completely renovated in a two-phase operation that lasted until 1892. During the restoration the remains of paintings in the interior of the building and on the façade were discovered and preserved, and some of them were restored.[21]

The model we admire today in the Deutsches Museum was probably built between 1880 and 1910, manufactured just before or during the restoration of the building in the nineteenth century in order to plan the design of the façade or to present the project to the city's elders and citizens. The unusually detailed design of the bas-reliefs on the model, which are reproduced as carvings in wood, and the walls, which are fully painted in great detail, seem to confirm this hypothesis. Unfortunately, no documents concerning the circumstances of the gift of the mayor of Strasbourg have been preserved, so the issue remains open. Even the Œuvre Nôtre-Dame in Strasbourg could not provide any documents to accompany this model.[22]

Almost the entire surface of the house, with its seventy-five windows, is decorated. The wooden struts, columns, and window frames are ornamented all over with carved bas-reliefs. The stone and plaster wall pieces are painted in bright colors. Inscriptions and sayings can be found on both show façades. The iconography of this decoration is, of course, of especial interest. Barbara Obrist, who has made a great contribution with regard to the significance of the Kammerzell House for the history of art, writes in her assessment of the building that the builder-owner, an uneducated but newly wealthy cheese merchant, did not attach any great importance to the representation of himself in a historical or humanist-cultural context when he selected the pictorial program, as an upper middle class, educated client would have done.[23] This owner chose a completely different set of decorations with as many different well-known characters as possible in

order to display his new wealth in this prominent position in front of the cathedral. Through the use of oak, this was done in a particularly durable and long lasting way.

A brief review of the pictorial program of the façades may give a general impression of the decoration. On the longer, western façade, eighteen heroes and heroines are depicted on the struts between the windows. These historical figures serve as role models for virtuous behaviour.[24] Below the windows of the side façades, sixteen musicians are shown playing various popular instruments.[25] On the cornerstone between the two front parts of the building reliefs symbolize the three cardinal virtues of faith, hope, and charity, with female figures and their attributes, from bottom to top. On the gable end, between the windows on the upper and middle floors, the ten ages of man are shown with figures as bas-reliefs and inscriptions, including their attributes. On the first floor, the five senses appear.[26] Beneath the windows of the gable we find the twelve signs of the zodiac.

Today, the Kammerzell House is one of the few preserved half-timbered houses in Strasbourg that survived not only the bombings of the city in 1870 and 1944 but also the later waves of modernization without being fundamentally damaged. Thus, it stayed intact, overwhelmingly unique within its urban context. It is considered an important historical and artistic three-dimensional document that, more than all the other qualities that it possesses, certainly enjoys a fitting use.

The model corresponds well to the present state of the original building. It impresses the viewer with its meticulous level of detail and appears to be accurate, serious, and authentic, without a trace of the kitschy "cuteness" that is only avoidable by real professional craftsmanship.

The model of the Kammerzell House is one of several models of timber-framed houses in the Deutsches Museum. In contrast to the others, this model shows all the details that are either carved in timber or painted on the remaining plaster spaces with meticulous accuracy because it was originally constructed to aid in planning of the restoration of the original façade. Apparently, these aesthetics alone were not sufficient for display in the eye of Oskar von Miller, the museum's founder. He had lights fitted inside the model in order to make it shine like the nativity scenes so popular in Bavaria, which are the prototypes for many other models owned by the Deutsches Museum. Courtesy of these changes, the model was no longer just a planning tool but was transformed into a museum object. Now it was able to attract the attention of visitors and show not only the decoration but also the structure of a timber-framed house. Today, we admire the enormously detailed presentation and the extraordinary workmanship and take it as an example for the conservation of monuments.

Space: The Heart of Architecture

The issue of "space" in an assembled reality is best expressed within a form of architecture that considers this topic its central concern: the Japanese house. The role that interior and exterior spaces and their interaction play in Japanese architecture is present in the layout, building material, construction processes, and even the furnishings of the house. The concept of pure, clear, and well-organized modular spaces is recorded in Japanese literature and treatises.

Although Japanese architects consciously employed and cultivated their space concepts over centuries, Western nations only began to recognize, understand, and reproduce this style from the end of the nineteenth century onward. The reception of Japanese architecture and the interest in it began after the publication of the book *Japanese Homes and Their Surroundings*, written by the zoologist Edward Sylvester Morse in 1886.[27] Franz Baltzer's *Die Architektur der Kultbauten Japans*, first published in 1907, is important for the knowledge of traditional Japanese design in Germany.[28] But it was particularly in the 1920s that traditional Japanese architecture began to exercise its influence on the representative architects of Western modernity.

The German architect Bruno Taut (1880–1938) in particular was deeply impressed by the Katsura Imperial Villa in Kyoto, where he recognized basic ideas of modernity: the unity of construction and design, the modular approach (based on the tatami pattern), the well-organized layout, and the interpenetration of habitat and nature. The Imperial Palace in Kyoto fascinated visitors like Taut with its undemanding elegance, the balance of its spatial appearance, and its reduction to the most necessary in the use of components. For over a century, the Japanese house impressed the Western viewer, and it still inspires architects and designers. During his exile in Japan between 1933 and 1936, Taut worked extensively with Japanese architecture and culture, kept a beautiful diary, wrote several treatises as manuscripts, and published his book *Houses and People of Japan* in Tokyo in 1937.[29] Some years before, Tetsuro Yoshida had already published his book *Das japanische Wohnhaus* in German.[30]

These books and some other publications made Japanese architecture popular not only among builders but also within the general public in the years leading up to 1933 and were thus a serious topic for the model collection in the Deutsches Museum. Later, when the German architect Walter Gropius (1883–1969) visited Japan in 1954, he wrote to his French colleague Le Corbusier (1887–1965), "The Japanese house is the latest and best that I know and a really prefabricated one."[31]

House building in Japan was illustrated by means of a group of three special house models and some additional original objects. They are probably not authentic in every detail, but they give an impression of building and living in Japan, able to satisfy the thirst for knowledge of the modern German architects of this time and to serve as useful examples for modern building. One of these models was acquired in Munich from a tea seller, who had formerly imported it from Japan as a kind of advertisement for his business. Another one was made especially for the Deutsches Museum by a Japanese architect in Yokohama. All of them are produced in a particular Japanese way, using authentic prototypes, local materials, and the original fashion: timber, straw, stones, and sand have been incorporated, making use of their natural properties as the only colorful design elements. These models are more prominent than the others in this global-dwelling model collection because of the personal and institutional relationship between the Deutsches Museum and the Japanese government, enterprises, and universities, a relationship that was intensified after World War II by the donation of an original Japanese house, further models of Japanese buildings, and technical innovations from Japan. This longstanding cooperation is significant and beneficial to both parties even today.

Two concepts are essential for the understanding of space in Japanese architecture: the modular design of the interior space and the relationship between the interior space of the house and the exterior of the garden. The basic modular measure of the living rooms of a Japanese house is the tatami, which has a size of approximately 2.95 × 5.91 ft (0.90 × 1.80 m). It is a floor mat made of pressed rice straw and covered with a material made of woven straw. The dimensions differ slightly from place to place from the basic measure. Living rooms are sized as a multiple of that tatami surface. These mats are not added arbitrarily but use a fixed pattern according to their total quantity. A social rule determines that they may only be stepped on with slippers. The second concept refers to the inside-outside relationship, which includes sliding doors that enable these two spaces to be separated or connected. Furthermore, a system of covered and open aisles is part of the plan. Last but not least, there is a garden, which is arranged according to Japanese gardening theories. The "shade's place," the toilet, is subject to particular spatial and behavioral rules. Taizaki Jun'ichiro ventures an approach to the aesthetical vision of these spaces in his publication *In Praise of Shadows*.[32]

All these elements are present in the models of Japanese houses collected in the Deutsches Museum. All three of them (Figures 2, 3, and 4) present houses with rooms designed in accurate tatami patterns and a properly styled garden, sliding doors, aisles, stairs, and the toilet's hidden space. Moreover all parts of the buildings are made of different kinds of timber, the color, texture,

2.
Japanese country house. Model scale 1:50. Picture Collection of the Deutsches Museum.

3.
Japanese house around 1850. Model scale 1:50. Picture Collection of the Deutsches Museum.

4.
Japanese teahouse. Model scale 1:50. Picture Collection of the Deutsches Museum.

and thickness of which are adapted to the part of the building to be represented. Even larger-scale decoration is shown as carving or painting on the building elements.

The first model represents a traditional Japanese teahouse at 1:50 scale.[33] It was purchased in 1908 by an import trade company for Japanese and Chinese goods for the Deutsches Museum. It shows some characteristics of Japanese teahouses. A Japanese house should not have direct contact with the ground; therefore all parts of the building are on stilts. The garden is decorated with stones, which indicate perhaps a stone garden. The perimeter of the ground plate, which at the time delimits the lot including the garden, is surrounded by an artistic wooden fence. There is no direct access to the garden because it is intended only to be looked at. The rooms in the two stories have the size of ten tatami each; the stair to the upper room is located in the interior of the lower one, an indication that both spaces are probably closely related. The smaller room on the ground floor has the size of eight tatami and is separated by a covered bridge from the two-story part of the building. There is a bench for waiting guests on the bridge. A small room, separated from the main building, is occupied by the toilet and can be reached through the exterior aisle.

The second model shows a Japanese dwelling house at 1:50 scale.[34] This model was donated to the Deutsches Museum in 1911 by a citizen of Fürstenfeldbruck. It is remarkable for its particularly fine workmanship and because of the inlay on the veranda. It represents a building in a style dating from around 1850, with two stories and with rooms with a twelve-tatami size. A smaller building with a side room is just eight tatami in size. Between the two parts of the building is the house containing the toilet. The upper area is reached by an outside staircase. From the two rooms on the ground floor, the garden can be reached by a two-step porch. The garden is decorated with a single stone, and its perimeter is limited by a simple wooden fence. The roof of the two-story building is covered with wood shingles, a traditional Japanese roof covering.

The third model is a Japanese country-style house in the same scale (1:50) as the others.[35] This lovely model was built by Dr. Hachiro Kumagawa Miyano-shita in Yokohama. The Deutsches Museum bought it in 1927 from a citizen of Munich in order to complete their collection of domestic models from 1908. The house consists of two rooms with twelve tatami each. In front of the room on the ground floor there is an entrance hall with a small tea kitchen; next to the residential building, a little house for the toilet can be recognized. The room upstairs can be reached via a steep, narrow staircase, which is outside of the building and accessible from the galleries. In the back of the room, on the ground floor, the tokonoma, a niche for special pictures, mostly of idols, saints, and sometimes special flowers, can be seen. In front of the house the garden extends. The veranda leads down into it with two steps. The sliding doors can actually be moved and stored in special boxes.

These three models were built for very different reasons: one was built to showcase a tea shop, another was built for a collector, and the third was assembled by a Japanese enthusiast. Nevertheless, all three are made of the same materials and represent a homogeneous style, with the same depth of presentation and the same aesthetic concept. When they were acquired, they were meant to inspire visitors and let their fantasies run wild and to show them how people

lived and built in strange countries so far away. However, by the time they became part of the Deutsches Museum's collections, Western architects were searching for modern solutions for buildings in the industrial age, and these models were surely used also by them as prototypes. Today, these models also stand for a part of the Western history of architecture, as incentives for the architecture now known as "classic modernity," and represent part of the cultural heritage of the world.

Function: How Architecture Works

When architects in 2002 began to plan the modernization of the historical municipal public baths (Stadtschwimmhalle) in Dessau, they had a serious problem: the historic information they required could not be taken, as it usually was, from plans preserved in the city archives because they had been totally destroyed during World War II.[36] Fortunately, they found out about a model of this building owned by the Deutsches Museum (Figure 5), which was the only useful historic document that allowed conclusions about the original design of the building, its surroundings, and the identification of later modifications.

The original public baths are situated on the outskirts of the historic center of Dessau and are surrounded very closely by a complete block of houses. The perimeter of this block includes a small number of Art Nouveau buildings, whereas the much larger part consists of buildings made of prefabricated concrete slabs from the 1960s and 1970s. The public baths suffered during their history, stretching back over a century, from many modifications, structural additions, and

5.
Stadtschwimmhalle (municipal public bath), Dessau, Germany. Model scale 1:50. Picture Collection of the Deutsches Museum.

long-lasting neglect. These baths, a jewel of Art Nouveau architecture and an urban landmark in Dessau, needed and deserved urgent renovation.

The first initiative for the construction of the city's public bath came thanks to the city's swimming clubs, who could only use outdoor pools. Therefore, they endorsed the construction of public indoor baths, which could be available year-round for swimming. In compliance with contemporary standards in hygiene, a section with bathtubs was required to be an additional part of the facility.[37] Following pressure from the community, the city council of Dessau decided to realize the project of public baths in 1904.[38] A suitable plot was bought in 1905. The construction site was located in the future court of a residential and commercial building that stretched along the Askanische Strasse that was under construction at the same time. The planning of the indoor baths with a pool and tub section was commissioned shortly after the acquisition of the plot and was carried out by the engineering company Börner & Herzberg from Berlin and the architect Daniel Schultz (1861–1909), who had moved to Dessau in 1895.[39]

The Art Nouveau decoration of the street façade of the commercial building was nearly destroyed in 1972 during renovation. However, on top of the entrance arc to the building and in the vault of the access passage to the bath, sculptures of bizarre animal figures and other decorative elements were preserved or restored. The main spatial characteristics of the building were also preserved and are now restored. A remarkable architectural detail is a basin with a fountain, built according to a design by the sculptor Emanuel Semper (1848–1911). This basin was originally used inside the building as a decoration for the swimming pool and was later transferred to the southeast façade of the bath, where it remains today. The original stained-glass windows are also worth mentioning, the design of which goes back to the stained-glass painter Franz Riess (1848–1928). The windows were completely destroyed in the two wars. The public baths were inaugurated on April 28, 1907, by members of the Dessau swimming club with a water polo game and a swimming dance performance.

The construction of the baths in a yard that was almost completely enclosed was indicative of a period in time that handled nakedness rather reservedly and during which segregation according to gender, especially in bathing facilities, was obligatory. Generous glazing, open lawns, and public areas were not well regarded. A swimming pool in which the whole family could enjoy bathing altogether was not realized until 1927.

Some time after the opening on May 11, 1909, Börner & Herzberg, which had been involved in the construction and planning, donated a model of the public baths to the Deutsches Museum. The museum's founder, Oskar von Miller, had been searching for a long time to find a suitable object representing public baths, modern and recently built, for his collection. The official correspondence discloses Miller's relationship with Börner & Herzberg, including his soliciting for a model that was to be built, according to his indications, precisely for the new museum.[40] Additionally, he received a complete bibliography from them and even from other companies and the latest publications, which were donated to the museum library. This model was one of several objects and models related to bathing and more generally to hygiene that

the museum's founder would put on display in 1909 in the temporary exhibition in the Schwere Reiter Kaserne in Zweibrückenstrasse, which after 1925 moved to the new Collection Building on Museum Island. In the galleries on the second floor, visitors could see the exhibits dealing with private bathrooms, spas, and finally indoor and outdoor swimming pools. "Gorgeous models illustrate the development of public baths," said the official museum guide from 1942.[41]

The model of the Stadtschwimmhalle, Dessau, is located on a base plate bordered by a black timber frame.[42] This treatment of the plate's end suggests that the model would have been capped with a glass cover, but the accompanying documents confirm that the model was to be presented uncovered. Thus, the function of the profiled and painted frame was merely to surround the perimeter of the displayed area. The building itself and its surroundings are portrayed on a scale of 1:50 and reveal a large, open lawn area, which today is completely covered with buildings. In very precise and elaborate detail, the model shows the swimming pool, the gallery on the mezzanine floor, the staircase, and the vaulted roof. The latter is partially cut open and gives a clear view into the interior of the hall. Two original subsidiary buildings are presented: a two-story building with bathtubs and dressing rooms and a boiler house with a large entrance hall above. The façade of the annex is made as a hinged wicket on the model so that the viewer can open the model and have a look into the interior floors and partitions and also see the tiny bath tubs and cabins (Figure 6). The details of the ceiling of the pillared hall are visible when the roof is raised.

6.
Model of public bath in Dessau. Detail. Picture Collection of the Deutsches Museum.

This model offers more detail, clarity, and technical information than a purely architectural model would do. Thus, it shows in an appealing and instructive manner both the technical installations and the operation of a public bathhouse. The original intention of this model was to stimulate curiosity and to dispel the prejudices the visitors, who had been educated in the Wilhelminian style, accustomed to physical modesty and dwelling in homes that were not equipped with private bathrooms. The majority of the population at this time lived in tenements and possibly knew nothing other than the toilet on the landing, but they were encouraged to start using these baths, which served public health. The promotion and the popularization of private and public hygiene and bathing and swimming as a physical exercise was a task clearly recognized by Oskar von Miller, who made this a permanent feature in his exhibitions.

While the model of the public baths was on display in Munich, the original building in Dessau degenerated over the years. During World War I, the basin was used for vegetable and potato storage, and it was not until 1920 that the section of the building that housed the bathtubs could be reopened; the swimming pool reopened in October 1921. During World War II, the hall was damaged in a bomb raid on October 7, 1944. The bathtub section was repaired by August 1945. In 1949, the pool could finally be put back into operation. During this time, the large arched windows on the side walls were replaced by two double-leaf windows with fanlights, and the roof of the hall was altered. In the 1950s, a laundry was established in the basement. In 1964, the city's sauna was established there, and in 1973, the hall was extensively rebuilt. The pool, its exterior borders, and the walls were retiled, modern sanitary facilities were built, and an aluminum framed window was put in on the upper floor, preserving the historical design. The entrance, with its arches and columns, was covered with grey marble slabs, and the fountain was relocated to the south gable.

The model, built especially for the museum for didactic and promotional purposes, became as obsolete as the original building once people were accustomed to personal hygiene and to living in houses equipped with private bathrooms. But this model stands today, physically unchanged, as a testament to Art Nouveau architecture in Dessau and to a historic period in which particular elements of modern behavior were introduced to society. Today, both objects, the original building and the model, lend each other mutual significance. Thus, the model, long preserved in the Deutsches Museum, was able to make an essential contribution to the reconstruction of the original building. The building and its restoration demonstrate once more the cultural value of the museum's collection.

Conclusion

The models evaluated here show how specific purposes, and hence specific aesthetics, can inform the representation of a feature of reality. Each model has been interpreted as assembled from a different basic component of architecture: façade, space, and function. Since models are made to put emphasis on a particular section of a certain reality, they are also able to communicate more strongly than many of the originals themselves could do: they are enormously instructive and

convincing. According to this interpretation, they are even able to increase our knowledge about the original and are expressive of the model builder and about his or her historical context and intentions.

Models, independent of their particular meaning, are able to extend and intensify our perception of reality and may reproduce a particularly broad horizon of experience. These qualities, together with the special aesthetic properties that can only be offered by a model, align them with the values that characterize works of art.

Within this context, the importance of aesthetics for the appreciation of any model cannot be emphasized enough because it is the aesthetic value that makes an exhibit attractive and appealing at first glance and subsequently worthwhile to observe more closely by the museum visitor. So aesthetics play a fundamental role in the study of models; it makes them both easy to read and appealing. But since models represent reality on a reduced scale, they may seem merely "cute" or "adorable"; if there is no other incentive beyond that, the attention of the spectator stops at recognizing just this "cuteness," which distracts the viewer from taking in the crucial meaning of the exhibit. To go even further, the aesthetic value of an exhibit is, in the end, a significant additional means of convincing the spectator of its inherent worth.

The age of the models presented here makes it possible, thanks to the perspectives considered here and following extensive research, to distinguish between original and actual meaning, presentation, and, finally, aesthetic values. This contribution also demonstrates the significance of studying the models not only within their historical context but also in terms of their symbolic, semantic, and aesthetic content in the different contexts of past and present. This essay describes an approach that helps us understand the connotations and meanings of models in a general way and provides the perspective necessary for a satisfying and complete analysis and validation of the Deutsches Museum's artifacts.

Notes

1. In terms of scale a building model is a representation made on any scale larger or smaller than 1:1 as a version at that scale is identified as a replica. A diorama is not necessarily bound to a fixed scale in all its parts: the objects are foreshortened and show a true perspective in relation to their surrounding scenery.

2. Bernd Evers, ed., *Architekturmodelle der Renaissance* (Berlin and Munich: Prestel, 1995), 11.

3. Hans Reuter and Ekhart Berckenhagen, *Deutsche Architekturmodelle—Projekthilfe zwischen 1500 und 1900* (Berlin: Deutscher Verlag für Kunstwissenschaften, 1994), 10.

4. Herbert Stachowiak, ed., *Modelle, Konstruktion der Wirklichkeit.* (Munich, Fink, 1983), 9.

5. Peter Galison, *The Architecture of Science* (Cambridge, MA: MIT Press, 1999).

6. Lorraine Daston, ed., *Things That Talk: Object Lessons from Art and Science* (New York: Zone Books, 2004).

7. Helmuth Trischler, "Modes, Constraints and Perspectives of Research: The place of Scholarship at Museums of Science and Technology in a Knowledge-Based Society," in *Research and Museums*, ed. Birgit Arrhenius, Görel Cavalli-Björkman, and Svante Lindqvist (Stockholm: Nobel Museum, 2008), 51–67; Susanne Lehmann-Brauns, Christian Sichau, and Helmuth Trischler, eds., *The Exhibition as Product and Generator of Scholarship* (Berlin: Max-Planck-Institut für Wisssenschaftsgeschichte, 2010).

8. A scientific colloquium titled Modelle und Architektur took place on November 6–8, 2009, at the Technische Universität München. See also U. Dirks and E. Knobloch, eds., *Modelle* (Frankfurt am Main, Germany: Lang, 2008); Raphaël Betillon, *Histoire de maquettes, maquettes à histoire* (Toulouse, France: Ecole nationale supérieure d'architecture de Toulouse, 2005); Maurice Culot, *La troisième dimension: Maquettes d'architecture* (Brussels, AAM editions, 2003).

9. Examples in the Deutsches Museum: Ceasar's Rhine Bridge (built 55 BC and reinterpreted in the 1950s), Grubenmann Bridge over the Rhine near Schaffhausen (built 1758), Elisabeth-Bridge in Budapest (built 1898–1903, destroyed 1945), and a timber-framed house in Marburg of the early Gothic Period.

10. Examples in the Deutsches Museum: Iller-Bridge, 1905 (built with rammed concrete); the Müngsten Bridge, 1897 (under construction at the end of 1896); Pont de Neuilly, 1768–1774 (four models of consecutive sections of processes); Normandy Bridge, 1994 (modern composite structure); Nibelungen Bridge in Mainz, 1951–1953 (cantilever method); and Ratsweg Bridge in Frankfurt, 1988 (timed shifting method).

11. Examples in the Deutsches Museum: hypocaustum in a Roman house, Prinzenbad in the Badenburg within the Royal Gardens of Nymphenburg in Munich, Sources Hall in the Kissingen bath resort, and a diorama of the beach resort of Norderney.

12. Examples in the Deutsches Museum: Toraja and Batak houses in Celebes, the Taj Mahal in Agra, desert tents of the Bedouins, other tents from Greenland, and a Mexican cuescomate.

13. Examples in the Deutsches Museum: wooden building set for an oriental house (S. F. Fischer,1900), villa nova building set (Brandt Enterprises, 1905), and Mero-System (1970).

14. Examples in the Deutsches Museum: funerary house models, Japanese silver pagoda, and a model of the Alamillo Bridge (designed by Santiago Calatrava).

15. Today, the building is rented and not only houses a beautiful restaurant but also offers cozy hotel rooms in the attic.

16. Inventory number 36296, 40.94 in. (1040 mm) high, surface area 21.46 in. (545 mm) by 18.90 in. (480 mm) without mounting plate, weighing ~75 lbs. (34 kg).

17. G. Binding, U. Mainzer, and A. Wiedenau, *Kleine Kunstgeschichte des deutschen Fachwerkbaus* (Darmstadt, Germany: Wissenschaftliche Buchgesellschaft, 1989), 61–97.

18. The oldest surviving building of this kind dates back to 1267 (Webergasse 8 in Esslingen on the Neckar); see also Binding et al., *Kleine Kunstgeschichte*, 62.

19. Barbara Obrist, *Une maison strasbourgeoise de la renaissance: La Kammerzell* (Besançon, France: Contades, 1990), 51–65.

20. According to the Allmendt-Book, the tax book of the city.

21. In 1904 and 1905 the walls and vaults on the ground and first floor were decorated with the imaginative frescoes by Léon Schnug (1878–1933), a Strasbourg artist.

22. In 1929 the Kammerzell House was declared a historic monument and in the years 1950 and 1984 the building was restored once again.

23. Obrist, *Une maison strasbourgeoise*, 84–93.

24. Obrist, *Une maison strasbourgeoise*, 95.

25. Obrist, *Une maison strasbourgeoise*, 107.

26. Obrist, *Une maison strasbourgeoise*, 106.

27. Edward S. Morse, *Japanese Homes and Their Surroundings* (Boston: Ticknor, 1886).

28. Franz Baltzer. *Die Architektur der Kultbauten Japans* (Berlin: Ernst, 1907).

29. Bruno Taut, *Houses and People of Japan* (Tokyo: Sanseido Co. Ltd., 1937); Bruno Taut, *Das japanische Haus und sein Leben: Houses and People of Japan* (Berlin: Gebrüder Mann, 1997).

30. Tetsuro Yoshida, *Das japanische Wohnhaus* (Berlin: Wasmuth, 1935); Tetsuro Yoshida, *Japanische Architektur* (Tübingen, Germany: Wasmuth, 1952).

31. Reference found in: Manfred Speidel, *Träume vom Anderen. Japanische Architektur mit europäischen Augen gesehen.-Einige Aspekte zur Rezeption zwischen 1900 und 1950* (archimaera, Aachen, Germany: Heft 1/2008), 93; Original postcard, dated June 1954 has been discovered by the Italian historian of architecture Francesco Dal Co in the Archive Fondation Le Corbusier in Paris and published in his book: *Katsura, Imperial Villa* (Milan, Italy: Electa 2005), 386–389.

32. Taizaki Jun'ichiro, *In Praise of Shadows* (Tokyo:, Kadokawa Shoten, Shōwa 28 1933).

33. Inventory number 1908-17151. Size: 27.44 × 14.41 × 14.65 in. (697 × 366 × 372 mm); weight: 7.8. lbs (3.55 kg).

34. Inventory number 1911-28125. Size: 22.36 × 11.34 × 14.61 in. (568 × 288 × 371 mm); weight: 5.7 lbs. (2.6 kg).

35. Inventory number 1927-59313. Size: 16.61 × 8.35 × 11.42 in. (422 × 212 × 290 mm); weight: 3.8 lbs. (1.71 kg).

36. Between 2004 and 2006 this building was transformed into a modern health spa, planned by BAUCONZEPT® Rabe, Lichtenstein (Saxony, Germany). The complete historical planning and construction process is published in BAUCONCEPT, *Stadtschwimmhalle Dessau: Ein Denkmal Deutscher Jugendstilbaukunst* (Lichtenstein, Germany: Bauconzept Ingenieure + Architekten, 2006).

37. "Sun and air" baths already had been popularized since 1888 following the publication of *Das Neue Naturheilverfahren* (The New Natural Healing) by the German "naturopath" Friedrich Eduard Bilz (1842–1922). The first indoor public baths, established as shower and tub facilities, came out around the turn of the nineteenth century in many cities in accordance with the new consciousness for hygienic needs. See also Neumann, "Das neueröffnete Dessauer Schwimmbad," *Veröffentlichungen der Deutschen Gesellschaft für Volksbäder* 4 (1908): 342–48.

38. Franz Brückner, ed., *Häuserbuch der Stadt Dessau, Stadtarchiv* (Dessau, Germany: Stadtarchiv, 1975–1997), 1123–27.

39. By then Schultz already had become well known in the region for his Art Nouveau buildings in the city that would become the residence of the famous Bauhaus style after 1926.

40. Archives of the Deutsches Museum, Official Correspondence.

41. Theodor Conzelmann, *Deutsches Museum: Rundgang durch die Sammlungen* (Munich: Deutsches Museum, 1942), 201.

42. Inventory number 19108. Model on a square base plate with 49.33 in. (1253 mm) side length; 15.35 in. (390 mm) tall, weighing 165.35 lbs. (75 kg).

Bibliography

Baltzer, Franz. *Die Architektur der Kultbauten Japans*. Berlin: Ernst, 1907.

BAUCONCEPT. *Stadtschwimmhalle Dessau: Ein Denkmal Deutscher Jugendstilbaukunst*. Lichtenstein, Germany: Bauconzept Ingenieure + Architekten, 2006.

Betillon, Raphaël. *Histoire de maquettes, maquettes à histoire*. Toulouse, France: Ecole nationale supérieure d'architecture de Toulouse, 2005.

Binding, G., U. Mainzer, and A. Wiedenau. *Kleine Kunstgeschichte des deutschen Fachwerkbaus*. Darmstadt, Germany: Wissenschaftliche Buchgesellschaft, 1989.

Brückner, Franz, ed. *Häuserbuch der Stadt Dessau, Stadtarchiv*. Dessau, Germany: Stadtarchiv, 1975–1997.

Conzelmann, Theodor. *Deutsches Museum: Rundgang durch die Sammlungen*. Munich: Deutsches Museum, 1942.

Correll, Ferdinand. *Deutsche Fachwerkbauten der Renaissance*. Berlin: Hessling, 1900.

Culot, Maurice. *La troisième dimension: Maquettes d'architecture*. Brussels: AAM editions, 2003.

Daston, Lorraine, ed. *Things That Talk: Object Lessons from Art and Science*. New York: Zone Books, 2004.

Dirks, U., and E. Knobloch, eds. *Modelle*. Frankfurt am Main, Germany: Lang, 2008.

Evers, Bernd, ed. *Architekturmodelle der Renaissance*. Berlin and Munich: Prestel, 1995.

Galison, Peter. *The Architecture of Science*. Cambridge, MA: MIT Press, 1999.

Latour, Bruno. *Iconoclash*. Berlin: Merve, 2002.

Lehmann-Brauns, Susanne, Christian Sichau, and Helmuth Trischler, eds. *The Exhibition as Product and Generator of Scholarship*. Berlin: Max-Planck-Institut für Wisssenschaftsgeschichte, 2010.

Morse, Edward S. *Japanese Homes and Their Surroundings*. Boston: Ticknor, 1886.

Neumann. "Das neueröffnete Dessauer Schwimmbad." *Veröffentlichungen der Deutschen Gesellschaft für Volksbäder* 4 (1908): 342–48.

Obrist, Barbara. *Une maison strasbourgeoise de la renaissance: La Kammerzell*. Besançon, France: Contades, 1990.

Reuter, Hans, and Ekhart Berckenhagen. *Deutsche Architekturmodelle—Projekthilfe zwischen 1500 und 1900*. Berlin: Deutscher Verlag für Kunstwissenschaften, 1994.

Ruch, Maurice. *La maison alsacienne à colombage*. Paris: Berger-Levrault, 1977.

Schleyer, W. *Bäder und Badeanstalten*. Leipzig: Carl Scholtze, 1909.

Stachowiak, Herbert, ed. *Modelle, Konstruktion der Wirklichkeit*. Munich: Fink, 1983.

Schwanzer, Berthold. *Architektur-Modelle und Sammlungen, Architekturführer*. Vienna: Modulverlag, 1994.

Speidel, Manfred. *Träume vom Anderen. Japanische Architektur mit europäischen Augen gesehen.-Einige Aspekte zur Rezeption zwischen 1900 und 1950*. archimaera Aachen, Germany: Heft 1/, 2008.

Taizaki Jun'ichiro. *In Praise of Shadows*. Tokyo: Kadokawa Shoten, Shōwa 28 , 1933.

Taut, Bruno. *Houses and People of Japan*. Tokyo: Sanseido Co. Ltd., 1937.

———. *Das japanische Haus und sein Leben: Houses and People of Japan*. Berlin: Gebrüder Mann, 1997.

Toursel-Harster, D., J.-P. Beck, and G. Bronner. *Dictionnaire des monuments historiques d'Alsace*. Strasbourg, France: La Nuée Bleue, 1995.

Trischler, Helmuth. "Modes, Constraints and Perspectives of Research: The Place of Scholarship at Museums of Science and Technology in a Knowledge-Based Society." In *Research and Museums*, edited by Birgit Arrhenius, Görel Cavalli-Björkman, and Svante Lindqvist, 51–67. Stockholm: Nobel Museum, 2008.

von Dyck, Werner, ed. *Katalog mathematischer und mathematisch-physikalischer Modelle, Apparate und Instrumente nebst Nachtrag*. Second Edition, Munich: Olms, 1994

Yoshida, Tetsuro. *Das japanische Wohnhaus*. Berlin: Wasmuth, 1935.

———. *Japanische Architektur*. Tübingen, Germany: Wasmuth, 1952.

Aesthetics of Technology

The question of "aesthetics," or the scholarly consideration of the elegance, beauty, or ineffable pleasingness exhibited by a human work, has fascinating applications in the realm of technology. Although originally associated with artistic production, this section reminds us that aesthetics involves all cultural products, including technologically oriented artifacts. Moreover, technologies themselves exert vital influence on the development of aesthetics in the realm of art.

Exploring technologies for their aesthetic qualities provides insights into aspects of their material realization that might otherwise be overlooked. In his study of the "Kilmer complex," Barney Mergen explores the impulse to construct technologies "not meant to be seen." As he reveals, the choice to design cell phone towers to masquerade as trees, rendering them "invisible," reflects myriad culturally mediated assumptions. Similarly, Margaret Weitekamp investigates toys as a means for "naturalizing" modern technologies, transforming spaceflight from something potentially threatening to something safe, appealing, and even cute.

As essays by Bryan DeWalt, Alison Taubman, and Martha Fleming demonstrate, the environment of the museum provides an ideal setting for teasing out some of the technological aesthetics of art and some of the aesthetic attributes of technology and its representation. The photographic practice of Yousuf Karsh reveals itself as a fascinating intersection of artistic, technological, and political trends when explored through an exhibition jointly hosted by the Canada Science and Technology Museum and the Portrait Gallery of Canada. Alison Taubman and Martha Fleming examine the interpretative aesthetics present in museums themselves, particularly as specific technologies are selected to illustrate nation building or the evolution of medical practice.

As material objects, grounded in a particular place and time, how do technological artifacts embody historicized preferences for attractive appearance, desirable feel, and practical use? Together, these studies reveal that assessments of aesthetics are not purely subjective. Rather, historically grounded principles underlie desirable landscapes, mathematical proportions shape perceptions of friendliness, and technologies carry with them, in their very construction, the histories of their creation, use, and purpose.

Karsh: Image Maker
Bringing Artifacts to an Art Show

Bryan Dewalt
Curator

Canada Science and Technology Museum

Ottawa, Ontario, Canada

Yousuf Karsh (1908–2002) was one of the most celebrated portrait photographers of the twentieth century. In the decades spanning World War II and the cold war he produced iconic portraits of many of the leading statesmen, scientists, and artists of the era. To mark the centennial of Karsh's birth, the Canada Science and Technology Museum collaborated with the Portrait Gallery of Canada to produce an innovative exhibition of and about his work. This project played on the individual strengths of the two institutions, both in terms of their rich Karsh holdings and their expertise.

The exhibition *Karsh: Image Maker* presented a unique opportunity to integrate and interpret these collections. Yet this opportunity also presented a challenge. Not only did technical artifacts, archival documents, and art works have to be presented in a seamless manner, but the different mandates and intellectual cultures of the two institutions had to be respected. The availability of diverse and comprehensive source material demanded an approach that would present a new reading of Karsh and his work through a synthesis of science museum, archival, and art gallery perspectives and methodologies. As a key organizing principle, the project team sought to understand these diverse historical materials as the tools and products of cultural practice. In the process, the project team hoped that the artificial conceptual boundaries that separate "technology," "culture," and "art" would be exposed and challenged.

This case study will provide an account of the exhibition development process as it unfolded between winter 2008 and the opening in June 2009. Beyond simply summarizing the key

messages and interpretive strategies, I will focus on Karsh's two rugged Calumet 8 × 10 cameras, which I selected from the Canada Science and Technology Museum's Karsh Collection for the exhibition. In developing a strategy to exhibit them, I was convinced that a deeper understanding of their technical characteristics and object histories would enrich visitor appreciation of Karsh and his aesthetic project.

Background

Yousuf Karsh was born in 1908 into a Christian family in the Armenian city of Mardin in the last years of the Ottoman Empire. In 1921, in the aftermath of the Armenian genocide, the family fled to Syria. Two years later, a teenage Yousuf emigrated alone to Canada. Karsh learned the art and business of portrait photography first under his uncle, George Nakash, who ran a portrait studio in Sherbrooke, Quebec, and then under John Garo, a Boston society photographer acquainted with Nakash. In 1931 Karsh moved to Ottawa, Canada's capital, where he opened his own studio. Karsh soon made connections with the city's artistic, social, and political elites and by the beginning of World War II had built a solid reputation for his skillful and stylish work. He was vaulted from the local to the international stage in late 1941 with his portrait of Winston Churchill, the "Roaring Lion," taken after the British prime minister's speech before a joint sitting of the Canadian Parliament. Prestigious commissions soon followed, and over the next five decades Karsh carved out a niche in the field of portraiture as a photographer of the accomplished, the powerful, and the celebrated. In 1958, at the height of his fame, he was named by *Popular Photography* magazine one of the ten greatest photographers of his time.[1]

In the summer of 2007 the Canada Science and Technology Museum (CSTM) was approached by the Portrait Gallery of Canada (PGC) to collaborate on Festival Karsh, a series of events, programs, publications, and exhibitions to mark the centennial of Yousuf Karsh's birth. It was in many ways a natural fit between my institution (CSTM) and PGC. Responsible for preserving and interpreting Canada's scientific and technological heritage, CSTM had accepted a significant donation of cameras, lights, and darkroom equipment from Karsh's Ottawa and New York studios. As a program of Library and Archives Canada (LAC), the Portrait Gallery was charged with public interpretation of LAC's massive Karsh Fonds, which includes more than 300,000 negatives, prints, and transparencies as well as business papers spanning his entire sixty-year career. Together, these two collections comprise the world's largest and most comprehensive repository of Karsh's photographs, tools, and supporting documentation.

The team tasked with the major exhibition component of Festival Karsh came from two institutions with very different cultures. CSTM is a science museum with roots in collecting technology and creating hands-on, child-friendly displays. Lacking a permanent exhibition site, PGC is program driven. It produces live events and temporary installations from a variety of archival, cultural studies, and art history perspectives. Although the exhibit team would jointly develop the content, members from each partner would "take the lead on those aspects of the project that suit[ed] each institution's strengths and experience."[2]

Exhibit Concept

There is a brief moment when all that there is in a man's mind and soul and spirit may be reflected through his eyes, his hands, his attitude. This is the moment to record. This is the elusive "moment of truth."[3]

—Yousuf Karsh

Karsh was schooled in the Pictorialist tradition and was influenced by the "straight photography" movement that emerged in reaction to it.[4] These influences were apparent not only in his visual style but in his public utterances about photography and art: the best photographs captured the essence of their subjects, but success depended on the photographer's artistic vision in composition and his or her intuition at the instant of exposure. Rather than confront these ideas directly, the exhibition team chose to study Karsh's photographic practice as a form of storytelling mediated by technology. Karsh traded in stories. He captioned his published portraits with anecdotes about the sittings, and the photographs themselves evoke mythic figures: the heroic leader, the thinker, the inspired artist, the female muse. Taken as a whole, Karsh's work comprised a hopeful counternarrative to the fragmentation, anomie, and despair he saw around him in the tumultuous years of midcentury. In feeding our culture's appetite for heroes, PGC's guest curator on the project, Melissa Rombout, argues Karsh became the master not of "private revelation" but of "the public face." We can read his portraits "less as transparent windows into the soul and more as distillations of the complexities and contradictions leading to a single purposeful narrative."[5] In this light, we can understand the excerpt from Karsh's 1962 autobiography, quoted above, as another myth, one that Karsh used to direct our reading both of his work and of his stature as an artist.

The "moment of truth" quotation would figure prominently both in the minds of the exhibit team and eventually on the wall of the exhibition itself. Its corollary was Karsh's affected disdain for the technical details of photography. Although admitting their necessity, he was loath to discuss them. Yet Karsh could not have achieved such success without meticulous attention to all stages in the planning and production of the finished portrait and to the selection, operation, and maintenance of his equipment. Far from a single moment of truth, the creation of a Karsh portrait was a process comprising many moments, each replete with crucial artistic and technical decisions.

From the beginning, the team agreed that one of the main organizing principles of the exhibit would be the interplay of product and process. This was the thrust of the conceptual map already produced by the PGC personnel, and it was at the core of the team's "big idea" in the exhibition brief: "Yousuf Karsh constructs portraits and reframes myths through carefully planned cultural, social and technical choices."[6] Product, in the form of Karsh's gorgeously printed portraits (selected by Melissa Rombout), would be omnipresent. Karsh had always been adept at managing the presentation of his images, whether through publication in glossy magazines or dissemination through sumptuous books and gallery exhibitions. These forms of packaging, though, would rarely include any hint of the hours of thought and labor so essential to creating the final product.

Process, therefore, would have to be conveyed by archival documents that captured Karsh's intentions and decisions, by marked up proofs and retouched negatives, by interactive elements that involved visitors in photographic decision making and, finally, by Karsh's tools themselves.

The exhibition brief, prepared by the team in May 2008, divided the exhibition into four substantive sections. The first dealt with the process of "Becoming Karsh": his arrival in Canada, his training, his early work, and the breakthrough portrait of Churchill. The second section, "In the Studio," guided visitors through the many artistic and technical decisions Karsh made, from the selection of his equipment through the planning and execution of the sitting through to development, retouching, and printing. The third section, "Karsh's Century" (later renamed the "Theatre of Personality" to suggest persona as performance), would feature a dramatic installation of both familiar and rarely seen Karsh portraits encircling a cluster of critical texts that encourage new readings of the collected works. The fourth section addressed Karsh's persisting presence in popular culture. Of these main exhibit zones, "In the Studio" would feature the most diverse range of exhibit media, including portraits, archival documents, negatives, a major interactive, and more than 30 pieces of photographic equipment. My challenge would be to integrate these photographic tools into the interpretation of the portraits and archival media.

Calumet Camera

One of the most important artifacts selected for the exhibition was Karsh's main studio camera. Having appeared in published portraits and candid photos of Karsh, as well as in film and television profiles, his various large-format view cameras had over the years acquired an iconic quality of their own. The camera had already appeared in two recent museum exhibitions: *A Tribute to Karsh* (2002), a small display at CSTM, and *Karsh 100: A Biography in Images* (2008–2009) at the Museum of Fine Arts in Boston. In both cases the camera had been displayed in a similar manner: mounted on its tripod, lens and bulb attached, red velvet focus cloth lovingly draped over the top and back, all protected by Plexiglas. Although not without merits, this strategy was limited in its narrative possibilities. The camera became a "thing" physically separate from the display of images and somewhat intellectually static. Surrounded by, but isolated from, the Karsh portraits, it became, at best, one icon among many, a product with a single, sterile message ("This is Karsh's camera"), rather than the locus of artistic and technical processes requiring exploration.

My first step in developing other display strategies was to learn more about this camera. What I already knew was that the museum had two. The first (CSTM 1997.0319) came from Karsh's Ottawa studio, and the second (CSTM 1998.0051) came from his New York City office. Karsh used these cameras not only for studio sittings but also for many on-location portrait sessions. Both cameras were manufactured in 1956 by the Calumet Manufacturing Co. (Chicago) and were used by Karsh continuously until his retirement in 1992. Both have the standard features of large-format view cameras: a flexible bellows connecting front and back panels, a ground-glass screen for through-the-lens viewing, a rack and pinion focusing mechanism, and adjustments to the vertical and horizontal angles of the front and back of the camera.

1.
A dramatic installation of Karsh portraits encircles a cluster of critical texts. Would the Calumet cameras fade into insignif-icance? Photograph by Graham Iddon. Courtesy of Portrait Gallery of Canada, a program of Library and Archives Canada, Ottawa. © Estate of Yousuf Karsh.

What was striking about the cameras, especially when first viewed in the CSTM reserve col-lection facility, was just how uninspiring they looked. A coat of drab gray paint had been brushed over the original finish, and the bellows were black. Neither bore any resemblance to the elegant white camera that was a Karsh trademark in the 1940s and 1950s. Constructed of machined aluminum with stainless steel hardware, the Calumet cameras looked like pieces of industrial equipment. I was afraid that next to Karsh's gorgeously presented portraits they would fade into insignificance (Figure 1).

Confronted by these cameras, museum visitors might notice two things about them: how big they were and how old fashioned they looked. At a time when the innovative thrust in pho-tographic equipment was toward miniaturization, small film formats, and handheld cameras, Karsh was using a camera design and negative format that dated back to the nineteenth century.[7] Karsh did use other cameras for commercial work and field assignments, but for his prestige portrait work, the work he wished to be recognized for, Karsh preferred the view camera. It might be tempting to use this large-format camera to characterize Karsh as an anachronism or as someone who self-consciously looked backward to an idealized past. After all, Karsh had appren-ticed in the technique and aesthetic of late nineteenth-century portraiture, and he was known for his courtly, old-world manners, his formal dress, and the respectful, celebratory treatment of

his subjects. The problem with this reading is not that it is wrong but that it sheds no light on how Karsh actually worked, on how he managed the interface where art and technology came together.

In his autobiography, Karsh said, "my dream has long been a camera which would be completely concealed."[8] He lamented the "intrusion" of technology into the sitting. Our goal in the exhibition, however, was to unveil this equipment and encourage visitors to explore the technical and artistic choices embodied in it. In his choice of the most intrusive camera possible, we asked a fundamental question: what kind of photographer did Karsh want to be? Whereas his contemporary, Henri Cartier-Bresson, snatched apparently spontaneous (though actually carefully composed) glimpses of everyday life, Karsh chose the tradition of the studio photographer. In the 1930s his inspiration was Edward Steichen, whose portraiture and fashion photography popularized a new emphasis on sharp focus, high contrast, and dramatic effects achieved with artificial lighting. Rather than snap strangers in the street, Karsh chose the structured environment of the studio, the formal social approach and polite negotiation, the carefully planned lighting, and the premeditated selection of props and poses.

In a studio, the large-format view camera was not the hindrance it would have been for a photojournalist. In fact, it offered something Karsh craved: control. First, the large-format view camera offered through-the-lens viewing of the actual image in full size on the ground-glass screen, giving Karsh complete control of framing, composition, and focus by direct visual inspection. Second, Karsh could swing and tilt the front and back of the view camera independently, changing the relation of the optical axis of the lens to the film plane. In particular, by swinging or tilting the front, he could adjust the depth of field to control which areas of the image were in sharp focus. This was critical to achieving three-dimensional modeling of facial features by rendering the eyes and front of face in sharper focus than the ears and back of head.

The view camera also enabled him to use precision, interchangeable lenses. His favorite, a Kodak Commercial Ektar 14 inch (355 mm) lens, had a long focal length that gave him the desired shallow depth of field and allowed him to place his camera far enough from the sitter to prevent the distortion arising from strong perspective. Purchased by Karsh in 1947, the Commercial Ektar lenses were Kodak's premium line. Designed for extremely low astigmatism, a primary cause of blurred edges, they were coated with magnesium fluoride to reduce surface reflection. According to Kodak, this "Lumenized" coating improved shadow contrast and detail and contributed to the "clarity and brilliance" of negatives.[9] Karsh treasured theses lenses, which were instrumental in rendering the fine detail and subtle shadows of his best portraits.

Finally, of course, the view camera offered a large negative. By using 8 × 10 inch sheet film rather than the smaller-format roll films, Karsh was able to develop each negative individually to achieve optimum density and contrast. This he did by inspection, a technique requiring a far more discerning eye than the "time and temperature" method practiced in most commercial laboratories. Contact prints for proofing, meanwhile, were large, and final prints lost little resolution through enlargement. The large image was also more easily manipulated after the fact. Karsh,

like most portrait and commercial photographers (and despite his assertions of the illusory "moment of truth"), engaged in routine retouching of negatives, as well as the dodging and burning of final prints.

So the case for a large-format view camera is clear. Visitors may well ask, though, why Karsh chose the Calumet. Fortunately, the Karsh Fonds yielded important clues in the form of correspondence between Karsh and his suppliers. In 1949 Karsh had purchased two identical Ansco Universal view cameras, but these proved a disappointment. Just two years later, he had to replace the steel tracks, and he complained to an Ansco representative that the wood had warped.[10] Perhaps more than his studio-bound colleagues, Karsh was hard on his cameras. He travelled extensively (up to eight months of the year), and the constant mounting and dismounting, packing and unpacking, and loading and unloading conspired with constant temperature and humidity changes to take a heavy toll on his equipment.

Small wonder, then, that in 1956 Karsh was attracted by Calumet's brochure for its new 8 × 10 with "all metal construction." The company touted its camera as a "precision instrument," the product of modern engineering and advanced production methods, designed for the exacting demands of architectural, commercial, and scientific photography. Not only did its aluminum body, protected by a pearl-gray Hammertone finish, promise strength and durability, but, even more important for a photographer, it offered rigidity. Once focus, swing, and tilt were set, they would not move. Moreover, like the Ansco Universal, the Calumet extension rack, or baseboard, folded up neatly to protect the camera back and to provide a compact, though not lightweight, unit for storage and shipment.[11]

Display Strategies

In many ways Karsh's view camera is a reflection of the identity he constructed for himself. It looks back to a mature technology and established aesthetic in photography, yet in its design, materials, and construction it is resolutely modern. In practical terms, it offered Karsh exactly what he needed: a camera that could stand up to the rigors of constant travel yet provide minute control over all aspects of photographic composition. The challenge in the exhibition was to convey this nuanced understanding of the artifact and the owner. In this regard we were fortunate to have two Calumet cameras. Each could serve a different purpose.

We erected Karsh's Ottawa camera in the conventional manner on its tripod, draped in Karsh's monogrammed red velvet focus cloth (Figure 2). Placed in a free-standing Plexiglas showcase, this ensemble would satisfy any visitor expectations for an iconic treatment. Several other elements in the case, though, explicitly addressed the implications of Karsh's camera choice. First, as proposed by my PGC colleagues, we inserted a 1936 Leica 35mm camera to represent the emerging trend toward "miniature" photography with light, handheld equipment. To amplify the effect of this juxtaposition, we also installed two framed photographs. One is Karsh's 1938 self-portrait (Figure 3), a classical composition in which the artist, formally attired with arms crossed, poses beside his view camera in the studio. The other is an apparently candid snapshot

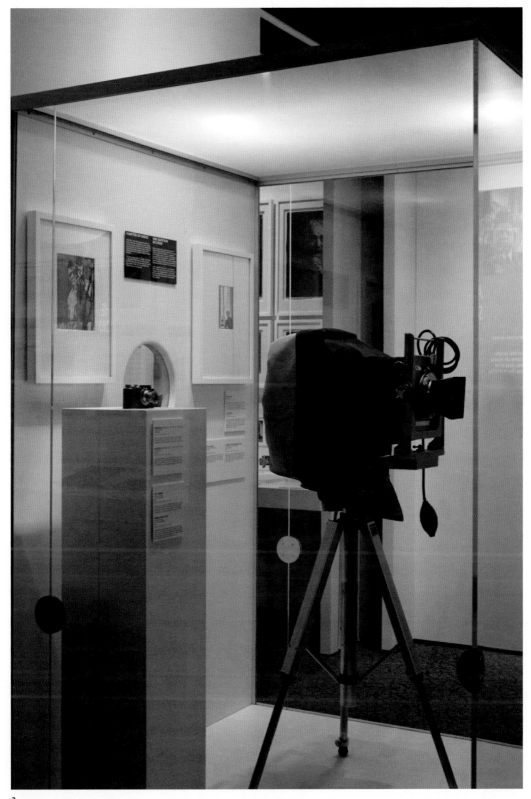

2.
Karsh's Ottawa camera, displayed beside a Leica and two contrasting portraits: the photographer that Karsh decided to be and the one that he did not. Photograph by Ioana Teodorescu.

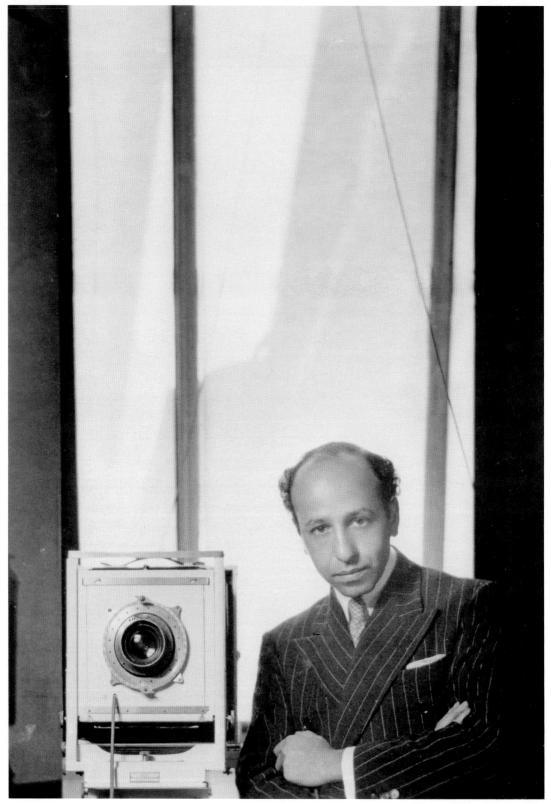

3.
Yousuf Karsh, self-portrait, 1938. Courtesy of Library and Archives Canada, Ottawa (negative number PA-212511).

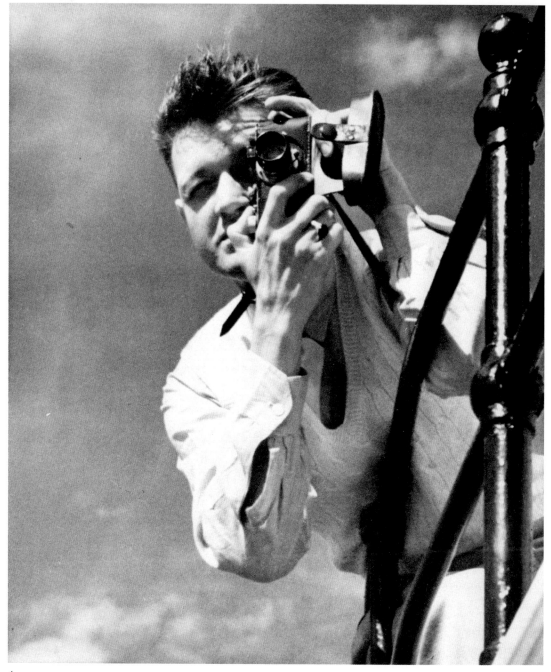

4.
D. Gordon McLeod, "Leicawocky," circa 1938. Courtesy of Library and Archives Canada, Ottawa (negative number PA-125746).

from the same period by D. Gordon McLeod (Figure 4). It shows a man in shirtsleeves, leaning over a railing and peering through the viewfinder of a Leica while the wind ruffles his hair. Its diagonal composition reflects an awareness of European avant-garde photography. Taken as a whole, the artifacts and the images in this showcase deftly contrasted the photographer that Karsh decided to be and the one that he did not.

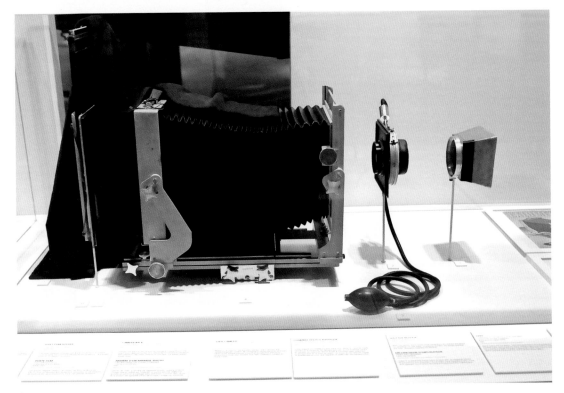

5.
The "exploding" Calumet: every component represented an artistic and technical choice. Photograph by Ioana Teodorescu.

For the New York camera I chose a straightforward explication of its technical features and functions. Aided by mounts devised by CSTM conservator Tony Missio, we created an "exploded" view of the camera, lens and lens hood, bulb and shutter, 8 × 10 back, film holder, and focusing cloth (Figure 5). Every component represented an artistic and technical choice, a choice that we made explicit in a short label (20–30 words) for each object. Beside this composition we arranged an advertisement for the Calumet 8 × 10 camera from the CSTM collection and three archival documents from the LAC Karsh Fonds. These illustrate Calumet's marketing strategy for its 8 × 10 camera and document Karsh's complaints about his wooden Ansco Universal cameras, his initial interest in the all-metal Calumet, and his eventual purchase of the two examples in our collection. Together, the two Calumet cameras were the first objects visitors saw when they entered the "In the Studio" section of *Karsh: Image Maker*. Our treatment of them established themes of choice and control that recurred again and again throughout this section of the exhibition.

Conclusion

In its interweaving of biography, art, and technology, *Karsh: Image Maker* was a major departure from the kind of exhibition normally undertaken by either the Canada Science and Technology Museum or the Portrait Gallery of Canada. The result of this collaboration was a more successful and profound exhibition than either could have produced on its own. From my perspective,

Karsh: Image Maker was an opportunity to introduce visitors to a new reading of CSTM's communications collection. In place of a conventional story of invention and technical evolution, objects were situated in a matrix of cultural practice, where they could be understood as essential tools in the creation of iconic images and as fundamental instruments of narrative. All technological objects are cultural artifacts. This is nowhere more apparent than in the field of communication, that fundamentally human endeavor where ingenuity and culture come together. I hope that *Karsh: Image Maker* can serve as a model for future explorations of this relationship.

Acknowledgments

I thank Melissa Rombout and Sharon Babaian for their comments on an earlier version of this text. I also thank my colleagues on the *Karsh: Image Maker* exhibit team, Melissa, Annie Jacques, Elizabeth Todd-Doyle, Carolyn Cook, Carole Noël, and Robert Evans.

Notes

1. For a comprehensive Karsh biography, see Maria Tippett, *Portrait in Light and Shadow: The Life of Yousuf Karsh* (Toronto: Anansi, 2007).

2. Long-form agreement for Karsh the Storyteller, draft, Canada Science and Technology Museum and Portrait Gallery of Canada, June 12, 2008, Section 8. The team consisted of three employees from CSTM: myself (curator), Annie Jacques (interpreter), and Carole Noël (project manager). From PGC came Melissa Rombout (guest curator), Carolyn Cook (PGC staff curator), Elizabeth Todd-Doyle (interpreter), and Robert Evans (consulting researcher). Design services were contracted to Lupien + Matteau, a Montreal firm.

3. Yousuf Karsh, *In Search of Greatness: Reflections of Yousuf Karsh* (Toronto: University of Toronto Press, 1962), 95.

4. For more information on these movements, see Beaumont Newhall, *The History of Photography from 1839 to the Present*, rev. ed. (New York: Museum of Modern Art, 1982), 141–97.

5. Melissa Rombout, "Approaching the Legends of Yousuf Karsh," *Queen's Quarterly* 105, no. 4 (Winter 1998): 587, 590.

6. Portrait Gallery of Canada, "Karsh: The Storyteller—Conceptual Map" (Ottawa, February 12, 2008); Canada Science and Technology Museum, "Karsh the Storyteller" (draft exhibition brief, Ottawa, May 26, 2008).

7. Brian Coe, *Cameras: From Daguerreotypes to Instant Pictures* (New York: Crown, 1978), 31.

8. Karsh, *In Search of Greatness*, 104.

9. Eastman Kodak Co., *Kodak Lenses: Shutters and Portra Lenses* (Rochester, NY: Eastman Kodak, 1948), 16, 19.

10. Karsh to Carl Priesing, 5 January 1949, Yousuf Karsh Fonds, File 27–32, R613, Library and Archives Canada; Karsh to Patrick D. Daly, 19 April 1951, Yousuf Karsh Fonds, File 39-12; Joyce Large to Calumet, 6 March 1956, Yousuf Karsh Fonds, File 57-23.

11. Calumet Manufacturing Co., *Calumet 8×10 Camera* (Chicago: Calumet, n.d.).

Bibliography

Calumet Manufacturing Co. *Calumet 8×10 Camera*. Chicago: Calumet, n.d.

Canada Science and Technology Museum. Karsh the Storyteller. Draft exhibition brief. Ottawa, May 26, 2008.

Coe, Brian. *Cameras: From Daguerreotypes to Instant Pictures*. New York: Crown, 1978.

Eastman Kodak Co. *Kodak Lenses: Shutters and Portra Lenses*. Rochester, NY: Eastman Kodak, 1948.

Karsh, Yousuf. *In Search of Greatness: Reflections of Yousuf Karsh*. Toronto: University of Toronto Press, 1962.

Newhall, Beaumont. *The History of Photography from 1839 to the Present*. Rev. ed. New York: Museum of Modern Art, 1982.

Portrait Gallery of Canada. Karsh: The Storyteller—Conceptual Map. Ottawa, February 12, 2008.

Rombout, Melissa. "Approaching the Legends of Yousuf Karsh." *Queen's Quarterly* 105, no. 4 (Winter 1998): 587–99.

Tippett, Maria. *Portrait in Light and Shadow: The Life of Yousuf Karsh*. Toronto: Anansi, 2007.

Yousuf Karsh Fonds. Library and Archives Canada, Ottawa, Ontario.

Softening the Orbiter
The Space Shuttle as Plaything and Icon

Margaret A. Weitekamp

Curator

Smithsonian Institution
National Air and Space Museum
Washington, D.C.

Aesthetics That Evoke Affection?

With its edges softened by protective tiles, attractive black-and-white "face," and human-friendly purpose, the space shuttle orbiters launched by the National Aeronautics and Space Administration (NASA) from 1981 until 2011 became iconic, attracting millions of fans. Indeed, thousands of people left work or school to watch the most flown surviving orbiter, *Discovery*, join the Smithsonian Institution's national collection at the National Air and Space Museum in April 2012. When asked why they had waited outside for hours to witness *Discovery*'s piggybacked flyover of the nation's capitol, many viewers answered that the space shuttle orbiters were inspiring symbols of American ingenuity and engineering achievement. Some expressed particular fondness for *Discovery*.[1] But did certain aesthetic principles also help to spark people's outpourings of affection for the individually named orbiters throughout their lifetimes? With its rounded shape, high contrast black-and-white coloring, and its seemingly tamed danger, the shuttle orbiter shared some apparent characteristics with another popular Smithsonian icon: the giant pandas beloved by so many visitors to the National Zoo. What can be learned by examining their common traits? Are there definable aesthetic qualities that evoke affection?

Space shuttle toys provide a rich source for such analysis because adapting a complex technological vehicle for children's play often required one of two overlapping aesthetic adaptations: the technology gets simplified and/or the orbiter is juvenilized. Even when examining a small

and, by definition, partial set of playthings, such trends become apparent. When the target age group was younger children, the adjustments made to the parent technology could be extensive. In contrast, older children's space shuttle toys often emphasized technological accuracy. But a closer comparison of real orbiters and their toy counterparts reveals changes in proportions that followed well-studied patterns rooted in studies of animal behavior and zoological displays of so-called "charismatic" animals.

In 1950, the animal behaviorist Konrad Lorenz first suggested that neoteny (rhymes with "monotony"), the retention or display of traits identified as juvenile correlated with physical characteristics that elicit affection. Likewise, analyses of the widespread anthropomorphization of zoo animals have revealed principles that underlie the outsized public enthusiasm for certain animals. Analyzing space shuttle toys using the same tools can help to explain some of the space shuttle's widespread popular appeal, rooted in its perception as safe and routine. A collection of toys given in 2008 to the National Air and Space Museum provided a rich source for investigating these questions linking aesthetics, technological information, and play.

A "Low-Cost, Economical Space Transportation System"

From the first orbital flights in 1981, the reusable vehicles at the center of NASA's Space Transportation System, or space shuttle, became symbols of progress. With its wings-and-wheels design, the space shuttle launched like a rocket and landed like an airplane, bringing people and cargo to low earth orbit and back in its immense payload bay. When assembled for launch, the whole system had three pieces: the white winged orbiter, the external fuel tank (ET), and two solid rocket boosters (SRBs). The term space shuttle was often used interchangeably to denote either the entire launch system (complete with ET and SRBs) or the reusable orbiter alone. But in every case, the orbiter was central. As the carrier of crew and payload, the individually named orbiters (*Columbia, Challenger, Discovery, Atlantis,* and *Endeavour*) became the most iconic components.[2]

Scholars of the space shuttle have tended to focus on two different aspects of the program: either the political, administrative, and technological development of the reusable spacecraft, with particular attention to the numerous compromises made in creating this "low-cost, economical space transportation system,"[3] or the program's two disasters (the loss of *Challenger* during launch in 1986 and the reentry disintegration of *Columbia* in 2003). In particular, political scientists and sociologists have analyzed NASA's organizational culture, including how the space agency assessed risk and tolerated dissent.[4] With only a few exceptions, coverage of the program's operational years came from participant accounts.[5] Only recently have scholars begun analyzing how the shuttle was promoted once it was declared operational.[6]

Likewise, histories of toys have not always recognized spaceships as significant playthings. In a history based on the Bethnal Green Museum of Childhood in London, Anthony Burton completely ignored the booming worldwide business in fantastical spaceflight toys when he argued

as late as 1996 that "space-ships have never caught on as transport toys, presumably because hardly any children have first-hand experience of them. Their time may yet come, if interplanetary travel becomes available to all."[7] But toys introduce children to many elements of their daily lives whether or not they experience those things firsthand. Long before many children fly in an airplane, they know what it is and what it does, in part because they are introduced to the vehicle's capabilities through toys. Many children have imagined rich adventures in space, played out through fictional characters and vehicles inspired *Buck Rogers* or *Flash Gordon* beginning in the late 1920s and 1930s through such franchises as *Star Wars* and *Star Trek* or even the more recent Buzz Lightyear character of *Toy Story* (1995) fame. Whether or not a child will ever pilot a real spacecraft, space-themed toys have allowed many children to imagine what it might be like to go into space. Moreover, since the 1980s, space shuttle toys introduced children to that particular vehicle, allowing them to identify its distinctive design and giving them some idea of how it worked.

In 2008, Valerie Neal, a curator at the National Air and Space Museum, donated 61 space shuttle-themed playthings to the Smithsonian Institution's national collection. Like all collectors whose interests shape their collections, Neal's considerable experience with the Space Shuttle Program (both as a NASA contractor writing space shuttle material in the 1980s and as the museum's curator of shuttle era human spaceflight) shaped this collection. As Neal explained in her accompanying rationale, she wanted to document the pervasiveness of the shuttle's representation in commercial playthings.

> Many (most?) of the major toy-makers of the Shuttle era produced one or more versions of the Space Shuttle aimed at different segments of the toy market, even [at] babies and toddlers: Brio, Fisher-Price, Hasbro, Kenner, Lego, Mattel, Tonka, and others. Furthermore, the Shuttle was rendered in the highly popular series toys of that era: Legos, Matchbox, Transformers—toys mostly geared to boys' interest in vehicles and manipulatives.[8]

Did manufacturers see themselves as caught up in the enthusiasm for educating the next generation for an impending space age? Or did they merely add a space shuttle toy to their toy lines in order to be perceived as current? Because the toys given to the Smithsonian Institution were purchased commercially or on the secondary market (such as eBay), the collection did not include documentation from toy manufacturers or designers explaining their creation or production. Nor did the collection contain sales or ownership information. Rather, the Neal collection's strength rested in the diverse representations of each individually named space shuttle orbiter and its functions.

Another story remains to be told about more technologically accurate toys in the collection, those aimed at older children—and their parents or toy buyers. (Investigating the records of toy makers and toy sellers to uncover the processes through which space shuttle toys were designed, marketed, and sold would also be a rich project.) Technologically accurate toys often emphasized the playthings' educational content, enhanced by packaging or inserts that explained the vehicle's particular features, its history, and its use. The greatest transformations between the parent technology and toy, however, occurred in translating the space shuttle orbiter for the youngest players.

Learning about the Shuttle through Toys

In her analysis of how toys transmit values, feminist scholar Wendy Varney argued that toys are themselves technologies, concluding "toys are among the earliest and most influential technologies with which children come into contact." Representational toys serve a basic purpose as agents of familiarization. In the nineteenth century, when horses provided a major form of daily transportation, many children owned hobby horses, rocking horses, or other toys that allowed them to mimic horseback riding. Although such toys still exist, they are less central to most children's play experiences. As space shuttle orbiters joined children's playtime vehicles, space shuttle toys introduced children to a technology to be recognized, named, and distinguished from other air or space vehicles.[9]

To do that, the shuttle's basic design, as translated into children's toys, had to conform to the requirements of easy, safe, and imaginative play while also retaining enough of the aesthetic characteristics of the original technology to remain recognizable as an analog to the flight vehicle. No matter how many liberties were taken with the form, color, texture, or proportions of the space shuttle orbiter, most space shuttle toys retained a core set of traits that defined the shuttle. Fittingly, these six common characteristics were also central to the parent vehicle's design. They were the vehicle's stubby delta wings (so named for their similarity to the triangular Greek letter), its massive payload bay doors, the black and white protective tiles (known collectively as the thermal protection system), the three rear-mounted engines, wheeled landing gear, and, finally, prominent U.S. flags or NASA symbols.

The first two features, delta wings and the payload bay, arose from compromises made to combine Department of Defense (DoD) needs with NASA's stated goals for the reusable orbiter. After extensive debate in the late 1960s, NASA engineers chose the orbiter's winged shape because delta wings offered the best solution for a cross-range capability of at least 1,100 miles (1,770 km), a requirement of the DoD, which was at the time a major client for the still-prospective launch system. Such wings would allow the orbiter to land at its launch site after only one polar orbit even though the earth's rotation "moved" the landing site approximately 1,000 miles (1,609 km) east during the flight's duration. Likewise, the shuttle's payload bay was sized to fit commercial and DoD satellites, space station segments, and other cargo. The vehicle's transportation capability, topped with distinctive sideways-opening doors, allowed it to be an orbital "space truck."[10] Almost all space shuttle toys represented some form of the orbiters' distinctive delta wings and payload bay doors (Figure 1).

The next three common traits found in most orbiter toys, tiles, engines, and wheels, were structural features that supported reusability. To make spaceflight routine, regular, and affordable, NASA made the shuttle reusable, likening the previous practice of launching expendable vehicles to the folly of throwing away the locomotive after each train trip. To that end, the orbiter's thermal protection system, made of specially fitted heat-resistant tiles and thermal "blankets," allowed the vehicle to endure the intense temperatures of orbital reentry. The thermal protection

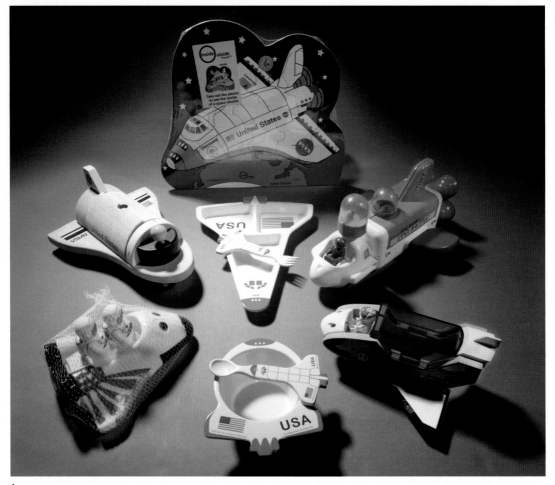

1.
As seen in these examples from the National Air and Space Museum's collection, no matter how many liberties toy makers took with space shuttle–themed playthings in color, shape, materials, and proportion, certain characteristics central to the vehicle's design remained consistent and recognizable. Photograph by Eric Long, National Air and Space Museum, Smithsonian Institution (SI 2010-00691).

system also gave each vehicle its characteristic softened appearance and distinctive face and body of black and white tiles.

In the quest for reusability, the three engines mounted on each orbiter's aft end and fed by the immense external fuel tank could be serviced and remounted. In contrast to earlier American human spaceflight launch vehicles (vertical rockets that featured one, two, or five engines), each orbiter sported three major engines (the space shuttle main engines) in a distinctive triangle configuration. Shuttle toys tended to depict either the three engine nozzles and/or the housing for the orbital maneuvering system (two large bumps called OMS ["ohms"] pods on either side of the vehicle's rear stabilizer), either in three dimensions or as a decal or other illustration if the basic structure of the toy did not allow for tangible engines. The quintessential element of the orbiter's reusability was the landing gear with wheels, which allowed the vehicle to land on a runway, as opposed to splashing down in the ocean and having to be retrieved. All of these features

supported the shuttle program's goal of affordable, routine human spaceflight, and all appeared, in one form or another, on most space shuttle toys.

Finally, the prominent display of the U.S. flag and/or NASA symbols on the orbiters' sides identified the vehicle as American. The Soviet Buran program began in 1974 in order to compete with the American space shuttle but flew only one unpiloted mission in 1988 before being completely abandoned in 1993. The Buran orbiter looked almost identical to the NASA shuttle. Although most children would never need to distinguish a NASA orbiter from a Soviet Buran, familiarizing children with the idea that space shuttles are an American space vehicle remained important throughout the cold war (Figure 2).

These six features appeared in some form or another in almost all of the toys in the Neal collection. In some cases, one or two features might change or be absent, as long as the others remain to anchor the depiction. Despite the importance of the shuttle as a *human* spaceflight vehicle, however, many of the most realistic toys did not represent people. In some ways, this reflected the challenge of scaling down the immense vehicle into something small enough for children. Proportionally, appropriately sized astronauts would be unsafe for small children and unsatisfyingly tiny for older players. When astronaut figures were included, the toy makers often took considerable liberties with the vehicle's structure to make them fit. The lack of people may also represent one characteristic of the shuttle's actual history of use. In a program in which dozens of astronauts became too numerous to be identified individually by the general public, the orbiters rather than the astronauts became the program's public face.

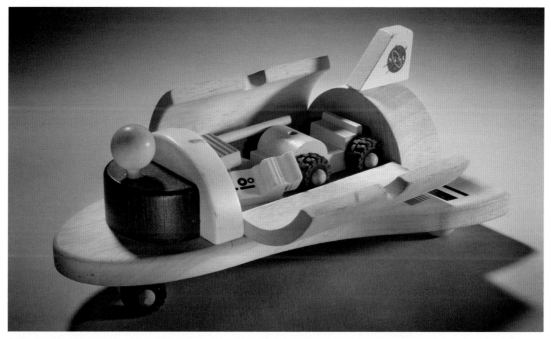

2.
Even in its simplified form, this wooden space shuttle orbiter toy by Plan Toys included movable payload bay doors, delta wings, rolling wheels, and American symbols as well as accessories that included a rover, a US flag, and an oversized astronaut. Photograph by Eric Long, National Air and Space Museum, Smithsonian Institution (SI 2010-00693).

Although the toys in the Neal collection did familiarize players with the parent technology's features, a small subset also contained a misleading element: a rover. Several of these playthings included space cars sized to fit inside the toy's payload bay. Perhaps toy makers assumed that adding an extra manipulative element outweighed the technological inaccuracy of including a landing vehicle with an orbital spacecraft. The simple four-wheeled vehicles echoed the lunar rovers used by the Apollo astronauts to explore the moon in the early 1970s. Such additions fed the misconception that space shuttle orbiters could reach the moon. (The shuttle's destination, low earth orbit, was only approximately 200 miles (321 km) above the earth, a mere fraction of the 250,000 mile (402,336 km) distance to the moon.) Most toys containing rovers were aimed at younger children. And the toys for the youngest children incorporated the most changes to the aesthetic qualities of the parent technology.

Grasping the Shuttle

When toy makers create playthings for a child's aesthetic, they know that children learn by touching and doing. Therefore, adapting the orbiter to a child's capabilities required cutting it down to size, making it colorful, and making it easy to handle. Examining the space shuttle toys in the National Air and Space Museum's collection, especially the three-dimensional toys (rather than the puzzles or model kits), one is struck immediately by the range of colors, shapes, proportions, and materials represented in objects that nonetheless remain recognizable as space shuttle toys.

For example, Brio, a Swedish company specializing in wooden toys, marketed a Lights and Sounds Space Shuttle (shown at the four-o-clock position in Figure 1) that simplified the orbiter's features while adding elements encouraging active play. Brio presented the orbiter's sides in wood, squaring off the vehicle's simplified construction. Illustrating key features on the toy's sides (such as the rear engines, which are drawn rather than three-dimensional) further simplified the toy. In contrast, features facilitating play, such as payload bay doors that open and close and wheels that allow the entire toy to be "raced" across the floor, are durable plastic. Despite making the payload bay doors translucent blue, the orbiter tiles' dominant coloring is retained in the white and black plastic used on the toy's cockpit and tail. Battery-powered lights embedded in the triangular delta wings also make the toy more attractive to children. At the toy's front end, a disproportionately huge yellow- and blue-suited astronaut sits in an open cockpit, a design choice that takes considerable liberties with the original form of the spacecraft in order to adapt it for small hands. Furthermore, although not included with the toy in the museum's collection, the Brio Lights and Sounds Space Shuttle probably included a rover. Two grooves exist in the payload bay floor and rear hatch (another creative adaptation of the real design), seemingly designed to allow a vehicle to be driven in and out. The orbiter is scaled down, simplified, and interactive, encouraging its owner to pretend to fly the vehicle and its astronaut through a series of adventures.

In contrast, a toy designed for a slightly older age group emphasized hands-on manipulation, changing the toy's core shape while retaining the traditional color scheme. In 1984, Bandai Co. Ltd. of Japan produced Spay-C, "[the] Friendly Robot Space Shuttle" for Tonka as an

addition to its line of Super Go-Bots. Conceived in Japan with a storyline about sentient robots disguised as everyday vehicles, Go-Bots were a contemporary and competitor of Transformers (owned by Hasbro). In its vehicle form, the shuttle toy looked like a conventional orbiter with accurate dimensions, faithful coloring, and some detailed features. But manipulating the toy's interlocking pieces changed it into a robot with arms, legs, a small head, and a large breastplate formed from the cockpit. The Go-Bot toy made the space shuttle especially manipulative. Moreover, it included the shuttle in the corpus of everyday vehicles that could disguise fantastical sentient robots.

In a two-dimensional design, a Lauri early learning puzzle from 1998 illustrated a very different way of adapting the orbiter for a child's aesthetic through graspable pieces and bright colors. Lauri manufactures puzzles and other manipulative toys, such as peg boards, for preschoolers. Indeed, this toy carries a prominent label recommending it for ages 3–6. Its simple, flat shapes are cut from durable, richly colored, textured crepe rubber (advertised to be difficult to tear or ruin). Together, they fit into a shallow plastic tray, revealing the puzzle image: the silhouette of the space shuttle's full-stack configuration. (Other Lauri puzzle designs include cars, trucks, construction equipment, animals, letters, and numbers: all classic elements for a preschooler to learn through play.) The puzzle distills the shuttle into easily grasped, colorful parts: the external tank (green), solid rocket boosters (blue), orbiter nose (red), vehicle body (orange), delta wings (black), and so on. Because the Lauri puzzle eliminates so many details and takes such liberties with the colors, the proportions and shapes of the launch vehicle's components are rendered accurately or else the image would have been unrecognizable.

All three of these toys illustrate some of the changes in color, structure, and appearance that allow children, literally and figuratively, to grasp the space shuttle orbiter. As toy makers aimed shuttle-themed toys at younger and younger audiences, including even toddlers, toy makers took increasing liberties with the orbiter's form and shape. When examining these toys designed for younger children, one notices especially how fundamentally the orbiter was reshaped. Sometimes it even gets friendlier looking. In these cases, not only is the parent technology being interpreted for children, but the vehicle itself is also made to look childlike, a trait called neoteny.

Neoteny or Juvenilization

As noted at the outset of this essay, neoteny's functions were suggested by animal behaviorist Konrad Lorenz. A German zoologist whose close observation of animals (particularly birds) led him to insights about the natural world, Lorenz famously explored the instincts of barnyard fowl by allowing newly hatched goslings to imprint on him and follow him around. But his interests in nature's underlying structures ranged widely. In a paper called "Part and Parcel in Animal and Human Societies," Lorenz argued in 1950 that human beings have a biologically innate impulse—he called it an "innate releasing mechanism"—to be kind or affectionate to creatures that look like babies. Biologists had long identified the trait of retaining juvenile characteristics into adulthood as neoteny. Lorenz's insight was exploring neoteny's implications: that juvenile

Fig. 4. *The releasing schema for human parental care responses.* left: *head proportions perceived as 'loveable' (child, jerboa, Pekinese dog, robin).* right: *related heads which do not elicit the parental drive (man, hare, hound, golden oriole)*

3.
In 1950, Konrad Lorenz published this illustration (reprinted in English in 1971 in *Studies in Animal and Human Behavior*, volume 2), comparing youthful appearances that elicit affection to mature profiles that do not. Similar proportions underlie the popular appeal of some zoo animals, cartoon characters, and space shuttle toys. Credit and copyright Piper Verlag, Munich, Germany.

characteristics elicited affirmative responses by making an animal appear cute or "loveable." Moreover, Lorenz concluded, those traits resided in easily identifiable proportions (Figure 3).[11]

To analyze the characteristics that elicit affection, Lorenz compared the heads of adult and infant animals and humans. Babies tend to have proportionally larger eyes, shorter noses, rounded faces, higher foreheads, and receding chins when compared to adults of the same species. The

often-reproduced illustration from Lorenz's paper (Figure 3) made the point. On the left, Lorenz illustrated appealing infantile characteristics in contrast with the mature features in the right-hand column. Lorenz argued that animals that retained childlike characteristics, especially as adults, elicited more positive responses than ones that lost their babylike traits as they grew. For example, puppies and dogs with a rounded, soft, or wide-eyed appearance inspired attraction; wolves, with their pronounced snouts, set-back eyes, and sharp features, did not.

Lorenz's ideas have been adapted in creative ways. In an article in *Natural History* in 1979, Stephen Jay Gould, the Harvard University professor and evolutionary biologist, applied Lorenz's definitions to Mickey Mouse. On the occasion of Mickey's fiftieth "birthday," Gould examined the trademark Walt Disney character's evolution from the mouse's first appearance in the black-and-white animation *Steamboat Willie* in 1928 to the character's modern-day incarnation as the cheerful front man for a global commercial empire. Over time, Mickey's proportionately larger eyes, rounder body, and shorter, thicker limbs all demonstrated neoteny. As Disney illustrators (and later "imagineers") developed the character, Mickey became more approachable as the character appeared more childlike. In contrast to Lorenz's belief in an innate releasing mechanism, however, Gould argued that human responses to cuteness were not biologically rooted, but rather a socially learned attraction to juvenile appearance. In making Mickey Mouse more appealing, he wrote, Disney's illustrators unwittingly employed the mathematical proportions underlying neoteny. As they made the character cuter, they inadvertently also made him look more juvenile.[12]

A similar set of proportional changes underlay the translation of the space shuttle orbiter into a toy. Although many designers appeal to anthropomorphism and neoteny to make toys (creating chubby, cute cars and trains, for instance), the space shuttle orbiter especially lent itself to the aesthetic transformations of neoteny. As one book for young people described the new spacecraft in 1979, "The orbiter itself looks like a misshapen jet liner. It has a fat fuselage, stubby wings, and huge engines mounted at its aft end."[13] Especially when compared with a commercial airliner, the space shuttle already exhibited rounded corners, thickened dimensions, and shortened "limbs." Unlike the long, pointed shapes of conventional single-use rockets, the protective tiles and specially constructed heat-resistant blankets of the thermal protection system visibly softened the orbiter's edges. Transforming the parent technology into a graspable plaything only exaggerated such characteristics.

The Fisher-Price Little People Space Shuttle toy produced in 1993 exemplified neoteny in a shuttle toy (Figure 4). In creating this representation, Fisher-Price's designers made several adaptations to the orbiter's proportions. The vehicle's nose became shorter, its body thicker, and the edges softer and rounder. The juvenile face of tiles and windows on the orbiter's nose was echoed by the similarly proportioned face of the Little People figure astronauts who can sit in the open cockpit above the windows. Overall, in its adaptation for preschoolers, this shuttle clearly got cuter.

Even when there was not a three-dimensional toy to be gripped, however, the shuttle orbiter was often represented as rounder, shorter, and thicker than it actually was. One telling example was the Inside/Outside Space Shuttle Puzzle, produced by The Straight Edge, Inc., (circa

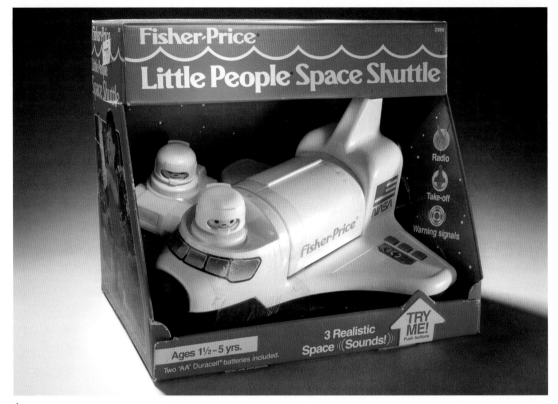

4.
The Fisher-Price Little People Space Shuttle illustrates neoteny (proportions identified with youth) in a toy depiction of the space shuttle. Its body is much shorter and thicker proportionately than the parent technology's is. Photograph by Eric Long, National Air and Space Museum, Smithsonian Institution (SI 2010-00694).

2002). In this case, the toy was a cardboard puzzle created from an illustration. Removing the pieces revealed interior views of the orbiter. In such a puzzle, there would seem to be no need to alter the vehicle's proportions. Nonetheless, even in this illustrated depiction, the orbiter was rendered as both shorter and thicker than its real proportions, with a stubbier nose.

In its most extreme form, the orbiter's changed proportions resulted in an entirely different shape. The shortest, fattest example of the shuttle orbiter donated by Neal was a Dollarama space shuttle key chain. In that representation, the orbiter's body, which was rendered in metal as a light-up key chain ornament, became so short and fat that it was almost a perfect triangle when viewed from the top. Without the white and black tiled exterior appearance to link it to the space shuttle orbiters, the resemblance to the parent technology might have been lost altogether.

The transformations that a technology could undergo while being turned into a plaything had limits. Go too far and the toy lost its relationship to what it represented. Examining space shuttle toys illustrates just how much change can occur and how those changes conform, in many cases, to recognized patterns of aesthetic proportions linked to youth. But childlike proportions were not the only way to people's hearts. Humanlike appearance could also elicit affection. Consider the anthropomorphization of zoo animals. This unusual comparison sheds light on how

the space shuttle's core characteristics contributed to its enduring popularity—and how a space shuttle orbiter may have much in common with a giant panda.

The Popularity of Pandas and Space Shuttles

Social scientists studying zoo animals have concluded that the most popular animals, termed charismatic fauna, often possess a common set of characteristics. Specifically, two different sets of scholars identified a series of traits that help explain the outsized popularity of giant pandas as zoo attractions. In their book *The Giant Panda*, Ramona and Desmond Morris itemized no fewer than twenty individual properties that contributed to the species' widespread appeal. Some years later, Bob Mullan and Gary Marvin built on those theories in their book *Zoo Culture*. From both books, some principles about the traits underlying popularity emerged, many of which also applied to space shuttle orbiters.[14]

In 1987, Mullan and Marvin consolidated the Morrises' long list of twenty traits into an only slightly shorter list of fourteen elements that contributed to anthropomorphizing the giant panda. They cited the pandas' flat faces, comparably large eyes, all-but-nonexistent tails, vertical seated posture, and ability to manipulate small objects—all evocative of humanity and therefore attractive. Significantly, they argued that pandas seem, by appearance, to be not very animalistic: they are killers (bears) turned nonkillers (herbivores); they appear harmless and friendly. With their complicated reproductive schedules and largely indistinguishable visible sex characteristics, they also seem sexless. Mullan and Marvin especially equated the lack of sexuality with a lack of threat, "the giant panda appears sexless and thus harmless, as opposed for example to the essentially male gorilla, which elicits very different responses." The final defining characteristics echoed Lorenz's assertions. Rounding out the fourteen characteristics that contributed to the species' popularity in zoos around the world, Mullan and Marvin cited the panda's playful, clumsy, soft, and rounded appearance, enhanced by its exotic history and origins.[15]

Similar arguments can be made about space shuttle orbiters and the toys made to represent them. In addition to desexing the outright masculinity of phallic rockets, the orbiter also appeared to have a rounded face composed from the tiles that surround the cockpit windows, which serve as the orbiter's eyes. Its nose was stubby and flattened. In fact, the orbiter's face was even reflected in the names of its parts. The panels below the real orbiter's nose (a term borrowed from aviation) were actually called the chin panels. Moreover, the orbiter's face was black and white, an easily viewed color scheme that also seems to correlate with popularity. As Mullan and Marvin concluded, "contrasting black and white coloration often seems to attract—witness the popularity of zebras, killer whales, and penguins."[16]

Most significant, like the panda, the space shuttle orbiters were perceived to be potential killers turned nonkillers. Unlike other spacecraft that retained a shape also shared by weaponry (most expendable rockets still looked like intercontinental ballistic missiles), the shuttle appeared

civilian and nonthreatening, even in its launch configuration. Likewise, although the space shuttle was partially developed with military funds and was sometimes used for classified military missions, the program's overall public image remained peaceful, scientific, and inspirational. In contrast to ballistic spacecraft, the shuttle orbiter appeared harmless and even friendly.

All of these aesthetic adaptations came together most dramatically in a set of water toys designed for young children: the Bath Machines Shuttle Tub Toys (circa 2002). For this bath toy, the orbiter was rendered in soft, squeezable, white rubberized plastic with rounded edges, a thickened body, and soft features (Figure 5). Most strikingly, however, the orbiter's front end boasted a literal face, complete with big eyes instead of cockpit windows and a small mouth tucked below the orbiter's nose. The toy was not only cute; it smiled! The accompanying astronaut toys—short, squat, and squeezable—exhibit the playful, round shape asserted to be so appealing.

Like the giant panda, the shuttle orbiter fit the description of something that was relatively soft, rounded, and even a bit clumsy. The padded appearance created by the thermal protection system has already been described. Famously, however, the real orbiters also flew like bricks when they reentered the earth's atmosphere. Unlike powered aircraft, which have engines to go around and retry a landing, space shuttle orbiters entered the atmosphere without power; they had to land on the first try. An orbiter could maneuver within the atmosphere, but it was not a visibly streamlined or particularly agile vehicle. As children learned about the space shuttle through play, many of the toys made to depict this tremendously complex, rocket-powered machine exaggerated the characteristics that most enhanced its public appeal.

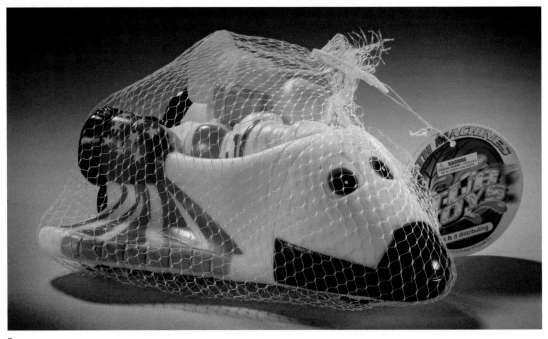

5.
This set of tub toys by D&D Distributing turned the space shuttle orbiter's appealing black- and white-tiled cockpit into a literal face, complete with a thin pink smile. Notice how the orbiter's proportions have been juvenilized to be thicker, rounder, and softer. Photograph by Eric Long, National Air and Space Museum, Smithsonian Institution (SI 2010-00698).

Broader Implications

The transformations described here had a very practical purpose: scaling down an immense technological spaceflight system into toys to familiarize children with the parent technology's existence and goals. This practical consideration also has a larger cultural context, however. The early years of the space shuttle's operational life included a concerted educational effort, promoted by NASA and the White House, to familiarize youth with the space shuttle program, inspiring young people to prepare themselves for life in a new space age, characterized by routine, affordable access to space. As the shuttle began regular operation, NASA's high hopes for the system's potential to achieve frequent spaceflights made it seem that a long-awaited future had arrived. Together, NASA officials and the Reagan administration participated in a concerted effort to equip young people for success in a world full of futuristic technologies that had become commonplace such as telephone answering machines, video cassette recorders, and home computers. Education about science and technology would be key for moving into this new future. Schools across the country created chapters of the Young Astronaut Program and nominated educators for the Teacher in Space program.[17]

At the same time, toy manufacturers saw an opportunity, supported by the rhetoric surrounding the space shuttle, to market shuttle-themed playthings for children. Toy makers were not a part of a vast conspiracy to prop up NASA's projections for its new space age, but the excitement of the cultural moment carried over into enthusiasm for the space shuttle orbiter and a booming market for versions of the vehicle that could be grasped and enjoyed, even by the very young. Changing the space shuttle's proportions for a child's plaything, literally rounding and softening the orbiter's shape, complemented NASA's larger depiction of the reusable vehicle as safe, routine, and reliable.

Toys that echo those aesthetic qualities can still be found. At the Kennedy Space Center, the shuttle's former launch (and sometimes landing) site, the gift shops sold two different kinds of plush shuttle toys. The first, available in several different sizes, represented the full-stack launch configuration: a soft white stuffed orbiter attached to a downy orange external tank bracketed by two fuzzy solid rocket boosters. The second depicted the orbiter alone, with details such as the cockpit windows, orbiter name (such as *Discovery*), NASA logo, and American flags embroidered onto the vehicle's furry white exterior. Squeezing the second type of stuffed plush orbiter activated an internal electronic noisemaker that emitted a weak echo of an engine's roar.

Plush space shuttle toys represented both a marketing novelty and a profound material statement. There were no contemporary plush toys—soft, cuddly, and warm—created to depict the Apollo Program's towering Saturn V rockets. Likewise, the converted intercontinental ballistic missiles used to launch the first Mercury astronauts or the Gemini program's paired space crews were not rendered in stuffed fabric as playthings. Only the space shuttle orbiter lent itself to this kind of popular depiction, one suitable to be embraced, literally and figuratively, by the public.

Space shuttle toys, both the plush examples and the ones that exhibited neoteny or anthropomorphized aesthetics, normalized and domesticated a vehicle that remained, at its core, like all

launch vehicles, a dangerous controlled explosion. Space shuttles were immensely powerful rockets designed to generate enough force to lift approximately 4.5 million pounds of vehicle, people, and payload to earth orbit in only eight minutes. Despite the very real, and largely successful, precautions taken to make the orbiter safe and reliable, NASA lost two orbiters and crews in 1986 and 2003. And yet, the space shuttle program flew 133 successful missions. Familiarizing young people with the space shuttle through graspable, appealing toys reinforced the public image of the shuttle as a reliable, reusable launch vehicle. In many ways, that depiction succeeded, at least in part, because space shuttle orbiters, and the toys they inspired, shared aesthetic characteristics also deeply associated with humans and babies.[18]

Acknowledgments

In addition to my thanks to the various members of the National Air and Space Museum's Writers' Group for their encouragement and support, I thank Paul Ceruzzi especially for the introduction to Lorenz's and Thompson's works, two linchpins for the arguments made here.

Notes

1. Brian Vastag, "For Discovery, a Spectacular Finale: NASA's Veteran Space Shuttle Delights Thousands of Onlookers in the Washington Area with a Sweeping Retirement Flight," *The Washington Post*, April 18, 2012, sec. C.

2. The Space Shuttle *Enterprise*, the atmospheric test vehicle, was never retrofit for spaceflight. Valerie Neal, "Bumped from the Shuttle Fleet: Why Didn't *Enterprise* Fly in Space?" *History and Technology* 18 (2002): 181–202.

3. NASA deputy administrator George Low as quoted in Roger D. Launius, "NASA and the Decision to Build the Space Shuttle, 1969–72," *The Historian* 57 (1994): 17–34. See T. A. Heppenheimer, *The Space Shuttle Decision: NASA's Search for a Reusable Space Vehicle*, NASA History Series, NASA Special Publication 4221 (Washington, DC: National Aeronautics and Space Administration, 1999); Dennis R. Jenkins, *Space Shuttle: The History of the National Space Transportation System, the First 100 Missions*, 3rd ed. (Cape Canaveral, FL: Dennis R. Jenkins Publishing, 2001) . See also chapters 9–11 in Roger D. Launius and Dennis R. Jenkins, eds., *To Reach the High Frontier: A History of U.S. Launch Vehicles* (Lexington: University Press of Kentucky, 2002).

4. Joseph J. Trento, *Prescription for Disaster: From the Glory of Apollo to the Betrayal of the Shuttle* (New York: Crown Publishers, 1987); Diane Vaughn, *The Challenger Launch Decision: Risky Technology, Culture, and Deviance at NASA* (Chicago: University of Chicago Press, 1997); Howard McCurdy, *Inside NASA: High Technology and Organizational Change in the U.S. Space Program* (Baltimore: Johns Hopkins University Press, 1993).

5. See, for example, Tony Reich and James A. Lovell, eds., *Space Shuttle: The First 20 Years; The Astronauts' Experiences in Their Own Words* (New York: DK Publishing, 2002), or Mike Mullane, *Riding Rockets: The Outrageous Tales of a Space Shuttle Astronaut* (New York: Scribner, 2006). An exception is Roger Launius, "Assessing the Legacy of the Space Shuttle," *Space Policy* 22 (2006): 226–34.

6. Margaret A. Weitekamp, "Selling Education in the Shape of a Shuttle," in "Celebrating 50th Anniversary NASA in Florida, (1958–2008)," special issue, *The Florida Historical Quarterly* 87 (Fall 2008): 210–234; Matthew Hersch, "The Short Life and Violent Death of the Space Shuttle Dream, 1972–86" (paper presented at American Historical Association National Meeting, Boston, MA, January 7, 2011).

7. Anthony Burton, *Children's Pleasures: Books, Toys, and Games from the Bethnal Green Museum of Childhood* (London: V & A Publications, 1996), 122.

8. Parentheses in original. Valerie Neal, "Space Shuttle Toys and Games acquired by curator Valerie Neal (2007)," January 16, 2008, Curatorial Files, Social and Cultural Dimensions of Spaceflight Collection, National Air and Space Museum, Smithsonian Institution, Washington, DC, 1.

9. Wendy Varney, "Of Men and Machines: Images of Masculinity in Boys' Toys," *Feminist Studies* 28 (Spring 2002): 153–74.

10. Heppenheimer, *The Space Shuttle Decision*, 212–13, 226; Stephen J. Garber, "Why Does the Space Shuttle Have Wings? A Look at the Social Construction of Technology in Air and Space," NASA History Office, http://history.nasa.gov/sts1/pages/scot.html (accessed April 24, 2012).

11. Konrad Lorenz, "Part and Parcel in Animal and Human Societies," in *Studies in Animal and Human Behavior*, vol. 2 (Cambridge, MA: Harvard University Press, 1971), 154–162.

12. Stephen Jay Gould, "Mickey Mouse Meets Konrad Lorenz," *Natural History* 88 (May 1979): 30–36. D'Arcy Thompson described the mathematics behind these transformations in *On Growth and Form*, ed. J. T. Bonner (Cambridge: Cambridge University Press, 1961).

13. L. B. Taylor, *Space Shuttle* (New York: Thomas Y. Crowell, 1979), 28.

14. Ramona Morris and Desmond Morris, *The Giant Panda* (New York: Penguin Books, 1966); Bob Mullan and Garry Marvin, *Zoo Culture*, 2nd ed. (Champaign: University of Illinois Press, 1999), 26.

15. Mullan and Marvin, *Zoo Culture*, 26.

16. Mullan and Marvin, *Zoo Culture*, 26.

17. Weitekamp, "Selling Education in the Shape of a Shuttle," *The Florida Historical Quarterly* 87 (Fall 2008): 210–34.

18. National Aeronautics and Space Administration, "Space Shuttle: Shuttle Basics," http://www.nasa.gov/returntoflight/system/system_STS.html (accessed April 26, 2012).

Bibliography

Burton, Anthony. *Children's Pleasures: Books, Toys, and Games from the Bethnal Green Museum of Childhood*. London: V & A Publications, 1996.

Gould, Stephen Jay. "Mickey Mouse Meets Konrad Lorenz." *Natural History* 88 (May 1979): 30–36.

Heppenheimer, T. A. *The Space Shuttle Decision: NASA's Search for a Reusable Space Vehicle*. NASA History Series. NASA Special Publication 4221. Washington, DC: National Aeronautics and Space Administration, 1999.

Hersch, Matthew. "The Short Life and Violent Death of the Space Shuttle Dream, 1972–86." Paper presented at the American Historical Association National Meeting, Boston, MA, January 7, 2011.

Jenkins, Dennis R. *Space Shuttle: The History of the National Space Transportation System, the First 100 Missions*. 3rd ed. Cape Canaveral, FL: Dennis R. Jenkins Publishing, 2001.

Launius, Roger D. "NASA and the Decision to Build the Space Shuttle, 1969–72." *The Historian* 57 (1994): 17–34.

———. "Assessing the Legacy of the Space Shuttle." *Space Policy* 22 (2006): 226–34.

Launius, Roger D., and Dennis R. Jenkins, eds. *To Reach the High Frontier: A History of U.S. Launch Vehicles*. Lexington: University Press of Kentucky, 2002.

Lorenz, Konrad. "Part and Parcel in Animal and Human Societies." In *Studies in Animal and Human Behavior*, volume 2, 154–162. Cambridge, MA: Harvard University Press, 1971.

McCurdy, Howard. *Inside NASA: High Technology and Organizational Change in the U.S. Space Program*. Baltimore: Johns Hopkins University Press, 1993.

Morris, Ramona, and Desmond Morris. *The Giant Panda*. New York: Penguin Books, 1966.

Mullan, Bob, and Garry Marvin. *Zoo Culture*. 2nd ed. Champaign: University of Illinois Press, 1999.

Mullane, Mike. *Riding Rockets: The Outrageous Tales of a Space Shuttle Astronaut*. New York: Scribner, 2006.

Neal, Valerie. "Bumped from the Shuttle Fleet: Why Didn't *Enterprise* Fly in Space?" *History and Technology* 18 (2002): 181–202.

Reich, Tony, and James A. Lovell, eds. *Space Shuttle: The First 20 Years; The Astronauts' Experiences in Their Own Words*. New York: DK Publishing, 2002.

Taylor, L. B. *Space Shuttle*. New York: Thomas Y. Crowell, 1979.

Thompson, D'Arcy Wentworth. *On Growth and Form*. Edited by J. T. Bonner. Cambridge: Cambridge University Press, 1961.

Trento, Joseph J. *Prescription for Disaster: From the Glory of Apollo to the Betrayal of the Shuttle*. New York: Crown Publishers, 1987.

Varney, Wendy. "Of Men and Machines: Images of Masculinity in Boys' Toys." *Feminist Studies* 28 (Spring 2002): 153–74.

Vaughn, Diane. *The Challenger Launch Decision: Risky Technology, Culture, and Deviance at NASA*. Chicago: University of Chicago Press, 1997.

Weitekamp, Margaret A. "Selling Education in the Shape of a Shuttle." In "Celebrating 50th Anniversary NASA in Florida (1958–2008)," special issue, *The Florida Historical Quarterly* 87 (Fall 2008): 210–34.

The Kilmer Complex
Artificial-Tree Cellular Towers and Landscape Aesthetics

Poems are made by fools like me,
But only God can make a tree.
—Joyce Kilmer, "Trees"

Bernard Mergen
Professor Emeritus

*The George Washington University
Washington, D.C.*

Towers for cell phone antennae and transmitters have become a familiar part of suburban and rural landscapes since the mid-1980s when they first appeared in the United States. (In cities the antennae are often located on existing radio and television towers and on tall buildings.) The most common tower types are the monopole, usually less than 100 feet (30.48 m) tall; the self-standing tower, about 150 feet in height; and the guy wired mast, rising to 300 feet. These towers dwarf most of the older features of the visible technological infrastructure, the telephone and electric power lines, adding to what some have called visual blight (Figure 1). To lessen the optic impact of the towers, cell phone companies began working with communities to make their antennae less obtrusive by concealing them in existing buildings, colocating them in church steeples and on flag poles, and camouflaging them as silos, water towers, sculptures, and trees. As I will show in this paper, artificial-tree cellular towers may be perceived as either good or bad design by individual viewers, but the designs have a history that must be considered when judging them. In the long and continuing dialogue between humanity and nature, the line between "real" and "fake" has never been absolute; humans and other animals have been making the landscape for millions of years. The technology to disguise a cell phone tower is only another manifestation of the demiurge.

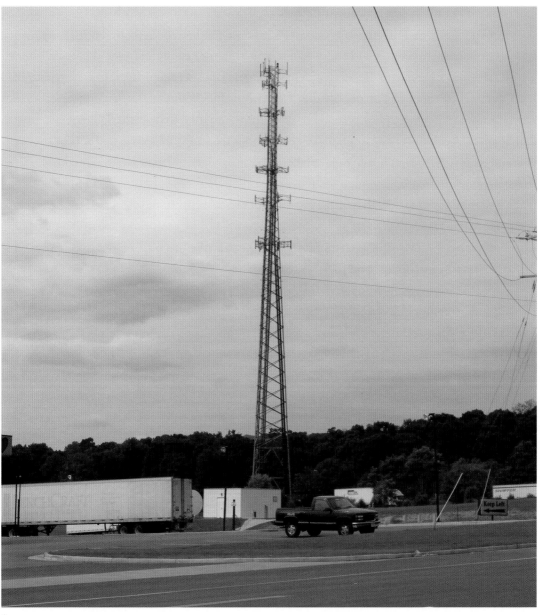

1.
Many cell phone towers, such as this example at Toms Brook, Virginia, dwarf the older features of the visible technological infrastructure, the telephone and electric power lines, adding to what some have called visual blight. Photograph by the author.

A class of artifacts variously labeled "fake trees," "faux fronds," "frankenpines," and "stealth towers" has appeared on American and world landscapes to conceal cell phone towers. By 2002 there were an estimated 32,000 disguised cell phone towers in the United States, about 25% of the total 130,000 towers, but only 2% (640) of the stealth towers were camouflaged as trees.[1] In 2010 the industry estimated there were 247,000 cell phone sites, with no guess as to the number of tree towers, but the percentage is probably the same—at least 1,235 towers disguised as trees.[2] This small but budding forest is further subdivided into a half dozen species of pines, palms,

and cypress. For the desert southwest there is a saguaro cactus tower. Each arborescent artifact is custom designed and manufactured for a specific site, although there are basic components, such as pine tree branches, that can be arranged in different configurations. When a customer, Sprint, Verizon, Cingular, or T-Mobile, for example, requires a camouflaged tower, a galvanized steel monopole is sent to Larson, Stealth, Cell Trees, Inc., Valmont, or some other fabricator where acrylics, fiberglass, plastics, and epoxy mixtures are used to make bark, branches, fronds, and needles. A cell tower is essentially a structure for mounting antennae and sets of transmitters and receivers; thus, it needs to be higher than surrounding structures that might block the transmissions. Although they often loom over nearby living trees, their manufacturers proudly claim that they are so lifelike that birds nest and bees build hives in the vinyl branches.[3] Because each tree is customized to local soil, wind, and temperature conditions, as well as aesthetic expectations, prices vary, but a 100 foot (30.48 m) eastern white pine with 216 branches cost $140,000 in 2008.[4] To understand the stealth tree phenomenon, we need to place it in two contexts, first, the history of attempts to hide elements of technology in public spaces and, second, the cultural meanings of trees.

As historians Leo Marx and David Nye have amply shown, Americans welcomed the machine in the garden and celebrated the technological sublime from the 1840s on. Railroads, suspension bridges, skyscrapers, electricity, the space program, even the atomic bomb, replaced mountain peaks, waterfalls, and thunderstorms when writers and artists sought to express their sense of grandeur. Substituting effects produced by the ingenuity of humans, Nye suggests, emphasized rationality over emotion, "a celebration of the power of human reason."[5] Yet the transformation of the landscape from "natural" to "technological" did not occur without dissent. As Erin McLeary points out elsewhere in this volume, green paints were developed in the nineteenth century to make iron work disappear into foliage. Another example of the technological reshaping of rural landscape, analogous in some ways to the mushrooming of cell towers, is the spread of highways, the most obvious sign of human activity on otherwise pastoral land. Highway beautification contributed to a landscape aesthetic based in part on what could be found in national parks where roads had been designed to seem natural since the 1920s.[6] By 1965, a movement to tear down billboards, improve highway design, and even bury utility lines was endorsed by President Lyndon Johnson.[7] Two decades later, when cell sites began to appear, Americans were less tolerant of technological skylines in suburbs and countryside. The controversies over cell phone towers suggest that they are part of a continuing evolution of landscape aesthetics. The artificial-tree cellular tower emerges as a possible compromise between the natural and the technological sublime.

The preference by even a minority of concerned citizens for trees to camouflage towers raises the question of whether trees and forests have special meanings for humans, meanings that influence their landscape preferences and make them willing to pay the price to preserve an arboreal ideal. The cell phone tree is an outgrowth (pardon the pun) of other man-made arboreal environments, from plastic Christmas trees to museum dioramas, from silk ficus for interior

decoration to the work of artists and designers, the work of new dendrologists, who claim that their trees bridge the gap between natural and artificial. The roadside pines and palms bearing the fruit of AT&T and Sprint have caught the eyes of art photographers such as Robert Voit and Emily Shur and countless Internet bloggers. Stealth trees and other manufactured disguises raise another conundrum: when does art succeed by being invisible?

The Technological Picturesque

David Nye observes that Americans have sought and found the sublime in various natural settings and technological phenomena, from Niagara Falls and the Grand Canyon to electricity and the atomic bomb, the common characteristics being "a particular affinity for sharp discontinuities in sensory experience, for sudden shifts of perspective, for a broken figure of thought in which the quotidian is ruptured."[8] Traditional definitions of the sublime usually include the presence of vast and powerful forces that inspire a sense of awe and reverence, in contrast to places and things that are small, subtle, and merely "beautiful" or picturesque. It would be an exaggeration to argue that the cell phone tower, camouflaged or not, is an example of the technological sublime, although the mobile phone itself has certainly brought about sharp discontinuities in sensory experience and ruptured the quotidian. Embraced by the vast majority of Americans and by most of the world, the cell phone and its technological infrastructure have, nonetheless, provoked criticism and led to efforts to limit their aural and visual impact. Disguising towers as trees is part of that negative response.

Like the reaction against poorly planned highways with roadside clutter, opposition to cell towers reveals an ambivalent attitude toward the technology itself and a belief that cosmetic improvements are better than none. Miles of asphalt and cell towers are simply the price we pay for the convenience of automobile transportation and instant communication, but highway beautification and camouflaged cell towers offer a way to assuage our guilty pleasures. If a cell tower is absolutely necessary for reliable phone service, even when it is an eyesore, then make it look like something else.

The successes of the scenic roads and highways movement are measured in billboards removed and trees planted to screen unsightly land beyond the shoulder. The achievements of the cell site protestors are also modest, limited by federal law. The Telecommunications Act of 1996 restricts the ability of local communities to regulate the placement of cell towers. Some local zoning restrictions are allowed, and communities across the nation have enacted new ordinances requiring cell phone companies to submit visual impact statements, consider alternate sites, and disguise the towers by concealment, colocation, or camouflage.

Two major producers of cell tower disguises, Stealth Concealment Solutions, Inc., in Charleston, South Carolina, and Larson Camouflage in Tucson, Arizona, were both founded, according to their Web sites, in 1992, suggesting that a reaction against cell towers began before the legislation that gave the cell phone companies a virtual power of eminent domain. Stealth claims to create over 350 sites annually, most of them colocations in church steeples and on flag

poles, although the company makes all types of trees and has even simulated an osprey nest in one of them.[9] Stealth also emphasizes its sensitivity to community concerns, including aesthetic values. A ten-point list of "Zoning Approval's Lessons Learned" involves driving a 2 mile (3.22 km) radius of the site to consider alternatives and meeting with area residents as well as with local government officials. Stealth boasts it "has a hidden solution for everyone." Larson Camouflage also conceals cell antennae in church steeples and belfries but emphasizes its trees. Before it got into the fake tree business it made habitats for Disney World, zoos, and museums. Larson lists over 150 sites in more than 20 states where it has built pines, elms, date palms, Mexican fan palms, and saguaro cacti to disguise towers. With the motto "You dream it, we'll build it," Larson has found markets in England, Mexico, Japan, Saudi Arabia, Bulgaria, and Fiji, among other countries.[10]

Representatives from both Larson and Stealth responded to my questions about the design process, aesthetic considerations, and environmental issues. Annabelle Sheen, Senior Manager, Inside Sales & Marketing for Stealth, pointed out that "Stealth is the last player in the game, we are usually contracted because city, zoning, communities, etc. have told the carriers that if they want to put the site up in the selected location, then the antennas must be concealed."[11] Sheen and Ryan McCarthy, Project Manager for Larson Camouflage, both acknowledged that aesthetic concerns need to be balanced with financial considerations and physical limitations of the site. According to one estimate in 2006, a tower could cost $150,000 to $200,000, whereas a disguised tower might add as much as $100,000 to the price. Sheen notes that sometimes antennae extend past the branches because the customer refuses to purchase longer branches: the "trees don't look that great but [it's] not due to the lack of capability from the concealment company." McCarthy observed that "a pine tree that has 200 branches will be more appealing than one of the same height that has only 100. However, the customer not only will incur the cost of 100 extra branches, but the extra wind load from the branches will also require that the pole be designed more stoutly."[12] Geographer Thomas Wikle found that most faux tree towers are located in relatively affluent urban and suburban areas of California, the Southwest, New England, and the District of Columbia, with other concentrations near Atlanta, Miami, Chicago, St. Louis, and Dallas-Fort Worth.[13] Individuals and communities willing to pay for concealed cell sites and a natural environment compatible with trees tall enough to function as towers largely determine their location.

Geographer Donald Meinig identifies ten ways of looking at the same scene, noting that "any landscape is composed not only of what lies before our eyes but what lies within our heads." His final category, *landscape as aesthetic*, is a place where all the functions of the scene are subordinate to an ideal of beauty which, although it differs from person to person, maintains that the scene has the power to inspire, heal, or in some way improve the human spirit and to reveal truths about the world in which we live.[14] What role, if any, does the fake tree play in this landscape? I think it is clear that our current landscape aesthetics can accommodate fake trees because we believe the machine is compatible with the grove as well as with the garden. In over

a century we have become accustomed to landscapes of power and telephone lines, radio and television transmission towers, and now cell phone masts and towers. We see their appearance as signs of technological progress and their disguise as a further sign of our ability to mitigate and manage the negative consequences of modernization.

Take, for example, the 106 foot (32.31 m) Larson cell tree at George Washington's Mount Vernon that sparked controversy when it was built (Figure 2). Twenty-five to thirty short limbs, beginning two-thirds of the way up the trunk, mask the antennae. In summer, deciduous trees hide the long bare trunk of the ersatz evergreen, allowing it to blend in with the other vegetation. In winter the unnatural symmetry of the trunk is more apparent, as is the adjacent shed containing fuel cell backup power systems and other apparatus. When viewed up close, the Mount Vernon tree is so massive that it is hard to see. At eye level it looks like a big brown column in the ground. The "bark" is relatively smooth, and after about ten years it is beginning to fall off the "trunk." Like a living tree, it has a life cycle and requires maintenance. The "tree" is obviously meant to be seen from a distance, as part of the surrounding forest, not as a lone pine. The cells are well concealed, and the majority of visitors to George Washington's home probably never notice the technological intrusion.

Photographs imply that artificial palms and saguaros often look more natural than the pines. Done properly, fake trees, such as those modeled on the Mexican fan palm (*Washingtonia robusta*), camouflage the antennae completely. But some models leave the antennae hanging like cans (Figure 3). Only the cacti completely cover all the components of a cell tower, and these towers are limited to less than 50 feet (15.24 m) in height.

The evidence suggests that the cell phone tree has taken root primarily at the edges of places already landscaped to suggest the wild and natural, the borders between city and suburb, suburb and countryside, and along highways landscaped to buffer technology from relatively undeveloped, but potentially threatened, lands. Countless studies have been done to prove that drivers on their daily commutes prefer to view rows of trees rather than the flags, pennants, and gonfalons of car dealerships and strip malls.[15] Amid the visual chaos of the typical roadside, the camouflaged cell phone monopole is a relatively quick fix.

Although the goal of cell site concealment is to be unnoticed, Larson Camouflage, Stealth Concealment Solutions, and other companies create a paradox by promoting good design that needs to be noticed to sell the product. The trees should be natural, but not clones. The line between craftsmanship and art begins to blur when artificial trees move from cell sites to atriums, hotels, hospitals, museums, and public art projects. NatureMaker, a company founded in 1983 by Bennett Abrams, "an ecological artist, naturalist, and sculptor," and Gary Hanick, an MBA, specializes in high-end "tree sculpture." Although NatureMaker's products are too expensive for cell tower camouflage, its sales pitch is similar to Larson's and Stealth's. "Always expanding the boundaries of arboreal arts and technology, NatureMaker has evolved as a significant force in the perception of 'nature in design,'" reads a line next to a photograph on their Web site of a giant walk-through sequoia at the American Wilderness Experience, Ontario, California. The company

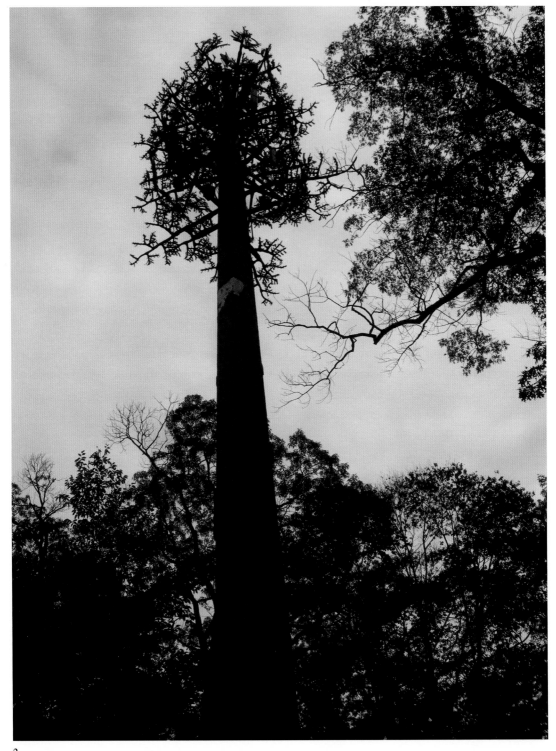

2.
This 106 foot (32.3 m) Larson cell tree at George Washington's Mount Vernon sparked controversy when it was built. Because twenty-five to thirty short limbs mask the antennae, however, the majority of visitors to Washington's historic home probably never notice the technological intrusion. Photograph by the author.

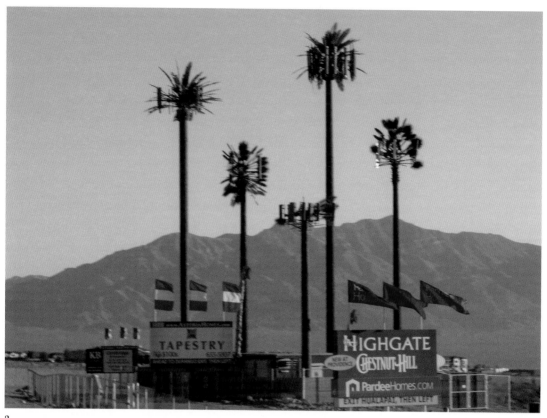

3.
When done properly, artificial-tree cell phone towers, such as those modeled on the Mexican fan palm (*Washingtonia robusta*), camouflage the antennae completely and can look more natural than towers disguised as pines. But some models leave the antennae hanging like cans. Photograph of fake palms near Las Vegas by Garry Schaefer.

got its start installing interior trees at Macy's in San Francisco and Marshall Fields in Chicago and was soon adding touches of nature in the neon wilderness of Las Vegas, including a 50 foot (15.24 m) tall hanging oak for the Buffalo Bill casino. More recently, it has built oak trees for hospitals in Georgia and Michigan to offer "a peaceful, meditative retreat for those dealing with illness and tragedy."[16]

Artificial plants, from plastic flowers on a restaurant table to a $250 silk Virginia pine Christmas tree, are ubiquitous but still offend those who prefer the real thing. The makers of indoor decorator trees do not seem to be trying to disguise anything, but they appear to share the aesthetic of the cell tower tree makers and expensive commercial artists like Bennett Abrams. As one dealer, who advertises twenty-two varieties of silk palms, comments, "silk palm trees are life-like and one could be forgiven for mistaking an artificial tree for an actual living palm," followed by a clue to the real purpose of decorator trees: "Adding a fake palm is a quick and easy way to add a touch of the tropics to any environment, from office to home."[17] What the garden variety of artificial-tree maker is camouflaging is the sterility of an office or a home. However,

as anyone who has experience with plastic trees knows, they require as much maintenance in dusting, repair, cleaning trash from their containers—as living trees do with watering, pruning, trash pickup. Further, for those with multiple chemical sensitivities, artificial trees provide no relief from allergies. Moreover, in an age of artificial trees there are dozens of artificial scents to enhance the illusion of naturalness, including scentsicles for Christmas trees and Little Trees (*Wunder-Baum* in Germany and the Nordic countries) from the Car-Freshner Corporation.

Placed in the context of the faux forests and beguiling gardens of interior landscapers and theme park operators, the artificial cell tower tree offers its own version of the fake tree as "destination." The fabricators of pines, palms, and cacti to conceal cellular towers modestly claim that their work merely serves commerce and the preservation of neighborhood beauty, yet their work has also become a destination site for those seeking evidence of human genius or folly. The cell tower tree and its congeners are the new picturesque, neither terrible in their sublimity nor simply pretty, but quirky, the unexpected woodman's hut tucked in a thicket of which nineteenth-century artists were so fond.[18]

Real Trees with Artificial Antennae

The second context for cell tower trees is the forest itself and the forest aesthetics that wooded land has inspired. The debate over whether humans evolved directly from arboreal ancestors or from related species that descended onto the savannahs begs the question. Trees are most certainly part of human evolutionary heritage. On the other hand, clearing forests by fire, ax, or chainsaw has been and continues to be a major activity in many parts of the world. Michael Williams, in his magisterial book *Americans and Their Forests: A Historical Geography*, estimates that about 45% of the land area of the coterminous United States was "well-formed 'commercial' forests" at the time of British colonization.[19] Today, the best estimates are that one-third of the country is forested, most of it in second and third growth with less biodiversity and fewer slow-growing hardwoods. More significant for understanding the aesthetic appeal of trees is that 400 years ago over four-fifths of American forests lay east of the Great Plains. The land between the Mississippi River and the Atlantic coast was, with local exceptions, "an almost unbroken expanse of forest."[20] Two hundred and fifty years later, the pioneer conservationist George Perkins Marsh surveyed the denuded land and warned of the far-reaching consequences of continued deforestation. Writing about the importance of forests everywhere for a healthy ecosystem, Marsh concluded that "the destruction of the woods, then, was man's first physical conquest, his first violation of the harmonies of inanimate nature."[21]

Williams reminds us that Americans felt a religious duty to tame the wilderness and clear the land for agricultural production and profit. Settlement meant progress, and even Romantics like Ralph Waldo Emerson and Henry David Thoreau were ambivalent and advocated a balance of urban civilization and forested wilderness. The compromise produced the rural and pastoral ideals that permitted some trees, but not too many. The backwoodsman became a

national symbol of independence and hardiness, his ax as much an emblem of American freedom as his rifle. This was part of the legacy the U.S. Forest Service inherited in the 1890s. Finding a middle way between the timber industry's demands for harvesting trees and the emerging Sierra Club ethos of preservation was not easy, but the forest aesthetics of John Muir offered a possibility. Writing in 1894, in the first of his many popular and influential books, Muir praised the "openness of the Sierra woods." "The trees of all the species stand more or less apart in groves, or in small, irregular groups, enabling one to find a way nearly everywhere, along sunny colonnades and through openings that have a smooth, park-like surface, strewn with brown needles and burs." Forest accessibility was a good thing, but, Muir cautioned, to truly know the "grandeur and significance" of the forests, "one must dwell with the trees and grow with them, without any reference to time in the almanac sense." In California in particular, "people look to megaflora for meaning."[22]

Openness and accessibility were values the Forest Service was eager to adopt, but they took it one step further. In 1907, the first "Use Book," a manual for rangers, declared that "the National Forests serve a good purpose as great playgrounds for the people."[23] Forests were no longer howling wildernesses or gateways to the universe, but leafy Coney Islands; distinctions between natural and technological were beginning to disappear.

There were other movements underway that began to define a forest, or at least treescape, aesthetic. The National Arbor Day campaign began in 1872, when Julius Sterling Morton, newspaper editor, amateur arborist, and member of the Nebraska Board of Agriculture, organized a tree planting day in April to teach people the value and beauty of trees. The National Arbor Day Foundation carries on Morton's mission, raising money to plant trees worldwide. Over 2,500 towns and cities in the United States have met the Arbor Day Foundation's criteria to become a "Tree City USA," whereas other communities identify with a particular kind of tree.[24] Arbor Day's emphasis on citizens, especially school children, planting their own trees shifts the aesthetic appeal from forests to single trees or small groves, often in towns and cities, and restores their symbolic importance. Tree planting is a political statement, an act of civic responsibility that appeals to both nostalgia and property values.[25] Tree preservation and planting also received encouragement from child psychologists, who, at the turn of the twentieth century, based human attachment to trees on evolution. Children were thought to have a natural desire to climb trees and to make them part of their play. Evolutionary theories are still part of the current discussion of landscape aesthetics.[26]

Some landscape critics are technophobes for whom pristine nature is the only antidote for the disease of ugliness caused by modern life.[27] Others advocate diversity in the landscape, even rejecting camouflage because technology should be seen so that it can be understood. Concealment is a denial of reality.[28] Most current writers on landscape aesthetics use assessment procedures that allow individuals to identify their favorite elements in a scene. Preferences are correlated with age, gender, income, ethnicity, and other factors to reveal that landscape

aesthetics is a complicated issue. City planners, park managers, and cell tower camouflagers cannot please everyone, but they can identify their clientele.

Working for the Forest Service and the Park Service, psychologists assert that "the most pressing task for behavioral scientists in urban forestry is to learn those attributes of trees valued by the people."[29] Robert Sommer of the University of California, Davis, and his associates administered a tree preference test to several hundred undergraduate students in a dozen countries. Sommer concludes that his preliminary research confirms the hypothesis that most people prefer spreading and fan-shaped trees, such as oaks and acacias, to columnar and narrow conical-shaped conifers and palms, regardless of the kinds of trees in their own environments. Although this might be a case of dendro-imperialism and seems not to bode well for the most popular types of cell tower trees, Sommer acknowledges the limits of his research and values all trees. Citing the British theologian Douglas Davies, he "attributes the attractiveness of a tree both to its physical form and its symbolic quality . . . 'As such, it avails itself as a historical marker and a social focus of events—trees are not simply good to climb, they are good to think.'"[30]

Thinking a tree is what humanists from the groves of academe have attempted in the past few years. In "Aesthetic Experience of Forests," Holmes Rolston III asks us to consider forests as archetypes of creation, life, death, and memory. Trees are not art or artifact, Rolston asserts: "Aesthetic appreciation of nature, at the level of forests and landscapes, requires embodied participation, immersion, and struggle. We initially may think of forests as scenery to be looked upon. That is a mistake. A forest is entered, not viewed."[31] We should enter a forest with enough scientific knowledge to appreciate its biodiversity and the processes that created it, even if the means were silviculture. That such a forest aesthetic is possible is amply demonstrated in Tom Wessels' *Reading the Forested Landscape: A Natural History of New England,* which leads the reader through the forest palimpsest where traces of fire, logging, pastures, beaver dams, insect invasions, blowdowns, and fungal blights remind us that we never step into the same woods twice.[32] Similarly, forest ecologist Nalini Nadkarni, who has made extensive studies of forest canopies in North and South America, offers a scientific and humanistic view of the forest suspended from its branches in climbing gear. Her forest aesthetic is enhanced by the instruments she carries into the tree tops, part of the "wired woodlands" providing real-time data on the state of the earth.[33]

The use of technology to immerse oneself in a forest brings us back to the technotree and the problems it raises when its location is not in the suburbs or along a highway but deep in a national park or forest where the Wilderness Act of 1964 prohibits roads, structures, and even scientific instruments if they pose a significant impact on wilderness character. Park superintendents are given some leeway in allowing cell towers on federal park land after considering the safety of the visiting public and the impacts on park resources. Determining the "public interest" is the key dilemma for federal land managers when the wireless industry wants to expand coverage in parks and forests.[34] In 2006 a controversy arose when several telecommunications

companies requested permits to erect towers in Yellowstone National Park, where six towers in five locations were already completed. At least thirty other parks have cell towers. "The whole idea of wilderness is that it is a place where technology doesn't invade," said one outdoor recreation professional. Another remarked that "cellular service might not be as vital as its proponents make it out to be. It's important to remember that we're talking about dial tone, not oxygen. It's not essential to life to have that phone."[35]

Like the fake trees installed in the summer of 2008 at the intersection of North Avenue and St. Paul Street in Baltimore by the artist Justin Shull as part of a public arts festival, cell phone trees will be noticed and commented on. It is a good thing when people fail to see Shull's fake trees at first because once a person sees them, that person begins to notice other things in new ways, according to Maren Hassinger, the director of Maryland Institute College of Art's Rinehart School of Sculpture.[36] Shull, an artist with degrees from Dartmouth and Rutgers, has created or proposed a number of outdoor sculptures that raise interesting questions about landscape aesthetics using fake trees and shrubbery. His *Porta Hedge (Mobile Observation Lab)* is a green rectangle, 21 feet × 8 feet × 6 feet (6.4 m × 2.4 m × 1.8 m), made of recycled Christmas trees on the exterior and mounted on a four-wheel trailer. Inside the hedge the occupants can observe the street and the birds that might fly into its branches. Shull also has a project, *7,000 Evergreens*, that encourages people all over the country to collect artificial Christmas trees and plant them outdoors. "Every tree planted is an investment in the American landscape."[37]

In 1999, Roxy Paine, an artist educated at the College of Santa Fe and the Pratt Institute in New York, began a series of large outdoor sculptures he calls "dendroids." These full-sized treelike objects are welded from steel rods that look like deciduous trees stripped of their leaves in winter. Writing about one of Paine's pieces, *Graft*, a 45 foot (13.7 m) tall creation erected in October and November 2009 in the National Gallery of Art Sculpture Garden on the National Mall in Washington, DC, art critic Blake Gopnik commented, "Set against the live trees already in the garden, Paine's piece has the strangest effect: It's grander and more impressive than them, but also so much deader. The trees, in a sense, critique the human artifice."[38] Paine aspires to reveal the tensions between organic and man-made objects when humans attempt to impose order on nature.[39]

Paine's work, more ambitious than the craftsmen at Larson Camouflage, nonetheless shares their willingness to have their creations stand side by side with living trees and endure invidious comparisons from viewers. A third artist, Joseph Smolinski, a graduate of the University of Connecticut, does paintings, drawings, and silkscreens of cell antennae in dead trees, inspired, he says, by the "shock the day I came across a giant fake tree looming above the interstate landscape. The pseudo-biotech hybrid was erected to camouflage the cellular communications transmitters beneath its fronds. It struck me as the beginning of a new history yet to be written. In this vision, parasitic cell towers populate the landscape in many forms that become historic landmarks, roadside curiosities and survivors of natural disasters."[40] Smolinski's gnarled tree trunks, with only

a few branches, do not disguise the antennae, but thrust them up, almost launching them like rockets into the sky. Smolinski takes the commentary on the aesthetics of artificial trees to a logical conclusion. Why not expose both technology and the dead or dormant tree? Both are finite, competing for attention in the landscape. The next step might be to disguise real trees with fake antennae.

Robert Voit, a German photographer, approaches cell site dendroids, in the words of art critic Philip Gefter, as "individual specimens of a 21st-century breed of industrial object." His 8 × 10 color photographs are shot in natural light with a precision that is "virtually scientific."[41] This ironic style, representing a virtual tree in a virtually scientific way, nicely sums up the critiques of the nature-culture debates. As the press release announcing Voit's exhibit of seventeen of his cell tree images puts it, "most [of the trees] have been transformed into caricatures of the natural world, odd sculptural forms that border on the absurd."[42] One commentator on the blog noted that the photographs are "at once documentary and a parody of the times we happen to be living in. It makes these ridiculous edifices into roadside attractions." Such a conclusion is natural because Voit only photographs stand-alone trees. The result is an artifact that is both a copy of nature and a fusion of art and technology, related in this sense to the glass flowers made in the 1850s for the Harvard arboretum and discussed by Ellery Foutch in this volume.

Art is solipsistic and therefore the best way to hide the things it copies. Two cell phone towers, one at Domino's Farm near Ann Arbor, Michigan, and the other in Fayetteville, North Carolina, illustrate this vividly. The Domino's tower resembles a bolt of blue lightning with a white transmitter and antennae on top like a small cloud. It is whimsical, but its position, in an empty field ringed by small trees, calls attention to itself as art more than to its function. The second tower, sculptor Tom Grubb's *Sprint Voyager*, is a 138 foot (42.06 m) monopole painted white with bands of yellow and red. Perched at the top of the pole is a 35 foot (10.66 m) tapering spar with a thin red piece resembling a feather on an arrow or an ornament on a weather vane, which, in fact, it is. Antennae are not visible. The design won first place at the Tower Summit and Trade Show, the annual gathering of telecommunications manufacturers, in Las Vegas in 2003. Curators from the National Building Museum and The Museum of Modern Art praised the design; they found pine tree towers absurd. The runners-up in tower design were a saguaro cactus from Larson and the spires of a Roman Catholic Church in Harpers Ferry.[43] Grubb's piece was installed for the centennial of flight celebration in Fayetteville in October 2002. His avowed aim was "to reestablish the connection between art and science, the earth and the cosmos"[44] (Figure 4).

Beginning as camouflage, the fake trees rapidly became iconic, attracted artists, and ended up on display on the Internet and in art galleries, sylvan simulacra that neither displaced the living trees that inspired them nor solved the problem of visual blight. What the stealth trees did was to complicate the discussion of forest aesthetics by blurring the distinctions among art, technology, and nature. Among the new questions that arose, one stands out—what are the aesthetics of those things that are not meant to be seen?

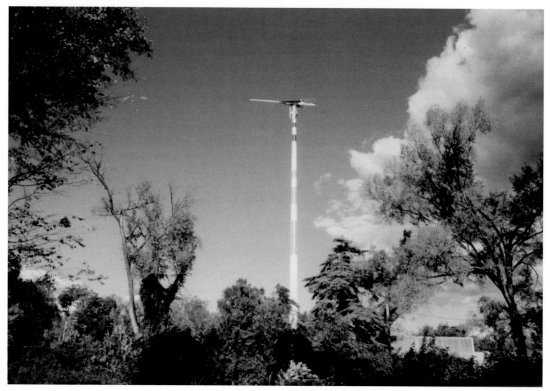

4.
Sculptor Tom Grubb's *Sprint Voyager*, a 138-foot (42.06 m) monopole, won first place at the Tower Summit and Trade Show, the annual gathering of telecommunications manufacturers, in Las Vegas in 2003. Photograph of *Sprint Voyager* by the artist.

Conclusions

The Joyce Kilmer dictum in his 1913 poem "Trees," that "only God can make a tree," is presently more honored in the breach than in the observance; literally as well as figuratively, the distance between trees, artificial and living, is growing closer.[45] In 1936, 3,800 acres (1538 ha) of the Nantahala National Forest in western North Carolina were set aside as the Joyce Kilmer Memorial Forest. Today, just 60 miles (96.56 km) away, a 100 foot (30.48 m) Larson cell tower pine, which, its makers say, is best viewed in the fall or winter "as the natural setting makes it indistinguishable in the summer months," proudly stands above the Blue Ridge Parkway Visitor Center Headquarters in Asheville, home to the famed Biltmore Estate where American forestry began.[46] By recommending that its camouflage tree be seen when the leaves are off the living trees, the manufacturer places its product squarely in the center of forest aesthetics. If a tree grows in the forest and no one sees it, it doesn't exist.

In his classic essay "What's Wrong with Plastic Trees?" urban planner Martin Krieger defended artificial trees, such as the Swiss Family Robinson Treehouse at Disneyland, because man-made objects are more easily and quickly replaced than natural ones. Later, he expanded his thoughts to argue the similarities between natural environments and artificial copies. Both, he contended, as I have in this essay, are cultural artifacts. All well-designed objects, natural and

artificial trees included, are authentic.[47] As environmental activist and writer Michael P. Cohen observes of attempts by photographers and tourists to find meaning in the bristlecone pine, "they are choosing a tree that fits an aesthetic preoccupation created not by nature but by the culture of modern art."[48] Appreciating that cell site trees and Kilmer's "Trees" are joined by this aesthetic encourages a more inclusive appreciation for both living and technological artifacts, for art and for nature.

Notes

1. Thomas A. Wikle, "Cellular Tower Proliferation in the United States," *The Geographical Review* 91 (January 2002): 46, 58.

2. Brent Johnson, "Disguised Cellular Phone Towers Sprout up across N.J.," http://www.nj.com/news/index.ssf/2010/10/cellular_phone_towers_sprout_u.html (accessed December 28, 2011).

3. Ryan McCarthy, e-mail to author, May 30, 2008.

4. Donald K. Burleson, "Fake Palm Tree & Pine Tree Disguises," The Discriminating Explorer, http://www.dba-oracle.com/golf_travel/fake_palm_tree_pine_tower_pole_disguises.htm (accessed December 27, 2011).

5. Leo Marx, *The Machine in the Garden: Technology and the Pastoral Ideal in America* (New York: Oxford University Press, 1964); David E. Nye, *The Technological Sublime* (Cambridge, MA: MIT Press, 1994), 60.

6. Linda Flint McClelland, *Building the National Parks: Historic Landscape Design and Construction* (Baltimore: The Johns Hopkins University Press, 1998). A related story, the planning of highways for the viewing of redwoods in northern California in the 1920s, is well told in Gabrielle Barnett's "Drive-by Viewing: Visual Consciousness and Forest Preservation in the Automobile Age," *Technology and Culture* 45, no. 1 (January 2004): 30–54.

7. *Beauty for America: Proceedings of the White House Conference on Natural Beauty* (Washington, DC: GPO, 1965).

8. Nye, *The Technological Sublime*, 281.

9. Stealth Concealment Solutions, Inc., http://www.stealthsite.com (accessed December 27, 2011).

10. Larson Camouflage, http://www.utilitycamo.com (accessed December 27, 2011).

11. Annabelle Sheen, e-mail to author, May 21, 2008.

12. McCarthy, e-mail to author, May 30, 2008.

13. Rachael Jackson, "That's No Tree—It's a Tower in Disguise," *The News Journal* (Deleware), December 20, 2006, sec. A; Thomas A. Wikle, "The Wireless Antenna Unseen: Disguising Technology on the American Landscape," *The North American Geographer* 3 (2001): 109–112.

14. D. W. Meinig, "The Beholding Eye: Ten Versions of the Same Scene," in *The Interpretation of Ordinary Landscapes*, ed. D. W. Meinig and John Brinckerhoff Jackson (New York: Oxford University Press, 1979), 33–48.

15. Kathleen L. Wolf, "Freeway Roadside Management: The Urban Forest Beyond the White Line," *Journal of Arboriculture* 29 (May 2003): 127–36.

16. NatureMaker, "The Art of Nature," http://www.naturemaker.com/ (accessed December 27, 2011).

17. Artificial Palm Trees, http://www.artificialplantsandtrees.com/palm-trees.html (accessed 27 December 2011).

18. For examples of Web site commentary, see http://danbricklin.com/log/celltowers.htm (accessed 27 December 2011) and http://waynesword.palomar.edu/faketree.htm (accessed 27 December 2011). Wayne's Word is the creation of W. P. Armstrong, a botanist at Palomar College.

19. Michael Williams, *Americans and Their Forests: A Historical Geography* (New York: Cambridge University Press, 1989), 1.

20. Williams, *Americans and Their Forests*, 2.

21. George Perkins Marsh, *Man and Nature; or, Physical Geography as Modified by Human Action* (1864; repr. Cambridge, MA: Harvard University Press, 1965), 119.

22. John Muir, *The Mountains of California* (1894; repr. Garden City, NY: Anchor Books, 1961), 112–113; Jared Farmer, "On Emblematic Megaflora," *Environmental History* 15, no. 3 (July 2010): 534.

23. Gerald Williams, *The USDA Forest Service: The First Century*, FS 650 (Washington, DC: USDA Forest Service, 2000), 43.

24. Shaul Ephraim Cohen, *Planting Nature: Trees and the Manipulation of Environmental Stewardship in America* (Berkeley: University of California Press, 2004).

25. Thomas J. Campanella, *Republic of Shade: New England and the American Elm* (New Haven, CT: Yale University Press, 2003); Susan Freinkel, *American Chestnut: The Life, Death, and Rebirth of a Perfect Tree* (Berkeley: University of California Press, 2007); Lori Vermass, *Sequoia: The Heralded Tree in American Art and Culture* (Washington, DC: Smithsonian Institution Press), 2003.

26. Robert Sommer, "The Dendro-Psychoses of J. O. Quantz," *Journal of Arboriculture* 27 (2000): 40–43; John O. Quantz, "Dendro-Psychosis," *American Journal of Psychology* 9 (1898): 449–506; Bernard Mergen, "Children and Nature in History," *Environmental History* 8 (October 2003): 643–69.

27. Pierce Lewis, "Geographer as Landscape Critic," in *Visual Blight in America*, ed. Pierce Lewis, D. W. Meinig, and Y. Tuan, Resource Paper 23 (Washington, DC: Association of American Geographers, Commission on College Geography, 1973), 1–48.

28. Michael Strobel, e-mail to author, April 29, 2008. Strobel is Director, National Resources and Conservation Service, National Water and Climate Center, USDA, Portland , Oregon. He was commenting on the use of scientific instruments in national forests and wilderness areas. See also Robert L. Thayer, *Gray World, Green Heart: Technology, Nature, and Sustainable Landscape* (New York: Wiley, 1994).

29. Robert Sommer and Joshua Summit, "Cross-National Rankings of Tree Shape," *Ecological Psychology* 8, 1996, 327.

30. Sommer and Summit, "Cross-National Rankings of Tree Shape," 329; Douglas Davies, "The Evocative Symbolism of Trees," in *The Iconography of Landscape*, ed. Denis Cosgrove and Stephen Daniels (New York: Cambridge University Press, 1988, 32–42).

31. Holmes Rolston III, "Aesthetic Experience in Forests," *The Journal of Aesthetics and Art Criticism* 56 (Spring 1998): 162.

32. Tom Wessels, *Reading the Forested Landscape: A Natural History of New England* (Woodstock, VT: Countryman Press, 1999).

33. Nalini Nadkarni, *Between Earth and Sky: Our Intimate Connections to Trees* (Berkeley: University of California Press, 2008); William J. Broad, "A Web of Sensors, Taking Earth's Pulse," *The New York Times*, May 10, 2001, sec. D4; Etienne Benson, "Paparazzi in the Woods," *Slate*, August 14, 2008, http://www.slate.com/toolbar.aspx?action+print&id+2197504 (accessed 27 December 2011); Etienne Benson, "The Wired Wilderness: Electronic Surveillance and Environmental Values in Wildlife Biology" (PhD diss., Massachusetts Institute of Technology, 2008); John Kleppe, e-mail message to author, May 12, 2008; William Norris, "Designing the Invisible SNOTEL" (MS thesis, University of Nevada, 2001).

34. Wilderness.Net, http://www.wilderness.net/index.cfm?fuse+NWPS&sec=legisAct (accessed 28 December 2011).

35. Jennifer Cutraro, "Cell Phone Towers in U.S. Parks Dial Up Debates," *National Geographic News*, May 31, 2006, http://news.nationalgeographic.com/news/2006/05/060531-cell-phones.html (accessed December 28, 2011).

36. Jill Rosen, "Missing the Forest for the Fake Trees," *The Baltimore Sun*, August 4, 2008.

37. Justin Shull, http://www.justinshull.net/projects/ (accessed December 28, 2011)

38. Blake Gopnik, "At the National Gallery, Art That Goes Out on a Limb," *The Washington Post*, November 1, 2009, sec. E.

39. National Gallery of Art, "Online Press Kit: Gleaming Steel *Graft* Installed in National Gallery of Art Sculpture Garden by Artist Roxy Paine," http://www.nga.gov/press/2009/paine.shtm (accessed December 28, 2011).

40. Mixed Greens Gallery, "Joseph Smolinski," http://www.mixedgreens.com/artist/Joseph-Smolinski-25.html (accessed December 28, 2011). The quotation has been removed from this site, but at least one painting remains. My thanks to Frank Goodyear for calling my attention to Smolinski's trees.

41. Philip Gefter, "This Is Not a Tree," The Daily Beast, http://www.thedailybeast.com/articles/2010/01/07/this-is-not-a-tree.html (accessed December 28, 2011). My thanks to Andrew Mergen for bringing Voit's photographs to my attention.

42. DLK Collection, "Robert Voit, New Trees @ Amador," http://dlkcollection.blogspot.com/2010/02/robert-voit-new-trees-amador.html (accessed December 28, 2011).

43. Norman Vanamee, "The Height of Ingenuity," *The New York Times*, November 30, 2003, http://www.nytimes.com/2003/11/30/magazine/the-way-we-live-now-11-30-03-how-to-the-height-of-ingenuity.html?scp=2&sq=Norman%20Vanamee,%20The%20Height%20of%20Ingenuity&st=cse (accessed December 28, 2011).

44. Grubb's Web site, http://www.tomgrubb.com/3/artist.asp?ArtistID=26608&Akey=L6CFL793. This site can also be found at http://www.tomgrubb.com (accessed December 28, 2011). For an image of the Domino's Farm sculpture cell tower, see this file photo from Ann Arbor.com, http://www.annarbor.com/assets_c/2010/04/Cell%20phone%20tower-thumb-200x313-38036.jpg (accessed October 9, 2012).

45. Joyce Kilmer, *Trees and Other Poems* (New York: Doran & Co., 1914), 19.

46. Larson Camouflage, "Single Carrier Pine Tree, Asheville, North Carolina," http://www.utilitycamo.com/Asheville.pdf (accessed March 19, 2010).

47. Martin H. Krieger, "What's Wrong with Plastic Trees?" *Science* 179 (February 2, 1973): 446–55; Martin H. Krieger, *What's Wrong with Plastic Trees? Artifice and Authenticity in Design* (Westport, CT: Praeger, 2000).

48. Michael P. Cohen, *A Garden of Bristlecones: Tales of Change in the Great Basin* (Reno: University of Nevada Press, 1999), 221.

Bibliography

Barnett, Gabrielle. "Drive-by Viewing: Visual Consciousness and Forest Preservation in the Automobile Age." *Technology and Culture* 45, no. 1 (January 2004): 30–54.

Beauty for America: Proceedings of the White House Conference on Natural Beauty. Washington, DC: GPO, 1965.

Benson, Etienne. "The Wired Wilderness: Electronic Surveillance and Environmental Values in Wildlife Biology." PhD diss., Massachusetts Institute of Technology, 2008.

Campanella, Thomas J. *Republic of Shade: New England and the American Elm.* New Haven, CT: Yale University Press, 2003.

Cohen, Michael P. *A Garden of Bristlecones: Tales of Change in the Great Basin.* Reno: University of Nevada Press, 1999.

Cohen, Shaul Ephraim. *Planting Nature: Trees and the Manipulation of Environmental Stewardship in America.* Berkeley: University of California Press, 2004.

Davies, Douglas. "The Evocative Symbolism of Trees." In *The Iconography of Landscape*, edited by Denis Cosgrove and Stephen Daniels. New York: Cambridge University Press, 1988, 32–42.

Farmer, Jared. "On Emblematic Megaflora." *Environmental History* 15, no. 3 (July 2010): 533–547.

Freinkel, Susan. *American Chestnut: The Life, Death, and Rebirth of a Perfect Tree.* Berkeley: University of California Press, 2007.

Kilmer, Joyce. *Trees and Other Poems.* New York: Doran & Co., 1914.

Krieger, Martin H. "What's Wrong with Plastic Trees?" *Science* 179 (February 2, 1973): 446–55.

———. *What's Wrong with Plastic Trees? Artifice and Authenticity in Design.* Westport, CT: Praeger, 2000.

Lewis, Pierce. "Geographer as Landscape Critic." In *Visual Blight in America,* edited by Pierce Lewis, D. W. Meinig, and Y. Tuan. Resource Paper 23. Washington, DC: Association of American Geographers, Commission on College Geography, 1973: 1–48.

Marsh, George Perkins. *Man and Nature; or, Physical Geography as Modified by Human Action.* 1864. Reprint, Cambridge, MA: Harvard University Press, 1965.

Marx, Leo. *The Machine in the Garden: Technology and the Pastoral Ideal in America.* New York: Oxford University Press, 1964.

McClelland, Linda Flint. *Building the National Parks: Historic Landscape Design and Construction.* Baltimore: The Johns Hopkins University Press, 1998.

Meinig, D. W. "The Beholding Eye: Ten Versions of the Same Scene." In *The Interpretation of Ordinary Landscapes,* edited by D. W. Meinig and John Brinckerhoff Jackson, 33–48. New York: Oxford University Press, 1979.

Mergen, Bernard. "Children and Nature in History." *Environmental History* 8 (October 2003): 643–69.

Muir, John. *The Mountains of California.* 1894. Reprint, Garden City, NY: Anchor Books, 1961.

Nadkarni, Nalini. *Between Earth and Sky: Our Intimate Connections to Trees.* Berkeley: University of California Press, 2008.

National Gallery of Art. "Online Press Kit: Gleaming Steel *Graft* Installed in National Gallery of Art Sculpture Garden by Artist Roxy Paine." http://www.nga.gov/press/2009/paine.shtm (accessed December 28, 2011).

Norris, William. "Designing the Invisible SNOTEL." Master's thesis, University of Nevada, 2001.

Nye, David E. *The Technological Sublime.* Cambridge, MA: MIT Press, 1994.

Quantz, John O. "Dendro-Psychosis." *American Journal of Psychology* 9 (1898): 449–506.

Rolston, Holmes, III. "Aesthetic Experience in Forests." *The Journal of Aesthetics and Art Criticism* 56 (Spring 1998): 157–166.

Rosen, Jill. "Missing the Forest for the Fake Trees." *The Baltimore Sun,* August 4, 2008.

Sommer, Robert. "The Dendro-Psychoses of J. O. Quantz." *Journal of Arboriculture* 27 (2000): 40–43.

Sommer, Robert, and Joshua Summit. "Cross-National Rankings of Tree Shape." *Ecological Psychology* 8 (1996): 327–341.

Thayer, Robert L. *Gray World, Green Heart: Technology, Nature, and Sustainable Landscape.* New York: Wiley, 1994.

Vermass, Lori. *Sequoia: The Heralded Tree in American Art and Culture.* Washington, DC: Smithsonian Institution Press, 2003.

Wessels, Tom. *Reading the Forested Landscape: A Natural History of New England.* Woodstock, VT: Countryman Press, 1999.

Wikle, Thomas A. "The Wireless Antenna Unseen: Disguising Technology on the American Landscape." *The North American Geographer* 3 (2001): 109–112.

———. "Cellular Tower Proliferation in the United States." *The Geographical Review* 91 (January 2002): 46–58.

Williams, Gerald. *The USDA Forest Service: The First Century.* FS 650. Washington, DC: USDA Forest Service, 2000.

Williams, Michael. *Americans and Their Forests: A Historical Geography.* New York: Cambridge University Press, 1989.

Wolf, Kathleen L. "Freeway Roadside Management: The Urban Forest Beyond the White Line." *Journal of Arboriculture* 29 (May 2003): 127–36.

Form Over Function?
Technology, Aesthetics, and Identity at the National Museum of Scotland

Alison Taubman

Principal Curator

National Museums Scotland
Edinburgh, Scotland

From a semiotic view point, a machine that no longer works and which is shown in a museum is an object which has known a process of desemantification-resemantification. It has been taken out of the production chain that gave it meaning, to be inserted into a "museum chain" that gives it another meaning. Their production functions have been suspended. Deprived of the pragmatic capacities, these machines are restricted to their cognitive and aesthetic capacities.[1]

In 1855, the first director of the newly established Industrial Museum of Scotland, Professor George Wilson, gave his inaugural lecture entitled "What is Technology?"[2] Professor Wilson was also about to take up post as Professor of Technology at the University of Edinburgh and embark on his vision to collect contemporary technology in mid-nineteenth century industrial Scotland, as well as from abroad. In his lecture, Professor Wilson stated,

> Every new discovery and improvement alters the significance and industrial importance of all which have preceded it; so that men, in employing knowledge of their forefathers, cannot deal with it as so much gold of standard worth, but only as a moveable property which is of continually fluctuating value. One of the great objects of a Chair of Technology, is to enable this value to be continually struck and made known to all.[3]

Since its inception as the Industrial Museum of Scotland, the original museum has undergone several name changes from the Museum of Science and Art (1864) to the Royal Scottish Museum (1904). The funding of a new museum building in the 1990s adjacent to the Victorian one—seen by some as an extension, by others as a separate entity—added another layer of complexity to the museum's identity.[4] Initially named the Museum of Scotland, this addition marked a shift in cultural and museological interpretation "from a collections-based museum to a narrative museum."[5]

The entire complex was renamed the National Museum of Scotland in 2006, a politically resonant choice in a country that regained its own parliament in 1999, with a nationalist government since 2007 still forging its own identity. Throughout these museum rebrandings, the science and technology collections have remained "moveable property" at the service of the identities being constructed.[6] Wilson defined technology as "the Utilitarian Art." He stated "the true object of Aesthetic or Fine Art is not Beauty, but Utility, through or by means of Beauty."[7] A concept of utility for a technology object will originally lie in its primary function. That utility can become relocated in its cultural resonance as well as its aesthetic when the primary utility has been stripped or decontextualized—recontextualized within a museum arena. Within national museums, science and technology collections, like all collections and whatever the historical context, are at the service of contemporary constructs of nationhood.

> The national imaginary often defines [the] future in terms of scientific and technological achievement. As nations cultivate the camouflage of ancient tradition, they simultaneously celebrate their scientific character, which they present as unprecedented. The unique achievement of the nation, they maintain, lies in its citizens' scientific competence, their position on the cutting edge of discovery.[8]

Debates surrounding identity issues and aesthetics in the display of collections became topical once more in 2011 with the opening of the ultramodern Zaha Hadid–designed Riverside Museum housing Glasgow's transport collections, contrasted with the relaunch of two long-standing nineteenth-century Edinburgh institutions after multimillion pound refurbishments.[9] One of the Scottish National Portrait Gallery's opening displays "charts scientific legacies and their enduring influence" in a gallery titled Pioneers of Science.[10] It shows the cloned sheep Dolly's death mask alongside portraits of such luminaries as Alexander Graham Bell and Sir Alexander Fleming. The National Museum of Scotland's Victorian building reopened after major building work and a complete redisplay of sixteen natural science, ethnographic, and decorative arts galleries, all of which now benefit from more multidisciplinary exhibitions incorporating science and technology objects. This approach was previously adopted in 2008 with the opening of *Scotland: A Changing Nation*, a gallery on Scotland in the twentieth century and into the twenty-first, providing the opportunity to display science and technology collections within historical, social, cultural, and economic contexts.

The *Scotland: A Changing Nation* exhibition space is on the top floor of the newer building. Its architecture means visitors follow a proscribed circular route around the gallery. To reach the

twentieth century, visitors have already potentially visited five floors of earlier Scottish histories and so have been acclimatized to the themes of war, trade, emigration, industry, daily life, and politics. These continue to feed existing constructs of Scottish identity, and it remains a part of the national psyche that technology and engineering should play a significant role. Among the 500 or so objects on display, science and technology collections are represented in all areas of the gallery and examine how technological change in Scotland affected industry, the workforce, and people's daily lives. The largest concentration, however, is displayed within the section specifically focusing on industry.

The goal of *Scotland: A Changing Nation* was to create a gallery with an overview of the country during the twentieth century and to give the gallery a different aesthetic from the rest of the museum. An attempt at this was posited through the display of contrasts—of materials, of size, of objects, of subjects. As one reviewer said, "The curators have gone to great lengths to present familiar objects in an unfamiliar light."[11] In the director's words, "Undoubtedly some visitors will think we have left things out that we shouldn't have done, and included things which they'd rather not see. What we wanted to do was stimulate debate and discussion—it is a good outcome if that happens."[12]

The gallery sits squarely within the parameters of a "traditional" museum exhibition, albeit one that pulls on a modernist display aesthetic highlighting the object rather than the subject at first glance. Just as artists have long acknowledged that museums as collecting institutions have influenced their work, so this gallery in its design and presentation of objects has called on contemporary art practices. This was in part a conscious design choice, but the overall strength of focus on the materiality of objects, especially in relation to science and technology, is one only revealed in retrospect. The gallery's object content is presented through larger, more robust material on open display, mounted on plinths, with smaller items grouped in display cases. The historical framework is provided on text panels and contextual background images. Many of these objects could be called mundane (riveting, welding, and mining equipment and oil industry safety gear, for example), whereas others offer insight into more recent, unfamiliar technology (silicon wafer manufacture and transgenic medicine). The inclusion of each brings its own aesthetic resonances.

> It [the museum] embodies a very particular display aesthetic which has a singular ability to transform magically the most humble object into something special, unique and generally more attractive or fascinating. Once placed in a vitrine, an object is perceived in a completely different way by the viewer, as compared with when it is viewed in its original context . . . Almost like a peep-show it seduces, concentrating, looking, staring at the untouchable and the unattainable.[13]

The exhibition team felt it was important to incorporate alternative nonauthorial voices, which are provided through film, poetry, and art pieces. Film footage is used throughout, as the medium that recorded the century and the medium that therefore helps to differentiate this gallery from

the previous five floors of earlier history. It provides sound and movement in an otherwise static environment.

The gallery begins with a general introduction and a section on the World Wars I and II, which includes a conventional relationship to art interpretation: paintings of wartime engineering—women munitions workers building howitzer field guns or ship construction. These pieces are included as artists' social records of wartime engineering work. The displays then turn to the subject of industry, focusing one by one on a range of industries that have adapted to change over the century. These start with shipbuilding. The section examines continuity and change, providing the opportunity to acknowledge ongoing shipbuilding on the river Clyde, displayed alongside older practices (transverse versus lateral ship construction techniques, for example). The subject is interpreted traditionally by the display of ship models and work tools. Next to these, a 6 foot (~2 m) high welded steel plate, a "commissioned" piece in that it was made to measure by the steelworkers at the ship yard, is included as a comparison, with a section of riveted hull, and to show the thinness of the steel used for the construction of the most recent Type 45 destroyer. The steel plate also deliberately acts as a sculptural end point to the shipbuilding section, to focus on the aesthetics of the material itself, with very faint echoes of the work of sculptors such as Richard Serra, who reference engineering skill and, specifically, shipbuilding technology in their work.[14] It is the materiality of the steel that is the focus, just as a few yards away it is the sculptural quality of vast links of chain that is the primary focus. The technical and historical context for the chain and the steel is provided by film footage projected nearby (Figure 1).

The coal and steel industries are presented largely through film. The objects represent the products of industry, in this instance a 1973 Hillman Imp car (mounted on a plinth). Song lyrics projected onto the vehicle allude to sites of deindustrialization and consequent emigration. As with the poetry on text panels throughout the gallery, use of such interpretation was a means of integrating a cultural response to the social impact of industrial or technological change. Next to the car, in a small case on its own, is an inch long sample of steel from the last strip rolling, a relic of industry. More ephemeral is the fragile "splash" of steel picked off the floor after the last pouring, now presented in a display case nearby, alongside safety clothing and redundancy notices. This is an industry now literally "untouchable and unattainable" by dint of the economic realities that closed the steelworks. Again, the steel splash echoes Richard Serra's lead *Splash Pieces*, but a vital difference separates them. His were deliberate creations; this one is the detritus of industry, although an inspired piece of curatorial collection.

A few steps further, the microelectronics material reflects a more recent past, illustrating an adaptability in Scottish engineering research and development, most of whose products are now manufactured in Asia. The key here is the contrast with previous technologies, of material as well as scale. A framed and mounted plot diagram of a chip shows its computer-designed circuitry. It could be mistaken for a sample of postmodern electronic tartan. The focus on the intricate makeup of chips and circuit boards in the case below makes them jewel-like. Opposite is a case of consumer goods, the products of low-wage assembly-line factories before their

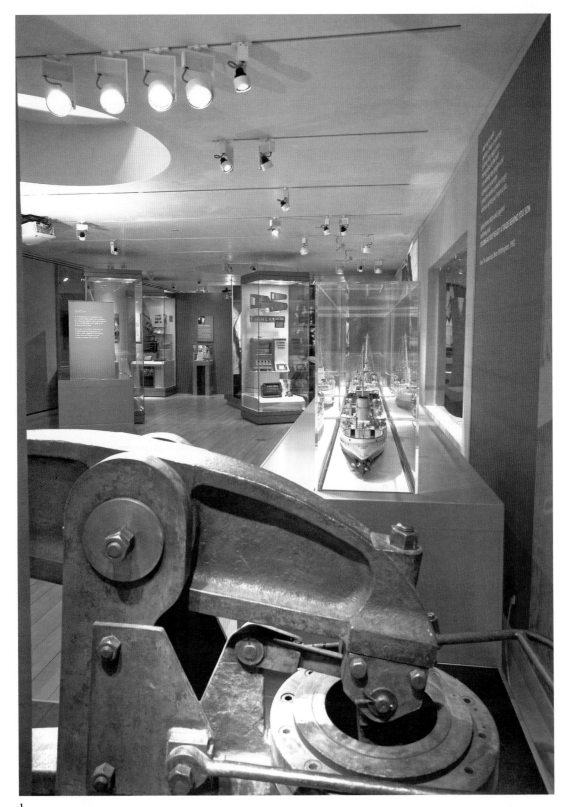

1.
 A hydraulic riveting machine represents heavy engineering at the beginning of the twentieth century. © Stewart Guthrie-Edinburgh.

multinational owners pulled out to Asia: a row of monochrome televisions, computers, cash registers, and video players.

Another few steps is another change of scale and a more questioning approach to the future of power generation on and off Scotland's shores. The oil and gas industry is represented by a model of a North Sea production platform framed by a 39 inch (1 m) diameter slice of oil pipeline, which indicates the scale of the enterprise to bring oil ashore. The cased display shows subsea valve assemblies, oil samples, and protective clothing alongside a safety award presented to the workers on the Piper Alpha rig in 1988, six months before an explosion killed 167 on that platform. The daily working environment is captured in etchings of those workers by Sue Jane Taylor, artist in residence on the rigs. As with the paintings of the munitions workers, such artists' works are employed throughout as a means of relating an industrial landscape created through objects to the workers operating within it. They provide a documentary role, yet with an expressive dimension, brought about via the individual sensibility of the artist.

The oil and gas industry is presented within a broader context of energy production, which touches on nuclear power and Scotland's more recent engagement with renewable energies. Here the country's first nuclear research reactor of 1957 is modeled in cast uranium glass, lit with ultraviolet light to create an eerie lime green glow. This represents the most politically direct artistic intervention in the gallery, by makers Kate Williams and John Lloyd. The curators deliberately used the display of named artists' work on this subject and one or two others elsewhere, such as emigration and health issues, to make use of the ability of artists to suggest oblique or questioning narratives across social and political domains while ostensibly leaving the institution at one remove from the debate (Figure 2).

Introduced by the vast substantiality of shipbuilding, the industry section ends with the insubstantial—figuratively and nowadays literally—financial industry. The "immateriality" of the subject proved a difficulty for museum interpretation. Instead, the objects are those made familiar by their inclusion in advertising for insurance and banking facilities, the signifiers of the industry for the buying public in the age of internet finance.

More concrete Scottish technological development continues as a thread throughout the remainder of the gallery, where the focus turns to social and political spheres. Daily Life includes the subject of health, or perhaps more a lack of it, as a catalyst for medical innovation. The first, monolithic, commercial medical ultrasound scanner is presented in this context, with reference to the use of ultrasound technology in heavy industry in Glasgow in the 1950s. In contrast, the experimental magnetic resonance imaging scanner is the size and shape of a cake tin. It looks homemade and inconsequential but produced the world's first MRI image in 1974.

The gallery ends under the banner of Innovation, displaying a range of bio- and micro-technologies currently being developed in Scotland. A prosthetic hand, the first commercially available with five articulating, individually powered digits, rests alongside a (stuffed) transgenic hen and eggs, the result of research into mass drug production at the Roslin Institute, birthplace of Dolly, the cloned sheep (on display elsewhere in the museum). This final display reinvests in

2.
Museum objects contextualized by art interventions in the gallery's energy section. © National Museums Scotland.

what is essentially a nineteenth-century notion of the Scot as engineer. It celebrates uncritically Scottish evolution into the microtechnologists and bioengineers of the twenty-first century. Some have critiqued such celebrations "as attentive to nations' anticipated futures as to their imagined pasts. The nation that seeks to demonstrate its long unbroken connection to an illustrious past also endeavors to present itself as oriented towards a scientific future."[15]

National museums are full of the unavoidable politics associated with presenting cultural and historical constructs, concerns that artists have long been interested in investigating and critiquing.[16] This gallery is no exception. Here science and technology is a subject area subservient to the brief of a national museum depicting a postindustrial nation with a history of significant decline and change, one in the process of reassessment and looking to exhibit regeneration though a filter of social, economic, and industrial adaptability. This framework has been constructed by the exhibition team, not mediated through commissioned artists, and the degree of examination may be that much less as a result. The curators knowingly placed certain technology objects to act as signifiers of technological change at key points in the exhibition. Their aesthetic qualities add an extra dimension beyond their original function since the objects

are removed from their original use. This has the potential to make them more accessible to an audience who might be resistant to or intimidated by a more technologically based exhibition. Conversely, it has the potential to alienate those who see the delivery of technical context as part of the museum's role.

As an example of constructed identity through the display of symbolic objects, it is useful that the hydraulic riveter in the shipbuilding section was made by Sir William Arrol & Co Ltd of Glasgow, one of the firms responsible for building the Forth Bridge in the 1880s, an icon of nineteenth-century Scottish engineering. Contrast this with the Japanese-made silicon ingot, placed at the beginning of the microelectronics display, which may appear to some as an art object since its primary function remains obscure to the majority of visitors, even with interpretation. Its vertical position is one adopted for maximum visual impact, echoing the shell displayed in the earlier section on war. Here it has become a marker suggesting to visitors that they are moving out of a display about decline into one celebrating innovation and foreign investment. These two objects were chosen by the curators, who were aware of practical issues such as availability, space, and floor loading, for example, to provide convenient narrative pointers. They were also chosen for their aesthetic impact and their "accessibility," which might not be directly related to an understanding of their primary technological function, but rather more to a reading of their representation within this exhibition context: heavy engineering in one case and new technologies in the other (Figure 3).

National Museums Scotland is an institution with multidisciplinary collections. This provides opportunities to display objects in relation to a wide range of other material. "By grouping the objects in one place, the museum helps to highlight similarities and differences that leads to knowledge: the collection is, in itself, a tool that produces knowledge."[17] The *type* of knowledge produced, however, will differ, depending on context. The gallery's frame of reference in this instance is social and cultural rather than a technological one. Gone is the technological knowledge that would have been associated with the manufacture and use of these industrial artifacts (unless, of course, visitors bring such knowledge with them). This is a gallery that therefore resonates with those visitors who are comfortable with these "culture objects."[18] The objects themselves may be unfamiliar, but the technology and engineering contexts are very familiar to a Scottish cultural language. This, of course, relies on an understanding of that language.

"The business of creating an inheriting community, through texts attached to real objects, spaces and places, involves the creation of boundaries, within which we are, and outside which the Other is located."[19] Evaluation of the *Scotland: A Changing Nation* gallery shows that the "inheriting community" is visitors who respond to the familiarity of this cultural framework and feel included and nostalgic. Those located as "the Other" include local visitors who resist those messages and those from farther afield, who cannot decode them and leave mystified.

The museum still has a science and technology wing, not yet updated as part of the latest upgrade, where technological innovation remains the focus. Objects are presented with this reading to the fore, demonstrating that

3.
A silicon ingot displayed to mark a shift from heavy engineering to microtechnologies. © Stewart Guthrie-Edinburgh.

> scientific and technical icons have a material reality that resists their complete reduction to empty sentiment. The scientific, or at least engineering, principles behind artifacts . . . continue to have a technological history even if their cultural meaning can be read as an instance of an invented tradition.[20]

Once part of a museum collection, the semantic values of technology objects are in flux, removed from their core function, with the potential for multiple recontextualizations. Museum artifacts invite interpretation—no gold standard as Professor Wilson stated—and their interpretation in relation to aesthetics is just one of those, alongside their technical, social, economic, or cultural functions.

Acknowledgments

My thanks to Andrew Patrizio (University of Edinburgh), Alison Morrison-Low, and Klaus Staubermann (National Museums Scotland) for their support and comments in the development of this paper.

Notes

1. Manar Hammad, "A Museum in a Factory," special issue, *La Lettre de l'OCIM*, May 2009:58.
2. George Wilson, *What is Technology? An Inaugural Lecture Delivered in the University of Edinburgh on November 7 1855* (Edinburgh: Sutherland and Knox, 1855), 16.
3. Wilson, *What is Technology?*, 5.
4. Charles McKean, *The Making of the Museum of Scotland* (Edinburgh: National Museums of Scotland Publishing, 2000).
5. McKean, *The Making of the Museum of Scotland*, 149.
6. Wilson, *What is Technology?*, 5.
7. Wilson, *What is Technology?*, 5.
8. Carol E. Harrison and Ann Johnson, eds., *National Identity: The Role of Science and Technology*, Osiris Second Series 24 (Chicago: University of Chicago Press, 2009), 3.
9. *Museums Journal*, October 2011, November 2011.
10. National Galleries of Scotland, Pioneers of Science, http://www.nationalgalleries.org/whatson/exhibitions/pioneers-of-science (accessed January 14, 2012).
11. Gillian Bowditch, "A Portrait of Scotland, Warts and All," *The Sunday Times*, July 6, 2008.
12. Mike Wade, "A Kaleidoscope of Scottish Life Across the Century," *The Times*, July 11, 2008.
13. James Putnam, *Art and Artifact: The Museum as Medium* (London: Thames and Hudson, 2009), 14.
14. Hal Foster, *The Un/making of Sculpture* (Los Angeles: Museum of Contemporary Art, 1998), 25.
15. Harrison and Johnson, *National Identity*, 14.
16. Putnam, *Art and Artifact*, preface.
17. Hammad, "A Museum in a Factory," 59.
18. Sharon J. Macdonald, "Museums, National, Postnational and Transcultural Identities," *Museums and Society*, 1, no. 1 (2003: 3.
19. Thomas A. Markus and Deborah Cameron, *The Words between the Spaces: Buildings and Language* (London: Routledge, 2002), 125.
20. Harrison and Johnson, *National Identity*, 6.

Bibliography

Bowditch, Gillian. "A Portrait of Scotland, Warts and All." *The Sunday Times*, July 6, 2008.

Follett, David. *The Rise of the Science Museum Under Henry Lyons*. London: Science Museum, 1978.

Foster, Hal. *The Un/making of Sculpture*. Los Angeles: The Museum of Contemporary Art, 1998.

Hammad, Manar. "A Museum in a Factory." Special issue, *La Lettre de l'OCIM*, May 2009:53–63.

Harrison, Carol E., and Ann Johnson. "Introduction: Science and National Identity." In *National Identity: The Role of Science and Technology*, edited by Carol E. Harrison and Ann Johnson, 1–14. Osiris Second Series 24. Chicago: University of Chicago Press, 2009.

Macdonald, Sharon J. "Museums, National, Postnational and Transcultural Identities." *Museum and Society*, 1, no. 1 (2003): 1–16.

Markus, Thomas A., and Deborah Cameron. *The Words between the Spaces: Buildings and Language*. London: Routledge, 2002.

McKean, Charles. *The Making of the Museum of Scotland*. Edinburgh: National Museums of Scotland Publishing, 2000.

Putnam, James. *Art and Artifact: The Museum as Medium*. London: Thames and Hudson, 2009.

Wilson, George. *What is Technology? An Inaugural Lecture Delivered in the University of Edinburgh on November 7 1855*. Edinburgh: Sutherland and Knox, 1855.

Martha Fleming / Exhibit Developer / London, England Martha Fleming Exhibit Developer London, England

CHAPTER 9

Split + Splice
An Experiment in Scholarly Methodology and Exhibition Making

Martha Fleming

Exhibit Developer

London, England

Split + Splice: Fragments from the Age of Biomedicine was an exhibition held at the Medical Museion of the University of Copenhagen from June 2009 to April 2010. It was groundbreaking in two distinct but intimately connected ways. Not only was it an innovative, Dibner-award-winning exhibition, but its production also engendered a new scholarly methodology for developing exhibitions—a prototype for research collaborations between historians and philosophers of science on the one hand and museum and design practitioners on the other.

I outline here the main processes and outcomes of the project, proposing a model to build on for future collaborations between museum professionals and historians of science, technology, and medicine new to material culture. The creation of exhibitions is a more complex and intellectually dynamic process than has been generally understood within the history of science community at large. Exhibitions have been viewed by numbers of those working in the history of science, technology, and medicine (HSTM) as a transparent medium through which our knowledge is communicated to the public, a medium for the dissemination of the real business of history and philosophy of science. When exhibitions are understood mainly as the pouring of book learning into glass cases, it is a serious underestimation of the scholarship required to work conceptually with material culture, to work "beyond words."

This position is no longer tenable in a period when we have complex exhibitions such as *Iconoclash*, cocurated with Bruno Latour and a host of advisors, including Peter Galison; *l'Ame*

au Corps, curated by Jean Clair; or *Making the Modern World* at the Science Museum, among others. Such exhibitions have fundamentally informed how HSTM is practiced in the twenty-first century.[1] These developments have been underscored by recent conferences such as "The Exhibition as Product and Generator of Scholarship," organized by Susanne Pickert, Helmuth Trischler, and Christian Sichau for the Max Planck Institute for the History of Science and the Deutsches Museum.[2]

In the fifteen years of its existence, the Artefacts group of science museum professionals has been meeting annually to make an HSTM contribution to the bridge being built across the gulf between objects and historians. It could be argued that this has been a major contribution to the growing understanding that exhibition making, practiced with objects, can be a scholarly practice when practiced by scholars.

Split + Splice was created inside a university museum: these institutions are uniquely well placed to hybridize humanities research methodologies with collection and exhibition practices.[3] The Medical Museion of the University of Copenhagen's Faculty of Health has taken a more pro-active role than most in this field, under the direction of Professor Thomas Söderqvist:

> By focusing on integration between research, collecting, education and dissemination be-
> yond the Museum world, the Medical Museion will go beyond the traditional division be-
> tween universities as pure research-and-teaching units, and museums which are primarily
> collection and dissemination institutions.[4]

Split + Splice was the first major research project to attempt this integration at Museion. Funded by Novo Nordisk Foundation, it was created by a core team of four postdoctoral researchers and a small group of skilled museum professionals from both inside and outside the institution itself. I am part of this latter group.[5] The postdocs were all working on the history and sociology of contemporary biomedicine and had no exhibition experience. They had, however, a deep interest in the material culture of their subject and had been asked to collect, conserve, and contribute to the Museion collections, concurrently extending both the collections and their own practice. The postdocs were Susanne Bauer, Søren Bak-Jensen, Sniff Andersen Nexø, and Jan Eric Olsén.

Their research interests range from epidemiological practices with data to organ transplant networks and techniques, from IVF developments and law to medical visualization techniques and their impacts. Their research, although aiming at close histories of biomedical research, also already drew on the scholarship of material and visual culture.[6] From the outset we decided that we would build the exhibition up from their research interests and not from any encyclopedic or public expectation of what an exhibition about contemporary biomedicine might contain. In our early exhibition brief we expressed our aims and some of the methods we hoped to employ in order to achieve it:

> The core aim of the exhibition is to facilitate visitors' informed reflections upon the ways
> in which recent biomedicine challenges significant cultural categories including the body

and identity, therefore influencing our very understanding of ourselves as human beings: our sense of "personhood."[7]

In creating the exhibition we wished to explore the way that both identities and bodies—two sides of the same "personhood" coin—are produced by current biomedical practices, produced and also constituted, reengineered, collected, circulated, fragmented, generated, extended, hybridized, mediated, suspended, digitized, controlled, and categorized.

We wanted to take the visitor beyond the user end of biomedicine and into its engine room and to experiment with innovative ways of bringing some of the big "invisibles" of biomedical practice to a larger public. Questions of samples and storage, data generation and management, the integration of analytical instruments with research and clinical bureaucracies, and the legal frameworks of biomedicine were all on our agenda. We wanted to address the social, political, and cultural enormities of contemporary biomedicine without losing sight of the historical. As historians and epistemologists, we did not want to teach people the science, but rather we wanted to teach people how to think about science; to think about how bodies are contingent, flexible, fluid, and resilient; how materials, tools, and instruments have a history; and how conditions for the production of medical knowledge change over time.

We took it as a strength that we would have to exchange our skills and knowledge rather than relying on a shared, museum-professional training. The main premise of our development process for the production of the concepts and the exhibition itself was twofold: we wanted to implement aesthetics as an analytical tool as well as a communication tool, and we wanted to show that epistemological inquiry can guide what an exhibition ends up looking like.

In a series of brainstorms that I designed and led, we worked toward meshing and intersecting different intellectual and critical methodologies. The ultimate aim of interdisciplinary collaboration is to produce not just new knowledge but also entirely new methods. It is demanding, and it takes time.

On the aesthetic side, I outlined formal and material inquiry practices I had used in other projects, including isomorphic comparison of objects from different disciplines. I proposed methods for the analyses of representational registers and linked that to precepts of information design. I helped my new colleagues to see how it could be possible to show ideological apparatuses as well as instrumental apparatuses. On the epistemological side, these same colleagues dissected for me the origins and effects of medical instrumentation, defined the conditions that give rise to biomedical practices, and showed me the precise ways in which bodies are "produced" by these practices. We effected this exchange through our discussions about the project at hand and through direct application to the project of creating the exhibition itself.

These brainstorms, concept meetings, and design workshops, some forty-five in total over six months, took place in an atmosphere of creativity and critique, included our exhibition assistant, Jonas Paludan, and functioned on four distinct, cumulative levels. Tier 1 focused on extruding the metaissues from the postdocs' specific research subjects. This involved identifying shared

themes and practices held in common or in relation between the widely differing subjects of the researchers' work, such as the following:

- the fragmentation of the body in biomedicine
- the containment and flow of both biomedical samples and data
- data generation and exchange
- the management of life processes through temperature and through legal frameworks
- the reliance of biomedical imagery on the inherent truth-value of photographs
- the optical history hidden in digital images
- the evolving relationship between the individual and the population in statistical practices of epidemiology

Tier 2 focused on conceptual materialization:

- teaching historians of science to think through objects by (1) playing with the objects and instruments involved in the practices they were researching, (2) using objects allegorically, (3) using instruments in nonmedical ways to develop interactives, and (4) exploring how materiality informs communication (with Ion Meyer, Collections Manager and Conservator)
- learning from display practices already existent inside biomedical research
- discovering how to get the most out of collection databases and collection storage visits (with Ion Meyer and Anders Olsén, Registrar)
- spatialization of thought: using the galleries conceptually, rather than chronologically or in the construction of a rigid narrative

Tier 3 involved meshing conceptual materialization with visitor experience, switching on the senses:

- appealing directly to the visitor through the senses (hearing, taste, smell, touch, temperature), which treats a visitor's body as a refined instrument, much like the instruments on display
- phenomenology deployed in the service of underpinning subjectivity

Tier 4 addressed overarching cohesion and doability:

- design: grids, information and idea flow, visitor flow, zones, graphics
- writing for exhibitions
- exhibition planning and logistics, defining and assigning tasks from a concept and from a design plan
- building and using a running budget

Brainstorms were also held with other Museion researchers outside the core team and with other design professionals, whose valuable contribution early on contributed to the shape of our discussions. Further meetings were held one-on-one between myself as creative director and each of the exhibition team members to achieve the necessary level of detail and conceptual clarity

in relation to specific research areas. At that point, we began to work with the appointed exhibition designer and graphics designer, respectively, Mikael Thorsted and Lars Møller Nielsen of Studio 8, Copenhagen.

The exhibition we created was a highly innovative and multimedia yet low-tech exploratory project that brought together a wide variety of materials, content, ideas, instruments, collections, and disciplines in entirely new ways. It was composed of the following items:

- 11 gallery rooms with 15 discrete installations on two floors, including over 300 museum, loan, and laboratory objects spanning some 250 years
- 14 videos (including 11 original edited loops)
- 12 interpretive panels
- 4 interactives (a fully functioning walk-in laboratory cold room, a fan heater, a surveillance camera on a time lag, and two fiber-optic endoscopes attached to a person-sized viewing box)
- 3 scientific explainer panels, including one about PET scanning
- 5 site-specific graphic intervention "wallpapers" of photographic and textual research, installed in staircases, on service ducts, gallery walls, and cupboards
- 3 audio soundtracks composing a staircase soundscape
- 2 live rabbits
- 2 LED moving-type signs
- 2 programmed motors
- 2 live cameras
- a two-way mirror
- a free pocket-sized *User Manual* functioning as catalog and containing all object labels (96 pages, bilingual in Danish and English)

The exhibition included the following:

- 3 major loans (a Scanlaf Wet Work Bench, Vestfrost refrigerator, and over 25 objects from the Dansk Data Historisk Forening)
- A number of other minor loans from clinics and other museums (Ergocycle, Dansk Medie Museet, etc.)
- Major donations of biomedical material in kind from medicoindustrial companies, such as ThermoFisher, Nunc, Nalgene, Greiner Bio-One, Abena, and Karl Storz
- Major donations of content in kind from the Danish National Hospital and other hospitals, such as Copenhagen Energi

All of these were mounted in extensive purpose-designed, purpose-built, and purpose-lit display structures of wood, acrylic, wrought iron, lacquer, paint, plasma screens, mirrors, and other items.

In *Split + Splice*, the most important body in the galleries was the body of the individual visitor. The intended audience was not defined by a demographic analysis, which would typically involve preconceptions about concerns, prior knowledge, or levels of education.

With the exception of the interpretive panels and wallpapers (significant texts grafted into the exhibition space as if they had always been there), every purpose-built display in the exhibition was freestanding, giving an airy feel of mobility for the visitor, who was free to move at will through the galleries. Created as a series of numbered propositions about biomedicine and society, the exhibition could be experienced in any order: the central main corridor of the ground floor galleries acted like the "spine" of the show; visitors could travel along it to any one of the exhibition rooms at any time.

An orientation text panel at the very beginning of the exhibition worked to situate visitors on the same footing as the curators themselves and invited them to consider their own bodies as measuring instruments for the exhibition:

> Biomedicine: a hybrid word for an interdisciplinary science. What is it exactly? Hard to tell. Don't expect us to have all the answers—no-one does. Asking the questions is the place to begin: we're right there with you. Come in and take the measure for yourself. Your body: the very stuff of biomedicine—it's a sensitive instrument all of its own.

Throughout the exhibition additional interpretive panels (one for each installation), although containing accurate science, also contained questions for the visitor, so that there was a direct appeal to visitor subjectivity and curiosity. This put the visitors at ease, enabling each to participate in a conversation about the biomedical apparatus with which they are—physically or ideologically, knowingly or not—completely entangled.

The main textual resource for the exhibition was actually an integral part of it: the *User Manual*, a free pocket-sized catalog whose very title signals to the visitor that an exhibition, too, is a "technology." The *User Manual* (still available from Museion) contains a floor plan and is divided numerically along not only gallery spaces but also according to numbered propositions. Exhibition objects were labeled by number to be part of the proposition, or installation, of which they were a part. The typographic design of both the interpretive panels and the *User Manual* gave the visitor a clear sense of navigation of the exhibition without artificially lending false authority to the information held within it. The watery feel of the typographic titles emphasized the "flow of liquid life" and signaled the subjective nature of the show, underlining that each of the propositions offers a point of view on the problematic of biomedicine and society—not one of these is an explanation or an answer.

Information was conveyed through sensory experience to a greater degree than most history of science or even science communication exhibitions. A direct appeal to the visitors' senses was made in a number of places to kick-start a deeper level of cognition: interactives that engage the entire body. With biomedicine, many scientific and social changes converge in the human body itself and are therefore difficult to observe with any distance or objectivity. Confronting this problem head-on, the exhibition acknowledged visitor subjectivity by placing the visitor inside biomedical practices but outside of biomedical treatment.

This exhibition was literally a sensation: the visitor was invited into a functioning cold room (among the biggest instruments in any biomedical laboratory) and in turn exposed to the heat

1.
Proposition 1: Confluence. "The objects in this room link together to direct a stream between human and animal, with the diagnostic laboratory as meeting point." (Interpretive text, *Split + Splice*, 2009). A human-animal encounter between visitors and pet rabbits: both are surrounded by the biomedical laboratory paraphernalia of antibody production, which could hypothetically both conjoin and divide them from each other. Photograph by the author.

levels of an incubator and surrounded by electronic alarms of the kind integrated into such instruments for the management of life processes. In other areas, the visitor was invited to play with biomedical containers, manual pipettors, and endoscopes. Visitors were brought face-to-face with two live rabbits and with the manifestations of human-animal relations inside both biomedical science and display practices (Figure 1). To explore medical imaging, we offered visitors the view from both sides of a two-way mirror, and also positioned a surveillance camera so that its feed would appear inside an array of moving images produced by a panoply of biomedical monitoring devices.

2.
Proposition 3: Avalanches of Data. "Measurement has become fundamental in doctors' general practice and also in large-scale health care projections. Recent biotechnologies have multiplied the information that can be created from a single blood sample. As avalanches of data and samples, the flow of 'life' is contained and processed in the fluid 'wet lab' of biochemistry and numerically modelled in the computerised 'dry lab' of bioinformatics." (Interpretive text, *Split + Splice*, 2009). Photograph by the author.

Older mechanical instruments and objects performed several essential functions. They gave a sense of the scale reductions that have revolutionized medicine into biomedicine (for example, there are several electrocardiographs of decreasing size spanning 100 years in the *Avalanches of Data* installation; Figure 2). Older instruments gave the visitor a chance to understand the basic functions of instruments that, in the present day, have become impenetrable electronic black boxes. Their visible mechanisms also helped to root the epistemological concepts of the exhibition in actual, historically bound objects and practices for the visitor.

3.
Ducts—An Interlude. "Throughout the exhibition we have marked the ducts carrying water and heat throughout the building with counterfeit signs to evoke the various 'flows' that biomedicine effects and is influenced by. The signs we have made are based on International Standards used for building and workplace security . . . Data is represented by the standard colour codes for Condensate; Capital is represented by the standard colour codes for Contaminated Oils; Power is represented by the standard black/yellow code for Danger." (Exhibition brief, *Split + Splice*, 2008). Photograph by the author.

The curators themselves had been "thinking through objects," and the visitor was invited to do the same: object label information was kept to a strict minimum in the displays themselves, inviting the visitor to look closely at the objects and explore the "syntax" that was made of the object clusters in displays.

Each object in *Split + Splice* worked double time: each artifact exposed its materiality and visuality, functioning simultaneously as information and as metaphor, revealing the complexity—and sometimes the inherent contradictions—in biomedicine today. Clustering and repeating objects extended these contexts: for example, the repeated use of biomedical containers in the exhibition functioned as historical background, illustrating a multiplicity of actual practices and showing how identities are produced by limitations—containments that are as much physical as ideational. Thus, the issues and themes that we had collectively identified as overarching the research projects of the historians were grafted site-specifically onto the Museion building itself, incorporating its ducts and pipes (Figure 3) and its public toilets and encompassing many of its historical referents as a college of physicians and surgeons, replete with eighteenth-century dissection theater.

Installations situated the biomedical laboratory and diagnostic techniques within a broader history of information technology, in terms of practices of measuring and computing as well as looking. In several instances the exhibit exemplified and condensed these issues by drawing on local case studies of biomedical research: the DAKO Company protein and antibodies laboratory, Danish biobanks, and government-managed central population registries. These in-depth local studies were made possible through a series of close collaborations with a range of research laboratories and local historical collections brokered by the postdocs and the exhibition assistant.

The main audiovisual component of *Split + Splice* was also a contextual structure: a mock-up of a surveillance control room displayed a series of moving-image examples of biomedical monitoring, from hospital patient monitors to PillCam footage and an SAS (Statistical Analysis Software) run on population data. Two live cameras were seamlessly integrated, and two other videos became historical objects inside display cases.

There were a series of visitor interactives, all of which were mechanical and handheld, creating a tactile experience rather than a screen-based one: this is more inclusive and also more playfully challenging as a strategy, having the added benefit of being less prone to breakdown. Handling pipettors, endoscopes, and a range of biomedical containers gave visitors a visceral sense of how aspects of biomedical practice partake of a technology of the self. These design choices contributed to the visitors' sense that this was an opportunity for exploring ideas, thoughts, and feelings.

Each of these concept-based installations of historical and contemporary objects grew directly out of curatorial field research into the history of recent biomedicine and epistemological inquiry into both effects and affects of biomedical practice. The very process of the exhibition's creation was rooted in several recent developments in the historiography of HSTM: specifically, the visual turn, the material culture turn, and the practice turn. Inspired by these approaches, and taking them further with curatorial and aesthetic methodologies, the show developed novel ways of thinking through objects that, in turn, can inform the field of HSTM studies. Combining perspectives in this way created novel routes for both rigorous historical investigations and also, significantly, for visitor engagement in the museum arena itself.

As a history of the present, *Split + Splice* created phenomenological experiences rather than simply trying to communicate hard science information: the visitor's own body and senses became a measurement instrument and a biomaterial at the same time. By rooting the curators' epistemological inquiry in the actual objects and practices on display, the visitor could easily follow and share the curators' developing ideas. The thinking skills and investigative methodologies this approach engenders in the visitor can be used in other contexts.

All exhibitions are unique and should be grounded deeply in the material culture and epistemologies of the subject to hand. But we can offer each other our successful approaches to the way in which we link these together. This exhibition team has shown that these methods really pay off: dovetailing individual research interests with collective exhibition making; extensive structured workshopping with practicing scientists, art and design professionals, and others; sharing process as well as product with the visitor; making collection objects do the work that text has done in the past; capitalizing on the site specificity of the galleries; exploring sound, temperature, and other senses; and above all, taking the time to learn from each other.

Notes

1. These exhibitions took place in the following institutions and years: Iconoclash, ZKM Center for Art and Media, Karlsuhe, 2002; L'âme au corps: Arts et sciences 1793–1993, Galeries nationales du Grand Palais, Paris, 1993; Making the Modern World, Science Museum, London, 2000.

2. "The Exhibition as Product and Generator of Scholarship" conference was organized by Susanne Pickert, Helmuth Trischler, and Christian Sichau for the Max Planck Institute for the History of Science and the Deutsches Museum in November 2008 (now published as Preprint 399/2010 by Max Planck Institute for the History of Science, Berlin). Another more recent example is "Beyond the Academy: Research as Exhibition," a conference organized by the London Centre for Arts and Cultural Exchange at Tate Britain with Bruno Latour as the keynote address in May 2010.

3. University Museums and Collections, International Council of Museums, http://publicus.culture.hu-berlin.de/umac/ (accessed December 5, 2010).

4. Vision statement from the Medical Museion Web site, http://www.museion.ku.dk/ommuseion/vision.aspx (accessed December 5, 2010). The Web site was in Danish only and is no longer accessible; translation is by the author, with help from Google Translate (http://translate.google.com/).

5. The Novo Nordisk Foundation funded "Danish Biomedicine: 1955–2005: Integrating Medical Museology and the Historiography of Contemporary Biomedicine" (principal investigator Thomas Söderqvist), which enabled a variety of research projects over a five-year period to culminate in the exhibition *Split + Splice*. The grant paid for the postdoc positions and also my own involvement, first as a visiting associate professor (2006–2007) in the Faculty of Health Institute of Public Health and then as a Museion-contracted creative director (2008–2009) for *Split + Splice*. The grant also funded a series of wider field workshops, conferences, and seminars, which we organized in 2007 and 2008 in the run-up to the exhibition development.

6. Their original postdoctoral research projects were available at http://www.museion.ku.dk/forskning/fire%20postdocs.aspx (accessed December 5, 2010, and no longer accessible). Postdoctoral positions are often pivotal in creating career pathways, and history of science is no exception: as of December 2010, Susanne Bauer is now working at the Max Planck Institute for the History of Science, Søren Bak-Jensen is now collections manager at the Copenhagen City Museum, Sniff Andersen Nexø is now working at the Saxø Institute for History, Copenhagen University, and Jan Eric Olsén is now a researcher with the Institute of Cultural Studies, Lund University.

7. This quote is from the unpublished exhibition brief, which was composed by me with the collaboration of the exhibition team.

Bibliography

Iconoclash. Karlsruhe: ZKM Center for Art and Media, 2002.

L'âme au corps: Arts et sciences 1793–1993. Paris: Galeries Nationales du Grand Palais, 1993.

Latour, Bruno. Keynote address, "Beyond the Academy: Research as Exhibition," London Centre for Arts and Cultural Exchange, Tate Britain, London, May 2010.

Making the Modern World. London: Science Museum NMSI, 2000.

Pickert, Susanne, Helmuth Trischler, and Christian Sichau. "The Exhibition as Product and Generator of Scholarship." Preprint 399/2010. Max Planck Institute for the History of Science, Berlin, 2010. [Available at http://www.mpiwg-berlin.mpg.de/Preprints/P399.PDF (accessed May 2, 2012).]

Artists Interpret Science and Technology

Artists' capacity to provide new perspectives on science and technology demonstrates how important it is to bring unfettered creative thought to fields generally recognized for their "useful" outcomes. In this section, historians of art, science, and culture explore the myriad ways that artists have engaged science and technology. These interdisciplinary connections are both international and transhistoric, with essays exploring the work of artists from Africa, Asia, Europe, and the United States from the eighteenth century to the present.

Beginning with David Bjelajac's analysis of John Singleton Copley's symbolic exploration of medicine, healing, and alchemy in *Watson and the Shark*, this section is organized chronologically. Essays by Tom D. Crouch, Christine Mullen Kreamer, Peggy Aldrich Kidwell, J. D. Talasek, Elizabeth A. Kessler, and Anne Collins Goodyear delves into the materiality of the artistic intersection with science and/or technology. From scrapbooks full of clippings or symbolic representations of cosmic stories to the glass plates that capture starlight or the medical technologies that manifest human genes, physical things link artists, science, and technology.

This section concludes with a three-part case study focusing on a recent collaboration between artist Shih-Chieh Huang and marine biologist Lynne R. Parenti, examining their groundbreaking exploration of marine phosphorescence. Program organizer Jane Milosch explains the context of their partnership, coordinated by the Smithsonian Artist Research Fellowship (SARF) program. The SARF program positions artistic explorations as a form of intellectual inquiry, based on the premise that artists, like other intellectuals, have rigorous methods for connecting and offering new insights into a broad range of fields of knowledge, including science and technology.

As this variety of topics and approaches demonstrates, the realms of mathematics, science, and technology stimulate the artistic imagination with glimpses into technologies of the future, new modes of organizing information, and new ways of understanding the self. Through their imaginative engagement with the culture of science and technology, artists provide new avenues for understanding how science and technology shape (and have shaped) our world.

Mercurial Pigments and the Alchemy of John Singleton Copley's *Watson and the Shark*

David Bjelajac

Professor

The George Washington University
Washington, D.C.

An exemplar of American realist painting, Watson *and the Shark* (Figure 1) by Boston-born artist John Singleton Copley (1738–1815) also displays a web of alchemical, astrological resemblances. This chapter reinterprets this history painting as a representation of medical healing and spiritual regeneration. I assign meaning not only to the picture's narrative, compositional, figural relationships but also to the materials and visual properties of the artist's oil painting medium. Copley scholars have not considered this painting of trauma and survival within the historically interrelated discourses of art and medicine. For eyes initiated into nature's secrets, hermetic oil varnish recipes and mercurial pigment compounds could sympathetically, analogically signify medical practices and panaceas rooted in traditions of alchemy and astrology. This chapter continues my exploration of Freemasonry and the alchemy of Anglo-American painting: Copley's painting charts a vulnerable youth's initiatory journey from death's door to ethereal rebirth, "ethereal" bearing both chemical and heavenly meanings.[1]

Within a harbor view of Havana, Cuba, *Watson and the Shark* narrates how London merchant Brook Watson (1735–1807) lost part of his right leg to a shark before being saved by fellow sailors. Exhibited at London's Royal Academy in 1778, the painting's original title proclaimed its factual basis: *A boy attacked by a Shark and rescued by some Seamen in a Boat; founded on a fact*

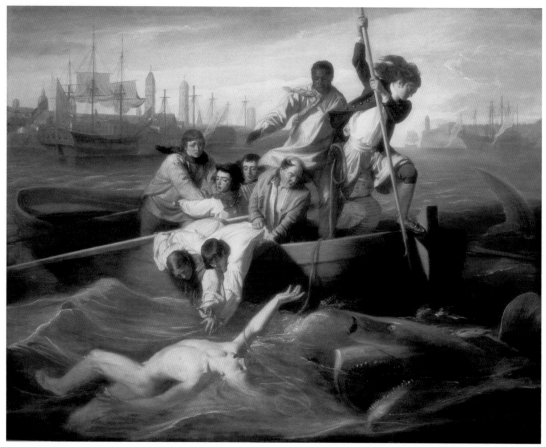

1.

John Singleton Copley, *Watson and the Shark* (1778). Oil on canvas, 71 ¾ × 90 ½ in. (182.1 × 229.7 cm). Ferdinand Lammot Belin Fund (collection number 1963.6.1). Image courtesy National Gallery of Art, Washington, DC. The original of three Copley versions, the painting's patron and heroic nude subject, Brook Watson, eventually bequeathed the picture to Christ's Hospital, a London charity.

which happened in the harbour at the Havannah. Reviews generally corroborated the picture's visual reportage. Beyond being Copley's patron, Watson was a family friend, who collaborated with the artist in supplying newspapers with details of the 1749 attack. His ship at anchor, the fourteen-year-old Watson, an apprentice sailor, had been swimming in Havana harbor when the shark struck. Nearby "honest Tars" drove off the predator and saved the boy at the "instant he was about to be seized the third time." The sailors' nickname "tars" derives from the oily tar that waterproofs tarpaulin sails and ships' hulls, but as we shall see, Copley's mariners also could personify medical cures attributed to tar.[2]

Evoking its healing theme, London's *Morning Chronicle* compared Copley's painting to "that sort of safe sea which is occasionally exhibited on the stage of Sadler's-Wells." A London theater built over medicinal water wells, Sadler's Wells originated in the seventeenth century as a spa famous for healthful glasses of mineral water. Tars, naval officers, and seafaring merchants frequented this nautically attuned entertainment venue.[3]

Pictorial contradictions that bothered contemporary critics invite a reinterpretation of *Watson and the Shark*'s purported realism. The *Morning Chronicle* critic wrote that Copley's sea creature visually differed from an actual shark and lacked a predator's voracious spirit: Its quiescent tailfin failed to lash the sea violently. *The General Advertiser* noted that waves and ships' sails are "unruffled," even though the harpooner's hair is strangely "blown to a great degree." For *St. James's Chronicle*, Copley's shark appeared a fantastic, "ravenous bloody Monster," "swift as lightning," with a "flaming Eye." Critics for the latter two newspapers questioned the central presence of an "idle Black," whose ineffectual handling of a lifeline seemed "unsailorlike."[4]

Observers apparently intuited that these representational oddities carried meanings beyond the imitation of visible reality and historical fact. Art historians have reinterpreted the painting as a typological reenactment of Christ's death and resurrection or as an allegory for the politics of slavery and the American Revolution.[5] However, when reframed by the intersecting discourses of fraternal ritual, medical astrology, alchemical panaceas, and painters' craft secrets, the picture's puzzling elements more persuasively coalesce to express humankind's oscillating suspension between visible and invisible realms of being. Avid consumers of yearly almanacs featuring alchemical, astrological lore, eighteenth-century readers still could see human fortunes and misfortunes written in the stars, where even heavenly constellations and zodiacal signs appeared empathetically "lame," "deformed," and "bereft of limbs." Copley's painting healingly assimilated the loss or absence of an individual limb to a larger, sociable constellation of spiritual presences.[6]

For peg-legged Watson, Copley's picture surely stirred visceral memories coupled with wonder not only that he had been rescued from the shark but also that his postattack amputation below the right knee had healed in "three months."[7] Celebrating this medical miracle, Copley's pictorial synthesis draws upon both traditional signs of nature's hidden sympathies and newer perceptual theories of visual representation. The painting's light-dark polarities are informed by post-Newtonian optics, chemistry, medicine, and "physico-theological" theories connecting scientific and spiritual truths.[8]

Scholars have drawn parallels between the color and light effects of Copley's Boston portraits and Anglican philosopher George Berkeley's *Essay Towards a New Theory of Vision* (1709).[9] Ennobled in the American consciousness by his teaching and preaching residency in Newport, Rhode Island (1729–31), and his never-realized project for a university and art academy on the island of Bermuda, Berkeley promoted the visual arts and argued in various treatises that light and colors are the immediate, primary objects of vision. Accordingly, we must learn to correlate visual perceptions with differing tactile sensations of shapes, textures, sizes, and distances. Berkeley's theory of vision posited nature as an arbitrary language of signs willed by a divine Author. Material objects have no independent existence outside of a perceiving mind. Culturally mediated perceptions of colors and light effects lead to an understanding of nature's regularities, its orderly, structured language. By analogical reasoning, humans employ sensory ideas of material things as stepping stones for gaining knowledge of God. Adumbrating the magical illusionism of

Watson and the Shark, Copley's detailed, sublimely luminous portraits parallel Berkeley's imagined chain of being linking humble materials to ethereal light and divinity's creative agency.[10]

Appearing to undergo a tortuous initiation into nature's mysteries, Copley's shark victim embodies eighteenth-century fascination with the rituals of Freemasonry and other fraternal groups. By the 1780s, if not earlier, Brook Watson belonged to the Royal Grand Modern Order of Jerusalem Sols, one of London's many quasi-Masonic friendly societies. Copley's stepfather, English-born printmaker and Freemason Peter Pelham, had been secretary to Boston's First Lodge and Worshipful Master of Boston's Third Lodge. Copley's elder stepbrother, Charles Pelham, a leading Masonic lodge master, became Grand Secretary of the Provincial Grand Lodge of Massachusetts. Though evidence is lacking that Copley joined Freemasonry, correspondence from patrons suggests his familiarity with Masonic texts. Sharing Freemasonry's taste for esoteric signs, Copley portrayed silversmith Nathaniel Hurd possessing books of secret ciphers and heraldic, hieroglyphic emblems.[11]

Copley immersed himself in the alchemy of painting materials, once creating an oil varnish comprising spermaceti from sperm whales, and he was born to tobacconist parents who would have promoted tobacco as an alchemical, pharmacological panacea for a host of ailments. Copley probably consulted William Salmon's *Polygraphice* (1672) and apothecary Robert Dossie's *Handmaid to the Arts* (1758), popular artists' manuals informed by alchemy and the chemistry of medicine. Copley's Boston patrons included alchemist Samuel Danforth (1696–1777) and Dr. Sylvester Gardiner (1708–86), a physician and apothecary who practiced medical chemistry partially inspired by famed Swiss-born alchemist Paracelsus (1493–1541). Bostonians referred to Copley's Beacon Hill house as "King's Hospital," probably because its former owner, Dr. Gardiner, had used it to care for sick and injured British sailors and soldiers.[12]

Prior to departing for London in 1774, Copley painted the portrait of the Harvard natural philosopher John Winthrop (1714–79), who alchemically explained that earthquakes loosened hardened crust and stones to create a fertile womb for growing precious metals and minerals. Synthesizing Newtonian science with the ancient occult wisdom of the legendary Egyptian magus Hermes Trismegistus, Dr. Winthrop believed that a vital spirit or ethereal fire infused all matter. Winthrop was a descendent of Connecticut's founding governor John Winthrop Jr. (1606–76), an alchemist and Royal Society member, who strove to distill a "red elixir" and roast New England ores into gold. Thanks to longstanding friendships, Copley may have had access to the Winthrop family's extensive alchemical library.[13]

Both Copley and Watson supported Anglican clergyman Jacob Duché, who argued that Holy Scriptures had absorbed "scattered rays of knowledge" originating with Egypt's "thrice great Hermes." Hermes Trismegistus, supposed author of the *Hermetica*, a collection of Greek and Latin theological, philosophical texts dating from late Alexandrian antiquity, was still assumed by George Berkeley, Sir Isaac Newton, and others to signify a far more ancient Egyptian wisdom. This Egyptian oracle's mythic identity linked him with the Greek Hermes and Roman Mercury, gods of alchemy, astrology, and the arts and sciences.[14]

A practicing alchemist, Sir Isaac Newton encouraged chemical interpretations of light. Copley read *An Essay on Painting* (1764) by Count Francesco Algarotti, a popularizer of Newtonian science, who noted in chemical terms that white light, far from being "simple and uncompounded," was composed of "several distinct substances." Algarotti urged artists to consider the divided rays of prismatic light as "so many colours on a painter's pallet." In later editions of the *Opticks* (1704), Newton appended "Queries," which expressed the alchemical idea that "the changing of Bodies into Light, and Light into Bodies, is very conformable to the Course of Nature, which seems delighted with Transmutations." Newton and his followers hypothesized that the motions of light particles, material bodies, and nature's attractive and repulsive forces could be accounted for by the existence of one or more invisible, ethereal fluids. Copley's painting alludes to concurrent assumptions within the Royal Society that astronomical, ethereal forces affect human health just as they govern "the flux and reflux of the sea."[15]

Watson and the Shark's topographical portrayal of Havana, Cuba, located just south of the Tropic of Cancer, geographically supports the idea that young Watson was undergoing a baptismal trial by fire and water. The northernmost latitude annually reached by the overhead, noontime sun, the Tropic of Cancer is identified with the summer solstice, which closely corresponds with the Christian feast day of St. John the Baptist. British and colonial American Freemasons followed ancient pagan and medieval Christian traditions by holding a festival on the day of St. John, or midsummer's day, when the sun, "the great type of the omnipotence of the Deity," appears "at its greatest altitude, and in the midst of its prolific powers." Early-modern midsummer civic festivals featured processions led by fantastic "fiery dragons," symbolizing the enflamed nature of midsummer's dry, hot air. By gathering on or near June 24 to honor John the Baptist, Freemasons practiced a religious syncretism that situated Christian tradition within a hermetic ancient theology, originating in Egyptian sun worship and the esoteric wisdom of Hermes Trismegistus.[16]

Copley's shark recalls the fiery dragons of midsummer festivals. In England, Copley could have witnessed such pageants and similar St. George's Day processions, which also featured dragons. In Boston, he surely would have seen his stepfather and stepbrother publicly parade in Masonic celebrations. Collaborative conversations with Brook Watson probably led Copley to view his patron's shark encounter as a quasi-Masonic initiation related to rituals that apprentice seamen endured. As described in popular travelogues and adventure books, deep-sea sailors performed baptismal initiation rites for novices, including impecunious travelers, who crossed the equator and the Tropics of Cancer and Capricorn for the first time. Unable to offer bribes exempting themselves from the ordeal, apprentice sailors were dropped from the ship's yardarm three times into the sea. Costumed crew members played mythological characters led by the sea god Neptune and his retinue of monstrous oceanic creatures akin to Copley's demonic shark. Prior to their ducking, initiates were smeared with tar, soot, and other blackening substances. Their faces were then "shaved" to remove the fictive beards, possibly as a sacrifice to Neptune for the prospect of fair sailing winds.[17]

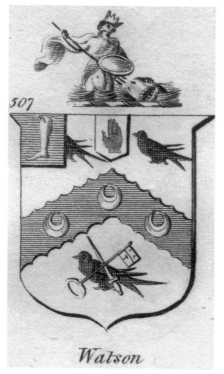

2.
Brook Watson's coat of arms, engraving published in William Betham, *The Baronetage of England*, vol. 5, *Supplementary* (London: E. Lloyd, 1805), plate 26, no. 507. This represents Watson's revised, post-1778, coat of arms, its crest including a shark inspired by Copley's painting and Neptune, presiding sea god for mariner initiations. Courtesy of Library of Congress, Prints and Photographs Division, Washington, DC.

Implicitly inviting associations with Christ's third-day resurrection and baptism's three immersions in the name of the Holy Trinity, London newspapers emphasized Watson's immanent third submergence as the moment of rescue and his later healing after just three months. Crossing-the-line submersions mimicked Christian baptism while generating fears that lurking sharks might "carry away a thigh." Watson likely imagined his shark encounter in terms of the Neptune-led sailors' ritual. Copley's painting inspired Watson to modify his coat of arms: he placed a shark-spearing Neptune atop an armorial shield decorated with a severed leg obscuring one of three legless black martlets (Figure 2). The artist's careful mapping of Havana's skyline made visible the otherwise invisible nearby latitude of the Tropic of Cancer, its crossing a trigger for harrowing mariner initiations.[18]

Collectively, Copley's tars embody the fraternal ideals of British commerce. First published in 1777, the year Copley began work on *Watson and the Shark*, George Richardson's English edition of Cesare Ripa's *Iconologia* (1593) cited the *Natural History* of Pliny the Elder to liken seafaring men of commerce to storks. Because of their "exceeding long necks and beaks," storks experience difficulty in supporting "themselves singly in a long passage; therefore, they have recourse to reciprocal aid—they fly in flocks, and when the foremost are weary, they retire behind, and by turns repose their necks on each other." Like storks, Copley's merchant sailors mutually assist each other: a strategically balanced division of labor and distribution of body weight insures that their boat stays upright and afloat during an intense moment of crisis and physical action. With arms extended, two lunging sailors act in unison, craning necks and bodies overboard to aid Watson. They recall the fishermen and storklike birds in Raphael's *Christ and the Miraculous Draught of Fishes* (circa 1515), a canonical painting in the British royal collection.[19]

Storks traditionally personified vigilance, as they stand on one leg, the other raised and poised for action in watchful concentration. *Watson and the Shark*'s sailor wielding the boat hook holds an intensely vigilant pose: left leg raised upon the boat's prow, his gaze is riveted upon the shark. This sailor recalls not only dragon slayers of pagan and Christian legend but also emblematic, snake-eating storks appearing in iconologies and books of heraldry as valorous scourges of snakes.[20]

3.
Mercury, circa 1780/circa 1850, after Giovanni Bologna (Giambologna). Bronze, 69⅝ × 19 × 37¼ in. (177 × 48.5 × 94.9 cm). Andrew W. Mellon Collection (collection number 1937.1.131). Image courtesy National Gallery of Art, Washington, DC. This anonymous copy of Roman provenance is based upon Giambologna's most famous bronze *Mercury* (circa1565), now in the Museo Nazionale del Bargello in Florence, Italy.

Images of Hermes/Mercury, god of commerce, inform Copley's nude youth. The Franco-Flemish sculptor Giambologna (1529–1608) designed several different, widely copied versions of a winged Mercury (Figure 3), whose youthful body corresponds with Watson's smooth, adolescent flesh. A cast of Giambologna's *Mercurius* was among the "living Models" on display for instructional, creative inspiration at London's Royal Academy of Arts, founded in 1768 as Britain's leading fine arts education and exhibition venue.[21] The one-legged Watson may have found comfort and inspiration in Giambologna's Mercury, who gracefully supports himself upon a single leg: storklike, the figure maintains body balance with only the left foot lightly touching the base. "The most watchful of all the ancient gods," Mercury became identified with vigilant storks. Mercury/Hermes was also Cyllenius or Cyllius, Greek names for a man missing hands and feet, referring to the legless, handless herms or statues that once guided travelers on ancient thoroughfares.[22]

Corresponding to the avian, mythic allusions in *Watson and the Shark*, Watson's early coat of arms (Figure 4), designed prior to 1773, displays a shield with three legless black birds. These martlets symbolize Watson's dismembered condition and suggest a parallel with Giambologna's Mercury, whose wings appear to free him from the need for weight-bearing legs. According to heraldic texts known to Copley, legless martlets teach landless, wandering youths "to trust to their wings of virtue and merit, to raise themselves." Identified with waterfowl in Virgil's *Aeneid*, Mercury employed storks to pull his heavenly chariot.[23] In *Watson and the Shark*, the sailors' rowboat becomes the vehicle for a modern-day Mercury's rebirth.

Legendary bearers of babies, storks symbolized the regeneration of life and the healing arts of medicine. An eighteenth-century compendium of "curious relations" reminded readers

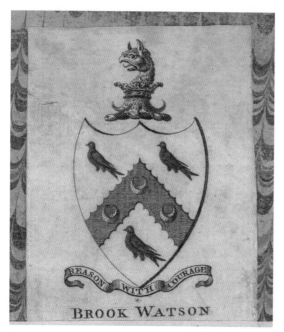

4.
Engraved bookplate bearing Brook Watson's earlier coat of arms. Inside John Milton, *Paradise Lost* (Glasgow: Robert and Andrew Foulis, 1770). Watson affixed his armorial shield to this gift book for Phillis Wheatley. The heraldic griffon crest signifies a fabulous hybrid, eagle-lion, predator of serpents. Image fAC7.W5602.Zz770m, Houghton Library, Harvard University, Cambridge, Massachusetts.

that storks taught apothecaries the art of "applying Clysters; a Thing . . . highly beneficial for the Health of Mankind . . . The Stork being seen on the Sea Shore to take up some Water into his Bill, and to squirt it into his Fundament, gave the first Prescription for that Practice among Apothecaries." Storks' syringe-like beaks conjured associations with enemas and also with all medical injections and purifying water bathing.[24]

Of relevance for shark victims and the symbolism of healing storks, Bishop George Berkeley's *Siris* (1744) recommended tar-water as a cure-all elixir for diseases, animal bites, and gangrenous injuries. Claiming the curative use of tar-water "in certain parts of America," Berkeley promoted its virtues for a trans-Atlantic audience, arguing that cold, pine-tar-infused water possesses healing, cleansing powers thanks to balsamic oils containing the "active ethereal substance of light." The Anglican clergyman cited Psalm 104:2 to link solar with divine light, the "garment" of God.[25] A probable inspiration for Copley, Psalm 104 catalogues God's diverse creation from the "leviathan," living within the "great and wide sea" (104:25–26) to the "stork," nesting within "the cedars of Lebanon," "fir trees" bounteously "full of sap" (104:16–17).

Berkeley cited the "cedar of Lebanon," a tree used for Solomon's temple (I Kings 5:6–10) and a still-valuable resource for light-activated tar-water. *Siris* fostered the production and marketing of tar-water, its popularity surely gaining Copley's attention. Sailors were encouraged to drink tar-water elixirs, while tar-water lotions and ointments prevented infections from injuries and severed limbs. Synthesizing ancient hermetic and platonic theories of an ethereal fire with post-Newtonian science, Berkeley's *Siris* charted an ascending chain from tar upward toward solar light and fire, finally leaving the sensible world for the triune God.[26]

Copley similarly encourages viewers to fly heavenward from earthly painting media representing lowly, storklike tars nestled in boats and ships. Through Hermes, these mariners find protection in pinewood hulls air powered by tarpaulin sails hermetically waterproofed by oily tar. Legendary inventor of hermetic seals, Hermes Trismegistus also was identified with sealing surgical wounds.[27] Emulating Hermes, Copley invented his own protective oil varnish recipe, comprising "Spirits of rectified Wine"; gum sandarac, a coniferous resin native to Africa; and "Canada Balsam," or "Balsam of Fir," the North American balm of Gilead fir, named after the biblical balm

of Gilead (Jeremiah 8:22), a Holy Land balm that Berkeley deemed a "precious" panacea. Copley's bottled mixture was placed "in a Summer Sun or near the fire" to dissolve and blend the African and American tree resins. Rich with religious associations, this distinctive varnish hermetically sealed pictures within a spirituous oil activated by sulfurous light. In Copley's shark painting, ships' cross-shaped rigs punctuate the skyline: these pine-made crosses signify the healing, balsamic powers of tar-rich evergreens as analogues for Christ's redemptive death and resurrection.[28]

Alchemists in pursuit of medical elixirs drew an analogy between the stork's anatomy and hermetic glass vessels, so-called stork vessels heated for the distillation of mercury and other substances (Figure 5). According to alchemists, volatile quicksilver, personified by Hermes/Mercury, threatened to fly away. Like surgical patients immobilized for amputations, Mercury had to be bound and imprisoned within his own hermetically sealed vessel and tortuously dismembered in the refiner's fire. Copley's shark, rich in sulfurous oils, personifies this fire deemed essential for sublime transmutations. Sometimes called storks in English travel literature, sharks also participate in nature's regenerative, cyclical processes.[29]

According to the German chemist Georg Stahl (1660–1734), successful alchemy required that "common Mercury," fluid quicksilver, must be divested of "all impurities" and become "impregnated with the requisite internal Fire or metallic Sulphur, so as in its whole Substance to become Philosophical Mercury," or the philosopher's stone, alchemy's transmuting agent. Through the dismembering, dissolving "philosophical Fire," of uncommon "philosophical Sulphur," "common Mercury" is reborn to a higher, golden state of being. According to the frequently republished artist's manual *Polygraphice*, Mercury is "immaturate Gold; and so remains immaturate in the baser Metals till a ripening and meliorating spirit quickens that seminal property lodged in the womb of impurity." Just as Harvard's John Winthrop argued that earthquakes beneficially loosened earth's crust for mineral growth, so did chemists like Stahl believe that the dissolution of common, immature mercury and other base minerals enabled the flowering of mercury's hitherto imprisoned "seed of Gold." Similarly, Berkeley's *Siris* pointed to experiments by German-born chemist Wilhelm Homberg (1652–1715) to suggest that a "burning-glass" focusing solar rays could transmute mercury into gold by "introducing light into its [mercury's] pores," the same sulfurous light Berkeley attributed to tar-water.[30]

The bending stork vessel of alchemy bears comparison with Copley's two white-shirted seamen who lean overboard as midwives for the nude boy's rebirth from the dark womb/tomb of the sea. The inverted triangle of tars reaching into seawater connotes healing tar-water, an analogue for baptismal regeneration. The distressed youth strives against deathly dissolution, as his injured right leg, losing form and solidity, dissolves into an amorphous fluid mixture of dark blood red and sea green pigments, terminating in inky blackness below the knee. Lower legs darkened in shadow and water, the boy's torso gleams luminous white, his head grows solar gold strands of hair. From the perspective of Psalm 104:2, cited in Berkeley's *Siris*, Copley's radiant adolescent is not so much nude as clothed in a fiery, divine light capable of transmuting immature mercury into gold.[31]

4 1 *L I B E R*

ueo mutuo inferitur, & dum ignis vim maximè vrgen-
te fuperne viuum euehitur, variæ notæ vitæ aquam per-
ficit, non quo altius extollitur, eò tenuior, quæ tardi-
grada, & humidior, craffior ac phlegmate redundans,
eò ignobilior, quod quia hydræ colla, & capita viden-
tur imitari, herculeam hydram vocamus feptem capi-
tum, fed alij æneo, vel aurichalceo, alij vitreo vtun-
tur. Vas G, litera notatur.

Vtimur quoq; recuruo vafe, fcilicet collo:fed am-
plo alueo in ijs fimplicibus, quæ minimè afcenderę
poffunt, quod quia Ciconiæ collum imitatur, Cico-
nias, vel ftortas vulgus vocat; eoq; in diftillandis va-
lidis aquis vtimur. Et quia torquet collum nos retor-
tas vocamus, vt quæ fublimari contumaces, peruica-
cesq; funt vi ignis vrgentis, per retortæ collum liben-
tius illabantur.
　　Neq; in vafum nomenclatione à plantarum, fru-
ctuum fimilitudine abftinuimus, nam fimplicia diftil-
lando, quæ validi halitus, & vrgentis fpiritus in fala-
moniacum,

5.
"Stork Vessel," woodcut from Giambattista della Porta, *De Distillatione*, Lib. IX (Rome:
Ex Typographia Reu. Cameræ Apostolicæ, 1608), p. 42. Neapolitan natural philosopher
Giambattista della Porta (1535–1615) influentially argued that chemical vessels should
imitate the varied physiognomies of animals to better effect different distilling processes.
Courtesy of Roy G. Neville Historical Chemical Library, Chemical Heritage Foundation,
Philadelphia, Pennsylvania.

　　Participating in the drama of light and dark forces, the blackness of the shark's abysmal
mouth and the blackening dissolution of the youth's bleeding leg relate to the black sailor holding
the tow line. Copley's black tar is a figure of Saturnine melancholy, signifying occult mysteries
buried in the bowels of the earth. He wears a long, blousy white shirt, relating him to illustra-
tions of emblematic black men with whitened torsos appearing in alchemical texts (Figure 6),

6.
Matthäus Merian, "Euthices," woodcut from Johann Daniel
Mylius, *Hermetico-Spagyrisches Lustgartlein Darinnen
Hundert und Sechtig . . . Chymico-Sophische Emblemata*, in
Johann Grasshoff, *Dyas Chymica Tripartita* (Frankfurt: Luca
Jennis, 1625). The print's inscription asserts the whitening
powers of soapy saltwater solutions: "We took away Blackness
with Natron Salt and Almizadir, and fixed whiteness with
Borax." Courtesy of Library of Congress, Prints and Photo-
graphs Division, Washington, DC.

including Jean-Jacques Manget's *Bibliotheca chemical curiosa* (1702), a copy of which belonged to Copley's alchemist-patron, Samuel Danforth. This image nominally portrays "Euthices Philosophus," likely referring to an ancient Roman, early Christian eunuch. But the figure's racial character also suggests the more famous Ethiopian eunuch from Acts of the Apostles (8:27–39), who converts to Christianity through baptismal cleansing. His white chest displaying solar and lunar hieroglyphs, the black-and-white Ethiopian symbolizes the three primary stages of alchemical transmutation: *nigredo*, blackening; *albedo*, whitening; and *rubedo*, solar reddening. An accompanying Latin inscription interprets the Ethiopian's baptism in terms of purifying chemical baths. The "whitewashed Ethiopian," or "Moor," appeared frequently in early modern emblem books. The seemingly impossible transmutation of "washing the Ethiope white" figured the alchemical, millennial goal of "a new beginning, or a Second Coming."[32]

Deep-sea sailors generally personified the *nigredo* of alchemy because their exposed flesh darkened under the sun and the sea itself signified primal, formless matter. But the Ethiopian eunuch, governed by the god Saturn, especially embodies leaden blackness. Notorious for castrating his father and devouring his children, Saturn is not only the dismembering, scythe-wielding grim reaper but also another name for the seminal fire hidden within the oceanic veils of nature. During the blackening, impure metals are heated and dissolved into formless primary matter. The alchemical opus then progressed to baptismal washing or whitening in preparation for the reddening stage, variously symbolized by subtropical Ethiopia; the heated, zodiacal crab of Cancer; and the summer solstice over the Tropic of Cancer, feast day for Saint John the Baptist. "Cancer" and "Ethiopian grain" are among the many names found in alchemical literature for denoting the reddened, golden, philosopher's stone. Yet, deemed eyeless and deformed, the crab of Cancer also symbolized primordial, oceanic waters and the subterranean mysteries of darkness and blackness. Copley's Ethiopian calls to mind the astrological Man of Signs, whose body, surrounded by signs of the zodiac, appeared in eighteenth-century almanacs. A pair of spirals or crab's claws traditionally signify Cancer.

In Copley's painting, the twin, spiraling ties of the Ethiopian's neckerchief invite associations with both the crab of Cancer and art's serpentine "line of beauty." In his widely read *Analysis of Beauty* (1753), the English painter William Hogarth celebrated this S-curved line as a shell-like hieroglyph symbolizing fire, light, and nature's mercurial transmutations.[33]

A synonym for all Africa and known as a "great store of herbs and stones," Ethiopia possessed a popular identification with magical powers and the healing arts. Berkeley entitled his medical treatise *Siris* after the Ethiopian name for the Nile River.[34] For painters and physicians, Ethiopia more specifically conjured "Æthiops mineral," a black pigment compounded of mercury (quick-silver) and sulfur. Contemporaries compared the medical benefits of Æthiops mineral, a pre-ventative for smallpox, to Berkeley's tar-water. Physicians also praised Æthiops for its sulfurous "cleansing" power and efficacy against "convulsive Fits." Apothecaries recommended "Aethiops mineralis" as a medicine and also described how black Æthiops mineral could be transformed into vermillion, the painters' pigment most closely identified with the philosopher's stone and final, reddening stage of alchemy. Through vaporization, condensation, and levigation, Æthiops mineral became red mercuric sulfide. Vermillion was a superior synthetic equivalent of natural cinnabar ore, a less pure mercury-sulfur compound that imparted color to much-desired red elix-irs. Ordering only the "finest Vermillion," Copley apparently feared color suppliers adulterating the valued pigment with weaker, baser substances.[35]

Painters employed vermillion for representing carnation red flesh tones expressive of an animating soul or spirit. In *Watson and the Shark*, the neckerchief spiraling across the black sail-or's chest reminds us that the crab of Cancer astrologically governs the human breast, protective shell for the blood-pumping heart, the body's internal sun. The neckerchief's coral red stripes appear to mimic the arterial, vascular flow of blood. To capture the ethereal fire of vermillion red blood, Copley sought to replicate Titian's oil glazing technique.[36] An opaque pigment, vermillion is unsuitable for creating oil glazes. But thanks to its bodily strength, vermillion may be read as an analogue for Copley's pictorial theme of death and resurrection from a watery abyss: buried beneath sealing glazes and varnishes, vermillion possesses the penetrating power to glow like an internal, seminal light triumphantly overcoming painterly entombment. Copley thus admired Flemish colorist Peter Paul Rubens for dramatically enlivening pictures with "almost pure Ver-million" in the "Dark shadows" of human flesh.[37]

With vermillion-tinged lips and a celestial, zodiacal scarf about to take flight, Copley's black sailor personifies the red-black pigment metamorphoses of mercuric sulfide compounds. In 1773, several years prior to commissioning Copley's shark painting, Brook Watson demonstrated a certain spiritual empathy for the Boston African American poet Phillis Wheatley, who was then visiting London. Watson gave her a 1770 edition of John Milton's *Paradise Lost*, inserting his own bookplate, its armorial shield populated by legless black martlets, birds famed for surmount-ing perceived physical deficiencies (see Figure 4). *Watson and the Shark*'s mercurial pigments and glowing African flesh parallel Wheatley's claim that "sable" black is not an immutable "di-abolic die." Like Copley's painting, Wheatley's poetry is filled with solar, subtropical imagery:

she harmonized African sun worship with Newtonian science and astrological metaphors found in European literature. Wheatley's "The Answer" (1774) celebrates both "great Sir Isaac" and Africa's "guilded shore,"

> Where cancers torrid heat the soul inspires;
> With strains divine and true poetic fires.[38]

Not differentiating between light ray mixtures and pigment mixtures, Newton denied the immutability of black and conceived the tonal scale of white, black, and intermediate grays as forming "one species of color that differs only in the amount of light reflected."[39] Newtonian natural philosophers taught that colored bodies, no matter how opaque, were composed of small, transparent corpuscles, each glassy, reflective corpuscle being analogous to a colorful soap bubble. Newton experimented with artist's pigments and oil media. He argued that "sulphureous oily Particles," found in linseed oil, turpentine, and other "unctuous Substances," enhanced the refractive, colorizing properties of bodies exposed to light. Newton cited cinnabar, a "red opake volatile Earth," and the fluidity of mercury to hypothesize that nature's metamorphoses, optical effects, and attractive and repulsive forces were facilitated by an invisible, ethereal medium.[40]

British natural philosophers were influenced by the Dutch physician Hermann Boerhaave (1668–1738), who redefined Newton's ethereal medium as a fire principle animating nature. The German chemist Stahl similarly argued that colors of natural bodies depended upon "phlogiston," a chemical fire or sulfurous, flammable substance that supposedly was released into the air when bodies burned. Stahl's phlogiston was akin to Newton's oily, light-refracting particles, the unctuous, corpuscular bubbles responsible for the colors of natural bodies. Meanwhile, Stahl's released, "dephlogisticated" air foreshadowed the later discovery of combustible oxygen, deemed by pigment and dye manufacturers to be nature's quintessential colorizing agent.[41]

Falling between mercurial youth and fiery shark, the looping lifeline held by Copley's Ethiopian symbolizes the alchemical marriage of mercury and sulfur. Copley's grasping tars form an elemental circle linking them with the shark arched around the boat. This configuration recalls the uroboros, or circular serpent biting its own tail, an emblem associated with Mercury and Saturn to signify nature's fluid transmutations and eternal regenerative cycles. During the Revolutionary era, the mercurial serpent decorated Masonic chairs as well as Massachusetts paper currency.[42]

Watson and the Shark's circular motion unites opposing light and dark forces. The shark's infernal fire links it astrologically to Scorpio, symbolized by the stinging, serpentine scorpion. The sailor situated below the harpooner's groin directs his gaze toward the scorpion-shark, whose zodiacal associations comprise both sexual, procreative pleasures of the groin and alliances with both the war god Mars and Pluto, a shadowy, chthonic god of death and resurrection. The shark's serpentine shape generates circular movement, manifesting its dual, cyclical nature, both destructive and healing. The shark's razor-sharp teeth paradoxically invite associations with folk medicine and the natural white magic of science. Known as snakestones because they resemble

serpents' tongues, sharks' teeth were thought to be an antidote for poisons. Sharks' heads generally symbolized the apothecary's dispensary of medicines and the notion that a poisonous disease could be cured by similitude, that is, by a like substance, a principle supported by Copley's Boston patron Dr. Sylvester Gardiner, a leading advocate of smallpox inoculations.[43]

As an amulet to ward off the evil eye, a shark's tooth was also called St. Paul's tongue, named after St. Paul, patron saint of the Anglican Church, who, biblically identified with Mercury (Acts 14:12), was known for his communication skills. Sharks' teeth or snakestones evoked the story of how St. Paul miraculously survived the bite of a venomous snake after being shipwrecked on the island of Malta. Travel guides to Malta reported that a small church dedicated to St. Paul had been built on the site of the viper attack and that an adjoining grotto produced a "whitish kind of stone" deemed a "sovereign remedy in many diseases." Seafaring St. Paul personified the medical arts, leading Copley's American rival Benjamin West (1738–1820) to represent the shipwrecked St. Paul shaking off the Maltese viper for the main altar at the chapel of the Royal Naval Hospital in Greenwich.[44]

In *Watson and the Shark*, the shark's mouth takes the shape of a pointed stonemasonry arch. Its dark interior, gleaming with tongue-like teeth, reminds us of St. Paul's eloquence and survival of a viper bite. But echoing the church architecture of the Havana skyline and the cross-shaped masts of the harbor's anchored ships, the shark's flickering teeth more broadly allude to the Pentecost of Acts 2, when the Holy Spirit sent "cloven tongues" of fire onto the heads of Christ's disciples, enabling them to evangelize in foreign lands. The shark's thick-lipped mouth and tongue-like teeth, together with the harpooner's windblown hair and black sailor's flying scarf, connote supernatural presence. Hermes/Mercury, winged messenger between heaven and earth, was a pagan type for John the Baptist and Christian spiritual descent: Brook Watson's whitened body signifies the Holy Ghost's baptismal fire (Luke 3:16).[45]

Dressed in white, the contemplative black sailor stands like a catechumen undergoing Christian instruction prior to his own baptism. Copley's Ethiopian sailor embodies the Pentecostal mission of disseminating God's Word among all peoples. With outstretched right hand, he personifies the African diaspora and evokes the prophecy of Psalms 68:31 that "Ethiopia shall soon stretch out her hands unto God." Clergymen cited this biblical passage in urging Christian conversion of African slaves.[46]

Contemporary natural philosophers joined theologians in repeatedly comparing the Holy Spirit to phenomena of electricity, light, and a fluid ethereal medium. Synthesizing Newtonian hypotheses with Matthew 3:11, Luke 3:16, and Acts 2:3, authors compared this invisible "universal Æther or fire" with the biblical idea that "Jesus Christ should baptize with *Fire*, that is, with the *Holy Ghost* and that the HOLY GHOST descended in the visible appearance of *Fire*." Copley's *Watson and the Shark* visually parallels Berkeley's *Siris* and physical-theological ether theories in assuming hidden correspondences between the terrestrial and celestial spheres.[47]

The moon astrologically governs Copley's shark: The creature's nostril and tailfin flare into crescent moons, conventional, traditional signs for sharks. Mythically, the zodiacal scorpion

defended the virginity of the moon goddess Artemis/Diana. A guide to London's Royal Academy noted that crescents are also emblems of the god Oceanus because oceanic waters and tides are subject to cyclical lunar phases. Crescents decorate the chevron of Brook Watson's coats of arms (see Figures 2 and 4) to signify the moon's role in shaping his seafaring, mercantile career. Spiritually, the moon also relates to Hermes/Mercury as the god who guides souls deep into the underworld. Copley's shark and youth are two contrasting aspects of the same protean god Mercury.[48]

Setting into motion astrological associations, Copley's mercurial leviathan emerges from the underworld advancing toward the boy while its half-moon tailfin simultaneously couples with the dawn light. The shark, Luna, marries Sol, the resurrected sun, whose healing rays bathe and clothe the golden-haired youth in baptismal fire. Coupled shark and swimming youth further signify the twin fish of Pisces, the zodiacal sign that traditionally appeared at the feet of the astrological Man of Signs. Governing afflictions of the feet, Pisces reminded Christians that just as fish cannot live without water, so do fallen humans require baptism's cleansing waters. Apart from the shark, the nude youth also may be read as the Ganymede of Aquarius, the cup pourer who astrologically personifies dissolving, primordial floodwaters. As Aquarius, Copley's androgynous youth is about to be uplifted by a Jupiter, here embodied by the Taurus, bull-like form of Copley's boatswain. This older, balding, sailor, his remaining hair coming to an excited, hornlike point, directs and holds onto the twinned sailors who reach over the boat toward the nude youth. Copley's brotherly pair, defined by their coalescing, extended arms, astrologically correspond to the Twins of Gemini, identified with the mythic Greco-Roman twins Castor and Pollux, demigod patrons and rescuers of sailors in distress.[49]

The lunar tailfin of Copley's shark elevates our eye toward Fort Morro, its tower standing at the eastern entrance of Havana harbor. Also called Moor Castle, this fort triggers historical, geographic associations with anti-Moorish, Christian crusading and black Africa as a source of imperial wealth. Playing upon popular racial stereotypes, the "wooly" hair of Copley's African sailor may represent the zodiacal ram of Aries, its wool evoking the Greek mariners' legend of Jason and the Argonauts capturing the golden fleece. With Havana the nautical gateway to Spanish American gold and silver, Copley's wooly-haired Ethiopian personifies the golden fleece and is overlapped by the harpooning sailor, whose astrological identity links him to the archer of Sagittarius, a Jason-like dragon slayer.[50]

Opposite Fort Morro, guarding the harbor channel, stands the tower of Point Castle, visible above the outstretched hand of the black tar. According to British mythologists, the word tar in antiquity was etymologically related to tur and other names for towers or coastal lighthouses. Built upon islands and insular promontories, such beacons created sacred spaces that worshippers dedicated to sea and travel gods as well as deities of light. *Watson and the Shark*'s harbor towers recall Antiquity's legless, armless stone herm statues guiding travelers.[51]

When Copley's picture was exhibited in the midst of the American Revolution, one London newspaper critic pointedly identified background ships as "English Men of War" and Havana as "the Place where our Tars so nobly exerted themselves." His commentary on the shark narrative

implicitly connoted the historically more significant and "glorious" time when, in the summer of 1762, the British navy lay siege to Fort Morro and conquered gold-rich Havana. Before Britain returned Havana to Spanish control at the end of the Seven Years' War, Joseph Sewall, a Boston clergyman and Copley patron, claimed its capture foreshadowed the Christian millennium and the building of a heavenly Jerusalem. *Watson and the Shark* nostalgically recalls this vision of Christian millennialism. An avid nationalist, Brook Watson may have come to identify his lost limb with military amputees and the noble sacrifice of so many British lives in the siege of Havana. The merchant patron's Anglican zeal led him to participate in the Jerusalem Sols, a patriotic, quasi-Masonic London fraternity that ritually identified Protestant Britain with King Solomon's temple and Christ's New Jerusalem.[52]

Elected lord mayor of London in 1796, Watson attended sermons affirming that all bodies were made "whole" by the resurrected Christ.[53] Watson later bequeathed *Watson and the Shark* to Christ's Hospital, a London educational charity that schooled many boys for naval careers. Every Easter, students of Christ's Hospital marched through London wearing signs declaring "He is risen."[54]

Displayed in the dining hall of Christ's Hospital, *Watson and the Shark* expressed the school's Christian mission by identifying British tars as Christ's mercurial messengers. An exotic Ethiopian in their midst, they form a primitive Christian community at the edge of the western world. Fishers of men, they embody the rituals of Christian conversion and baptismal initiation. Copley countered the theme of Watson's dismemberment with the Masonic, fraternal metaphor of brothers "cemented with love."[55] Astrological, alchemical men of signs, they spiritually journey between terrestrial and celestial spheres and signify the stone-by-stone building of Christian civilization.

At the picture's horizon near its compositional center, the extended right hand of the Ethiopian hovers above the heads of two sailors balancing the boat's left and right sides. Together, hand and heads connote the scales or balance of Libra and the orderly, providential balance of opposites. Keeping the rescue boat steady and upright, Copley's carefully balanced pyramid of heroic tars constitutes the painting medium itself as a reliable hermetic vessel for healing discord. The artist's mercurial pigments, sulfurous oils, and saltwater tars signify alchemy's triadic mediating principles. Mercury, sulfur, and salt stand as natural analogues for the harmonic triad of spirit, soul, and body that situates vulnerable, aspiring human beings squarely in the airy, ethereal middle of God's Creation.[56]

Acknowledgments

This project began when I was a senior fellow at the Smithsonian American Art Museum. I also benefited from a research fellowship at the Winterthur Museum. I wish to thank the administrative, curatorial, and library staffs of both museums. I also thank the Smithsonian Institution for inviting me to participate in the 2008 Artefacts Conference on Science/Technology and Art. I am grateful to Anne Collins Goodyear and Margaret A. Weitekamp for their encouragement and

editorial suggestions. Jules David Prown also kindly responded to a query. Gregory Borchardt provided valuable research assistance. Special thanks, as always, go to Lou Dellaguzzo.

Notes

1. Copley painted several versions of *Watson and the Shark*. I focus upon the original, now in the National Gallery of Art. Copley made a 1778 copy (Museum of Fine Arts, Boston) and a 1782 version (Detroit Institute of Arts) with a different, more vertical, composition. Jules David Prown, *John Singleton Copley*, vol. 2, *In England 1774–1815* (Cambridge, MA: Harvard University Press, 1966), 267–74, figs. 371–73; Craig Ashley Hanson, *The English Virtuoso: Art, Medicine, and Antiquarianism in the Age of Empiricism* (Chicago: University of Chicago Press, 2009); David Bjelajac, *Washington Allston, Secret Societies and the Alchemy of Anglo-American Painting* (Cambridge: Cambridge University Press, 1997), 37; David Bjelajac, *American Art: A Cultural History*, 2nd ed. (Upper Saddle River, NJ: Prentice Hall, 2005), 108–13, 131–35.

2. *The St. James's Chronicle; or British Evening-Post*, April 25–28, 1778, and *The Morning Chronicle, and London Advertiser*, April 17, 1778, quoted in Ellen G. Miles, "Watson and the Shark," in *American Paintings of the Eighteenth Century*, ed. Ellen G. Miles (Washington, DC: National Gallery of Art, 1995), 56, 70.

3. *The Morning Chronicle, and London Advertiser*, April 25, 1778, quoted in Miles, "Watson and the Shark," 70; James Stevens Curl, *Spas, Wells, and Pleasure-Gardens of London* (London: Historical Publications, 2010), 49–63.

4. *The Morning Chronicle, and London Advertiser*, April 25, 1778, *The General Advertiser, and Morning Intelligencer*, April 27, 1778, and *The St. James's Chronicle; or British Evening-Post*, April 25–28, 1778, quoted in Miles, "Watson and the Shark," 70–71.

5. Irma B. Jaffe, "John Singleton Copley's *Watson and the Shark*," *American Art Journal* 9, no.1 (May 1977): 15–25; Roger B. Stein, "Copley's *Watson and the Shark* and Aesthetics in the 1770s," in *Discoveries and Considerations: Essays on Early American Literature and Aesthetics Presented to Harold Jantz*, ed. Calvin Israel (Albany: State University of New York Press, 1976), 85–130; Albert Boime, *The Art of Exclusion: Representing Blacks in the Nineteenth Century* (London: Thames and Hudson, 1990), 20–36; Ann Uhry Abrams, "Politics, Prints, and John Singleton Copley's *Watson and the Shark*," *The Art Bulletin* 61 (June 1979): 265–76; Jennifer L. Roberts, "Failure to Deliver: *Watson and the Shark* and the Boston Tea Party," *Art History* 34, no.4 (September 2011): 674–95.

6. Marcus Manilius, *Astronomica*, trans. G. P. Goold, bk. 2.256–2.264, Loeb Classical Library (Cambridge, MA: Harvard University Press, 1977), 103; Mark Harrison, "From Medical Astrology to Medical Astronomy: Sol-Lunar and Planetary Theories of Disease in British Medicine, c. 1700–1850," *The British Journal for the History of Science* 33 (March 2000): 25–48; Peter Eisenstadt, "Almanacs and the Disenchantment of Early America," *Pennsylvania History* 65, no. 2 (Spring 1998): 143–69; Bryan Jay Wolf, *Romantic Re-vision: Culture and Consciousness in Nineteenth-Century American Painting and Literature* (Chicago: University of Chicago Press, 1982), 123.

7. *The Morning Chronicle, and London Advertiser*, April 17, 1778, quoted in Miles, "Watson and the Shark," 56; Gordon Bendersky, "The Original 'Jaws' Attack," *Perspectives in Biology and Medicine* 45 (Summer 2002): 426–32.

8. David Sorkin, *The Religious Enlightenment: Protestants, Jews, and Catholics from London to Vienna* (Princeton, NJ: Princeton University Press, 2008), 19.

9. Jennifer Roberts, "Copley's Cargo: *Boy with a Squirrel* and the Dilemma of Transit," *American Art* 21 (Summer 2007): 36–39.

10. George Berkeley, *Siris: A Chain of Philosophical Reflexions and Inquiries Concerning the Virtues of Tar Water*, ed. T. E. Jessup, vol. 5 of *The Works of George Berkeley*, ed. A. A. Luce and T. E. Jessup (Edinburgh: Thomas Nelson and Sons, 1948), 140–41.

11. David Bjelajac, *Washington Allston*, 32–65; F. W. Levander, "The Jerusalem Sols and Some Other London Societies of the Eighteenth Century," *Ars Quatuor Coronatorum* 25 (1912): 9–38; "Portraits of Peter and Charles Pelham," in *Proceedings of the Most Worshipful Grand Lodge of Ancient Free and Accepted Masons of the Commonwealth of Massachusetts . . . 1900* (Boston: Rockwell and Churchill Press, 1900), 121–28; Isaac Smith Jr. to Copley, 1772, in *Letters and Papers of John Singleton Copley and Henry Pelham, 1739–1776*, ed. Guernsey Jones, Charles Francis Adams, and Worthington Chauncey Ford (1914; repr., New York: Kennedy Graphics and Da Capo Press, 1970), 185; Jules David Prown, *John Singleton Copley*, vol. 1, *In America 1738–1774* (Cambridge, MA: Harvard University Press, 1966), 53–54, fig. 177.

12. Copley to Henry Pelham, 25 June 1775, in Jones et al., eds., *Letters and Papers*, 337–38; J. William Shank, "John Singleton Copley's Portraits: A Technical Study of Three Representative Examples," *Journal of the American Institute of Conservation* 23 (Spring 1984): 130–52; Randall A. Clack, *Marriage of Heaven and Earth: Alchemical Regeneration in the Works of Taylor, Poe, Hawthorne and Fuller* (Westport, CT: Greenwood, 2000), 42–43; Henry Wilder Foote, *Annals of King's Chapel from the Puritan Age to the Present Day*, vol. 2 (Boston: Little Brown and Co., 1896), 148–49; William Salmon, *Polygraphice*, 5th ed. (London: Thomas Passinger and Thomas Sawbridge, 1685); Robert Dossie, *The Handmaid to the Arts* (London: J. Nourse, 1758); Robert Dossie, *The Elaboratory Laid Open; or, the Secrets of Modern Chemistry and Pharmacy Revealed* (London: J. Nourse, 1758); Carrie Rebora, Paul Staiti, et al., *John Singleton Copley in America* (New York: Metropolitan Museum of Art, 1995), 130–31, 172–74; Hanson, *English Virtuoso*, 108–21; Iain Gately, *Tobacco: A Cultural History of How an Exotic Plant Seduced Civilization* (New York: Grove Press, 2001), 40–54, 96–97, 122–24. In an October 8, 1810, Boston court deposition, a retired mason named William Homer referred to Copley's house as "King's Hospital." See Jules David Prown Papers, accession no. 2000-M-124, group 1749, box 2, fol. "Notes—Intro. and Part I," Manuscripts and Archives, Sterling Memorial Library, Yale University; Prown, *John Singleton Copley*, vol. 1, pp. 7–9, 17–18, 29–31, 64–65, figs. 73, 318; T. A. Milford, *The Gardiners of Massachusetts: Provincial Ambition and the British-American Career* (Durham: University of New Hampshire Press, 2005), 22–23.

13. Brandon Brame Fortune, *Franklin and His Friends: Portraying the Man of Science in Eighteenth-Century America*, with Deborah J. Warner (Washington, DC: Smithsonian National Portrait Gallery, 1999), 66, 84–89, fig. 5-1. John Winthrop, "A Lecture on Earthquakes" (1755), in *The Scientific Work of John Winthrop*, ed. Michael N. Shute (New York: Arno Press, 1980), 28–31; Lawrence Shaw Mayo, *The Winthrop Family in America* (Boston: Massachusetts Historical Society, 1948), 185; Ronald

Sterne Wilkinson, "The Alchemical Library of John Winthrop, Jr. (1606–1676) and His Descendants in Colonial America," pts. 1 and 2, *Ambix* 11 (February 1963): 33–51; 13 (October 1966): 139–86; John L. Brooke, *The Refiner's Fire: The Making of Mormon Cosmology, 1644–1844* (Cambridge: Cambridge University Press, 1994), 80. Winthrop is mentioned as a "worthy" friend by a Copley relative: see Peter [Pelham?] to Copley, 28 April 1766, in Jones et al., eds., *Letters and Papers*, 38.

14. Jacob Duché, *Discourses on Various Subjects*, vol. 1 (London: J. Phillips, 1779), 285; Mr. Copley, of Leicester-square, and Brook Watson, Esq. of London, are among Duché's unpaginated list of "Subscribers Names." Copley moved to Leicester Square in 1776. Prown, Prown, 2:259. M. Hughes, "Newton, Hermes and Berkeley," *British Journal for the Philosophy of Science* 43 (1992): 1–19.

15. Francesco Algarotti, *An Essay on Painting* (London: Davis and Reymes, 1764), 50–51. Copley cites Algarotti in a letter to Benjamin West, 12 November 1766, in Jones et al., eds., *Letters and Papers*, 51; Isaac Newton, "Quest. 30," in *Opticks*, 4th ed. (1730; repr., New York: Dover Publications, 1979), 374; Betty Jo Teeter Dobbs, *The Janus Faces of Genius: The Role of Alchemy in Newton's Thought* (Cambridge: Cambridge University Press, 1991), 218–49; Richard Mead, "A Treatise Concerning the Influence of the Sun and Moon upon Human Bodies, and the Diseases Thereby Produced," in *The Medical Works of Richard Mead, M.D.* (1775; repr., New York: AMS Press, 1978), 122.

16. William Hutchinson, *The Spirit of Masonry* (1775; repr., Wellingborough, UK: The Aquarian Press, 1987), 55–57, 229; John Brand, *Observations on the Popular Antiquities of Great Britain*, rev. ed. by Henry Ellis, vol. 1 (London: G. Bell, 1883), 321; Steven C. Bullock, *Revolutionary Brotherhood: Freemasonry and the Transformation of the American Social Order, 1730–1840* (Chapel Hill: University of North Carolina Press, 1996), 19–20, 52–55.

17. Robert Withington, *English Pageantry* (1926; repr., New York: Benjamin Blom, 1963), 1:23–47, 64–70; Henning Henningsen, *Crossing the Equator: Sailors' Baptism and Other Initiation Rites* (Copenhagen: Munksgaard, 1961), 73–74, 93–97; Henry Miller Lydenberg, *Crossing the Line: Tales of the Ceremony during Four Centuries* (New York: New York Public Library, 1957), 15–65; Knut Weibust, *Deep Sea Sailors: A Study in Maritime Ethnology* (Stockholm: Nordiska museets Handlinger, 1969), 7; Alexandre Exquemelin, *The History of the Bucaniers of America* (London: Thomas Newborough, John Nicholson and Benjamin Tooke, 1699), 1:2–4. A 1774 edition of Exquemelin's treatise, with its description of sailor baptismal rituals, is listed in the library sale of Copley's son; see Prown, *John Singleton Copley*, 2:397.

18. Antoine-Joseph Pernety, *The History of a Voyage to the Malouine or Falkland Islands Made in 1763 and 1764, under the command of M. de Bougainville*, trans. from the French, 2nd ed. (London: W. Goldsmith, 1773), 28; William Betham, *The Baronetage of England; or, the History of the English Baronets* (London: E. Lloyd, 1805), 5:540–42, pl. 26, no. 507.

19. George Richardson, *Iconology; or, A Collection of Emblematical Figures*, vol. 2 (London: G. Scott, 1779), pl. LXXII, fig. 275; Jaffe, "John Singleton Copley's *Watson and the Shark*," 20–21, fig. 8.

20. "Vigilanza," in Cesare Ripa, *Iconologia* (1611; repr., New York: Garland Publishing, 1976), 531–33; George Wither, *A Collection of Emblems, Ancient and Modern* (1635; repr. Columbia: University of South Carolina Press, 1975), 155; *Curious Relations; or, the Entertaining Correspondent* (London: G. Smith, 1738), 1:63–66; Giambattista della Porta, *Natural Magick* (1658; repr., New York: Basic Books, 1957), 10; Hans Biedermann, *Dictionary of Symbolism*, trans. James Hulbert (New York: Meridian, 1994), 328–29.

21. Charles Avery, *Giambologna: The Complete Sculpture* (Oxford: Phaidon, 1987), 21–27, 124–31, 256, 258–59, 261; Joseph Baretti, *A Guide through the Royal Academy* (London: T. Cadell, 1781), 9, 12.

22. John Mulryan and Steven Brown, trans. and eds., *Natale Conti's Mythologiae*, (Tempe: Arizona Center for Medieval and Renaissance Studies, 2006), 1:361; Andrew Tooke, *The Pantheon*, 6th ed. (1713; repr., New York: Garland Publishing, 1976), 65.

23. John Guillim, *A Display of Heraldry*, 5th ed. (London: S. Roycroft, 1679), 171; bk. 4.370–379 of Virgil's *Æneis*, trans. by John Dryden, in *The Works of John Dryden*, ed. Alan Roper, vol. 5, *Poems: The Works of Virgil in English, 1697*, ed. William Frost (Berkeley: University of California Press, 1987), 463–65; Hope B. Werness, *The Continuum Encyclopedia of Animal Symbolism in Art* (New York: Continuum, 2004), 420–21.

24. *Curious Relations*, 1:65; R. B. Pysent, "The Devil's Stench and Living Water: A Study of Demons and Adultery in Czech Vernacular Literature of the Middle Ages and Renaissance," *The Slavonic and East European Review* 71, no. 4 (October 1993): 622.

25. Berkeley, *Siris*, 31, 34–35, 58, 91–92.

26. Berkeley, *Siris*, 39, 71, 138–64; Thomas Prior, *An Authentic Narrative of the Success of Tar-Water* (Dublin: Margt. Rhames, 1746), 206–9.

27. *Oxford English Dictionary Online*, "Hermetic," http://dictionary.oed.com (accessed October 7, 2012).

28. Based upon a 1775 letter received from Copley, Ozias Humphrey recorded the full recipe for "Mr. Copelys Varnish" in his memo book for March 22, 1779: "a pint of Spirits of rectified Wine / ¼ of a pd of Gum Sandrack / 4 Spoon-fulls of Canada Balsam [Copley called it Balsam of Fir] put these together in a Bottle & place them either in the Summer Sun or near the fire, remembering that the Bottle must not be stop'd close as it wd certainly burst." Quoted in Prown, *John Singleton Copley*, 2:254, note 28. Berkeley, *Siris*, 38. J. William Shank notes that Copley's original varnishes have "long since been removed and replaced." Shank, "John Singleton Copley's Portraits," 137. On "spirit varnishes," see Leslie Carlyle, *The Artist's Assistant: Oil Painting Instruction Manuals and Handbooks in Britain, 1800–1900* (London: Archetype Publications, 2002), 73–97. On gum sandarac derived from *Callitris quadrivalvis*, an evergreen native to northwest Africa, see *Oxford English Dictionary Online*, "Sandarac." On Canada balsam being derived from the North American Balm of Gilead fir, see *Oxford English Dictionary Online*, "Balm." On balms and balsams as alchemical panaceas, see Lyndy Abraham, *A Dictionary of Alchemical Imagery* (Cambridge: Cambridge University Press, 1998), 16.

29. Abraham, *Dictionary*, 99–100, 191–92. Thomas Dallam refers to sharks as storks in a 1600 diary entry in James Theodore Bent, ed., *Early Voyages and Travels in the Levant* (London: Hakluyt Society, 1893), 95.

30. Georg Ernest Stahl, *Philosophical Principles of Universal Chemistry*, trans. Peter Shaw (London: John Osborne and Thomas Longman, 1730), 401–2; 416, 475; Salmon, *Polygraphice*, 475; Berkeley, *Siris*, 97–98.

31. Berkeley, *Siris*, 92.

32. Johann Daniel Mylius, *Opus Medico-chymicum* (1618), in *The Golden Game: Alchemical Engravings of the Seventeenth Century*, ed. Stanislaus Klossowski de Rola (New York: George Braziller, 1988),133, 142, 151, fig.157; Johann Daniel Mylius, *Hermetico-Spagyrisches Lustgartlein Darinnen Hundert und Sechtig . . . Chymico-Sophische Emblemata*, in Johann Grasshoff, *Dyas Chymica Tripartita* (Frankfurt: Luca Jennis, 1625), plate facing p. 10. The emblem appears also in Daniel Stolcius de Stolcenberg, *Hortulus Hermeticus* (1627), in *Bibliotheca Chemica Curiosa*, ed. Jean Jacques Manget (Geneva: Sumpt. Chouet, et al., 1702), 2: plate IX, fig. 15, facing p. 897. Dr. Samuel Danforth (1740–1827), son of alchemist Samuel Danforth (1696–1777), Copley's patron, donated Jean Jacques Manget's *Bibliotheca Chemica Curiosa* (1702) to the Boston Athenaeum. See Athena: The Boston Athenæum Online Catalog, http://catalog.bostonathenaeum.org/. On the Ethiopian figure, see also Laurinda S. Dixon and Petra ten-Doesschate Chu, "An Iconographical Riddle: Gerbrandt van den Eeckhout's *Royal Repast* in the Lichtenstein Princely Collections," *The Art Bulletin* 71 (December 1989): 624–25; Kim F. Hall, *Things of Darkness: Economies of Race and Gender in Early Modern England* (Ithaca, NY: Cornell University Press, 1995), 114–15. On Euthices, see Jacobus de Voragine, *The Golden Legend: Readings on the Saints*, trans. William Granger Ryan, (Princeton, NJ: Princeton University Press, 1993), 1:309–10.

33. Berkeley, *Siris*, 90; Abraham, *Dictionary*, 71, 178–79; Antoine-Joseph Pernety, *An Alchemical Treatise on the Great Art*, trans. and ed. Edouard Blitz (1898; repr., York Beach, ME: Samuel Weiser, 1995), 185–86; Antoine-Joseph Pernety, *Dictionnaire Mytho-Hermétique*, (1758; repr., Milan: Archè, 1980), 66; Withington, *English Pageantry*, 1:73; Peter Eisenstadt, "Almanacs and the Disenchantment of Early America," *Pennsylvania History* 65, no. 2 (Spring 1998), 155–56; Jon Butler, *Awash in a Sea of Faith: Christianizing the American People* (Cambridge, MA: Harvard University Press, 1990), 80–82, fig. 3; Marcus Manilius, *Astronomica* (2.244–2.269), 101–3; Jean Chevalier and Alain Gheerbrant, "Cancer (22 June–22 July)," in *A Dictionary of Symbols*, trans. John Buchanan-Brown (London: Penguin Books, 1996), 150–51; William Hogarth, *The Analysis of Beauty* (1753; repr., New Haven, CT: Yale University Press, 1997), 2–12, 21.

34. Giambattista della Porta, *Natural Magick*, 2; G. S. Rousseau and Marjorie Hope Nicolson, "Praxis 1: Bishop Berkeley and Tar-Water," in G. S. Rousseau, *Enlightenment Borders: Pre- and Post-modern Discourses Medical and Scientific* (Manchester, UK: Manchester University Press, 1991), 152.

35. Ephraim Chambers, *A Supplement to Mr. Chambers's Cyclopædia; or, Universal Dictionary of Arts and Sciences*, vol. 2 (London: W. Innys et al., 1753), s.v. pox; George Cheyne, *The English Malady* (1733; repr., Delmar, NY: Scholars's Facsimiles and Reprints, 1976), 89; Dossie, *The Elaboratory*, 244–50; Dossie, *The Handmaid*, 42–47; Copley, memorandum in Henry Pelham to Henry and Thomas Bromfield, 6 June 1771, in Jones et al., eds., *Letters and Papers*, 115; Donald R. Dickson, "Thomas Henshaw and Sir Robert Paston's Pursuit of the Red Elixir: An Early Collaboration between Fellows of the Royal Society," *Notes and Records of the Royal Society of London* 51 (January 1997): 64.

36. John S. Copley Jr. to Mrs. Greene, 9 August 1802, in Martha Babcock Amory, *The Domestic and Artistic Life of John Singleton Copley* (1882; repr., Freeport, NY: Books for Libraries Presses, 1970), 230–31. On vermillion and Copley's palette, see Shank, "John Singleton Copley's Portraits," 134, 141; J. E. Cirlot, "Heart," in *A Dictionary of Symbols*, trans. Jack Sage (1971; repr., Mineola, NY: Dover Publications, 2002), 141–42.

37. Copley to Henry Pelham, 7 September 1774, in Jones et al., eds., *Letters and Papers*, 250.

38. Phillis Wheatley, "On Being Brought from Africa to America," in *The Poems of Phillis Wheatley*, ed. Julian D. Mason (Chapel Hill: University of North Carolina, 1989), 53. On Brook Watson, see Wheatley's letter to Col. David Worcester, 18 October 1773, in Wheatley, *Poems*, 197. Wheatley, "The Answer," in *Poems*, 160–61.

39. Alan E. Shapiro, "Artists' Colors and Newton's Colors," *Isis* 85 (1994): 616.

40. See Book two, part III, prop. X and Quest. 30 in Newton, *Opticks*, 274–75, 374–75; Alan E. Shapiro, *Fits, Passions, and Paroxysms: Physics, Method, and Chemistry and Newton's Theory of Colored Bodies and Fits of Easy Reflection* (Cambridge: Cambridge University Press, 1993), 247.

41. G. N. Cantor and M. J. S. Hodge, "Introduction: Major Themes in the Development of Ether Theories from the Ancients to 1900," in *Conceptions of Ether: Studies in the History of Ether Theories, 1740–1900*, ed. Geoffrey N. Cantor and M. J. S. Hodge (Cambridge: Cambridge University Press, 1981), 24–26; Alan E. Shapiro, *Fits, Passions, and Paroxysms*, 244, 264–76; Bjelajac, *Washington Allston*, 37–38.

42. Salmon, *Polygraphice*, 333, 480; Bjelajac, *American Art*, 124, 134, figs. 4.13, 4.29; Bjelajac, *Washington Allston*, 44–45.

43. Harold B. Gill Jr., *The Apothecary in Colonial Virginia* (Williamsburg, VA: Colonial Williamsburg Foundation, 1972), 14; Walter W. Skeat, "Snakestones and Stone Thunderbolts as Subjects for Systematic Investigation," *Folklore* 23 (March 1912): 48; Manilius, *Astronomica* (2.453–2.465), 119; "Scorpio," in Cirlot, *Dictionary*, 280–81; "Scorpio (23 October–21 November)," in Chevalier and Gheerbrant, *Dictionary*, 835; Milford, *The Gardiners of Massachusetts*, 22–23.

44. G. Zammit-Maempel, "The Evil Eye and Protective Cattle Horns in Malta," *Folklore* 79 (Spring 1968): 3; Patrick Brydone, *A Tour through Sicily and Malta*, 2nd ed., (Dublin: T. Ewing and W. Wilson, 1774), 1:231–32; Esther Sparks, "*St Paul's Shaking off the Viper*: An Early Romantic Series by Benjamin West," *Art Institute of Chicago Museum Studies* 6 (1971): 59–65.

45. Douglas Brooks-Davis, *The Mercurian Monarch: Magical Politics from Spenser to Pope* (Manchester, UK: Manchester University Press, 1983), 1–2; Edgar Wind, *Pagan Mysteries in the Renaissance*, rev. ed. (New York: W. W. Norton and Co., 1968), 252–53.

46. Thomas S. Kidd, *The Great Awakening: The Roots of Evangelical Christianity in Colonial America* (New Haven, CT: Yale University Press, 2007), 213–39.

47. Richard Barton, *The Analogy of Divine Wisdom* (Dublin: 1750), 80; G. N. Cantor, "The Theological Significance of Ethers," in Cantor and Hodge, eds., *Conceptions of Ether*, 147–49.

48. *Curious Relations*, 2:39; Baretti, *A Guide*, 5; "Scorpion," in Chevalier and Gheerbrant, *Dictionary*, 836; Nicholas Goodrick-Clarke, *The Western Esoteric Traditions: A Historical Introduction* (Oxford: Oxford University Press, 2008), 17.

49. "Luna" and "Sun," in Abraham, *Dictionary*, 119–20, 194–95; Barbara E. Lacey, "Visual Images of Blacks in Early American Imprints," *The William and Mary Quarterly* 53 (January 1996): 176–78; George Ferguson, *Signs and Symbols in Christian Art*

(Oxford: Oxford University Press, 1973), 18; Carol F. Lewine, "Aries, Taurus and Gemini in Raphael's *Sacrifice at Lystra*," *The Art Bulletin* 72, no. 2 (June 1990): 277–78; George G. Carey, "The Tradition of St. Elmo's Fire," *American Neptune* 23 (1963): 29–38; G. P. Goold, "Introduction," in Manilius, *Astronomica*, xxiv–xxv; "Aquarius," in Cirlot, *Dictionary*, 14–15.

50. George Cockings, *War: A Heroic Poem from the Taking of Minorca by the French to the Reduction of Manila*, 4th ed. (London: S. Hooper, 1765), 153; Shane White and Graham White, "Slave Hair and African American Culture in the Eighteenth and Nine-teenth Centuries," *The Journal of Southern History* 61, no. 1 (February 1995): 55–56; Lewine, "Aries, Taurus," 278; "Sagittarius," in Cirlot, *Dictionary*, 277.

51. Jacob Bryant, *A New System; or, An Analysis of Antient Mythology* (London: J. Walker, 1807), 2:110–27.

52. *The St. James's Chronicle; or British Evening-Post*, April 25–28, 1778, quoted in Miles, "Watson and the Shark," 70; Joseph Sewall, *A Sermon Preached at the Thursday-lecture in Boston, September 16, 1762, before the Great and General Court of the Province of the Massachusetts-Bay, in New-England. On the Joyful News of the Reduction of the Havannah* (Boston: John Draper, Edes and Gill, 1762); Levander, "The Jerusalem Sols," 24, 27–28.

53. George Stepney Townley, *Six Sermons Preached before the Right Hon. Brook Watson, Lord Mayor of the City of London* (London: W. Wilson, 1797), 100.

54. William Pitt Scargill, *Recollections of a Blue-Coat Boy; or, A View of Christ's Hospital* (1829; repr., New York: Johnson Reprint Corporation, 1968), 161. Watson's bequest to Christ's Hospital is quoted in Miles, *American Paintings*, 67, note 1.

55. Berkeley, *Siris*, 34. In Masonic prints, the inscription "cemented with love" sometimes appears on emblematic stonemasonry arches. See Bullock, *Revolutionary Brotherhood*, 88, fig. 7.

56. Allen G. Debus, *The French Paracelsians: The Chemical Challenge to Medical and Scientific Tradition in Early Modern France* (Cambridge: Cambridge University Press, 1991), 10–11; "Salt, Sulphur and Mercury," in Abraham, *Dictionary*, 176–77; "Libra," in Chevalier and Gheerbrant, *Dictionary*, 600.

Bibliography

Abraham, Lyndy. *A Dictionary of Alchemical Imagery*. Cambridge: Cambridge University Press, 1998.

Abrams, Ann Uhry. "Politics, Prints, and John Singleton Copley's *Watson and the Shark*." *The Art Bulletin* 61 (June 1979): 265–76.

Algarotti, Francesco. *An Essay on Painting*. London: Davis and Reymes, 1764.

Amory, Martha Babcock. *The Domestic and Artistic Life of John Singleton Copley*. 1882. Reprint, Freeport, NY: Books for Libraries Presses, 1970.

Avery, Charles. *Giambologna: The Complete Sculpture*. Oxford: Phaidon, 1987.

Baretti, Joseph. *A Guide through the Royal Academy*. London: T. Cadell, 1781.

Barton, Richard. *The Analogy of Divine Wisdom*. Dublin: 1750.

Bendersky, Gordon. "The Original 'Jaws' Attack." *Perspectives in Biology and Medicine* 45 (Summer 2002): 426–32.

Bent, James Theodore, ed. *Early Voyages and Travels in the Levant*. London: Hakluyt Society, 1893.

Berkeley, George. *Siris: A Chain of Philosophical Reflexions and Inquiries Concerning the Virtues of Tar Water*. Edited by T. E. Jessup. Vol. 5 of *The Works of George Berkeley*, edited by A. A. Luce and T. E. Jessup. Edinburgh: Thomas Nelson and Sons, 1948.

Betham, William. *The Baronetage of England; or, the History of the English Baronets*. Vol. 5. London: E. Lloyd, 1805.

Biedermann, Hans. *Dictionary of Symbolism*. Translated by James Hulbert. New York: Meridian, 1994.

Bjelajac, David. *American Art: A Cultural History*. 2nd ed. Upper Saddle River, NJ: Prentice Hall, 2005.

———. *Washington Allston, Secret Societies and the Alchemy of Anglo-American Painting*. Cambridge: Cambridge University Press, 1997.

Boime, Albert. *The Art of Exclusion: Representing Blacks in the Nineteenth Century*. London: Thames and Hudson, 1990.

Brand, John. *Observations on the Popular Antiquities of Great Britain*. Rev. ed. by Henry Ellis. 3 vols. London: G. Bell, 1883.

Brooke, John L. *The Refiner's Fire: The Making of Mormon Cosmology, 1644–1844*. Cambridge: Cambridge University Press, 1994.

Brooks-Davis, Douglas. *The Mercurian Monarch: Magical Politics from Spenser to Pope*. Manchester, UK: Manchester University Press, 1983.

Bryant, Jacob. *A New System; or, An Analysis of Antient Mythology*. 6 vols. London: J. Walker, 1807.

Brydone, Patrick. *A Tour through Sicily and Malta*. 2nd ed. 2 vols. Dublin: T. Ewing and W. Wilson, 1774.

Bullock, Steven C. *Revolutionary Brotherhood: Freemasonry and the Transformation of the American Social Order, 1730–1840*. Chapel Hill: University of North Carolina Press, 1996.

Butler, John. *Awash in a Sea of Faith: Christianizing the American People*. Cambridge, MA: Harvard University Press, 1990.

Cantor, Geoffrey N., and M. J. S. Hodge, eds. *Conceptions of Ether: Studies in the History of Ether Theories, 1740–1900*. Cambridge: Cambridge University Press, 1981.

Carey, George G. "The Tradition of St. Elmo's Fire." *American Neptune* 23 (1963): 29–38.

Carlyle, Leslie. *The Artist's Assistant: Oil Painting Instruction Manuals and Handbooks in Britain, 1800–1900*. London: Archetype Publications, 2001.

Chambers, Ephraim. *A Supplement to Mr. Chambers's Cyclopædia; or, Universal Dictionary of Arts and Sciences*. 2 vols. London: W. Innys et al., 1753.

Chevalier, Jean, and Alain Gheerbrant. *A Dictionary of Symbols*. Translated by John Buchanan-Brown. London: Penguin Books, 1996.

Cheyne, George. *The English Malady*. 1733. Reprint, Delmar, NY: Scholars's Facsimiles and Reprints, 1976.

Cirlot, J. E. *A Dictionary of Symbols*. Translated by Jack Sage. 1971. Reprint, Mineola, NY: Dover Publications, 2002.

Clack, Randall A. *Marriage of Heaven and Earth: Alchemical Regeneration in the Works of Taylor, Poe, Hawthorne and Fuller*. Westport, CT: Greenwood, 2000.

Cockings, George. *War: A Heroic Poem from the Taking of Minorca by the French to the Reduction of Manila*. 4th ed. London: S. Hooper, 1765.

Curious Relations; or, the Entertaining Correspondent. 2 vols. London: G. Smith, 1738.

Curl, James Stevens. *Spas, Wells, and Pleasure-Gardens of London*. London: Historical Publications, 2010.

Debus, Allen. *The French Paracelsians: The Chemical Challenge to Medical and Scientific Tradition in Early Modern France*. Cambridge: Cambridge University Press, 1991.

Dickson, Donald R. "Thomas Henshaw and Sir Robert Paston's Pursuit of the Red Elixir: An Early Collaboration between Fellows of the Royal Society." *Notes and Records of the Royal Society of London* 51 (January 1997): 57–76.

Dixon, Laurinda S., and Petra ten-Doesschate Chu. "An Iconographical Riddle: Gerbrandt van den Eeckhout's *Royal Repast* in the Lichtenstein Princely Collections." *The Art Bulletin* 71 (December 1989): 610–27.

Dobbs, Betty Jo Teeter. *The Janus Faces of Genius: The Role of Alchemy in Newton's Thought*. Cambridge: Cambridge University Press, 1991.

Dossie, Robert. *The Elaboratory Laid Open; or, the Secrets of Modern Chemistry and Pharmacy Revealed*. London: J. Nourse, 1758.

———. *The Handmaid to the Arts*. London: J. Nourse, 1758.

Duché, Jacob. *Discourses on Various Subjects*. Vol. 1. London: J. Phillips, 1779.

Eisenstadt, Peter. "Almanacs and the Disenchantment of Early America." *Pennsylvania History* 65, no. 2 (Spring 1998): 143–69.

Exquemelin, Alexandre. *The History of the Bucaniers of America*. 2 vols. London: Thomas Newborough, John Nicholson and Benjamin Tooke, 1699.

Ferguson, George. *Signs and Symbols in Christian Art*. Oxford: Oxford University Press, 1973.

Foote, Henry Wilder. *Annals of King's Chapel from the Puritan Age to the Present Day*. Vol. 2. Boston: Little Brown and Co., 1896.

Fortune, Brandon Brame. *Franklin and His Friends: Portraying the Man of Science in Eighteenth-Century America*. With Deborah J. Warner. Washington, DC: Smithsonian National Portrait Gallery, 1999.

Gately, Iain. *Tobacco: A Cultural History of How an Exotic Plant Seduced Civilization*. New York: Grove Press, 2001.

Gill, Harold B., Jr. *The Apothecary in Colonial Virginia*. Williamsburg, VA: Colonial Williamsburg Foundation, 1972.

Goodrick-Clarke, Nicholas. *The Western Esoteric Traditions: A Historical Introduction*. Oxford: Oxford University Press, 2008.

Guillim, John. *A Display of Heraldry*. 5th ed. London: S. Roycroft, 1679.

Hall, Kim F. *Things of Darkness: Economies of Race and Gender in Early Modern England*. Ithaca, NY: Cornell University Press, 1995.

Hanson, Craig Ashley. *The English Virtuoso: Art, Medicine, and Antiquarianism in the Age of Empiricism*. Chicago: University of Chicago Press, 2009.

Harrison, Mark. "From Medical Astrology to Medical Astronomy: Sol-Lunar and Planetary Theories of Disease in British Medicine, c. 1700–1850." *The British Journal for the History of Science* 33 (March 2000): 25–48.

Henningsen, Henning. *Crossing the Equator: Sailors' Baptism and Other Initiation Rites*. Copenhagen: Munksgaard, 1961.

Hogarth, William. *The Analysis of Beauty*. 1753. Reprint, New Haven, CT: Yale University Press, 1997.

Hughes, M. "Newton, Hermes and Berkeley." *British Journal for the Philosophy of Science* 43 (1992): 1–19.

Hutchinson, William. *The Spirit of Masonry*. 1775. Reprint, Wellingborough, UK: The Aquarian Press, 1987.

Jaffe, Irma B. "John Singleton Copley's *Watson and the Shark*," *American Art Journal* 9, no. 1 (May 1977): 15–25.

Jones, Guernsey, Charles Francis Adams, and Worthington Chauncey Ford, eds. *Letters and Papers of John Singleton Copley and Henry Pelham, 1739–1776*. 1914. Reprint, New York: Kennedy Graphics and Da Capo Press, 1970.

Jules David Prown Papers. Manuscripts and Archives, Sterling Memorial Library, Yale University.

Kidd, Thomas S. *The Great Awakening: The Roots of Evangelical Christianity in Colonial America*. New Haven, CT: Yale University Press, 2007.

Kim, Mi Gyung. "Chemical Analysis and the Domains of Reality: Wilhelm Homberg's *Essais de Chimie*, 1702–1709." *Studies in History and Philosophy of Science* 31, no. 1 (2000): 37–69.

Lacey, Barbara E. "Visual Images of Blacks in Early American Imprints." *The William and Mary Quarterly* 53 (January 1996): 137–80.

Levander, F. W. "The Jerusalem Sols and Some Other London Societies of the Eighteenth Century." *Ars Quatuor Coronatorum* 25 (1912): 9–38.

Lewine, Carol F. "Aries, Taurus and Gemini in Raphael's *Sacrifice at Lystra*." *The Art Bulletin* 72, no. 2 (June 1990): 271–83.

Lydenberg, Henry Miller. *Crossing the Line: Tales of the Ceremony during Four Centuries*. New York: New York Public Library, 1957.

Manilius, Marcus. *Astronomica*. Introduction and translation by G. P. Goold. Loeb Classical Library. Cambridge, MA: Harvard University Press, 1977.

Mayo, Lawrence Shaw. *The Winthrop Family in America*. Boston: Massachusetts Historical Society, 1948.

Mead, Richard. *The Medical Works of Richard Mead, M.D.* 1775. Reprint, New York: AMS Press, 1978.

Miles, Ellen G. *American Paintings of the Eighteenth Century*. Washington, DC: National Gallery of Art, 1995.

Chapter 10

Milford, T. A. *The Gardiners of Massachusetts: Provincial Ambition and the British-American Career.* Durham: University of New Hampshire Press, 2005.

Mulryan, John, and Steven Brown, trans. and eds. *Natale Conti's Mythologiae.* 2 vols. Tempe: Arizona Center for Medieval and Renaissance Studies, 2006. Original published in 1581.

Mylius, Johann Daniel. *Hermetico-Spagyrisches Lustgartlein Darinnen Hundert und Sechtig . . . Chymico-Sophische Emblemata.* In Johann Grasshoff. *Dyas Chymica Tripartita.* Frankfurt: Luca Jennis, 1625.

———. *Opus Medico-chymicum.* 1618. In *The Golden Game: Alchemical Engravings of the Seventeenth Century,* edited by Stanislaus Klossowski de Rola, 133–55. New York: George Braziller, 1988.

Newton, Isaac. *Opticks.* 4th ed. 1730. Reprint, New York: Dover Publications, 1979.

Pernety, Antoine-Joseph. *An Alchemical Treatise on the Great Art.* Translated and edited by Edouard Blitz. 1898. Reprint, York Beach, ME: Samuel Weiser, 1995.

———. *Dictionnaire Mytho-Hermétique.* 1758. Reprint, Milan: Archè, 1980.

———. *The History of a Voyage to the Malouine or Falkland Islands Made in 1763 and 1764, under the command of M. de Bougainville.* Translated from the French. 2nd ed. London: W. Goldsmith, 1773.

Porta, Giambattista della. *Natural Magick.* 1658. Reprint, New York: Basic Books, 1957. Translation of *Magiae naturalis.*

"Portraits of Peter and Charles Pelham." In *Proceedings of the Most Worshipful Grand Lodge of Ancient Free and Accepted Masons of the Commonwealth of Massachusetts . . . 1900,* 121–28. Boston: Rockwell and Churchill Press, 1900.

Prior, Thomas. *An Authentic Narrative of the Success of Tar-Water.* Dublin: Margt. Rhames, 1746.

Prown, Jules David. *John Singleton Copley.* 2 vols. Cambridge, MA: Harvard University Press, 1966.

Pysent, R. B. "The Devil's Stench and Living Water: A Study of Demons and Adultery in Czech Vernacular Literature of the Middle Ages and Renaissance." *The Slavonic and East European Review* 71, no. 4 (October 1993): 601–30.

Rebora, Carrie, Paul Staiti, Erica E. Hirshler, Theodore E. Stebbins Jr., and Carol Troyen, *John Singleton Copley in America.* New York: The Metropolitan Museum of Art, 1995.

Richardson, George. *Iconology; or, A Collection of Emblematical Figures.* 2 vols. London: G. Scott, 1778–1779.

Ripa, Cesare. *Iconologia.* 1611. Reprint, New York: Garland Publishing, 1976.

Roberts, Jennifer. "Copley's Cargo: *Boy with a Squirrel* and the Dilemma of Transit." *American Art* 21 (Summer 2007): 20–41.

———. "Failure to Deliver: *Watson and the Shark* and the Boston Tea Party." *Art History* 34, no.4 (September 2011): 674–95.

Rousseau, G. S. *Enlightenment Borders: Pre- and Post-modern Discourses Medical and Scientific.* Manchester, UK: Manchester University Press, 1991.

Salmon, William. *Polygraphice.* 5th ed. London: Thomas Passinger and Thomas Sawbridge, 1685.

Scargill, William Pitt. *Recollections of a Blue-Coat Boy; or, A View of Christ's Hospital.* 1829. Reprint, New York: Johnson Reprint Corporation, 1968.

Sewall, Joseph. *A Sermon Preached at the Thursday-lecture in Boston, September 16, 1762, before the Great and General Court of the Province of the Massachusetts-Bay, in New-England. On the Joyful News of the Reduction of the Havannah.* Boston: John Draper, Edes and Gill, 1762.

Shank, J. William. "John Singleton Copley's Portraits: A Technical Study of Three Representative Examples." *Journal of the American Institute of Conservation* 23 (Spring 1984): 130–52.

Shapiro, Alan E. "Artists' Colors and Newton's Colors." *Isis* 85 (1994): 600–30.

———. *Fits, Passions, and Paroxysms: Physics, Method, and Chemistry and Newton's Theory of Colored Bodies and Fits of Easy Reflection.* Cambridge: Cambridge University Press, 1993.

Shute, Michael N., ed. *The Scientific Work of John Winthrop.* New York: Arno Press, 1980.

Skeat, Walter W. "Snakestones and Stone Thunderbolts as Subjects for Systematic Investigation." *Folklore* 23 (March 1912): 45–80.

Sorkin, David. *The Religious Enlightenment: Protestants, Jews, and Catholics from London to Vienna.* Princeton, NJ: Princeton University Press, 2008.

Sparks, Esther. "*St Paul's Shaking off the Viper:* An Early Romantic Series by Benjamin West." *Art Institute of Chicago Museum Studies* 6 (1971): 59–65.

Stahl, Georg Ernest. *Philosophical Principles of Universal Chemistry.* Translated by Peter Shaw. London: John Osborne and Thomas Longman, 1730.

Stein, Roger B. "Copley's *Watson and the Shark* and Aesthetics in the 1770s." In *Discoveries and Considerations: Essays on Early American Literature and Aesthetics Presented to Harold Jantz,* edited by Calvin Israel, 85–130. Albany: State University of New York Press, 1976.

Stolcius de Stolcenberg, Daniel. *Hortulus Hermeticus.* 1627. In *Bibliotheca Chemica Curiosa,* edited by Jean Jacques Manget, vol. 2, pp. 895–904. Geneva: Sumpt. Chouet, et al., 1702.

Tooke, Andrew. *The Pantheon.* 6th ed. 1713. Reprint, New York: Garland Publishing, 1976.

Townley, George Stepney. *Six Sermons Preached before the Right Hon. Brook Watson, Lord Mayor of the City of London.* London: W. Wilson, 1797.

Virgil's Æneis. Translated by John Dryden. In *The Works of John Dryden.* Edited by Alan Roper. Vol. 5, *Poems: The Works of Virgil in English, 1697,* edited by William Frost. Berkeley: University of California Press, 1987.

Voragine, Jacobus de. *The Golden Legend: Readings on the Saints*. Translated by William Granger Ryan. Vol. 1. Princeton, NJ: Princeton University Press, 1993.

Weibust, Knut. *Deep Sea Sailors: A Study in Maritime Ethnology*. Stockholm: Nordiska museets Handlinger, 1969.

Werness, Hope B. *The Continuum Encyclopedia of Animal Symbolism in Art*. New York: Continuum, 2004.

Wheatley, Phillis. *The Poems of Phillis Wheatley*. Edited by Julian D. Mason. Chapel Hill: University of North Carolina Press, 1989.

White, Shane, and Graham White. "Slave Hair and African American Culture in the Eighteenth and Nineteenth Centuries." *The Journal of Southern History* 61, no. 1 (February 1995): 55–56.

Wilkinson, Ronald Sterne. "The Alchemical Library of John Winthrop, Jr. (1606–1676) and His Descendants in Colonial America." Pts. 1 and 2. *Ambix* 11 (February 1963): 33–51; 13 (October 1966): 139–86.

Wind, Edgar. *Pagan Mysteries in the Renaissance*. Rev. ed. New York: W. W. Norton and Co., 1968.

Winthrop, John. "A Lecture on Earthquakes." 1755. Reprinted in *The Scientific Work of John Winthrop*, edited by Michael N. Shute. New York: Arno Press, 1980.

Wither, George. *A Collection of Emblems, Ancient and Modern*. 1635. Reprint, Columbia: University of South Carolina Press, 1975.

Withington, Robert. *English Pageantry*. 2 vols. 1926. Reprint, New York: Benjamin Blom, 1963.

Wolf, Bryan Jay. *Romantic Re-vision: Culture and Consciousness in Nineteenth-Century American Painting and Literature*. Chicago: University of Chicago Press, 1982.

Zammit-Maempel, G. "The Evil Eye and Protective Cattle Horns in Malta." *Folklore* 79 (Spring 1968): 1–16.

C. A. A. Dellschau
An Outsider Artist and the Dream of Flight

Tom D. Crouch

Senior Curator

Smithsonian Institution
National Air and Space Museum
Washington, D.C.

Introduction

In the last week of July 1899, Wilbur Wright, a thirty-two-year-old resident of Dayton, Ohio, flew an odd-looking biplane kite from the grounds of the Union Theological Seminary, ten or twelve blocks from the bicycle shop that he operated with his younger brother Orville at 22 South Williams Street. While a small group of boys looked on, he manipulated the kite lines, causing the little craft to climb, dive, and bank on command. The Wright brothers had taken their first step down a path that would lead to the invention of the airplane.[1]

Just before Christmas that same year, Charles August Albert Dellschau, a seventy-year-old retired butcher living in Houston, Texas, began working on two volumes of reminiscences, both richly illustrated with vivid water colors of fanciful airships that looked as if they had flown off the garish cover of a dime novel. He insisted, however, that these machines were the product of discussions among a group of friends in the California gold fields half a century before.

In the two volumes Dellschau recounted the tale of the Sonora Aero Club, its members, and their airships, some of which he claimed had been secretly built and flown over the Sierra mining camps, whereas others were only pipe dreams. He spent the next two decades filling scrapbook after scrapbook with collages in which he mixed vibrant water color images of the half-century-old imaginary flying machines with news clippings chronicling the latest developments in aeronautics. Although his project may well have been rooted in distant memories of

1.
Charles A. A. Dellschau, 1830–1923.

camp fire discussions of aeronautics among a group of friends during the 1850s, it is clear that the extended narrative and the thousands of paintings were the products of his rich imagination.

Charles A. A. Dellschau fits the pattern of an outsider artist. The term describes an untrained painter working without reference to the artistic mainstream in pursuit of a highly personal creative vision with a compulsive zeal that often dominates his or her life. Jean Dubuffet, the French scholar who pioneered this field, explained that he was referring to "artistic works . . . owing nothing to the imitation of art that one can see in museums, salons and galleries . . . works which the artist has entirely derived (invention and expression) from his own sources, from his own impulses and humors, without regard for the rules, without regard for current convention."[2] This chapter will consider C. A. A. Dellschau as an outsider artist and examine the way in which his work was shaped by and reflected his fascination with the rapid evolution of aeronautical technology during his lifetime (Figure 1).

The Early Years

Born in Prussia in the spring of 1830, eighteen-year-old Dellschau probably entered the United States through the port of Galveston, Texas, in 1849. The following year one A. A. Dellschau registered his intention to file for U.S. citizenship. He apparently spent some of the next decade in California. Back in Texas, Dellschau obtained his citizenship in 1860, married, and began a family. Following service in the Confederate Army, he returned to his growing family and the life of a butcher in Richmond, Fort Bend County, Texas.

The closing decades of the nineteenth century were filled with family tragedy for Dellschau. By 1899, when he began recording his *Reminiscences of Years Past of Time and a Way of Life Written and Illustrated in Idles Hours* in the pages of a hand-bound maroon notebook, he had outlived his wife and three children and was retired and living in the home of his widowed stepdaughter in Houston. This manuscript volume and a second volume that would be completed in 1902 offered an account of the time that Dellschau had spent in Sonora, Tuolumne County, California, between 1856 and 1859.[3]

What could have impelled Dellschau to begin his work at that point? It is worth noting that outsider artists frequently launch their obsessive projects in the wake of personal crisis. Barbara Ross Geiger notes that individuals like Dellschau, "often at times of intense psychic crisis . . . begin to draw or paint . . . in ways that . . . [are] highly personal and idiosyncratic."[4] Art historian Roger Cardinal suggests that old age and personal trauma can spark intense artistic creativity among such individuals, and John Beardsley reports a case in which another self-trained artist recovering from a family tragedy "grabbed onto his vision of a more perfect world, a world of total elations, perhaps as a compensation or this loss."[5]

Whatever led to their creation, the manuscripts revealed something of Dellschau's life as a butcher and tradesman in the California gold country, described the leading personalities of the community, and offered a highly entertaining account of the rough and tumble pranks and hijinks that were the order of the day in the mining camps. The focus of the memoir, however, was on the activities of a secret society with which he claimed to have been involved. Dellschau initially identified the organization as the Plaines Omnibus Compagnie but ultimately preferred to call it the Sonora Aero Club.

According to the memoir, the club was established in 1856–57, inspired by the work of Peter Mennis, whom Dellschau identified as a "German-Californian gold digger, in his forties, a simple man without formal education, but with a heart of gold." Although "never sober and always flat broke," his friends regarded him as a man blessed with "a genius of making practical things."[6]

Working in secret and "borrowing nails, screws, wire and other items from his friends," Mennis constructed the *Goosey*, "an airship consisting of two balloons" with a basket fitted out with a pilot's seat and steering wheel. Dellschau explained that the inventor generated lift by mixing "soupe," a secret "lifting fluid," with water in a special apparatus inside the two balloons. One Sunday he invited his friends along Wolf Creek to watch his takeoff on a test flight to Sonora and return.[7] "The many skeptics that thought Peter would not return alive or break his neck were proven wrong," Dellschau noted (Figure 2). "When the *Goosey* alighted, many of the big talkers popped their eyes in surprise."[8]

Inspired by Mennis, members of the community formed the Sonora Aero Club, which met every Friday evening at "Madame Glanz's Saloon and Boarding House," where a number of them resided. Each member was required to take the podium at least once a quarter "and thoroughly exercise their jaws," describing their own plans for an airship. Half a century later, Dellschau illustrated his two volumes of *Reminiscence* and *Recolections* [sic] with water color paintings of the fantastic aerial craft that he claimed were designed by his old friends and colleagues so many years before: the *Multiplus*, the *Maikaefer* (*Maybug*), the *Trebla*, the *Aero Rideme*, the *Habicht* (*Hawk*), and the *Taube* (*Dove*).[9]

And that was not the end of the matter. Beginning in 1902–1903 and continuing until 1921, Dellschau filled one large scrapbook after another with hundreds of drawings illustrating scores of the additional airships, including the *Aero Dart*, *Aero Buster*, *Aero Nix*, *Aero Meeo*, *Aero Mina*, *Aero Sicher*, *Aero Gaurda*, *Dora*, *Doubly Browns Doubly*, *Moveable*, and *Long Anna*. The airships

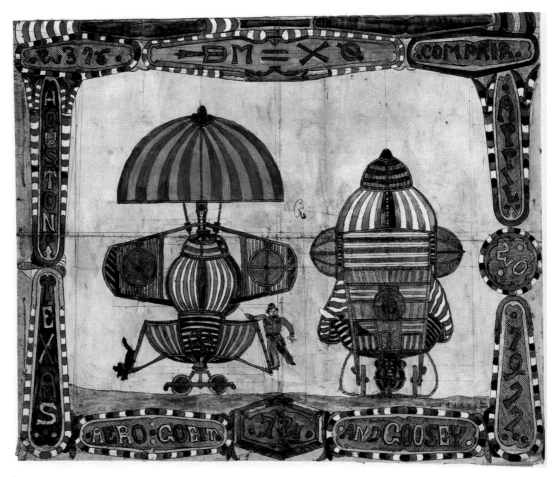

2.
Aero-Goeit (left) and *Goosey* (right). The fellow in the red shirt is Peter Mennis, whom Dellschau identified at the genius behind the Sonora Aero Club. The Dellschau works are from Lauren Redniss, *Charles A. A. Dellschau, 1830–1923* (New York: Ricco/Maresca Gallery, 1997).

were complicated craft, sporting lovely stripped envelopes that were illustrated both empty and inflated. Dellschau drew many versions of the same craft, offering side, top, and cutaway views. As a result, the paintings, all of which are done in vivid water color, often have the feel of artistically rendered technical illustrations (Figure 3).[10]

The artist's draftsmanship, and the marvelous sense of whimsy so apparent in the names of his aircraft, is exercised in his drawings of the members of the club. Shown gazing at the aircraft, climbing aboard, or comfortably ensconced in the operator's position, they are drawn with the precision and charm of comic strip characters. Each of them is a distinct individual. Peter Mennis is always shown with a bright red shirt and high boots. "Doc" Goree, the local physician, is a corpulent, elegantly dressed fellow. One member of the group is bald; others wear distinctive items of clothing.

Each page of the scrapbooks is framed with an intricate, colorful, and distinctive border. The number of the drawing in the total series is often included in the border, as are the name of the

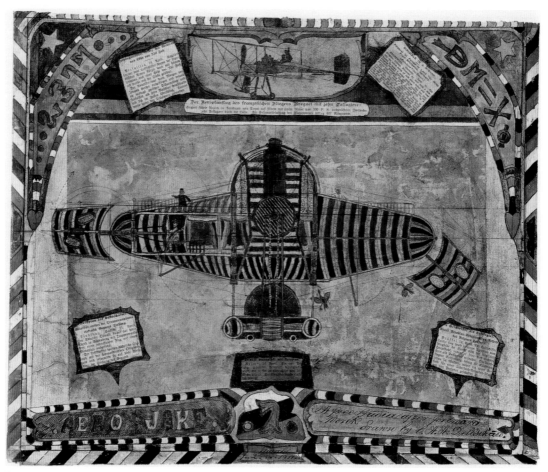

3.
Aero Jake, with press blooms describing recent events in aeronautics. The Dellschau works are from Lauren Redniss, *Charles A. A. Dellschau, 1830–1923* (New York: Ricco/Maresca Gallery, 1997).

airship and the date when the drawing was completed. Dellschau often included commentary on the scene in what may be described as "cursive calligraphy." He frequently included messages written in a code of his own devising. The same short, mysterious "word" appears on many of the images: DM=XO.

But Dellschau's works of art are not simple water color paintings. They are intricate collages in which the airships share the scrapbook page with news clippings, which Dellschau referred to as "press blooms." Most pages are bordered, often elaborately, and dated. In the early years most pages contain both drawings and clippings. Others, particularly those prepared during World War I, are often simply pages of clippings presented in the usual decorated frame. Dellschau continued to churn out finished pages for nineteen years, finally halting in 1921, three years before his death. The sheer bulk of the work is impressive, indicating that the artist averaged almost one page every other day for over two decades.

Is Dellschau's account true, or is the story a figment of his rich artistic imagination? Not a single name of the more than fifty individuals whom the artist names, including himself, can be

identified in local California records. Moreover, art historian Tracy Baker-White has identified some of the names in local Texas records dating from the late nineteenth century. Is it possible that Dellschau populated his account with the names of individuals, and perhaps even personalities and physical types, whom he knew in later life?[11]

At the same time, the place names and at least one business where Dellschau tells us he was employed can be identified in California records. His account of life in the mining camps rings true. Although there is no record of a Sonora Aero Club, such informal social and drinking clubs were to be found in that time and place. The Plaines Omnibus Compagnie has the classical ring of E. Clampus Vitus, one of the best known of the social organizations that flourished in the camps.

As for the airships themselves, when we take a close look at Dellschau's account, we see that only Peter Mennis is claimed to have actually built and flown a machine. In his *Reminiscence* the artist notes that "only the *Goosey* and the *Dove* really functioned, the others were of no more value than the idle dreams that they were built on."[12] Even the *Goosey*, Dellschau noted, "was crude," built of "any simple material" that Mennis "could scrounge up."[13]

If the *Goosey* really did leave the ground, and we have only Dellschau's word that it existed, we can only assume that it was a primitive balloon. Balloonists of the period used sulfuric acid, which Dellschau identifies as the secret of Mennis's machine, to generate the hydrogen gas that filled their envelopes. Even if the *Goosey* did fly, it would not have earned Mennis laurels for having made the first flight in California. That honor goes to a sixteen-year-old fruit vender named Joseph "Ready" Gates, who ascended from Oakland on August 28, 1853, aboard a balloon owned by a Mr. S. Kelly.

Between 1855 and 1857, the period to which Dellschau dates the foundation of the Sonora Aero Club, "Professor" Samuel Wilson attempted, "by lecture and experiment," to convince California investors to finance the creation of a "balloon line" connecting the San Francisco Bay area to the Atlantic Coast. On one occasion in the spring of 1856, Wilson's giant balloon, measuring 100 feet tall (30.5 m) and 90 feet (27.4 m) in diameter, exploded during inflation in Placerville, California. When the professor was reported to have made a successful ascent from Mexico City in June 1857, Californians seemed both surprised and delighted.[14]

Why did C. A. A. Dellschau spend the last two decades of his life filling page after page with drawings of imaginative airships and news clippings chronicling the progress of flight technology? We do not have to look too far for his inspiration. Beginning in the 1850s and continuing throughout his life, newspapers and magazines were filled with stories of flying machines. California newspapers of the 1850s offered many accounts of balloon flights in America and Europe. Dellschau filled his scrapbooks with just such press blooms. It is by no means difficult to imagine a loosely knit group of friends who gathered for a lively discussion of the possibility of building a flying machine that would enable them, as the artist explained, "to cross the plains—and avoid Indian—or White man's stares." Certainly aerial navigation was very much a topic of conversation elsewhere during the era of the California gold rush.[15]

Dellschau and the Dream of Flight

Rufus Porter, a New England born artist and mechanic and the founder of the *Scientific American*, opened the discussion with a pamphlet published in the year the gold rush began: *Aerial Navigation: The Practicability of Travelling Pleasantly and Safely From New York to California in Three Days*. A second pamphlet followed the next year. Porter explained to his readers that he was "making active progress in the construction of an Aerial Transport, for the express purpose of carrying passengers between New York and California." The cigar-shaped, hydrogen-filled airship would carry 50 to 100 passengers on a nonstop journey across the continent at a speed of 60 (96.6 km) to 100 (160.9 km) miles per hour.[16]

Powered by two steam engines, the envelope of the airship, or Aeroport, would be 800 feet (243.8 m) long and 50 feet (15.2 m) in diameter. A salon, or combination passenger cabin and crew compartment, would be suspended beneath the gas bag. Porter announced that transcontinental flights would begin on or about April 1, 1850. The cost of a one-way ticket to California on the first six flights would be $50. After that, the fare would increase to $200. Two hundred tickets, Porter noted, had already been sold.[17]

The inventor had a long-standing interest in flight. He constructed his first model airship in 1833 and published plans for two different airships in 1834 and 1835 issues of the *Mechanic's Magazine*. By the 1840s, Porter was selling stock in the Aerial Navigation Company and had built and flown two model Aeroports filled with hydrogen and powered by clockwork.

The California gold rush offered the perfect opportunity for Porter to realize his dream. The discovery of gold near Sutter's Mill guaranteed that California would become an integral part of the nation and underscored the enormous difficulties faced by the thousands who sought to reach the gold fields. Inland gold seekers swarmed to St. Louis or St. Joseph, Missouri, where they swelled the ranks of what had been a mere trickle of overland emigrants only a few months before. Residents of the eastern cities often preferred to book passage around Cape Horn. Those of a more adventurous, or less patient, temperament faced the threat of disease and other hardships involved in a trek across the Isthmus of Panama, shortcutting the four to six month, 18,000 mile (28,968 km) ocean voyage around the Horn.

Small wonder that Porter's promise of a three-day, 3,000 mile (4,828 km), scenic aerial cruise over prairies, mountains, Native Americans, and grizzly bears caught the attention of the press and public. Across the nation people read of his plan in their newspapers and magazines; subscribed to his newsletter, *The Aerial Reporter*; and flocked to the theaters and lecture halls where he demonstrated his models of the Aeroport.

Intriguing as they might sound, however, schemes involving the dream of aerial navigation were still fair game for skeptics and humorists, as indicated by a Nathaniel Currier comic print of 1849. In that illustration, would-be miners crowd a dock, attempting to recall a departing fleet of California-bound ships while a Porter Aeroport cruises serenely overhead, accompanied by a

man riding an "Aerial Steam Horse," a one-man rocket of the sort patented by the Englishman Charles Golightly in 1841.[18]

For Rufus Porter, as for Charles Dellschau and the other members of the Sonora Aero Club, flight remained only a dream. Unable to convince Congress to provide him with a $5000 grant that would enable him "to extend his experiments, and apply his invention on a practical scale," Porter launched a new stock issue. He continued to attract large audiences to demonstration flights of his model airships, including the steam-powered *Pioneer*, which measured 22 feet (6.7 m) in length and featured the painted faces of happy passengers peering out of the windows of the salon, but the enormous sums required to continue his work failed to materialize. By the mid-1850s the project was fading away.

The honor of building and flying the first (barely) navigable airship went to the Frenchman Henri Giffard in 1852. Powered by a 5 hp steam engine that drove it at a top speed of less than 7 miles per hour (11.3 kph), Giffard's airship would have taken far longer than three days to reach California, but unlike the dream ships of the Sonora Aero Club and Rufus Porter, it did fly.

Folk Aeronautics in the Lone Star State

Whatever the impact of balloon flights and discussions of navigating the air had on a group of friends in the gold camps of California, Dellschau would hear plenty of talk of flying machines following his return to Texas. Although there is no evidence to suggest that he ever met Jacob Friedrich Brodbeck (1821–1910), the two men had a great deal in common. A native of Platten-hart, Wurtemburg, Brodbeck emigrated to Texas in August 1846 with his younger brother Johann Georg. A graduate of a prestigious teacher's college in the old country, he settled in Fredericks-burg, a predominantly German community north of San Antonio, where he worked as a teacher and school administrator.

Always fascinated by mechanical problems, Brodbeck began experimenting with an ice-making machine and assured his students that human beings would one day fly like the birds. "For more than twenty years I have labored to construct a machine that should enable a man to use like a bird the atmosphere region as a medium of travel," he explained many years later. Like so many other aeronautical enthusiasts over the years, Brodbeck began with observations of birds in flight and proceeded to an investigation of the "mechanical laws governing these wonderful structures."[19]

Having concluded his observations, the inventor claimed to have built his first flying machine in 1863. Powered by a clock spring, the craft featured "a system of wings, both movable and fixed . . . entirely different from the sails of vessels." His call for investors, published in local newspapers in 1865, raised sufficient cash to enable him to build a machine large enough to carry a pilot, whose duties included keeping the massive spring wound.

The first test flight was conducted on September 20, 1865. "The plane [rose] . . . as high as the trees, [and] sailed around for several minutes," one supposed witness explained to a San Antonio reporter in 1937. Legend has it that the flight ended in a crash from which Brodbeck escaped

with minor injuries. He tried again in 1874. "My ship took off and I sailed around until the power of the coil spring gave out," Brodbeck explained. "Then down into the corn field I crashed, but I was not badly injured, only bruised from head to toe." A heart condition ended Brodbeck's aeronautical career soon thereafter, although he lived until 1910.[20]

Although it is unlikely that Brodbeck ever left the ground, his work was fairly well publicized. Announcements of his stock issues were carried in San Antonio newspapers and picked up by other newspapers around the state. His airship was apparently exhibited at the Gillispie County Fair during the decade following the Civil War and in Illinois in 1874 during a fundraising campaign. If Dellschau, then living in Richmond, just south of Houston, was paying as much attention to aeronautical matters during these decades as he did at the turn of the century, he may have known something of Brodbeck's work.

Moreover, Jacob Brodbeck was not the only flying machine experimenter active in Texas. W. D. Custead earned his living as a ticket agent and telegrapher for the Missouri, Kansas, & Texas Railroad, manning the little station at Tokio, Texas. At the time of the McLennan County Centennial in 1949, old-timers described a 5 mile (8.04 km) aerial voyage that Custead is said to have made in or about 1897 with a passenger-carrying ornithopter. Old neighbors and Custead's son, interviewed in the 1940s and 1950s, described additional flights with what may have been a second machine in 1901. The craft may have been powered by an engine produced by Gustave Whitehead of Bridgeport, Connecticut, perhaps the best known of all pre-Wright flight claimants. "Eyewitness" claims collected decades after the fact can scarcely be regarded as solid evidence, however. Like Brodbeck, Custead is best seen as a local folk hero rather than as a successful flying machine pioneer.[21]

Many of the good people living in and around Pittsburg, Texas, in 1902 were convinced that Reverend Burrell Cannon, pastor of the local Baptist church, had flown 60 feet (18.3 m.) over a local pasture at an altitude of 10 feet. He named his craft the Ezekiel Flying Machine, naturally enough. The design was based on the biblical description of the heavenly flying machine seen by the prophet Ezekiel. Cannon sold stock in his Ezekiel Airship Manufacturing Company and, in 1904, shipped his machine to St. Louis for display at the Lewis and Clark Exposition. When the original craft was destroyed in a train wreck, Cannon built a second machine in Chicago, where he is said to have made a brief hop. At time of his death at the age of 74, he was hard at work on a mechanical cotton picker and boll weevil destroyer.[22]

Some of the airships making headlines in late nineteenth-century Texas and elsewhere were more mysterious than others. One of the most puzzling stories of the decade began on the evening of November 17, 1896, when some 100 citizens of Sacramento, California, saw three bright lights moving slowly across the night sky at an altitude of 1,000 feet (304.8 m.). The craft returned to Sacramento five days later and visited San Francisco that evening as well. Over the next few days, strange lights were seen in the skies over Washington state and western Canada. Early the next year, the airship seemed to be moving east. In February, March, and April 1897, strange lights were seen in the skies over Nebraska, Kansas, Missouri, Texas, Iowa, Illinois, and Michigan.[23]

On April 15, 1897, newspapers across the nation carried a report that the "airship," as it was now identified, had exploded and crashed near Kalamazoo, Michigan. The noise was like that of "heavy ordnance," followed by "the distant sound of projectiles flying through the air." Four days later, the *Dallas Morning News* published an even more intriguing report of the demise of the strange craft. Early on the morning of April 17, witnesses noticed an airship slowly "settling to earth" as it moved toward the little north Texas town of Aurora. Passing over the town square at a speed estimated at only 10–12 miles per hour (16–19.3 km), it struck a windmill on the north edge of Aurora and "went to pieces with a terrific explosion." Citizens combing through the wreckage were stunned to discover the badly disfigured body of an individual who was obviously "not an inhabitant of this world." S. E. Heydon, the local businessman who filed the story, closed his account with a note that the body would be buried in the town cemetery the next day.[24]

There can be no doubt that the single article describing the episode was a deliberate hoax of a sort that was relatively common in the in the nineteenth century and almost unknown today. The University of Texas–sponsored Handbook of Texas Online explains that Heydon was attempting to increase the visibility of his dying community. Rediscovered by a *Dallas Morning News* reporter seventy years later, the case was, for a time, a favorite of flying saucer enthusiasts.[25]

Dellschau and the Birth of the Air Age

Dellschau's fascination with flight may well have begun in his childhood. The artist captioned one drawing showing a boy flying a kite, "Wind, Muehlberg, 1845." Could the boy be Dellschau? In any event, the media stories about flight that Dellschau so carefully preserved in his scrapbooks are both evidence of his obsession and the fuel that fed it.[26]

By 1902, when Dellschau completed his *Reminiscence* and began work on the scrapbooks, the great airship hoax had given way to stories of genuine achievement in the air. The first Zeppelin airship flew in 1900, just after Dellschau had begun writing. Four hundred and twenty feet (128 m) long, it would have impressed even Rufus Porter. Alberto Santos-Dumont, a Brazilian living in Paris, became the toast of the continent when he flew from the Paris suburb of St. Cloud to the Eiffel Tower and back in a one-man airship the following year. Since the mid-1890s, newspapers and magazines in Europe and America had been headlining the efforts of heavier-than-air flying machine experimenters like the German Otto Lilienthal, the Englishman Percy Pilcher, and the Americans Samuel Pierpont Langley and Octave Chanute, who were laying the foundation for the invention of the airplane. Clippings detailing all of these experiments dot the pages of Dellschau's scrapbooks.

Dellschau kept abreast of the latest developments in aeronautical technology. "Should I ever build an airship," he noted in his *Reminiscence*, "I will make it out of aluminum and in the shape of a cigar. Such ships have been built and flown." He could only have been referring to an aircraft designed by the Austrian engineer David Schwartz, the only all-aluminum airship that had been built and flown up to that time. Completed by the widow Schwartz following her husband's death, the *Metallballon* consisted of a tubular aluminum framework covered with thin plates of the same material.

One hundred and fifty-six feet (47.5 m) long, the craft rose into the air from Berlin on November 3, 1897. At an altitude of perhaps 100 feet (30.5 m), the belt driving the propellers began to slip. The soldier who had been drafted to serve as pilot panicked and began energetically valving hydrogen. He survived the ensuing crash landing, but ground winds and an excited crowd damaged the world's first rigid airship beyond repair.[27]

Dellschau was perfectly willing to pass judgment on the increasing number of aeronautical schemes described in the newspapers. In November 1899 the *Houston Daily Post* published an article describing "a safe airship" invented by Mr. W. Burton of Burton, Texas. "This man," Dellschau commented, "does not know what he is talking about."[28]

He was especially interested in aircraft propulsion. Most airship designers, he noted, placed their propellers "in the back or the sides," so that "the wheels or propellers split the air or moved the air like a whirlwind." That arrangement seemed ineffective to Dellschau. "After all," he noted, "the laws of nature states [that] when action equals reaction, the airship will not move." Instead, he proposed the use of "fast revolving blade-turbines that suck the air in at a high rate and expel the concentrated air at the other end." This prescient notion, which would serve as the basis for turbojets and high bypass fan-jets, had a direct impact on his art as well.[29]

Dellschau clipped articles from Houston newspapers, including the *Houston Daily Post*; *Scientific American*, the historic journal founded by Rufus Porter; various illustrated magazines and journals; and German language newspapers. He was not only very widely read but extraordinarily articulate, as evidenced by the often wry and humorous commentary on the paintings and press blooms.[30]

The earliest scrapbooks that have survived (1908) give the impression of a dialogue between the creative products of Dellschau's imagination and the press blooms describing the reality of a world that was taking to the air at long last. The links between the past and the present, the dream and the reality, were often underscored. In response to a series of articles on the latest wonders of the air age, Dellschau commented, "*Goosey* beats you all in 1857." Elsewhere, he wonders what he and his friends might not accomplish if they were together and working today (Figure 4).[31]

Clearly, however, Dellschau applauded the achievements of the first generation of airmen. The press blooms contain dozens of articles on the Wright brothers, Octave Chanute, Glenn Curtiss, and the others who were pioneering aviation in the United States. The technical papers and the German language newspapers yielded a wealth of clippings covering events in Europe, from Wilbur Wright's first public flights near Le Mans, France, in 1908, through Louis Bleriot's historic first flight across the English Channel in July 1909 and the great flying meet at Reims a few weeks later.

Dellschau's scrapbooks are a particularly rich source of information on local aeronautical history. The press blooms chronicle the events surrounding the touring French aviator Louis Paulhan's visit to Houston, where he made the first airplane flight in the state on February 18, 1910. We have no way of knowing whether the artist saw Paulhan fly. Given the level of enthusiasm indicated by the extensive clippings, however, it is difficult to believe that he would have missed the opportunity.

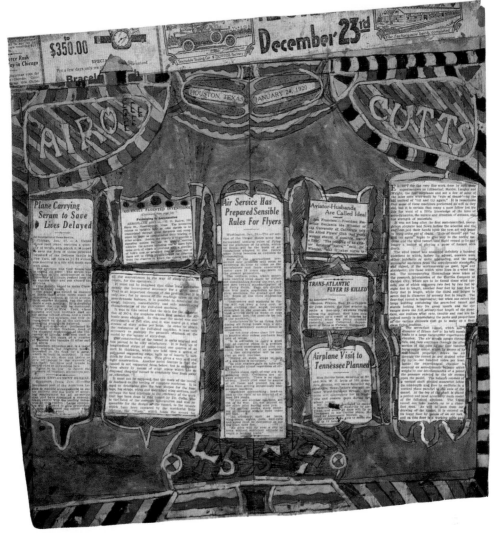

4.
Aero Cuts, a typical illustrated page of press blooms. The Dellschau works are from Lauren Redniss, *Charles A.A. Dellschau, 1830–1923* (New York: Ricco/Maresca Gallery, 1997).

Dellschau also followed the aeronautical controversies of the era with great interest. The artist clipped a series of articles describing the progress of the law suits that the Wright brothers had brought for patent infringement in Europe and America. It was a particularly big story in Houston. On February 17, 1910, the day before Louis Paulhan made the first flight in the city and the state, U.S. Circuit Court Judge Learned Hand issued a temporary injunction restraining Paulhan from flying his Henry Farman biplane, which was said to infringe upon the Wright patent. The defendant was required to post a $25,000 bond in order to meet his commitments and continue his tour for another month. The details of the story are recorded in Dellschau's press blooms.

The Dellschau scrapbooks for the years 1908–1912/1913 express unmistakable high spirits. The quality of his artwork was at its peak, and the press blooms communicated the excitement

of world aviation achievement. Pilots fell victim to aerial accidents at an appalling rate, but the sense of flying higher, faster, and farther through the air, a thing considered to be the very definition of impossible only a decade before, was exhilarating.

There is a decided change in the scrapbooks with the approach of 1914. As war clouds gathered over Europe, the artwork seems to lose a level of detail. It is entirely possible that the aging Dellschau may have been suffering from health problems. The scrapbooks reflect other fundamental changes, as well. The ratio of paintings to press blooms dropped sharply, and the clippings are no longer solely devoted to the latest developments in aeronautics. In addition to articles on the evolving air war, there are page after page of items on virtually all aspects of military technology: new kinds of guns, tanks, surface ships, and submarines.

Ultimately, the press blooms are no longer restricted even to technological topics. There are articles focusing on the politics of the war as well as the war aims and methods of the Allies and the Central powers. The growing number of clippings of this sort in both German and English strongly suggest that Dellschau, like so many other German immigrants, struggled with deep questions of loyalty and conscience as World War I approached. In the process, the sense of excitement, enthusiasm, and bright hopes for the future of a new technology that mark the prewar scrapbooks gives way to dark reflections on the growing horror of a technological war.

Understanding Dellschau

How are we to define Dellschau's art? The work fits comfortably into art historian Roger Cardinal's description of an outsider aesthetic defined by

> dense ornamentation; compulsively repeated patterns, metamorphic accumulations, an appearance of instinctive though wayward symmetry; configurations which occupy an equivocal ground in between the figurative and decorative; other configurations which hesitate between representation and an enigmatic calligraphy, or which seek the perfect blending of image and word.[32]

The intricacy and precision of Dellschau's paintings, his attention to the minute details that fill the frame, the vibrant colors, the ornate borders, the meticulous adherence to a rigid numbering system, the use of code words whose meaning are known only to the artist, and the connection between the painted images, the words that are part of the image, and the printed words of the press blooms all mark Dellschau as the classic outsider artist. John Maizels argues that outsider art results from "a compulsive flow of creative force that satiates some inner need."[33] The length of time that Dellschau pursued the project and the huge body work underscore the obsessive nature of an effort driven by an inner need (Figure 5)

It is interesting to compare Dellschau to other artists identified as outsiders. The Swiss artist Adolf Wölfli (1864–1930) was admitted to a psychiatric hospital in 1895 and remained there for the rest of his life. In 1908 he began work on what can only be regarded as an epic rooted in

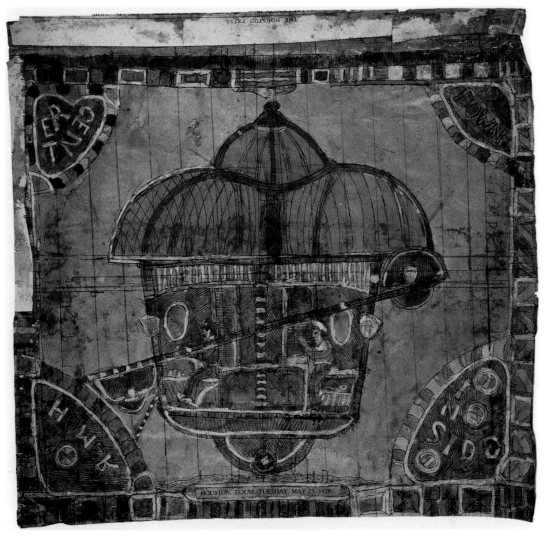

5.
A typical work showing the interior and crew of an airship. The Dellschau works are from Lauren Redniss, *Charles A. A. Dellschau, 1830–1923* (New York: Ricco/Maresca Gallery, 1997).

autobiography that would eventually stretch to 45 volumes and 25,000 pages. The work was a mix of words and incredibly complex, intensely colored pictures that stretched from edge to edge within elaborate frames.[34] Henry Darger (1892–1973), a reclusive Chicago janitor, emerged as a celebrated outsider artist following his death, when his 15,143-page manuscript, *The Story of the Vivian Girls, in What is known as the Realms of the Unreal, of the Glandeco-Angelinnian War Storm, Caused by the Child Slave Rebellion,* was discovered along with hundreds of drawings, water colors, and collages intended to illustrate that and other works of fantasy.[35]

Wölfli was a mental patient and Darger was apparently barely able to function in normal society. Although Dellschau was described as a "grouchy" eccentric and may have had an obsessive-compulsive personality, he does not seem to have suffered from the severe psychiatric problems

that plagued some other outsiders. He lived and worked his entire life, married, fathered children, and earned a living. Still, the links that bind these artists are striking. All three spent decades creating extended and very complex narrative fantasies that mixed their own words and those of others in highly individualistic works of graphic art. The stylistic links, particularly between Wölfli and Dellschau, are striking.

Unlike traditional folk artists, who, although untutored, usually see their work as a product for sale, outsider artists like Dellschau clearly work only to please themselves, with no expectation that their art might become known to the world. The work of Darger and Dellschau was discovered accidentally and narrowly escaped destruction. The psychological factors at work and the process of creation may thus have been much the same for both men, although the nature of their obsessions, their themes, styles, and sources of inspiration were very different.

Unlike Wölfli and Darger, however, there is no indication that Dellschau had any difficulty distinguishing fantasy from reality. The complex interplay between the fantastic airships that he painted and the real-life news stories presented in the press blooms indicate a conversation between the artist's dreams of flight and the triumph and tragedy of aeronautical reality. Whatever the obsession driving Dellschau to paint and create scrapbook pages day after day for almost twenty years, the project clearly indicated that he had a very deep interest in aviation technology.

Conclusion

Following Dellschau's death in 1923, the family moved all of his material into the attic of the house in which he died. There it remained until the 1960s, when a house fire led to a visit from the fire marshal and an order to clear such inflammable materials out of the house. The artist would have vanished into history but for an observant sanitation worker who pulled the scrapbooks from the garbage and sold them to a Houston flea market, where Mary Jane Victor, an employee of art collector Dominique de Menil, found them. Menil bought four scrapbooks. Peter Navarro, a Houston graphic designer, purchased eight others.[36]

As art historians became familiar with the material, Dellschau emerged as an exemplar of naïve, or outsider, art. Today, major collections of his work are held by the University of St. Thomas Gallery, the San Antonio Museum of Art, the Minel Collection, the American Visionary Museum, the American Folk Art Museum, and the Witte Museum, among others. His work has been the focus of or included in at least seventeen exhibitions of outsider art mounted by major museums and galleries since 1969.[37]

Just as interesting, from a cultural point of view, is the extent to which Dellschau has attracted the attention of individuals interested in esoteric mysteries. Could the airships that graced the pages of the scrapbooks have actually soared through the night sky over the gold rush country? Is it possible the Dellschau and his friends were part of a nationwide secret society of airship builders? Was there a relationship between the Sonora Aero Club and the wave of mysterious airship sightings half a century later? And what was the connection between Dellschau and that extraterrestrial body buried in his home state of Texas? Those questions, and others, have been

explored in issues of *Fate* magazine, in several books, and on various Internet sites. Serious interest in the artist and his work ranges from the lofty realms of museum scholarship to the shadowy depths of Internet paranoia.[38]

C. A. A. Dellschau's reputation as an extraordinary creative talent is well established. The obscure butcher who kept to his room and painted obsessively has been accorded an honored place among American outsider artists. On quite another level, his work is evidence of the American love affair with the notion of flight. Although the wondrous machines illustrated in Dellschau's scrapbooks would never have left the ground, it is not difficult to imagine the artist and his friends gathering on occasion to raise a glass and describe the flying machines that they dreamed of building. The work to which he devoted the last two decades of his life is proof that Dellschau pursued that dream to the end of his life.

Acknowledgments

I thank Tracy Baker-White, the pioneering student of C. A. A. Dellschau, whose efforts both inspired and informed this paper.

Notes

1. Tom D. Crouch, "The Wright Brothers Fly a Kite," *The Drachen Journal*, December 1999, http://www.drachen.org/collections/experiments-1899-wilbur-and-orville-wright-fly-kite (accessed October 4, 2012).

2. Jean Dubuffet, quoted in Colin Rhodes, *Outsider Art: Spontaneous Alternatives* (New York: Thames and Hudson, 2000), 11.

3. The Dellschau manuscripts are titled *Reminiscences of Years Past of Time and a Way of Life Written and Illustrated in Idles Hours* (1899) and *Recolections Reall and Speculative Works on Ideas of Friends and Higher Aims, Long Gone by* (1902). The original manuscripts are now in private hands and not available to researchers. All quotations from the manuscript are drawn from a summary and partial translation provided by Tracy Baker White of the San Antonio Museum of Art. The citations to the sections and pages of the original manuscript are provided in the Tracy Baker White summary. Hereafter cited as Dellschau, "Reminiscence."

4. Barbara Ross Geiger and Susan Hellwell, *Outsiders: Art Beyond the Norms* (New York: Rosa Esman Gallery, 1986), 1.

5. The Roger Cardinal and John Beardley quotes are from Tracy Baker-White, "Flight or Fancy? The Secret Life of Charles A.A. Dellschau," *Folk Art*, Vol. 25, No. 3, Fall 2000: 50.

6. Dellschau, "Reminiscence," pt. 2, sec. 1, 4–7.

7. Dellschau, "Reminiscence," pt. 2, sec. 1, 4. Dellschau was almost certainly referring to Columbia, California, a small town near Sonora.

8. Dellschau, "Reminiscence," pt. 2, sec. 1, 5.

9. Tracy Baker-White, "Flight or Fancy," 10.

10. There are no Dellschau scrapbooks for the years 1902–1907. In view of the fact that the oldest surviving scrapbook, dating to 1908, opens with drawing number 1601, however, it seems safe to assume that the artist began work on the scrapbooks soon after completing the "Reminiscence."

11. Tracy Baker-White, "Flight or Fancy," 53.

12. Dellschau, "Reminiscence," pt. 2, sec. 1, 74.

13. Dellschau, "Reminiscence," pt. 2, sec. 1, 74.

14. Gary F. Kurutz, "An Informal History of California Ballooning," *The Californians*, Vol. 6, No. 4, July–August 1988: 18–19; *Sacramento Daily Union*, "The Balloon Explosion," May 27, 1856; *Sacramento Daily Union*, "News of the Morning," October 29, 1856; *Daily Alta California*, "Ballooning in Mexico," June 25, 1857.

15. Note on drawing 152v (1912), Dellschau Collection, San Antonio Museum of Art, in Tracy Baker White, "C.A.A. Dellschau: The Butcher Who Wanted to Fly." Manuscript in author's collection.

16. Rufus Porter, *Aerial Navigation: The Practicability of Travelling Pleasantly and Safely From New York to California in Three Days . . .* (New York: H. Smith, 1849). The pamphlet is available in Rhoda Gilman, *A Yankee Inventor's Flying Ship: Two Pamphlets by Rufus Porter* (St. Paul: Minnesota Historical Society, 1969). Porter's second pamphlet, *An Aerial Steamer, Or Flying Ship, Invented by Rufus Porter* (Washington, DC: W. Greer, 1850), is also included.

17. For a full account of the aeronautical work of Rufus Porter, see Tom D. Crouch, *Eagle Aloft: Two Centuries of the Balloon in America* (Washington, DC: Smithsonian Institution Press, 1983).

18. The print appears as an illustration in Ralph K. Andrist, *The California Gold Rush* (New York: American Heritage, 1961), 59.

19. Jacob Brodbeck, quoted in Edwin W. Gibson, "First Airplane Flight," *Enchanted Rock Magazine,* April 1996:15; for additional information on Brodbeck, see Michael Brockway, "People and Planes," *Aviation History,* January 1995, Vol. 5, No. 1, 21–22; Anita Titsch, ed., *Jacob Brodbeck Reached for the Sky in Texas* (n.p., n.d.), copy in Pioneer Memorial Library, Fredericksburg, Texas.

20. Brockway, "People and Planes," 22.

21. Custead is also linked to the Gustave Whitehead story. See, for example, Stella Randolph, *Before the Wrights Flew: The Story of Gustave Whitehead* (Washington, DC: Places, Inc., 1937), 94, 123.

22. Mike Elswick, "Pittsburgh's Ezekiel Airship to Come to Life," *Longview Morning Journal,* September 22, 1985; *The Sunday Companion,* "Airship Built by a Minister," November 16, 1901 (author's collection).

23. For a full account of the subject, see Daniel Cohen, *The Great Airship Mystery: A UFO of the 1890s* (New York: Dodd, Mead, 1981).

24. S. E. Heydon, "A Windmill Demolished It," *Dallas Morning News,* April 19, 1897, in "Once Upon a Time in Aurora," http://www.forteantimes.com/articles/115_aurora.shtml (accessed December 21, 2011); see also "The Mystery Airship of 1896," http://www.realshades.com/myst-airship-1896.html (accessed December 21, 2011).

25. Handbook of Texas Online, http://www.tsha.utexas.edu/cgi-bin/web_evaluate (accessed January 9, 2011).

26. The illustration is in Lauren Redniss, "Charles Dellschau," *Raw Vision,* no. 30 (Spring 2000): 47.

27. Dellschau, "Reminiscence," pt. B, pt. 1, 86.

28. Dellschau, "Reminiscence," pt. B, pt. 1, 88. At one point Dellschau remarks that he found articles on Burton in the *Houston Daily Post* for November 28, 1899, and October 2, 1900. A close reading of those issues fails to reveal the articles. It is seems likely that he simply made a mistake with regard to the date. A search of relevant files at the National Air and Space Museum and the Library of Congress fails to reveal any mention of Burton or his airship.

29. Dellschau, "Reminiscence," pt. B, pt. 1, 88.

30. The term press bloom was an expression of Dellschau's wry humor. Bloom is apparently drawn from the German *Bloomen,* for flowers. The specially decorated pages of news clippings are thus press blooms, or pressed flowers.

31. Quotes are from a 1909 Dellschau scrapbook in the collection of the Witte Museum, San Antonio, Texas.

32. Roger Cardinal, "Toward an Outsider Aesthetic," in *The Artist Outsider: Creativity and the Boundaries of Culture,* ed. Michael D. Hall and Eugene Metcalfe (Washington, DC: Smithsonian Institution Press, 1994), 33–34, quoted in Baker-White, "Flight or Fancy," 52.

33. John Maizels, *Raw Creation: Outsider Art and Beyond* (London: Phaidon Press, 1996), 11.

34. Walter Morgenthaler, *Madness and Art: The Life and Works of Adolf Wölfli* (Lincoln: University of Nebraska Press, 1992).

35. For additional information on Henry Darger, see Michael Bonesteel, ed., *Henry Darger: Art and Selected Writings* (New York: Rizolli, 2000); Brooke Davis Anderson, *The Henry Darger Collection at the American Folk Art Museum* (New York: Harry N. Abrams, Inc., 2001).

36. The account of the discovery and dispersal of the Dellschau papers is from Cynthia Greenwood, "Secrets of the Sonora Aero Club," *HoustonPress,* December 10, 1998, http://www.houstonpress.com/1998-12-10/news/secrets-of-the-sonora-aero-club/ (accessed September 24, 2008).

37. See the Charles Dellschau entry in Wikipedia for a partial list of exhibitions including Dellschau works: http://en.wikipedia.org/wiki/Charles_Dellschau (accessed October 22, 2008).

38. The fringe literature identifying Dellschau as the answer to the great airship scare of the 1890s continues to grow. See, for example, Jerome Clark and Loren Coleman, "Mystery Airships of the 1890s," http://www.keelynet.com/gravity/aero1.htm (accessed September 24, 2008); Dennis Crenshaw, *The Secrets of Dellschau,* in collaboration with P. G. Navarro (San Antonio, TX: Anamolist Books, 2009); Michael Busby, *Solving the 1897 Airship Mystery* (New Orleans: Pelican Publishing, 2004); J. Allan Danelek, *The Great Airship of 1897: A Provocative Look at the Most Mysterious Aviation Event in History* (Kempton, IL: Adventures Unlimited Press, 2009). Searching Dellschau's name on the Web will produce any number of sites linking him to the airship mystery. See, for example, Zimbio, "Mystery Airships: The Steampunk UFOs Part Three," http://www.zimbio.com/UFOs/articles/495/Mystery +Airships+Steampunk+UFOs+Part+Three (accessed September 26, 2008). This is but one current example of the many connections between Dellschau and the mystery airships to be found on the Web illustrating the extent to which Dellschau has been woven into the broader fabric of what can only be regarded as the fringe area of American historical paranoia.

Bibliography

Anderson, Brooke Davis. *The Henry Darger Collection at the American Folk Art Museum.* New York: Harry N. Abrams, Inc., 2001.

Andrist, Ralph K. *The California Gold Rush.* New York: American Heritage, 1961.

Bonesteel, Michael, ed. *Henry Darger: Art and Selected Writings.* New York: Rizolli, 2000.

Brockway, Michael. "People and Planes." *Aviation History,* Vol. 5, No. 6. January 1995:21–22.

Busby, Michael. *Solving the 1897 Airship Mystery.* New Orleans: Pelican Publishing, 2004.

Cardinal, Roger. "Toward an Outsider Aesthetic." In *The Artist Outsider: Creativity and the Boundaries of Culture,* edited by Michael D. Hall and Eugene Metcalfe. Washington, DC: Smithsonian Institution Press, 1994:20–43.

Cohen, Daniel. *The Great Airship Mystery: A UFO of the 1890s.* New York: Dodd, Mead, 1981.

Crenshaw, Dennis. *The Secrets of Dellschau.* In collaboration with P. G. Navarro. San Antonio, TX: Anamolist Books, 2009.

Crouch, Tom D., *Eagle Aloft: Two Centuries of the Balloon in America.* Washington, DC: Smithsonian Institution Press, 1983.

———. "The Wright Brothers Fly a Kite," *The Drachen Journal,* December 1999, http://www.drachen.org/collections/experiments -1899-wilbur-and-orville-wright-fly-kite (accessed October 4, 2012).

Danelek, J. Allan. *The Great Airship of 1897: A Provocative Look at the Most Mysterious Aviation Event in History*. Kempton, IL: Adventures Unlimited Press, 2009.

Geiger, Barbara Ross, and Susan Hellwell. *Outsiders: Art Beyond the Norms* (New York: Rosa Esman Gallery, 1986).

Gibson, Edwin W. "First Airplane Flight." *Enchanted Rock Magazine*, April 1996:15

Gilman, Rhoda. *A Yankee Inventor's Flying Ship: Two Pamphlets by Rufus Porter* (St. Paul: Minnesota Historical Society, 1969).

Kurutz, Gary F. "An Informal History of California Ballooning." *The Californians*, July–August 1988: 35–47.

Maizels, John. *Raw Creation: Outsider Art and Beyond*. London: Phaidon Press, 1996.

Morgenthaler, Walter. *Madness and Art: The Life and Works of Adolf Wölfli*. Lincoln: University of Nebraska Press, 1992.

Randolph, Stella. *Before the Wrights Flew: The Story of Gustave Whitehead*. Washington, DC: Places, Inc., 1937.

Redniss, Lauren. "Charles Dellschau." *Raw Vision*, No. 30 (Spring 2000): 42–49.

Rhodes, Colin. *Outsider Art: Spontaneous Alternatives*. New York: Thames and Hudson, 2000.

Titsch, Anita, ed. *Jacob Brodbeck Reached for the Sky in Texas*. N.p., n.d.

White, Tracy Baker, "C.A.A. Dellschau: The Butcher Who Wanted to Fly," Manuscript in author's collection.

———. "Flight or Fancy? The Secret Life of Charles A.A. Dellschau." *Folk Art*, Vol. 25, No. 3 (Fall 2000): 50–55.

African Cultural Astronomy and the Arts
A Preliminary Enquiry

Christine Mullen Kreamer
Deputy Director and Chief Curator

Smithsonian Institution
National Museum of African Art
Washington, D.C.

Turn out the lights and watch the real ones in
 heaven—
those our ancestors' imaginative minds used
to mold a wonderful poetic imagery about themselves
and their relation to the universe.
 —Anthony F. Aveni, *Conversing with the Planets:*
 How Science and Myth Invented the Cosmos

This essay considers the topic of African cultural astronomy and the arts through the exhibition *African Cosmos: Stellar Arts,* which I organized at the Smithsonian's National Museum of African Art. *African Cosmos* is the first major traveling exhibition and publication that explores the historical legacy of African cultural astronomy and its intersection with both traditional and contemporary African arts (Figure 1). The 2012 exhibition project considers the continent's long and rich history of astronomical observations and the ways that celestial bodies and phenomena serve as inspiration and symbol in the creation of African arts dating from ancient times to the present.

My interest in African cultural astronomy stems from my determination to create exhibitions that challenge visitors' limited perceptions about Africa.[1] Misperceptions about Africa are largely shaped by the popular media that tends to emphasize Africans as exotic, "primitive," timeless, illiterate, removed from ordinary experiences, cut off from the wider world, and/or beset by social, political, and economic upheaval. *African Cosmos* aims to educate students, scholars, and the general public about Africa's contributions to the science and practice of astronomy. Building on the public's general interest in stargazing and space exploration, *African Cosmos* forges

1.
Gavin Jantjes (born 1948), untitled (*Zulu* series), South Africa, 1989–1990. Acrylic on canvas, 78¾ × 118 ⅛ in. (200 × 300 cm). Collection number 96-23-1, National Museum of African Art, Washington, DC, purchased with funds provided by the Smithsonian Collections Acquisition Program. Photograph by Franko Khoury. The work is from his series entitled Zulu, a term meaning "sky" or "heavens," referring to the southern African myth about the creation of the Milky Way. The myth recounts how a girl threw ashes into the sky, where they formed the Milky Way, and is drawn from his sketchbook notes on astronomy and southern African rock art.

connections with visitors' experiences and attracts new audiences to the museum and toward an appreciation of African art. With a focus on the arts, it demonstrates in visually powerful and engaging ways how art and cultural expression are essential components of the human endeavor.

African Cosmos: Stellar Arts

African Cosmos: Stellar Arts addresses the rich, complex, and little-studied topic of African cultural astronomy as a way to challenge popularly held notions of Africans as cultural, but not scientific, beings. Cultural astronomy, also referred to as archaeoastronomy or ethnoastronomy, explores the distinctive ways that astronomy is "culturally embedded . . . in the practices and traditions of lay experts and non-experts who relate, in the broadest sense, to the sky."[2] Africa's contributions to cultural astronomy have received only limited scholarly attention, although publications in the past few years have begun to redress this.[3]

The expansive ideas and range of materials that inform my thinking on the admittedly vast topic of the African cosmos are tempered by the realization that I work within the confines of a unique educational instrument—the art exhibition. Thus, my exploration of this subject is told primarily through works of art and within the spatial and other constraints that form part of the

museum experience. Therefore, I see this project as *beginning* the discussion of a neglected aspect of African intellectual history, rather than a comprehensive overview, and told through the prism of works of art. Indeed, the focus of the project is not on the science of astronomy in Africa, but rather on the *practice* of it as specialists and laypersons alike gaze skyward and formulate ideas about the cosmos as it relates to human experience and, in particular, to the creation and use of works of art. The exhibition is accompanied by a scholarly publication, an edited volume of essays by scholars from a variety of disciplines as well as artists whose contributions illustrate a range of cultural and artistic responses to the topic.[4] Importantly, *African Cosmos* emphasizes significant scholarly and artistic contributions by African colleagues who have limited opportunities to contribute to an exhibition and book project of this magnitude. Furthermore, although the book is more extensive than the exhibition and includes harder-to-exhibit topics that are not object centered, such as cultural performances and architectural spaces, the exhibition features only a limited number of objects that illustrate selected ways that Africans, over time, have looked up at the sky and considered their relationships to the sun, moon and stars and to celestial phenomena such as rainbows, thunder, and lightning, bringing them down to earth, if you will, as part of African intellectual and aesthetic experience.

Throughout Africa, time reckoning and the seasonal calendar of work and ritual are associated in varying degrees with the position of the celestial bodies in relation to Earth. Borana and neighboring peoples of Ethiopia, for example, follow a lunar calendar tied to social and agricultural activities and reckoned by the appearance of the crescent moon against constellations, including the Pleiades, Orion's Belt, and Sirius.[5] Lunar calendars are used to regulate agricultural work in many other African societies, not to mention the religious calendars of millions of African Muslims. Sirius (or the Dog Star), among the brightest stars in the Southern Hemisphere, is noted in the astronomical observations of African societies, including the Dogon of Mali, and may well serve as a celestial "anchor" in calculating time and space. But the relative paucity of studies devoted to cultural astronomy in Africa and the controversies that have arisen in the scholarly community about interpretations of the cosmos in specific African cultures have tended to keep any definitive account of Africa's contributions in astronomy at arm's length.[6] Such controversies include speculation that the Dogon of Mali had knowledge of Sirius' companion star called Sirius B long before its detection by Western astronomers through high-magnification telescopes.[7] Controversies and debates notwithstanding, the timing was right for the *African Cosmos* project, as it benefited from recent initiatives within and outside Africa that have begun to formalize and publicize the study of African cultural astronomy.[8] The project also capitalized on a wave of interest in Africa's contributions to astronomy due to events surrounding the International Year of Astronomy 2009.

African interest in and observation of the cosmos and its connection to the arts has a long history. Nabta Playa is a site in southern Egypt dating to the fifth millennium BC (roughly a thousand years before Britain's Stonehenge). The stone circles and megaliths of the Nabta Playa site have been interpreted as one of the world's earliest archeoastronomical devices marking star

alignments and the summer solstice.[9] Ancient Egyptian and Nubian religious beliefs fostered a correlation between the major deities and the sun, the moon, the earth, and other planets known in Egypt during the time of the pharaohs. Among the most prominent were Ra, the primary sun god; Horus, the falcon god, linked with both the sun and moon; Geb, the earth god; and his wife Nut, the sky goddess.[10]

The main temple at Dendera, built (circa 54–20 BC) to honor the ancient Egyptian sky goddess Hathor, bears relief carvings of a celestial map and constellations, including Sirius, whose appearance before dawn in the eastern sky each year coincides with the annual flooding of the Nile River.[11] The ceiling also includes signs of the zodiac (introduced by the Romans) and images of Nut, the sky goddess, who was believed to swallow the sun disk each evening at sunset, giving birth to it again at dawn.

Long after the time of the ancient Egyptians, centuries-old manuscripts from archives in Timbuktu, Mali, document the transmission of astronomical knowledge across the Sahara and the extent of local astronomical observations. Family- and government-owned manuscript libraries in Timbuktu contain manuscripts hundreds of years old that hold a wealth of knowledge on a range of topics, including medicine, mathematics, ethics, law, and astronomy. Selected manuscripts include diagrams of celestial constellations and the rotation of the heavens, with the text conveying knowledge about the movement of the stars and their relationship to the beginning of the seasons as well as to casting horoscopes. In *African Cosmos*, selected ancient Egyptian and Nubian works of art, as well as illustrations of Nabta Playa and information from Timbuktu's ancient manuscripts, frame the topic historically, demonstrating Africa's early engagement with celestial observations and its connections to the visual arts.

African Cosmos also includes nineteenth- and twentieth-century works of traditional African art that illustrated the enduring legacy of celestial observation and how it is used by artists as a rich source of metaphor in the arts. The idea is to use the visual and performative cues in works of art to establish African cultural connections to the cosmos. An obvious starting point in the project is to focus broadly on African beliefs and practices associated with the sky, particularly as a domain of founding ancestors, deities, and certain spiritual beings. For example, the forms and contexts of Dogon sculptures from Mali relate to Dogon origin myths that connect earth and sky. The dual disks of a Dogon stool (Figure 2) have been interpreted to symbolize the celestial home of the Dogon's ancestral spirits and the terrestrial domain to which they descended. Figure pairs with upraised arms may call for rain and have also been documented to depict the founding ancestors, or *nommo*, who were born of sky and earth. Dogon *kanaga* masks are danced with sweeping, athletic moves that allow the mask's cross-bar superstructure to touch the earth in the four cardinal directions during performances.

Among the Yoruba of Nigeria, the sky is the domain of Shango, the Yoruba god of thunder and the legendary sacred king of the ancient city of Oyo-Ile. Figurative wooden staffs are danced by Shango devotees (Figure 3). The form of the dance staff often includes a kneeling female devotee whose head extends into the depiction of double axe heads. These represent

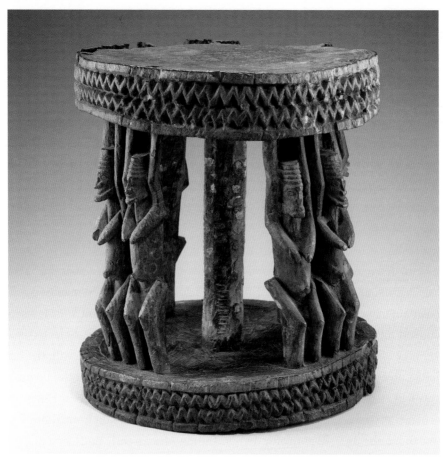

2.
Stool, Dogon peoples, Mali, late nineteenth to early twentieth century. Wood, pigment, 14 ³⁄₈ ×
12 ¹⁵⁄₁₆ × 12 ½ in. (36.5 × 32.8 × 31.8 cm). Collection number 2005-6-40, National Museum of African
Art, Washington, DC, gift of the Walt Disney World Co., a subsidiary of The Walt Disney Company.
Photograph by Franko Khoury. The stool's dual disks may represent the celestial home of spirits and
the terrestrial domain to which they descended. The figure pairs with upraised arms may call for rain
and may also depict the founding ancestors, or *nommo*, who were born of sky and earth.

Neolithic stone blades said to be hurled to earth as thunderbolts against those who anger the
fiery-tempered Shango.

Of the sky's celestial bodies, the sun is probably the most important in Africa, as elsewhere
in the world. It provides light, warmth, and the conditions for productive labor and the founding
of communities. It is often equated with a supreme or solar deity, and the word for God in some
African languages is also the word for sun. This may account for the lack of solar representation
in much of African art, but there are, of course, some examples. Among the Bamana of Mali,
a carved wooden dance crest (Figure 4) depicts the mythic being Chi Wara, part human, part
roan antelope, who brought the knowledge of farming to the Bamana. Its cosmic connection
is reflected in the openwork mane of the antelope, which is said to represent the sun's journey
across the sky. Antelope crest pieces were danced in pairs—male and female—at the start of the
planting season with the hope of a bountiful harvest.

3.
Shango devotee dances with her staff, honoring Shango, the thunder god, whose powers are manifested in thunder and lightning. Ohori, Nigeria, 1975. Photograph by H. J. Drewal. Eliot Elisofon Photographic Archives, Drewal Collection, National Museum of African Art, Smithsonian Institution, Washington, DC.

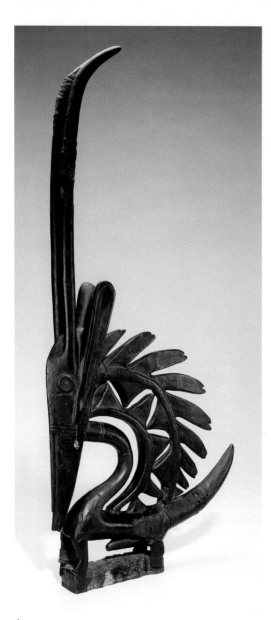

The sun is also reflected in Kongo beliefs in central Africa and the African diaspora, in the cosmogram called *dikenga*, a cross within a circle or diamond. The sign depicts the four moments of the sun's path through the sky and symbolizes the continuity of human life and the spiritual crossroads where human beings and the spirit world meet and communicate.[12]

The moon, a feminine symbol in many African societies, may link metaphorically with human and agricultural fertility, and its phases can denote philosophical opposites—understanding and confusion, fortune and misfortune, goodness and evil—which are used by African societies in constructing their notions of social order. A mask carved by Songye-related peoples (the Sungu-Tetela or Tempa-Songye peoples) of the Democratic Republic of the Congo (Figure 5) has radiating red, black, and white linear patterns that may suggest the phases of the moon. It was used for the dance of the new moon and for funerals and other occasions. Tabwa artworks from the Democratic Republic of the Congo include carvings of ancestors, beaded headdresses, and basketry that bear patterns of parallel isosceles triangles called *balamwezi*, literally "the rising of the new moon."[13] In some traditions from central Africa, the light of the full moon illuminates positive social interactions, whereas the new moon's darkness is associated with antisocial behavior that, at times, is mitigated through the performances of powerful masquerades and rituals.

4.
Antelope crest mask depicting the mythic being Chi Wara, who taught the Bamana to farm. His openwork mane has been depicted as suggesting the path of the sun. Bamana peoples, Mali, early to mid-twentieth century. Wood, metal, plant fiber, hide, cowrie shells, 42 × 4 × 18 in. (108 × 10 × 47 cm). Collection number 73-7-56, National Museum of African Art, Washington, DC, bequest of Eliot Elisofon. Photograph by Franko Khoury.

Celestial combinations of sun, moon, and stars appear as design motifs in Asante *adinkra* cloths from Ghana. The motifs illustrate aphorisms that convey the wisdom of leadership and appropriate behavior within the community. The moon is used to convey faith, patience, and determination and as a symbol of leadership that matures over time and relies on the wisdom of advisors and the support of the nation's people. It recalls the Akan proverb, "It takes the moon some time to go round the nation." The star, said to be a

child of the heavens, recalls the saying, "A child of the Supreme Being, I do not depend on myself. My illumination is only a reflection of His." The crescent moon can be a female symbol, but when the moon and the star are together in a design, it brings male and female symbols together to convey devotion, love, harmony, and faithfulness and recalls an Akan saying about the North Pole Star being in love and awaiting the return of her husband, the moon.[14] When used in Akan leadership regalia, the moon and star design suggests the stable presence of a rule (the star) in contrast to forces of change, likened to the varying phases of the moon. Of course, the precise meaning of any one design is in relation to others depicted on the cloth as well as the contexts in which an *adinkra* cloth is worn.

African Cosmos also includes works by African contemporary artists who draw on the cosmos for inspiration. Stars and celestial phenomena, African myths, and scientific enquiry serve as points of departure as artists reflect on the ways they consider their position on, below, or above the earth and in relation to the heavenly bodies that inhabit the skies. Artworks selected for the project are by a range of internationally recognized artists, including El Anatsui, Alexander "Skunder" Boghossian, Willem Boshoff, Romuald Hazoumè, Gavin Jantjes, William Kentridge, Julie Mehretu, Marcus Neustetter, Karel Nel, Yinka Shonibare, Berco Wilsenach, and Sandile Zulu.

Interestingly, a number of the artists—Boshoff, Jantjes, Kentridge, Neustetter, Nel, Wilsenach and Zulu—are from South Africa, suggesting, perhaps, a heightened interest in the topic due to the country's ancient rock art and oral traditions that connect earth and sky and reflecting, as well, South Africa's prominence on the continent in the science of astronomy dating from the nineteenth-century observatory in Cape Town on up to the twenty-first-century Southern African Large Telescope (SALT) complex and its future work on the Square Kilometre Array

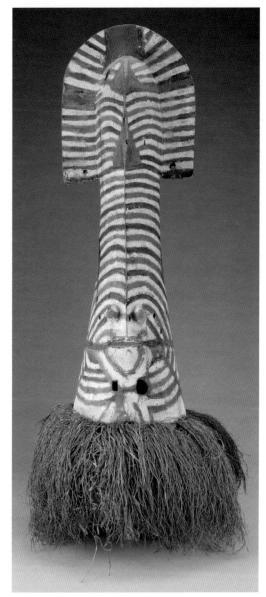

5.
Helmet mask used for the dance of the new moon and for funerals and other occasions. Sungu-Tetela peoples, Democratic Republic of the Congo, early twentieth century. Wood, pigment, fiber, 35 1/8 × 10 5/8 × 11 7/8 in. (89.2 × 27 × 30.2 cm). Collection number 84-6-6.1, National Museum of African Art, Washington, DC, acquisition grant from the James Smithson Society. Photograph by Franko Khoury.

radio telescopes sited in the Karoo region of the Northern Cape. Gavin Jantjes, for example, created a series of works in 1990 entitled *Zulu*, a term meaning "sky" or "heavens." A painting in this series (see Figure 1) refers to the southern African myth about the creation of the Milky Way. The myth recounts how a girl, dancing with her friends by the light of the fire, threw ashes into the sky, where they formed the Milky Way. The subject matter is drawn from the artist's sketchbook notes on astronomy and southern African rock art. Other works from Jantjes' *Zulu* series explore celestial knowledge and social concepts as they relate to crop production in Africa or as they provide political commentary on current leadership in Africa through associations the artist makes with the constellation Draco, the dragon beast.

South African artist Karel Nel forges a particularly strong link between art and the science of astronomical observation. Nel is the sole artist among a group of over 100 scientists working on a multiyear project called the Cosmic Evolution Survey (COSMOS) that has access to major ground- and space-based telescopes, including Hubble, to explore a two-degree square area of the sky. This has allowed the astrophysicists to see further and further back in time, observing the universe as it was near the beginning and as it has evolved. Nel has been privy to the discussions and observations of the scientific team, whose findings have been extraordinary, detecting two million galaxies and spanning about 75% of the age of the universe. For his part, Nel has been creating an exciting body of work reflecting this research and his own interrogation of darkness and light and one's place in the universe (Figure 6). His work has explored the idea of red shift, "an astronomical means of measuring the great distances of deep space" that also describes the phenomena of things moving away from us in our ever-expanding universe, blue shift, "a term used for the rare blue trace of something moving towards us," and the qualities of light in space.[15]

Karel Nel's cosmic works dating to 2007 and 2008 consider dark matter and the fragile images of light that left their source millions of year ago. Many of his works have thickly textured surfaces built up with ancient and elemental materials: white ocean salt and a coal-like substance millions of years old. The artist contends that these works "grapple with our capacity to map and comprehend infinite vastness and our place within it." In his 2009 work entitled "Trembling Field," "an oval elliptical stretch of water with a submerged dark mirror [and] an etched image of . . . radio sources from the two square degrees," Nel engages his audience to activate the water and initiate "unpredictable configurations of distorted light patterns" as a way to consider how astronomers study light and use it in astronomical measurements.[16]

Conclusion

The African Cosmos project draws attention to indigenous African knowledge of the universe and its relationship, and relevancy, to Western astronomy. Broad in approach and featuring both traditional and contemporary works of art, both the exhibition and its accompanying publication explore African arts as creative means for articulating connections between human ideas and values and the cosmos. The location of the *African Cosmos* exhibition in a gallery with a soaring two-story-high ceiling and its open design plan communicates on multiple levels the vastness of our

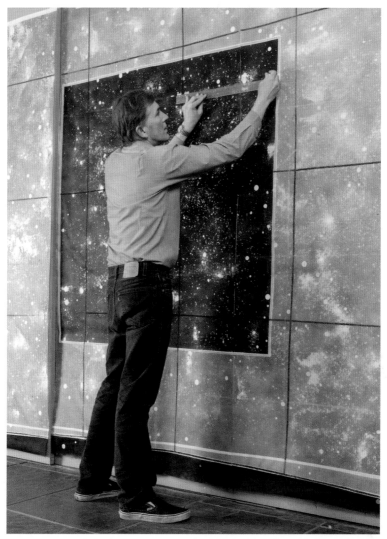

6.
Karel Nel working on *The Collapse of Time*, 2008. Sprayed pigment on bonded fiber fabric, 94 ½ × 141 ¾ in. (240 × 360 cm) (three-part screen). Photograph by John Hodgkiss.

universe, the shared human experience of gazing skyward and bringing meaning and relevancy to the heavenly bodies above, and the role of art in expressing the ineffable.

Acknowledgments

I thank Amy Staples, Supervisory Archivist, Eliot Elisofon Photographic Archives, for her help in securing images for this essay.

Notes

1. For example, my 2007 exhibition and book entitled *Inscribing Meaning: Writing and Graphic Systems in African Art* challenged popularly held beliefs that Africa was historically without written traditions and thus illiterate from a Western perspective; Christine Mullen Kreamer et al., *Inscribing Meaning: Writing and Graphic Systems in African Art* (Washington, DC: National Museum of African Art, Smithsonian Institution in association with 5 Continents, 2007).

2. Jarita C. Holbrook, "Chasing the Shadow of the Moon: The 2006 Ghana Eclipse Conference," in *African Cultural Astronomy*, ed. Jarita C. Holbrook, Rodney Thebe Medupe, and Johnson O. Urama, Current Archaeoastronomy and Ethnoastronomy Research in Africa Series: Astrophysics and Space Science Proceedings 8 (New York: Springer, 2008), 2.

3. See, for example, T. G. Brophy and P. A. Rosen, "Satellite Imagery Measures of the Astronomically Aligned Megaliths at Nabta Playa," *Mediterranean Archaeology and Archaeometry* 5, no. 1 (2005): 15–24; Jarita C. Holbrook, Rodney Thebe Medupe, and Johnson O. Urama, eds., *African Cultural Astronomy*, Current Archaeoastronomy and Ethnoastronomy Research in Africa Series: Astrophysics and Space Science Proceedings 8 (New York: Springer, 2008); J. McKim Malville et al., "Astronomy of Nabta Playa," in *African Cultural Astronomy*, ed. Jarita C. Holbrook, Rodney Thebe Medupe, and Johnson O. Urama, 131–43, Current Archaeoastronomy and Ethnoastronomy Research in Africa Series: Astrophysics and Space Science Proceedings 8 (New York: Springer, 2008); Rodney Thebe Medupe et al., "The Timbuktu Astronomy Project: A Scientific Exploration of the Secrets of the Archives of Timbuktu," in *African Cultural Astronomy*, ed. Jarita C. Holbrook, Rodney Thebe Medupe, and Johnson O. Urama, 179–88, Current Archaeoastronomy and Ethnoastronomy Research in Africa Series: Astrophysics and Space Science Proceedings 8 (New York: Springer, 2008).

4. *African Cosmos:Stellar Arts* is an edited volume that accompanies the exhibition organized by Christine Mullen Kreamer, Deputy Director and Chief Curator, National Museum of African Art, Smithsonian Institution. In addition to essays by Kreamer, the volume includes contributions by artists and scholars who draw on their research and/or artistic practice to consider the connections between art and cosmos in Africa.

5. Anthony F. Aveni, *Ancient Astronomers* (Montreal: St. Remy Press, 1993), 93.

6. Christine Mullen Kreamer, "Africa's Moral Universe," in *Beyond Earth: Mapping the University*, ed. David DeVorkin (Washington, DC: National Geographic Society, 2002), 60–71.

7. Marcel Griaule and Germaine Dieterlen, "The Dogon," in *African Worlds: Studies in the Cosmological Ideas and Social Values of African Peoples*, ed. D. Forde (1954; repr., London: Oxford University Press, 1970), 83–110; Robert K. G. Temple, *The Sirius Mystery* (London: Sidgwick and Jackson, 1976).

8. This includes a 2006 conference in Ghana held to coincide with the total solar eclipse on March 29, which brought together astronomers, ethnographers, historians, archaeologists, elementary school educators, and others to discuss African contributions to cultural astronomy and the methods, strategies, and resources for researching and teaching it; see Holbrook, Medupe, and Urama, *African Cultural Astronomy*. The conference led to the formation of the African Cultural Astronomy project, an information-sharing network organized by a number of conference participants from Nigeria and South Africa. A multidisciplinary Timbuktu Astronomy Project, initiated in 2006 between the governments of Mali and South Africa, focuses on the study and conservation of Timbuktu's ancient manuscripts that contain information on a range of topics, including astronomy; see Medupe et al., "The Timbuktu Astronomy Project." A 2009 documentary film entitled *The Ancient Astronomers of Timbuktu*, produced and directed by South African filmmaker Sharron Hawkes, highlights recent findings associated with this ongoing collaborative research project and emphasizes the cultural and scientific value of Timbuktu's ancient manuscripts. It builds upon the film *Cosmic Africa* (released 2003) produced in South Africa and directed by South African filmmakers Craig and Damon Foster, which documents astrophysicist R. Thebe Medupe's consideration of the interface between cultural and Western astronomy as he journeys to sites and meets with local, self-taught specialists in Namibia, Mali, and southern Egypt.

9. Brophy and Rosen, "Satellite Imagery Measures," Malville et al., "Astronomy of Nabta Playa."

10. Pascal Vernus, *The Gods of Ancient Egypt*, trans. Jane Marie Todd (New York: George Braziller, 1998), 185–90.

11. Antoni Paprocki, "Some Aspects of the Astronomy of Ancient Egypt as the Elements of Measurement of Life Duration," *Africana Bulletin* (Warsaw) 17 (1991): 110.

12. Robert Farris Thompson, *Flash of the Spirit: African and Afro-American Art and Philosophy* (New York: Vintage Books, 1984).

13. Allen F. Roberts, "Social and Historical Contexts of Tabwa Art," in *Tabwa: The Rising of a New Moon: A New Century of Tabwa Art* (Ann Arbor: The University of Michigan Museum of Art, 1985), 1.

14. W. Bruce Willis, *The Adinkra Dictionary* (Washington, DC: The Pyramid Complex, 1998), 154, 177, 178.

15. Karel Nel, *Lost Light: Fugitive Images from Deep Space*, ed. Emile Maurice (Johannesburg: Standard Bank Gallery, 2007), 24; Nel, "Trembling Field," in *Penelope and the Cosmos* (Johannesburg: CIRCA on Jellicoe, 2009), 16.

16. Karel Nel, *Karel Nel: The Brilliance of Darkness* (London: Art First Contemporary Art, 2008); Nel, "Trembling Field," 20.

Bibliography

Aveni, Anthony F. *Conversing with the Planets: How Science and Myth Invented the Cosmos*. New York: Times Books, 1992.

———. *Ancient Astronomers*. Montreal: St. Remy Press, 1993.

Brophy, T. G., and P. A. Rosen. "Satellite Imagery Measures of the Astronomically Aligned Megaliths at Nabta Playa." *Mediterranean Archaeology and Archaeometry* 5, no. 1 (2005): 15–24.

Griaule, Marcel, and Germaine Dieterlen. "The Dogon." In *African Worlds: Studies in the Cosmological Ideas and Social Values of African Peoples*, edited by D. Forde, 83–110. London: Oxford University Press, 1970. First published 1954 by Oxford University Press.

Holbrook, Jarita C. "Chasing the Shadow of the Moon: The 2006 Ghana Eclipse Conference." In *African Cultural Astronomy*, edited by Jarita C. Holbrook, Rodney Thebe Medupe, and Johnson O. Urama, 1–19. Current Archaeoastronomy and Ethnoastronomy Research in Africa Series: Astrophysics and Space Science Proceedings 8. New York: Springer, 2008.

Holbrook, Jarita C., Rodney Thebe Medupe, and Johnson O. Urama, eds. *African Cultural Astronomy*. Current Archaeoastronomy and Ethnoastronomy Research in Africa Series: Astrophysics and Space Science Proceedings 8. New York: Springer, 2008.

Kreamer, Christine Mullen. "Africa's Moral Universe." In *Beyond Earth: Mapping the University*, edited by David DeVorkin, 60–71. Washington, DC: National Geographic Society, 2002.

Kreamer, Christine Mullen, Mary Nooter Roberts, Elizabeth Harney, and Allyson Purpura. *Inscribing Meaning: Writing and Graphic Systems in African Art*. Washington, DC: National Museum of African Art, Smithsonian Institution in association with 5 Continents, 2007.

Kreamer, Christine Mullen, Erin L. Haney, and Katharine Monsted. *African Cosmos: Stellar Arts*. Washington, DC: National Museum of African Art, Smithsonian Institution in association with The Monacelli Press, 2012.

Malville, J. McKim, Romuald Schild, Fred Wendorf, and Robert Brenmer. "Astronomy of Nabta Playa." In *African Cultural Astronomy*, edited by Jarita C. Holbrook, Rodney Thebe Medupe, and Johnson O. Urama, 131–43. Current Archaeoastronomy and Ethnoastronomy Research in Africa Series: Astrophysics and Space Science Proceedings 8. New York: Springer, 2008.

Medupe, Rodney Thebe, Brian Warner, Shamil Jeppie, Salikou Sanogo, Mohammed Maiga, Ahmed Maiga, Mamadou Dembele, Drissa Diakite, Laya Tembely, Mamadou Kanoute, Sibiri Traore, Bernard Sodio, and Sharron Hawkes. "The Timbuktu Astronomy Project: A Scientific Exploration of the Secrets of the Archives of Timbuktu." In *African Cultural Astronomy*, edited by Jarita C. Holbrook, Rodney Thebe Medupe, and Johnson O. Urama, 179–88. Current Archaeoastronomy and Ethnoastronomy Research in Africa Series: Astrophysics and Space Science Proceedings 8. New York: Springer, 2008.

Nel, Karel. *Lost Light: Fugitive Images from Deep Space*. Edited by Emile Maurice. Johannesburg: Standard Bank Gallery, 2007.

———. *Karel Nel: The Brilliance of Darkness*. London: Art First Contemporary Art, 2008.

———. "Trembling Field." In *Penelope and the Cosmos*. Johannesburg: CIRCA on Jellicoe, 2009.

Paprocki, Antoni. "Some Aspects of the Astronomy of Ancient Egypt as the Elements of Measurement of Life Duration." *Africana Bulletin* (Warsaw) 17 (1991): 109–21.

Roberts, Allen F. "Social and Historical Contexts of Tabwa Art." In *Tabwa: The Rising of a New Moon: A New Century of Tabwa Art*, 1–48. Ann Arbor: The University of Michigan Museum of Art, 1985.

Temple, Robert K. G. *The Sirius Mystery*. London: Sidgwick and Jackson, 1976.

Thompson, Robert Farris. *Flash of the Spirit: African and Afro-American Art and Philosophy*. New York: Vintage Books, 1984.

Vernus, Pascal. *The Gods of Ancient Egypt*. Translated by Jane Marie Todd. New York: George Braziller, 1998.

Willis, W. Bruce. *The Adinkra Dictionary*. Washington, DC: The Pyramid Complex, 1998.

The Mathematical Paintings of Crockett Johnson, 1965–1975
An Amateur and His Sources

Peggy Aldrich Kidwell
Curator of Mathematics

Smithsonian Institution
National Museum of American History
Washington, D.C.

My own "geometric painting" is an effort to put geometry itself to conscious craft use.[1]

—Crockett Johnson

Introduction

Changes in the status of mathematics in American culture have long been associated with changes in the visual representation of mathematical ideas. In the early nineteenth century, when elementary mathematics came to be commonly taught in American common or primary schools, enterprising vendors introduced models and charts for classroom use. The spread of engineering mathematics at midcentury led to an introduction of string models of ruled surfaces in the style of French engineering education. Late in the century, universities bought German models designed by mathematicians to tangibly demonstrate an admiration of the ideal of the research university. During the same time period, the vast expansion of high school education encouraged new approaches to teaching subjects like geometry with instruments like the common protractor. In the mid-twentieth century, a burgeoning school-age population, an outstanding group of popular writers on mathematical subjects, and concerns about national preparedness when the Soviet Union launched the Sputnik satellite in 1957 fostered popular interest in mathematics and the history of mathematics. Firms needing technically trained workers for work in aerospace and computing encouraged the movement.

Books, school curricula, teaching apparatus, educational films, and museum exhibits were devoted to popularizing mathematics.[2]

The mathematical paintings of the American cartoonist, children's author, and illustrator Crockett Johnson (1906–1975) well illustrate the connection between the prominence of mathematics in the cold war and its popular influence. Contemporary painters such as Piet Mondrian, Ad Reinhardt, Josef Albers, Alexander Calder, and Richard Anuszkiewicz had used geometric forms in their paintings. Artists like Alfred Jensen paid tribute to mathematicians in paintings like *Honor Pythagoras–Per I–Per IV* (1964).[3] Crockett Johnson not only used mathematical shapes and honored mathematicians but also painted constructions that had been of importance in the history of mathematics. For inspiration, he drew heavily on contemporary popularizations of mathematics and consulted with mathematicians. He also came to create his own mathematical constructions. In other words, as stated in the epigraph, his geometric painting was about geometry.[4]

As many others have shown, mathematical theories had been deeply entwined with changes in art long before Crockett Johnson. The Renaissance theory of perspective offers one example of this interaction and even inspired two Crockett Johnson paintings.[5] Linda Dalyrymple Henderson has explored complex interconnections between early twentieth-century art and both geometrical discussions of four-dimensional spaces and alternatives to Euclid's parallel postulate. She traces the path from popular accounts of the fourth dimension and of non-Euclidean geometry to specific works of Jean Metzing, Juan Gris, Marcel Duchamp, and others.[6] As we shall see, Crockett Johnson stuck more closely to traditional geometry.

Crockett Johnson worked in an era when both painters and mathematicians claimed that their endeavors should be guided by internal professional standards, not the demands of patrons. His success as a graphic artist and author made it possible for him to pursue his own visions of both painting and mathematics. He remained an amateur in both of these areas. Although he formed close friendships with both painters and mathematicians, they did not embrace his view of their disciplines. Several scholars have studied Crockett Johnson and his work.[7] This essay examines his career as it reveals the boundaries of both the professional art and the professional mathematics of his time. It is part of a larger exploration of American mathematical recreations from the early years of the republic. Major sources are some eighty of the paintings as well as correspondence and other documentation, largely as these survive in the collections of the Smithsonian's National Museum of American History.[8]

Crockett Johnson's Early Career: Art Director, Cartoonist, and Author

Crockett Johnson was born David Johnson Leisk in New York City and spent his early years there. He was the son of a bookkeeper and a former department store salesclerk. After brief studies at Cooper Union, he took a variety of jobs in graphic arts, working successively in the advertising department at Macy's department store, as art editor for *Aviation* magazine (later *Aviation Week*),

and as arts editor for the Marxist publication *New Masses*. In these new roles he adopted a new name, Crockett Johnson. I shall call him by this moniker or by the initials he used, CJ. At the *New Masses*, he solicited illustrations and cartoons from the Pennsylvania-born artist Abe Ajay (1919–1998) and the abstract expressionist painter Ad Reinhardt (1913–1967), both of whom became lifelong friends.[9] In 1940, he met Ruth Krauss; they married three years later.

From the start of his career, quotidian concerns dominated Crockett Johnson's work. He produced ephemeral art in a timely manner rather than lavishing countless hours on single masterworks. This attitude served him well not only in his early career but later, when he became a cartoonist and then a children's author. It also would be reflected in his mathematical paintings. His wordless cartoons *Little Man with the Eyes* ran in *Colliers* magazine from 1940 until 1943. By 1942, he had decided that a comic strip with dialogue would have merits and launched the strip *Barnaby*. It featured five-year-old Barnaby Baxter, his family, and his cigar-smoking "fairy godfather," Mr. O'Malley. Their adventures appeared in a few dozen newspaper, and were collected in paperback books.[10]

Life magazine described *Barnaby* as having a "high I. Q. for comic strip humor."[11] Readers included Duke Ellington, Dorothy Parker, W. C. Fields, artist Rockwell Kent, and radio dramatist Norman Corwin.[12] As one would expect for a work making these claims, there were mathematical discussions. One character was Atlas, the Mental Giant, a calculating whiz whose status was marked by the slide rule he carried. Reader Thomas Ehrenkranz of New York City pointed out that Atlas's slide rule was by no means the standard item then in use and sent the cartoonist a diagram of what Atlas should have had.[13] Another early portrayal of Atlas contained an equation that was pure gibberish. Alerted by readers, Crockett Johnson paid more attention to the accuracy of his mathematical statements in later strips.[14]

Barnaby was sufficiently successful for Krauss and Crockett Johnson to move to Connecticut and buy a home near the shore. Crockett Johnson and various assistants continued *Barnaby* through 1952. Ruth Krauss wrote her first successful children's books, some illustrated by her husband. His interests shifted to this area, particularly with the success of a book he wrote and illustrated, *Harold and the Purple Crayon*.

As Phil Nel has noted, in both comic art and children's books Crockett Johnson used a simple, spare style to represent figures. The works are imbued with optimism, self-confidence, imagination, and intelligence.[15] He also portrayed drawing as a way to create opportunities and resolve problems. Harold, the leading character in *Harold and the Purple Crayon*, used his crayon to draw a moon to light his walk, a path to walk on, an apple tree, and a frightening dragon to guard the apples. He drew a boat to cling to when he was drowning, a picnic lunch when he was hungry, and a balloon to keep him aloft when he was falling through the air. A correct drawing of his window brought him home, where he drew a bed where he could sleep.[16] Crockett Johnson would carry over into his mathematical painting both his spare style and his confidence in imaginative drawing as a way to understand and resolve problems.

CJ's comic art reflected contemporary events. He was most aware of labor strife in the 1930s and McCarthyism in the early 1950s. Similarly, his children's books followed contemporary

trends. By the late 1950s, he and other Americans were intrigued by the possibilities of space flight. In *Harold's Trip to the Sky* (1957), Harold decided to go to the moon and drew a simple rocket to get him there. Missing his target, he drew stars and comets to light his way further into space. Seeking a place to land, he drew a bit of a planet and labeled it Mars. After creating and coming to fear a Martian, he returned to earth on a convenient shooting star.[17] Similarly, two of the letters in *Harold's ABC* (1963) were represented by astronomical themes. *O* stood for "our earth," as seen from mountains on the moon. The letter *T* was represented by a telescope.[18]

Interest in space exploration, combined with a perceived threat from Soviet missiles and a booming school-age population, soon placed a premium on Americans trained in science and mathematics.[19] In the early 1960s, CJ resumed production of *Barnaby*, updating the story line for the times. Characters like Atlas, the Mental Giant, had new opportunities in the space age, as a strip from February 1962 suggested. Here a store owner proposed that Atlas could do his book-keeping. The Mental Giant, like others trained in mathematics, shrugged off this opportunity and aspired to other things.[20]

CJ's Early Mathematical Paintings: Diagrams as Inspiration

Crockett Johnson and his contemporaries recognized the opportunities and enthusiasms of the space age in other ways. Art historians have explored some of the interconnections between science, technology, and art of the period. Ann Collins Goodyear has examined the activities of artist Gyorgy Kepes as he planned the Center for Advanced Visual Studies, which opened at MIT in 1967. She compares this work with the attempts of engineer Billy Klüver to foster art based on modern engineering practice through the New York–based organization Experiments in Art and Technology (founded 1966).[21] As these figures sought to foster ties between artists, modern science, and contemporary engineering, administrators at the U.S. government's National Aeronautics and Space Administration hired artists to record achievements in space.[22] Technically grounded art even shaped the representation of the United States at the 1970 World's Fair.[23]

In late 1965, Crockett Johnson turned from graphic arts to painting. He described his "masterpieces" in a letter to Ad Reinhardt, who apparently had taken exception to his use of this term. The budding painter replied,

> Thanks for your prompt reply to my rather uninformative note about the masterpieces. I don't use the word loosely, stickler that I am I know it can only be used in the singular; but as each painting turned out less bad than the previous one in my lengthy three-month career it was a masterpiece, and once a masterpiece always a masterpiece. Anyway, they are neat and tidy, reasonably straight-edged and flat surfaced, and have an irresistible appeal to people that like coldly intellectual abstractions and warmly emotional realistic art. They comprise a series of romantic tributes to the great geometric mathematicians from

Pythagoras on up; in other words the shapes and disciplines are pilfered (but interpretation is the greatest form of plagiarism and besides I am very willing to share credit with Euclid, Descartes, et al) . . . At worst it is a slight unifying gimmick for a show. The thing it offered me was a simple-minded chance to put something down with paint without too many cornball shapes bubbling out of my punkin [*sic*] head.[24]

Crockett Johnson had already shown the paintings to Ajay and hoped Reinhardt would come up to see them.

Following his usual pattern of producing work quickly, Crockett Johnson showed little interest in the technical details of painting. He did not work on canvas, but rather on what he called "the lovely rough side of inexpensive masonite." He preferred small paintings of "an economical two or three-foot size."[25] Although he did not mention this to Reinhardt, he also painted in house paint mixed at a local hardware store.[26] These preferences were not entirely fixed; by early 1966 he had already tried one larger painting and would do others. However, over the ten years he painted, his medium remained house paint and his support masonite (he sometimes used the smooth side).

A postcard from the Ad Reinhardt–Abe Ajay correspondence suggests that his friends regarded Crockett Johnson's new enthusiasm with some amusement. Reinhardt wrote Ajay,

Abe, I'll tell you what, if Dave is having a good time paint-work-wise, means he isn't doing any good work. If he's struggling and suffering, that's Ruth's problem. If he's going about it coolly, calmly, half-smirking, half-crying, to keep from half-laughing, then we got to get together soon, break into that chicken-coop he calls a studio, some dark night when he's at Judson church looking at Poet's Theatre Productions, [and] dump all that illegal, tax-deductible stuff in Norwalk Bay. Find out if he using an easel, if he's shaping his canvases, pushing or pulling his brush, staining or squeezing his image, then call me pronto.[27]

Other sources suggest that Crockett Johnson's studio was indeed modest and frequently flooded. His letters, paintings, and mathematical library indicate that he was working calmly and systematically. The February 1966 letter quoted said that he had then been painting for three months, which would place the beginning of this work to late November of 1965. Seven paintings in the National Museum of American History collections and at least one elsewhere are signed "CJ65," suggesting an efficient novice.

When CJ began painting, he relied heavily on popular accounts of mathematics. As David Lindsay Roberts has noted, the 1940s had been a golden age of mathematical popularization in the United States. Books by several foreign-born authors, some of them distinguished mathematicians, such as G. H. Hardy, Richard Courant, and H. S. M. Coxeter, were widely available. Of greater importance to Crockett Johnson was the journalist James R. Newman, who collaborated with mathematician Edward Kasner of Columbia University in a volume *Mathematics and the Imagination* (1940).[28] Newman then devoted fifteen years to preparing *The World of Mathematics*, a four-volume compilation of historical papers, translations of important mathematical texts, and appropriate

commentaries. This was published in 1956 and sold some 150,000 copies—a bestseller indeed for a mathematical popularization.[29] Crockett Johnson owned a copy of the second printing of this book and examined it carefully. All of his 1965 paintings are based on diagrams in the first volume of *The World of Mathematics*.[30] He was particularly interested in a lengthy essay entitled "The Great Mathematicians." This was a reprint of a book having the same title by the Scottish mathematics professor and historian of mathematics Herbert W. Turnbull.[31] I do not know how Newman came to Crockett Johnson's attention, but the artist's annotated copy of the book survives at the National Museum of American History.

Crockett Johnson planned an exhibition of historically important theorems from Pythagoras onward. As one might expect, one of his first paintings presented the Pythagorean Theorem (Figure 1). He planned his painting by looking at a diagram in Newman and drawing a rectangle around it to indicate where the edges of the painting would be. He then calculated the lengths of the line segments required to enlarge the image and drew the figure in pencil on masonite. Paint followed. He described the painting to Reinhardt as follows:

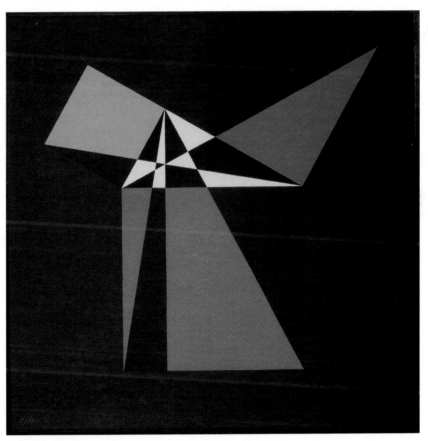

1.
Proof of the Pythagorean Theorem (Euclid), 1965. SI negative number 2008-2519. This image and the others shown in this article are of paintings by Crockett Johnson in the Mathematics Collections, Division of Medicine and Science, National Museum of American History, Smithsonian Institution, Washington, DC.

So far I have enlarged only one [painting], Euclid's famous proof of the Pythagorean right triangle, to four feet by four feet, still on masonite, and it is a kind of imposing thing, like God or your 5B teacher confronting you. It is very pretty, too. Flat red, white, blue and yellow with part of it indicated by Reinhardt dark on dark areas I borrowed because you are not using them anymore.[32]

Most of the 1965 paintings concerned Euclidean and projective geometry, although one represented a theorem from mathematical astronomy. This painting also was based on a diagram from Newman.

In 1966, Crockett Johnson widened his mathematical reading. Nathan Altshiller-Court's *College Geometry: An Introduction to the Modern Geometry of the Triangle and the Circle* (1964) inspired as many as nine of his paintings. This was a textbook by a University of Oklahoma mathematics professor, not a popularization. The artist also sampled a book on art and geometry by William M. Ivins Jr., former curator of prints at the Metropolitan Museum of Art, and a more technical volume of A. S. Smogorzhevskii.[33] He continued to find inspiration in Newman's *The World of Mathematics*.

By the spring of 1967, Crockett Johnson had accumulated enough mathematical paintings to mount Abstractions of Abstractions, a show at the Glezer Gallery in New York City. He included thirty paintings, six of them larger than 3 feet × 3 feet (~1 m ×1 m). Associations were with mathematicians from Thales and Pythagoras to Einstein. Geometry dominated, but there were topics from calculus, number theory, astronomy, and mathematical physics. The exhibit was not an artistic sensation.[34]

Cold War Publications and a Shift in Focus

In November of 1966 California author and television producer Evans G. Valens sent Crockett Johnson his popular account of mathematics entitled *The Number of Things: Pythagoras, Geometry, and Humming Strings*. The men apparently had known one another since the early 1950s. "Red" Valens inscribed the book to "Dave" and wrote

I have for some while known that great science is always an art (and most often is art) . . . that art worth living with is always cognizant (humbly or not) of science . . . and the two words are just as phony as body / mind / soul . . . So I send you this for the art therein, obvious and potential.[35]

Valens pointed out a figure in his book that the Mental Giant might particularly enjoy.

Valens's book was the first written in the post-Sputnik era to have a major influence on Crockett Johnson's painting. It was part of a more general effort of publishers, parents, educators, mathematicians, scientists, public officials, and instrument makers to improve mathematics and science education in the United States.[36] The E. P. Dutton Company of Chicago, Valens's publisher, had published books on various technical topics in 1950 and a general textbook called

Physics for Everyone in 1956. In the 1960s, the company's titles expanded to include a wide range of children's books on scientific subjects, especially physics.[37] Thus, Valens's *The Number of Things* reflected not only his talents as a popular author but also one publisher's conscious attempt to beef up its publications in mathematics and the physical sciences. Other publishers made similar efforts.[38]

Valens inspired Crockett Johnson to move from representing well-known mathematical constructions to proposing his own theorems. Johnson not only considered the artistic possibilities of mathematics but also came to propose his own constructions. This did not happen immediately. In 1967, Crockett Johnson used one of Valens's diagrams as the basis of a construction of a spiral. He also began to think about geometric constructions that make it possible to represent the area of figures bounded by curved lines with other figures bounded by straight lines. The ancient Greek mathematician Hippocrates had been one of the first to "square" a figure bounded by a curve. He showed that two moon-shaped lunes could be drawn that were equal in area to a right-angled triangle inscribed in a related circle. Crockett Johnson extensively annotated Valens's account of this work, working out mathematical details. He also prepared two paintings of squared lunes. In a 1966 version of the painting, he shows only the lunes and underlying circle and triangle. Another painting shows more details (Figure 2). Crockett Johnson's annotated copy of the book shows that he actively followed the mathematical argument, writing out equations and labeling figures. His painting omits the final detail of the proof, in which the triangle is equated to a square.

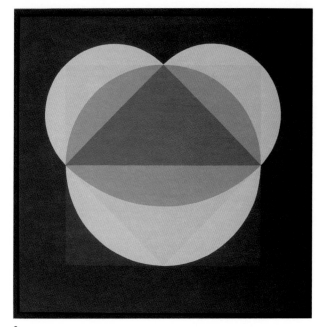

2.
Squared Lunes (Hippocrates of Chios), undated. SI negative number 2008-2500.

Other books in CJ's library described Archimedes' quadrature of the parabola. This led to two paintings entitled *Parabolic Triangles (Archimedes)*, one from 1967 and one from 1969. In his proof, Archimedes first constructed a triangle whose sides consisted of two tangents of a parabola and the chord connecting the points of tangency. He then showed that the area under the parabola is two-thirds of the area of the triangle that circumscribes it. Once the area bounded by the tangent could be expressed in terms of the area of a triangle, it was easy to construct the corresponding square.

It proved more difficult to find strictly by ruler and compass construction a square equal in area to a given circle. For a circle of radius 1, this is equivalent to finding a square that has

3.
Squared Circle, 1968. SI negative number 2008-2466.

area π and sides equal in length to the square root of π. In 1882, Carl Louis Ferdinand von Lindemann proved that π is a transcendental number, and hence, this is impossible. Eighteenth- and nineteenth-century mathematicians did develop ways to approximate π very accurately by calculating the value of series that converged to that number.[39]

Crockett Johnson developed constructions that allowed him to approximate π to four places. The figure was complex at best and required numerous pages of handwritten calculations. He sent a description of his construction to Valens, who later reported that "you really snowed me with that first assault, and I tried to understand it and got half way to first base and decided I had to wait until I had some free hours."[40] Crockett Johnson also found his first construction unsatisfactory, and by the end of 1968 he was able to provide an alternative (Figure 3). He sent a manuscript on the painting to Harley Flanders, editor of the *American Mathematical Monthly*, a publication for college mathematics professors. Flanders rejected it outright. In a letter to Crockett Johnson, Flanders explained, "I hope you will understand that it is absolutely impossible for me to publish anything in the *Monthly* on squaring the circle other than a possible new very short proof of its impossibility. You have no idea how much mail I receive from would-be circle-squarers, angle-trisectors, etc. The publication of a single article in this direction always unleashes a real flood of new contributions. What is more, mathematicians simply are not interested in these problems anymore."[41] However, Flanders was a great fan of *Barnaby* and an enthusiast for mathematics. He sent Crockett Johnson a copy of H. S. M. Coxeter's book *The Real Projective Plane* and asked if Crockett Johnson might know where he could get a copy of the second volume of *Barnaby* cartoons. Johnson arranged this. *Scientific American* columnist Martin Gardner was equally reluctant to enter into the topic but suggested that the *Mathematical Gazette* might be interested in the paper and sent the address of the editor.[42] This proved to be the case, with Crockett Johnson's approximation of π appearing there in early 1970.[43] The following year, Crockett Johnson also published the construction in the literary magazine *Penumbra*.[44]

Having gained a taste for original mathematical efforts, Crockett Johnson went on to work on several other constructions of his own design. Most notable were his attempts to construct a regular heptagon. Constructing polygons with equal sides and angles had interested mathematicians from ancient times. Crockett Johnson developed a way of constructing the seven-sided

figure using a compass and a marked straight edge. As in his work on squaring, he prepared and circulated drawings of his heptagon construction and used responses to craft a paper. The work led to paintings and a short mathematical article.[45]

By the early 1970s, most mathematicians had little interest in new results in plane geometry, whether they used a marked or an unmarked straight edge. Crockett Johnson also had taken a different path from contemporary painters who used geometric forms. In 1971, he prepared an article on his mathematical paintings that would be published in the journal *Leonardo*. He originally entitled the essay "Geometric Geometric Painting," stressing that he not only used the language of geometry but was seriously interested in the mathematics itself. As he wrote in a draft of the paper,

> In . . . recent times painting has echoed the language of geometry with words and phrases for methods and movements, "the golden-rectangle canvas," "dynamic symmetry," "cubism," all of which have had little to do with mathematical graphics. Today there is "geometric painting," a term for any use of compass-and-straightedge [*sic*] designs or conic shapes, whether chosen by the artist for experiment in color and optic effect, for hopefully evoking new emotions with ancient symbols, for plain plane emblazonment, or for a score of purposes to which geometry is unrelated or merely incidentally connected. As my own "geometric painting" is an effort to put geometry itself to conscious craft use I am rather pushed into the redundancy of the above title.[46]

At the urging of the editor and referees, Crockett Johnson revised both the title and the text of his paper. However, his original words well express the distinction between his use of mathematics and that of contemporary painters.

Crockett Johnson sent reprints of his paper to mathematical acquaintances such as Harley Flanders and Martin Gardner. At least Flanders was inspired to ask if he had lithographs or prints of the paintings available. More generally, the essay seems to have had little influence.[47]

Crockett Johnson's emphasis on paintings with mathematical and scientific content is reflected in where his work was shown. Exhibitions appeared at the IBM Gallery in Yorktown Heights, New York; at the General Electric Gallery in Fairfield, Connecticut; and at what was then the Smithsonian's Museum of History and Technology.[48] Text of the scripts focused on the paintings as they illustrated mathematical theorems and the work of mathematicians, not on connections to contemporary art.

Conclusion

When Crockett Johnson began his mathematical paintings, he was a well-informed and proficient professional artist, but an amateur painter. He used mathematical illustrations from popular books as topics of a series of abstract paintings that reflected both the work of contemporary painters and his own proclivity for simple, efficiently produced work.

Crockett Johnson regarded his paintings more as a pleasing recreation than a subject of intense scrutiny. He was happy to limit his materials to house paint on a masonite support. While

he showed his paintings several times, they never greatly influenced the artistic community. As time went on, Crockett Johnson came to rely on his own mathematical insights as a source of ideas. These constructions proved of only modest interest to mathematicians, and he remained an amateur in the discipline. His work appealed to several organizations seeking to inspire future mathematicians, including the Smithsonian Institution. Thus, his paintings may best be understood as a tangible manifestation of cold war American concerns for mathematics and mathematics education and of the enduring power of geometry to capture the visual imagination.

Acknowledgments

Work on an online catalog of paintings and related documentation of Crockett Johnson in the collections of the National Museum of American History inspired this essay. Numerous museum staff contributed to that project, with special thanks to photographers Harold Dorwin and John Dillaber and interns Kristen Haring and Emmy Scandling. Earlier research of Uta C. Merzbach, Judy Green, Stephanie Crawthorne, J. B. Stroud, and Phil Nel has been most useful. I also thank Bernard Finn for arranging the Artefacts conference where the paper was presented, Anne Goodyear and Margaret Weitekamp for their editorial expertise, and anonymous reviewers for helpful comments.

Notes

1. Crockett Johnson, "Geometric Geometric Painting," 1971 typescript, Crockett Johnson Collection, Mathematics Collections, National Museum of American History, Smithsonian Institution, Washington, DC. Henceforth Crockett Johnson Collection.

2. For references, see P. A. Kidwell, Amy Ackerberg-Hastings, and David Lindsay Roberts, *Tools of American Mathematics Teaching, 1800–2000* (Baltimore: Johns Hopkins University Press, 2008); P. A. Kidwell, "Mobilizing Minds: American Mathematics and Science Education for the Cold War," *Rittenhouse* 21, no. 1 (June 2007): 46–64.

3. Images of work of Jensen, Mondrian, and Reinhardt can be found at the Web site of the Smithsonian American Art Museum (http://americanart.si.edu/).

4. Crockett Johnson may have hoped to attract a client for his painting series. On paintings sponsored by the Container Corporation of America under the title "Great Ideas of Western Man," see M. R. Norelli, *Art, Design and the Modern Corporation: The Collection of the Container Corporation of America, a Gift to the National Museum of American Art*, with an essay by N. Harris (Washington, DC: Smithsonian Institution Press, 1985).

5. Judith V. Field, *The Invention of Infinity: Mathematics and Art in the Renaissance* (Oxford: Oxford University Press, 1997). The paintings, both from 1965, are *Squares of a 3-4-5 Triangle in Scalene Perspective (Dürer)* and *Perspective (Alberti)*. For an overview of work on the large topic of the interconnections of art and mathematics, two volumes edited by Michele Emmer offer a useful starting point. They are *The Visual Mind: Art and Mathematics* (Cambridge, MA: MIT Press, 1993) and *The Visual Mind II* (Cambridge, MA: MIT Press, 2005).

6. Linda Dalrymple Henderson, *The Fourth Dimension and Non-Euclidean Geometry in Modern Art* (Princeton, NJ: Princeton University Press, 1983).

7. On Crockett Johnson's career, see P. Nel, "Crockett Johnson and the Purple Crayon: A Life in Art," *Comic Art* 5 (2004): 2–18. See also S. Cawthorne and J. Green, "Harold and the Purple Heptagon," *Math Horizons* 17, no. 1 (September 2009): 5–9; J. B. Stroud, "Crockett Johnson's Geometric Paintings," *Journal of Mathematics and the Arts* 2, no. 2 (June 2008): 77–99; Phil Nel, *Crockett Johnson and Ruth Krauss* (Jackson: University Press of Mississippi, 2012).

8. Images of the paintings and some of the documents may be examined at the Web site of the National Museum of American History (http://americanhistory.si.edu/collections/object-groups/mathematical-paintings-of-crockett-johnson).

9. M. Corris, *Ad Reinhardt* (London: Reaktion Books, 2008), 33–60, 175–84.

10. Unless noted, biographical information is taken from Nel, "Crockett Johnson and the Purple Crayon."

11. "Speaking of Pictures . . . 'Barnaby' Has High I. Q. for Comic Strip Humor," *Life*, October 4, 1943:11.

12. Ellington and Parker are mentioned in Nel, "Crockett Johnson and the Purple Crayon." See W. C. Fields to Crockett Johnson, 10 October 1944; N. Corwin to Crockett Johnson, 7 July 1945; and R. Kent to H. K. Taylor, September 18, 1943, Crockett Johnson Collection.

13. T. Ehrenkranz to Mr. Johnson, 29 January 1944, Crockett Johnson Collection.

14. Cawthorne and Green, "Harold and the Purple Heptagon," 5–6.

15. P. Nel, "Crockett Johnson and the Purple Crayon."

16. Crockett Johnson, *Harold and the Purple Crayon* ([New York]: Harper and Brothers, 1955).

17. Crockett Johnson, *Harold's Trip to the Sky* ([New York]: Harper and Brothers, 1957).

18. Crockett Johnson, *Harold's ABC* (New York: Harper and Row, 1963).

19. For an overview of this topic, see M. W. Rossiter, *Women Scientists in America: Before Affirmative Action, 1940–1972* (Baltimore: Johns Hopkins University Press, 1995), 50–68. See also W. Patrick McCray, *Keep Watching the Skies: The Story of Operation Moonwatch & the Dawn of the Space Age* (Princeton, NJ: Princeton University Press, 2008).

20. Crockett Johnson, *Barnaby*, February 10, 1962.

21. Ann Collins Goodyear, "Gyorgy Kepes, Billy Klüver, and American Art of the 1960s: Defining Attitudes Toward Science and Technology," *Science in Context* 17, no. 4 (2004): 611–35.

22. Anne Collins Goodyear, "NASA and the Political Economy of Art, 1962–1974," in *The Political Economy of Art: Making the Nation of Culture*, ed. Julie F. Codell (Cranbury, NJ: Associated University Presses, 2008), 191–202.

23. Anne Collins Goodyear, "Expo '70 as Watershed: the Politics of American Art and Technology," in *Cold War Modern: Design 1945–1970*, ed. David Crowley and Jane Pavitt (London: V&A Publishing, 2008), 198–203.

24. Crockett Johnson to A. Reinhardt, 27 February 1966, Ad Reinhardt Papers, Smithsonian Archives of American Art, Washington, DC. I thank Philip Nel for drawing my attention to this letter.

25. Crockett Johnson to A. Reinhardt, 27 February 1966, Ad Reinhardt Papers.

26. P. Nel, telephone interview with Antonio Frasconi, October 12, 2000.

27. A. Reinhardt to A. Ajay, [February?] 1966, Abe Ajay–Ad Reinhardt Correspondence, microfilm 4909, Smithsonian Archives of American Art, Washington, DC.

28. E. Kasner and J. R. Newman, *Mathematics and the Imagination* (New York: Simon and Schuster, 1940).

29. D. L. Roberts, "WFF 'N PROOF and the Climate for Mathematical Recreations in the 1950s and 1960s," unpublished manuscript. I thank Roberts for allowing me to read this paper.

30. J. R. Newman, *The World of Mathematics: A Small Library of the Literature of Mathematics from A'h-mosé the Scribe to Albert Einstein* (New York: Simon and Schuster, 1956).

31. H. W. Turnbull, *The Great Mathematicians* (London: Methuen, 1929). Later editions of this book appeared in London in 1933, 1941, 1951, and 1962. The first American edition (other than Newman's reprint) seems to have been published in New York by Simon & Schuster in 1962.

32. Crockett Johnson to A. Reinhardt, 27 February 1966, Ad Reinhardt Papers. Reinhardt was known for painting severely symmetrical, nearly monochromatic paintings, sometimes divided into regions of slightly different coloring (as black on black). See Lucy R. Lippard, *Ad Reinhardt* (New York: The Jewish Museum, 1966).

33. W. M. Ivins, *Art and Geometry: A Study in Space Intuitions* (1946; repr., New York: Dover, 1964), 76; A. S. Smogorzhevskii, *The Ruler in Geometrical Constructions*, trans. Halina [sic] Moss (New York: Blaisdell, 1961), 37.

34. A leaflet listing the paintings exhibit is entitled *Abstractions of Abstractions* and is in the Crockett Johnson Collection. It includes comments by psychoanalyst Gilbert J. Rose and art journalist Michael Benedikt on Crockett Johnson's paintings. It also quotes Alfred Barr of the Museum of Art as stating that "it's obvious today that comics are art. Just because these things are vulgar doesn't mean they are not art." Barr said nothing about the paintings. The exhibit was included in a listing of What's New in Art, *New York Times*, April 2, 1967, but no details are given. The exhibit was described in the *Times* as entitled "Geometry in Oil" in advertisements that ran April 1, 2, 8, and 9, 1967. Benedikt published a paragraph on the show in Reviews and Previews, *Art News*, April 1967. He emphasized Crockett Johnson's cartooning and children's books but commented that Crockett Johnson had moved beyond the diagrams he found in textbooks. He "spaces in a lively way, converts theorem-subjects to decorative motifs, alters colors. As a result, Johnson's geometry emerges haunted—a fate which, ever since Euclid, geometry has certainly deserved. The painting is a kind of cool Hard-Edge, but bouncy over-all."

35. E. G. Valens, inscription in *The Number of Things: Pythagoras, Geometry, and Humming Strings* (New York: E. P. Dutton, 1964), Crockett Johnson Collection.

36. On mathematics and science teaching in the age of Sputnik, see J. L. Rudolph, *Scientists in the Classroom: The Cold War Reconstruction of American Science Education* (New York: Palgrave, 2002). See also D. L. Roberts and A. L. E. Walmsley, "The Original New Math: Storytelling versus History," *Mathematics Teacher* 96, no. 7 (October 2003): 468–73.

37. On Dutton publications in the 1960s, see the E. P. Dutton Papers, Special Collections Research Collection, Syracuse University, Syracuse, NY.

38. On the material culture of American mathematics and science education in this period, see P. A. Kidwell, "Mobilizing Minds: American Mathematics and Science Education for the Cold War," *Rittenhouse* 21, no. 1 (June 2007): 46–64.

39. C. L. F. von Lindemann, "Über die Zahl π," *Mathematische Annalen* 20 (1882): 215. On early attempts to square the circle, see David Eugene Smith, "Historical Survey of the Attempts at the Computation and Construction of π," *American Mathematical Monthly* 2, no. 12 (December 1895): 348–51.

40. Red Valens to Crockett Johnson, 22 April [1968 or 1969], Crockett Johnson Collection.

41. H. Flanders to Crockett Johnson, 18 August 1969, Crockett Johnson Collection. See also H. Flanders to Crockett Johnson, 6 August 1968, Crockett Johnson Collection.

42. M. Gardner to Crockett Johnson, 2 [?] April 1968, Crockett Johnson Collection.

43. Crockett Johnson, "A Geometrical Look at $\sqrt{\pi}$," *Mathematical Gazette* 54 (February 1970): 59–60.

44. Crockett Johnson, "A Geometric Painting of a Squared Circle," *Penumbra*, no. 9 (February 1971). The journal is not paginated.

45. Crockett Johnson, "A Construction for a Regular Heptagon," *Mathematical Gazette* 17 (March 1975), 17–21.
46. Crockett Johnson, "Geometric Geometric Painting," 1971 typescript, Crockett Johnson Collection.
47. Crockett Johnson, "On the Mathematics of Geometry in My Abstract Paintings," *Leonardo* 5 (1972): 97–101.
48. Exhibition at IBM Gallery in Yorktown, NY, circa 1975 (see *New York Times*, "Crockett Johnson, Cartoonist, Creator of 'Barnaby,' Is Dead," July 13, 1975); Theorems in Color, Museum of History and Technology, Smithsonian Institution, summer 1980. The Smithsonian exhibit was noted in *Antiques and the Arts Weekly*, July 13, 1980. On the posthumous exhibit of Crockett Johnson's mathematical paintings at the General Electric Gallery in Fairfield, Connecticut, see the Ruth Krauss Collection, University of Connecticut.

Bibliography

Cawthorne, S., and J. Green. "Harold and the Purple Heptagon." *Math Horizons*, September 2009:5–9.

Corris, M. *Ad Reinhardt*. London: Reaktion Books, 2008.

Dutton, E. P., Papers. Special Collections Research Collection. Syracuse University, Syracuse, NY.

Emmer, Michele, ed. *The Visual Mind: Art and Mathematics*. Cambridge, MA: MIT Press, 1993.

———. *The Visual Mind II*. Cambridge, MA: MIT Press, 2005.

Field, Judith V. *The Invention of Infinity: Mathematics and Art in the Renaissance*. Oxford: Oxford University Press, 1997.

Goodyear, Ann Collins. "Gyorgy Kepes, Billy Klüver, and American Art of the 1960s: Defining Attitudes Toward Science and Technology." *Science in Context* 17, no. 4 (2004): 611–35.

———. "Expo '70 as Watershed: the Politics of American Art and Technology." In *Cold War Modern: Design 1945–1970*, edited by David Crowley and Jane Pavitt, 198–203. London: V&A Publishing, 2008.

———. "NASA and the Political Economy of Art, 1962–1974." In *The Political Economy of Art: Making the Nation of Culture*, edited by Julie F. Codell, 191–202. Cranbury, NJ: Associated University Presses, 2008.

Henderson, Linda Dalrymple. *The Fourth Dimension and Non-Euclidean Geometry in Modern Art*. Princeton, NJ: Princeton University Press, 1983.

Ivins, W. M. *Art and Geometry: A Study in Space Intuitions*. New York: Dover, 1964. Originally published 1946 by Harvard University Press.

Johnson, Crockett. Crockett Johnson Collection. Mathematics Collections. National Museum of American History, Smithsonian Institution, Washington, DC.

———. *Harold and the Purple Crayon*. [New York]: Harper and Brothers, 1955.

———. *Harold's Trip to the Sky*. [New York]: Harper and Brothers, 1957.

———. *Harold's ABC*. New York: Harper and Row, 1963.

———. "A Geometrical Look at $\sqrt{\pi}$." *Mathematical Gazette* 54 (February 1970): 59–60.

———. "A Geometric Painting of a Squared Circle." *Penumbra*, no. 9 (February 1971): n.p.

———. "On the Mathematics of Geometry in My Abstract Paintings." *Leonardo* 5 (1972): 97–101.

———. "A Construction for a Regular Heptagon." *Mathematical Gazette* 17 (March 1975): 17–21.

Kasner, E., and J. R. Newman. *Mathematics and the Imagination*. New York: Simon and Schuster, 1940.

Kidwell, P. A. "Mobilizing Minds: American Mathematics and Science Education for the Cold War." *Rittenhouse* 21, no. 1 (June 2007): 46–64.

Kidwell, P. A., Amy Ackerberg-Hastings, and David Lindsay Roberts. *Tools of American Mathematics Teaching, 1800–2000*. Baltimore: Johns Hopkins University Press, 2008.

Lippard, Lucy R. *Ad Reinhardt*. New York: The Jewish Museum, 1966.

McCray, W. Patrick. *Keep Watching the Skies: The Story of Operation Moonwatch & the Dawn of the Space Age*. Princeton, NJ: Princeton University Press, 2008.

Nel, P. *Crockett Johnson and Ruth Krauss*. Jackson: University Press of Mississippi, 2012.

———. "Crockett Johnson and the Purple Crayon: A Life in Art." *Comic Art* 5 (2004): 2–18.

Newman, J. R. *The World of Mathematics: A Small Library of the Literature of Mathematics from A'h-mosé the Scribe to Albert Einstein*. New York: Simon and Schuster, 1956.

Norelli, M. R. *Art, Design and the Modern Corporation: The Collection of the Container Corporation of America, a Gift to the National Museum of American Art*. With an essay by N. Harris. Washington, DC: Smithsonian Institution Press, 1985.

Reinhardt, Ad. Papers. Smithsonian Archives of American Art, Washington, DC.

Roberts, D. L., and A. L. E. Walmsley. "The Original New Math: Storytelling versus History." *Mathematics Teacher* 96, no. 7 (October 2003): 468–73.

Rossiter, M. W. *Women Scientists in America: Before Affirmative Action, 1940–1972*. Baltimore: Johns Hopkins University Press, 1995.

Rudolph, J. L. *Scientists in the Classroom: The Cold War Reconstruction of American Science Education*. New York: Palgrave, 2002.

Smith, David Eugene. "Historical Survey of the Attempts at the Computation and Construction of π." *American Mathematical Monthly* 2, no. 12 (December 1895): 348–51.

Smogorzhevskii, A. S. *The Ruler in Geometrical Constructions*. Translated by Halina [*sic*] Moss. New York: Blaisdell, 1961.

"Speaking of Pictures . . . 'Barnaby' Has High I. Q. for Comic Strip Humor." *Life*, October 4, 1943: 11.

Stroud, J. B. "Crockett Johnson's Geometric Paintings." *Journal of Mathematics and the Arts* 2, no. 2 (June 2008): 77–99.

Turnbull, H. W. *The Great Mathematicians.* London: Methuen, 1929.

Valens, E. G. *The Number of Things: Pythagoras, Geometry, and Humming Strings.* New York: E. P. Dutton, 1964.

von Lindemann, C. L. F. "Über die Zahl π." *Mathematische Annalen* 20 (1882): 213–225.

Art in the Context of the Science Institution
A Case Study of the Cultural Programs of the National Academy of Sciences

J. D. Talasek

Cultural Programs Director

National Academy of Sciences
Washington, D.C.

Although the National Academy of Sciences (**NAS**) was chartered in 1863 under President Abraham Lincoln, this prestigious organization did not have a permanent address until 1924, when a building designed by architect Bertram Grosvenor Goodhue was erected within sight of the Lincoln Memorial. Academy member and astrophysicist George Ellery Hale headed the building committee and raised funds to build the academy's headquarters—a structure that would be regarded by many as the home of science in the United States. Hale, whose noteworthy accomplishments included the construction of the Hale Telescope and the invention of the spectroheliograph, was a cultural visionary who saw commonality rather than differences between art, science, and literature. Hale recognized the power of art to communicate the ideas and impact of science on society and marshaled it to create a visual identity for the institution. He supported Goodhue in commissioning three artists to define the space of the building. Throughout the neoclassical building appear tributes to science in the form of bronze sculptures and stone reliefs created by sculptor Lee Lawry. Large murals by Albert Herter depict classical themes, such as Prometheus stealing the fire of knowledge, and more historical scenes, with President Lincoln standing with the academy's other founding fathers. In the expansive domed ceiling of the Great Hall, the centerpiece of the building, artist Hildreth Meière fashioned a constellation of bold, colorful images depicting the history of science as it was understood in 1924. The feeling of grandeur created by the artists and

the architectural design contributed to the building being referred to as a "temple of science."[1] Hale, whose vision was reflected in the act of engaging artists for this purpose, had initiated a relationship with art at the academy that would continue to evolve into the present.

Continuing this precedent, the NAS instituted a program of art exhibitions in the early 1970s. This rotating program has evolved over the past three decades in response to the growing number of artists who are interested in exploring scientific concepts and processes. The NAS building provides a significant context for such work, one that is rooted in the academy's history and mission. Visitors to gallery spaces in the NAS range from the general public to members of the academy and members of committees formed to provide expert opinions on pertinent issues of the day. The expectations and mind-set of visitors to the NAS differ from those who tour a traditional art museum or gallery. In this context, certain interpretations can arise, providing a platform for a cross-disciplinary exchange of ideas.

One of the many fascinating things about art and art history is that a single work of art can record elements of both an individual and a culture, especially since neither can be entirely separated from the other. Artworks produced during any given time period provide a wealth of information for historians, illuminating prevalent ideas or revealing nuanced attitudes and values of a time, place, and culture. Artists work not only with the material and technology of their time but also with pervading ideas, perspectives, and ideologies.[2] Contemporary artists are no exception. Considering the cultural impact of advancements in science and technology, it is little surprise that artists gravitate toward these tools and themes in their own arc of inquiry. Artists have functioned as observer, critic, and commentator on a number of salient contemporary issues, such as the impact of the advancements in genetics on self-identity[3] or the human impact on environmental issues,[4] to name only a couple of prominent examples. The works of new-media artists, designers, and other creative practitioners have provided creative examples of how technology could be used and implemented as well as its possible impact on society and culture.[5] Yet with all of this engagement, fine art communities and museums, as a whole, have been significantly slow to respond seriously to the domain of science-related art. Most practitioners in this milieu still feel marginalized within the art community. Marvin Heiferman, curator of *Paradise Now: Picturing the Genetic Revolution,* has mentioned the utter lack of response from the art press toward his exhibition a decade ago despite its significance as a survey of genetic artists.[6] Opportunities are increasing for artists to present their work within the context of science institutions.[7] Perhaps with the growing intensity of this dialogue, acceptance of this type of art practice will also grow within the fine art community. As a catalyst for change, continued and increasing critical examination of new-media arts and of new art practices addressing salient contemporary issues may cause museum and galleries to take note of the importance of embracing epistemological exchanges.

So what benefit is there to the larger discourse when this type of art work is exhibited outside the traditional context in which art is expected to be found? Specifically, how does the interpretation of the work shift when it is placed within the context of science? First, to illustrate in broader terms, here is an example of a commonly known work of art. In her book *Art and the*

Power of Placement, Victoria Newhouse traces the history of the placement of Michelangelo's iconic *David* to describe how a shift in context alters meaning.[8] The statue was commissioned for a buttress of the cathedral of Santa Maria del Fiore in Florence, Italy. In this location *David* would have been interpreted as a biblical hero. As the statue was nearing completion in 1504, however, the decision was made to locate it in front of the town hall. It was placed high on a rostrum and parapet next to Florence's entrance portal, facing south toward Rome. According to Newhouse, "The *David* was seen by many in Florence as a warning to their Goliath: the exiled Medici who opposed the Florentine Republic."[9] Today, the statue stands alone in a special gallery in Florence's Galleria dell'Accademia, where it is viewed as an artistic masterpiece of historical significance.[10]

When works of art are moved to a science center, the artwork itself most likely does not change, nor does the intent of the artist in creating it. The difference lies in interpretation. The mind-set and educational perspective of viewers and what they expect based on past experiences, traditions, and norms will shape their response, as will the history and politics of the space. Artist Richard Serra addressed this when he wrote of site-specific work, "Analysis of a given site takes into consideration not only formal but also social and political characteristics of the site."[11] Interpretation of art within the traditional museum will most likely be influenced by the "white cube" exhibition space and how it conjures ideas of art practice, history, theory, and so on. Presenting artworks within a science institution, for example, the NAS, will most likely disrupt constructed perceptions, and this context will inevitably affect the interpretation of the work and cause themes to surface in the consciousness of viewers that might not arise in the context of a traditional art space. Questioning constructed norms in this way can only be beneficial since it challenges perceptions as well as traditions.

With this idea in mind, the art exhibited at the NAS focuses on a growing genre of artists who are interested in engaging science in innovative ways as a means of cultural investigation. Conversely, the potential exists for engaging scientists in creative processes since a portion of the audience is composed of the sort of people who, since the end of the Civil War, have influenced and shaped the making of policies in the United States. When it is most effective, the work presented in this context challenges viewers to consider the usefulness of constructed perceptions in diverse epistemologies. The NAS building offers a venue where artworks can be interpreted within the context of science and potentially build a bridge of discourse between what Charles Percy Snow termed "the two cultures," that is, the constructed difference between the epistemologies of science and the humanities.[12] The academy's art galleries, for example, are placed within a working science environment. Pathways through the galleries connect meeting rooms and conference centers, allowing visiting scientists to engage with art within the context of their work. This encourages the ideas that are presented by the artwork to be integrated into the daily working lives (and thought processes) of the visiting committee members who actively address science-related issues and polices. The absence of the white cube does not diminish the respect for or the significance of the work, but instead elevates it to thought-provoking relevance.

1.
Hildreth Meière, artist, and Betrum Grovner Goodhue, architect, the Great Hall of the National Academy of Sciences, Washington DC, 1924. Photograph by Mark Finkenstaedt.

As noted previously, the history of presenting artwork within the academy dates back to the construction of the building itself. Muralist Hildreth Meière, whose work is seen in the Great Hall of the NAS, was one of the first artists to integrate art into the building (Figure 1). Meière's use of iconography on the dome, arches, and pendentives creates a system of symbols that connects the NAS to the history of science. The dome is divided into eight sections, with figures in each section representing the sciences as they were recognized in 1924. Flanking each figure are two smaller medallions that illustrate associated subjects, tools, and theories. Figures in the pendentives supporting the dome pay homage to the science of the ancients by representing the four classical elements of earth, air, water, and fire. In the four arches, Meière's drawings link the American Academy to its older sister academies through the depiction of accomplishments associated with each one.[13]

A recent resurgence of interest in Meière's work can be credited to the 2009 retrospective exhibition *Walls Speak: The Narrative Art of Hildreth Meière* held at the Regina A. Quick Center for the Arts at St. Bonaventure University in western New York. In the accompanying catalog, curator Catherine Brawer points out that Meière's NAS project (her first architectural commission) involved learning how to work effectively with architect and client.[14] Within this work-for-hire situation, Meière visually interpreted the ideas of the building committee, but their recognition of the power of the visual in creating the commission is notable. Brawer also describes a technical

challenge Meière had to solve in the final execution of her designs. Meière's drawings were to be painted on a porous acoustical tile, but a certain percentage of the tile had to remain uncovered in order to be effective. Since the Great Hall would be used for lectures and events, sound needed to be distributed evenly throughout the space. The artist, who was experienced in working with mosaics, had to collaborate with the building engineers to develop a new technique of applying paint to a gesso base. This type of cooperative problem solving is prevalent today, especially when technologies change and advance at an exponential rate. Artists, especially those dealing with new media, often seek out collaborators who possess the necessary knowledge and skills to make their work a reality. In this way, contemporary art processes somewhat parallel those of science when teams, formally or not, are created to share their specialized knowledge.

At the core of the science-art-technology discussion is the debate over how the disciplines relate to one another. What form does an effective collaboration take? Does this nexus result in art functioning as a handmaiden to science, or can art and artists contribute cognitively to the scientific discovery process? In the relationship between the NAS and Meière, the artist's task was to create visual symbols that conveyed the ideas of the building committee. By contemporary art standards that value the originality of the artist's voice, commissioned work is often considered a lesser form of expression. Regardless, Meière valued the collaborative process with the building committee and engineers and the visual interpretation of their ideas. After all, some of the world's most notable works of art, such as Michelangelo's *David*, were commissions.

Meière's work, although decorative, is based on a symbolic system that was conceived by the building committee to communicate the history of science, thus illustrating the way art can be (and often is) enlisted to educate and illustrate. In contrast, it is useful to consider two teams of artists who have exhibited their work at the NAS within the past decade: Mike and Doug Starn and Tim Rollins + K.O.S. Both use collaborative artistic processes that explore the significance of the artists' voices in the creation and shaping of meaning. Unlike earlier commissions, the artists'

2.
Mike and Doug Starn, *Structure of Thought #13*, 2000–2005. MIS Lysonic inkjet prints on Gampi, Thai mulberry, and tissue papers, with wax and varnish, 25 × 134 in (63.5 × 340.4 cm)

Chapter 14

contributions to concept and execution are acknowledged and allow for cultural and personal perspectives to be integrated into the work.

Twins Mike and Doug Starn, who rose to international fame in the 1980s with their photography-based multimedia work, use the visual power of juxtaposing the meaning of culturally charged images as a way to build new connections in the minds of viewers. Employing old and new technologies, they explore the complexity and interconnectivity of meaning that is embedded in visual culture. In the work selected for the exhibition *Absorption + Transmission*, held at the NAS in 2005, the Starns explored the metaphorical potential of a range of neurological imagery derived from new technological advances.[15] In one work (Figure 2), an image of a tadpole's neuron was layered with images of trees that mimic the structure of the neuron. Traditional photography processes and new imaging technologies were integrated in creating digitally printed images on mulberry paper, the delicate texture of which created a feeling of timelessness and tension with the contemporary medical imagery. The sheets of mulberry paper, enhanced with encaustic and albumen, were then layered over one another to produce a work with sculptural qualities. The act of layering these images while combining old and new processes and materials in itself becomes a metaphor for the layering and interconnectivity of ideas. As the imagery of the tree evokes deeply rooted traditions in the visual arts and literature, it becomes a metaphor for knowledge, from the biblical reference to the tree of knowledge to the "tree of life," while resonating with the branchlike structure of the neurons. The exhibition of Mike and Doug Starn's work in the context of the NAS building provided yet another layer of meaning to their work, asking the viewer to consider the fertile ground that advancing medical imagery, such as MRIs, provides for expanding the artist's vernacular and questioning old and new visual metaphors.

Combining the process of learning with the act of creating art provides the groundwork for the work of the collaborative team of Tim Rollins + K.O.S. (Kids of Survival). Rollins and

2.
Continued.

his students first received recognition from the art community in the 1980s for their minimalist aesthetic and their conceptual practice in which process is paramount. Rollins's work addresses issues of education through process, research, and interpretation. Formed in the Bronx, the collaboration was initiated by Rollins and consisted of middle and high school students who had been labeled "unteachable" by the educational system. Additionally, the home life of many of these students was unstable, and the hostile nature of their environment created barriers to learning. The dire nature of the situation is apparent in a statement Rollins received from an administrator in the school system: "Don't try to teach them. Just try to keep them alive."[16]

The approach Rollins adopted was simple and elegant in concept: engage the minds of students by engaging their hands in the creative process of making art. Rollins + K.O.S.'s paintings are based on literature (and in some cases classical music), with pages from books often literally becoming the foundation for the pieces. Students read, discuss, and research the work as they use it to create objects of art. They also consider the history of the visual representation of ideas through art, mass media, and popular culture. Today, the collaboration's work is in the collections of many international museums, but perhaps it is even more important that many of the unteachable students have gone on to receive college degrees.

In 2009, Cultural Programs of the NAS (CPNAS) commissioned Rollins + K.O.S. to create a painting based on Charles Darwin's *On the Origin of Species* in celebration of the 150th anniversary of the publication and the 200th anniversary of Darwin's birth (Figure 3).[17] Far from representational and rooted in the tradition of minimalism, the work is based on the words of Darwin and takes the form of a grid made from pages of the book. Rollins + K.O.S. created a stencil of Darwin's sketch of the tree of life, an iconic image that itself signifies the power of imagery to transform understanding.[18] As the students discovered in their research, contemporary evolutionary biology has replaced Darwin's original ideas. It has been suggested that Darwin's original drawing of a tree might be replaced by a web, thus better signifying the complexity of evolution as it is understood today.[19] By repeating the stenciled tree of life over the pages of the book, the collaboration established the idea that Darwin's original drawing was the building block on which the ideas of current evolutionary biology are built. In this process, Rollins and the students made the image their own, finding personal connections with the subject matter through the process of learning and research that were part of their methodology.

With the current atmosphere of concern about the educational system in this country and the declining test scores in math and science of American students, the educational process and related issues are of concern at the National Academies.[20] Rollins and the development of his teaching methodology underscore the facts that not all students learn in the same ways and alternative teaching practices can be very effective in reaching those who do not learn as well as others in traditional environments. Rollins's interactive process also shows that art as an educational tool and art as an exploratory tool are not mutually exclusive. The collaboration's research informs the work while the visual interpretation of the material enables young people to find personal and creative relationships with the work and with each other.

3.

Tim Rollins + K.O.S., *On the Origin of Species (After Darwin)*, 2009. India ink, graphite transfer, matte acrylic, book pages, 72 × 120 in (182.9 × 304.8 cm). Courtesy of the artists. From the collection of the National Academy of Sciences, Washington, DC.

This case study provides a sample of the range of work that is being presented at the NAS as it collaborates with artists. Themes and perspectives are only limited by the boundaries of creativity. Visual exploration often can lead the scientist and engineer to discovery, and it is part and parcel of the artist's endeavor. Since artists offer a reflection of the perception, or even misperception, of scientific concepts as they are absorbed into the cultural consciousness, this is an opportunity for scientists to examine how their work is received. The intersection between disciplines is far more interesting and ultimately productive than the differences. Through a shift in context, exhibiting artwork at the NAS, as well as at other science institutions, encourages interpretation and discussion along these lines. To view the role of the artist as that of a mere conduit for science communication and education misses a wider range of possibilities. Art has the potential to augment perspectives and inspire fruitful paths of exploration while it serves as a historical marker for a trajectory of ideas.

Notes

1. In his dedication of the building in 1924, President Calvin Coolidge refers to the building as a "temple of science." The dedication address was published in the 1923–1924 Annual Report of the National Academy of Sciences (p. 45): "The Carnegie Corporation of New York then donated the building, which may be termed the Temple of Science in America. It is not a place of mystery, but one to lead the public in thinking deeply and seeing how research can explain fundamental problems."

2. This point has been researched and published on extensively by such noted scholars as Linda Henderson. For additional information, see Linda Henderson, *Reimagining Space: The Park Place Gallery Group in 1960s New York* (Austin, TX: Blanton Museum of Art, 2008). See also Linda Henderson, *The Fourth Dimension and Non-Euclidean Geometry in Modern Art*, 1st ed. (Princeton, NJ: Princeton University Press, 1983).

3. For an extensive look at artists working in this area, see Suzanne Anker and Dorothy Nelkin, *The Molecular Gase: Art in the Genetic Age* (Cold Spring Harbor, NY: Cold Spring Harbor Laboratory Press, 2004)

4. The Nevada Museum of Art in Reno, and the research and archives at the Center for Art + Environment, for example, has focused on collecting and exhibiting the work and archives of artists working in this particular area. For further research on the museum's collection, see the following exhibition catalog: Ann Wolf, ed., *Altered Landscape: Photographs of a Changing Environment* (New York: Skira Rizzoli Press in association with the Nevada Museum of Art, 2011).

5. For further investigation, see Stephen Wilson, *Information Arts: Intersections of Art, Science and Technology* (Cambridge, MA: MIT Press, 2002). Also see the Web site for the Museum of Modern Art's exhibition curated by Paola Antonelli entitled Design and the Elastic Mind, http://www.moma.org/interactives/exhibitions/2008/elasticmind/ (accessed May 2, 2012).

6. Suzanne Anker and J. D. Talasek, *Visual Culture and Bioscience* (Baltimore: Center for Art, Design and Visual Culture, University of Maryland, Baltimore County, 2008).

7. In addition to CPNAS, other science institutions with a history of exhibiting artwork include the Exploratorium in San Francisco, the Museum of Natural History in London, the Wellcome Trust in the UK, the Harvard Museum of Natural History in Massachusetts, and starting in 2010, the Smithsonian Institution's National Museum of Natural History, to name only a few.

8. Victoria Newhouse, *Art and the Power of Placement* (New York: Monacelli Press, 2005), 10.

9. Newhouse, *Art and the Power of Placement*, 10.

10. Contemporary culture continues to transform the icon and its meaning through a variety of reproductions and appropriations. When kitschy reproductions are sold on the street, Michelangelo's *David* is transformed once again as it contributes to the local economy and tourist trade.

11. Richard Serra, "Rigging," interview with Gerard Hovagymyan, in *Richard Serra: Interviews, Etc., 1970–1980* (Yonkers, NY: Hudson River Museum, 1980), 128.

12. C. P. Snow, *The Two Cultures* (1959; repr., Cambridge: Cambridge University Press, 1998).

13. The four institutions referred to include the Accademia dei Lincei in Rome, the museum of Alexandria, the Royal Society of London, and the Academie des Sciences, Paris.

14. Catherine Brawer, *Walls Speak: The Narrative Art of Hildreth Meière* (St. Bonaventure, NY: St. Bonaventure University, 2009).

15. Mike Starn and Doug Starn, *Absorption + Transmission* (Washington, DC: Cultural Programs of the National Academy of Sciences, 2005).

16. Conversation with Tim Rollins, 2007.

17. The first painting commissioned from Tim Rollins + K.O.S. was based on the epic *On the Nature of the Universe* by Lucretius. Students from Banneker High School in Washington, DC, contributed to the painting through a three-day workshop (April 13–15, 2005) led by Rollins.

18. It should be noted that Darwin's sketch, which was the only illustration used in his publication *On the Origin of Species*, was not referred to by Darwin as a tree. For more information, see the transcripts from the online symposium on Visual Culture and

Evolution hosted by CPNAS in April 2010, http://www.vcande.org (accessed December 8, 2010). The publication *Visual Culture and Evolution*, containing the edited transcripts from the symposium, was published in 2012.

19. In their research for the painting, Rollins + K.O.S found inspiration in a drawing and article by Norman Pace (*Science*, 276 [1992]: 734–40) and in an article by Margaret Wertheim, "Figuring Life," originally published in *Cabinet*, 27 (Fall 2007). ·

20. For more information, see National Research Council, *What Is the Influence of the National Science Education Standards? Reviewing the Evidence, A Workshop Summary,* Karen S. Hollweg and David Hill, eds., Steering Committee on Taking Stock of the National Science Education Standards: The Research, Committee on Science Education K-12, Center for Education, Division of Behavioral and Social Sciences and Education (Washington, DC: The National Academies Press, 2003). Also see National Research Council, *Learning Science in Informal Environments: People, Places, and Pursuits,* Committee on Learning Science in Informal Environments, ed. Philip Bell, Bruce Lewenstein, Andrew W. Shouse, and Michael A. Feder, Board on Science Education, Center for Education. Division of Behavioral and Social Sciences and Education (Washington, DC: The National Academies Press, 2009).

Bibliography

Anker, Suzanne, and Dorothy Nelkin. *The Molecular Gase: Art in the Genetic Age.* Cold Spring Harbor, NY: Cold Spring Harbor Laboratory Press, 2004.

Anker, Suzanne, and J. D. Talasek. *Visual Culture and Bioscience.* Baltimore: Center for Art, Design and Visual Culture, University of Maryland, Baltimore County, 2008.

Brawer, Catherine. *Walls Speak: The Narrative Art of Hildreth Meière.* St. Bonaventure, NY: St. Bonaventure University, 2009.

Henderson, Linda. *The Fourth Dimension and Non-Euclidean Geometry in Modern* Art. 1st ed. Princeton, NJ: Princeton University Press, 1983.

———. *Reimagining Space: The Park Place Gallery Group in 1960s New York.* Austin, TX: Blanton Museum of Art, 2008.

National Research Council. *What Is the Influence of the National Science Education Standards? Reviewing the Evidence, A Workshop Summary.* ed Karen S. Hollweg and David Hill. Steering Committee on Taking Stock of the *National Science Education Standards*: The Research, Committee on Science Education K–12, Center for Education, Division of Behavioral and Social Sciences and Education. Washington, DC: The National Academies Press, 2003.

———. *Learning Science in Informal Environments: People, Places, and Pursuits.* Committee on Learning Science in Informal Environments. ed Philip Bell, Bruce Lewenstein, Andrew W. Shouse, and Michael A. Feder. Board on Science Education, Center for Education. Division of Behavioral and Social Sciences and Education. Washington, DC: The National Academies Press, 2009.

Newhouse, Victoria. *Art and the Power of Placement.* New York: Monacelli Press, 2005.

Serra, Richard, and Clara Weyergraf. *Richard Serra: Interviews, Etc., 1970–1980.* Yonkers, NY: Hudson River Museum, 1980.

Snow, C. P. *The Two Cultures.* 1959. Reprint, Cambridge: Cambridge University Press, 1998.

Starn, Mike, and Doug Starn. *Absorption + Transmission.* Washington, DC: Cultural Programs of the National Academy of Sciences, 2005.

Talasek, J. D., Rick Welch, and Kevin Finneran, eds. *Visual Culture and Evolution: An Online Symposium.* Baltimore, Md.: The Center for Design, Art and Visual Culture, UMBC, 2012.

Wertheim, Margaret. "Figuring Life." *Cabinet 27* (Fall 2007).

Wilson, Stephen. *Information Arts: Intersections of Art, Science and Technology.* Boston, MA: MIT Press, 2002.

Wolf, Ann, ed. *Altered Landscape: Photographs of a Changing Environment.* New York: Skira Rizzoli Press in association with the Nevada Museum of Art, 2011.

CHAPTER 15

Retaking the Universe
Art and Appropriated Astronomical Artifacts

Elizabeth A. Kessler

Visiting Lecturer

Stanford University
Stanford, California

Perhaps no set of scientific images has captured the public imagination as thoroughly as photographs of the stars. Romantic associations with the infinite and the sublime provide a means for labeling the spatial uncertainty they convey as well as an avenue by which the images can travel easily into another discursive arena. Their minimalism, the starkness of white dots against fields of blackness, matches contemporary taste while also appealing to ancient impulses to find patterns in the night sky. Views of the heavens often evoke an almost generic sense of awe and wonder, and it is easy to assume that one can understand, even experience, such representations of the cosmos without taking into account their scientific source. They seem timeless, unmediated, and transparent in a way that many contemporary scientific images never could.

Astronomical images have also moved smoothly into the art world, and they have been greeted with a similar enthusiasm for their aesthetic appeal. Over the last several decades, artists Linda Connor (1944–), Thomas Ruff (1958–), and Vija Celmins (1938–) have appropriated astronomical photographs, reworking them while maintaining a very close correspondence to the original representation. Their acts of borrowing goes beyond simple aesthetics or a vague experience of awe, and the resulting work does not replace or ignore the scientific significance of the originals. These artists appropriate artifacts, manmade representations that record both the light of the cosmos and particular ways of observing and depicting it. They reproduce views of the starry sky, but more importantly, they explore how the heavens are represented: the technologies,

intentions, and practices that shape the pictures. All three make images of *images* of the heavens. In doing so, they acknowledge the complexity of image making by pointing to the multifaceted character of astronomical images, which exist simultaneously as artifacts, data, and aesthetic objects. At the same time, Connor, Ruff, and Celmins play with the scientific purposes that guide the appearance of the images. By experimenting with and reworking the original scientific intentions, they shift our response from a generic sense of wonder to one of sustained engagement with the artifacts of science and the act of making representations.

Because of their distinct practices, Celmins, Ruff, and Connor might seem like an unlikely trio. Through her work in a range of media, Celmins has combined pop art's interest in familiar objects with minimalism's austerity. During the 1960s, she made paintings and sculptures of objects found in her studio: an eraser, a comb, a space heater. She also began meticulously copying photographs from magazines and newspapers, often focusing on violent scenes. Since the early 1970s, the ambiguity of star fields, waves, deserts, and spider webs have occupied her. Ruff's career also brings together different aspects of the art world. Like many others in the 1980s, he embraced appropriation, for example, imitating the pose and framing of passport photographs for a series of portraits. But Ruff has also investigated developments in photographic technologies, borrowing and reworking digital images from the Internet and using night vision equipment to photograph urban scenes. Connor, perhaps the most traditional of the three, has spent decades photographing the art and architecture of different times and places, including petroglyphs of the American Southwest, ancient sculptures in Thailand, and decaying mosques in Turkey. The nostalgia of her images extends to her choice of materials, and she typically uses printing-out paper, a contact printing process, and develops negatives with sunlight rather than in a darkroom. Different as these artists are, their shared choice to appropriate astronomical photographs—and to do so over a series of works—offers an opportunity to examine the relationship between borrowed images and their original contexts and, in this case, between art and science.[1]

Within the pantheon of the sciences, astronomy has a unique relationship to vision and observation. Unlike scientists in other fields who can employ several senses, poking and prodding at the phenomena of the world or conducting experiments in laboratories, astronomers must rely on observation and instruments of vision that magnify, collect, represent, and measure light. Telescopes, photographic plates, and now electronic detectors enable the study of the cosmos. Since the widespread adoption of photography in the late nineteenth century, astronomers have taken a huge number of pictures of the universe. Until the end of the twentieth century, most astronomical observatories used glass plate negatives because, unlike film, which stretches and bends, the fixed surface of the glass enabled astronomers to make reliable measurements of the distance between celestial objects. A recent census of glass photographic plates in North America concluded that a tally of 2.4 million plates *underestimated* the total number of astronomical photographs held by observatories, universities, and private individuals.[2] The switch to digital detectors has only increased the production of images, and the Hubble Space Telescope alone has collected over 100,000 observations during its more than twenty years of operation.[3] Relatively few of these

astronomical images reach a wide audience. When analyzing images astronomers translate them into numbers, converting them into coordinates, magnitudes, and wavelengths. These numeric values substantiate and support the conclusions astronomers reach about the structure of the universe and its history. Although astronomical journals publish more images today than in past decades and the rise of the Internet eases the distribution of pictures, only a small fraction of the representations accumulated by astronomers circulate widely. Far more are hidden from sight in observatory archives.[4]

It is no wonder that artists have found astronomical photographs compelling. Such a store of largely unknown visual images invites reexamination. All three of the artists analyzed here rely on different bodies of images and use different methods for reproducing—or redescribing, a term that Celmins prefers—the original astronomical views.[5] Photographers Connor and Ruff culled through large archives of astronomical observatories and redeveloped selected images. Connor appropriated photographs taken at Lick Observatory, which was constructed in the 1880s and was the world's first permanent mountaintop observatory. She favored nineteenth-century observations of the moon or the Milky Way, dense with stars and nebulosity (Figures 1 and 2). Ruff acquired the complete set of

1.
Linda Connor, "June 26, 1892 (Dense Star Field)," 1996. Gold-toned printing-out paper, 10 × 12 in (25.4 × 30.5 cm). Copyright Linda Connor. Courtesy of the University of California Observatories, Lick Observatory, Santa Cruz.

2.
Linda Connor, "September 3, 1895 (Lunar Eclipse)," 1996. Gold toned printing out paper, 10 × 8 in (25.4 × 20.3 cm). Copyright Linda Connor. Courtesy of the University of California Observatories, Lick Observatory, Santa Cruz.

3.
Thomas Ruff, "Stars, 17h51m/–22 degrees," 1990. C-print, 102 × 73 in (260 × 188 cm). © 2013 Artist's Rights Society (ARS), New York/VG Bild-Kunst, Bonn.

negatives for the European Southern Observatory's survey of the heavens above the Southern Hemisphere. He then chose sections of the plates to reproduce as large prints, often focusing on anonymous star fields (Figure 3). Unlike the other two, Celmins did not borrow from a single source, but instead adopted a range of different subjects over more than forty years (Figure 4). Her exploration began with views of the lunar surface in the late 1960s, then turned galaxies and comets in the early 1970s, and took up star fields in the early 1980s. Rather than reprinting them, she meticulously translated the scenes into paint or pencil. In all cases, historicizing the astronomical photographs illustrates the diversity of the originals. Looking more closely at the conversation between the artists and their scientific sources demonstrates the enduring relevance of the complex scientific interests, observing protocols, and instruments that shaped the originals.

Linda Connor: Nebulosity

Connor's interest in astronomical photographs began with a single image: a discarded print from Lick Observatory that another photographer gave to her. It hung in her kitchen for years as she reflected on its formal elements and considered ways to incorporate astronomical photographs into her work. Her decision to appropriate the images stands out as distinct from her larger project of constructing a global travelogue. However, Connor often photographs the art and architecture of the past and reproduces these visual artifacts in another medium. Although not appropriating in the usual sense, her photographs similarly remove the monuments from their usual context and require the viewer to examine them once again.

The nineteenth-century observatory, atop Mount Hamilton and just east of San Jose, stands as a monument as well, not to art, but to astronomers' efforts to improve their vision. By positioning their telescopes above layers of the earth's obscuring atmosphere, astronomers gained a much

4.
Vija Celmins, *Galaxy #3 (Coma Berenices)*, 1973. Graphite on paper, 12 ½ × 15 in (31.5 × 38 cm). Copyright Vija Celmins. Courtesy of McKee Gallery, New York.

clearer view than available at lower altitudes. While working at Lick Observatory, scientists, especially E. E. Barnard, a staff astronomer at the observatory from 1887 to 1895 and the original source of many of the negatives Connor reprinted, including the ones discussed here, also made significant advances in the use of photography to record the cosmos. Astronomers began experimenting with photography soon after its invention, but the relative insensitivity of photographic emulsions made it difficult for them to capture all but the brightest objects. Barnard was a particularly skilled observer and photographer, and he was the first to photograph the Milky Way in a manner that preserved the nebulosity seen by the naked eye.[6] Although for different reasons, Barnard and Connor share an interest in nebulosity, and both explored the cloudy regions of the night sky as a means to gain new levels of insight.

Connor's decision to appropriate the images was influenced in part by the apparent anonymity of scientific images. She says of the Lick Observatory photographs, "If artists had been . . . making these things, I doubt if . . . [I would have] appropriate[d] these things for my own work because somebody else's authorship would have been on them. I feel like I can do that more easily when somebody . . . did them for a very different purpose."[7] Connor's project required her

to search through a large collection of images. She traveled to Mount Hamilton and methodically studied the glass plate negatives, many of which had been stored for more than a century on wooden shelves in the observatory's photographic plate archive. She sought out dense negatives, and as a result, appropriated mostly older examples when the relative insensitivity of the photographic emulsion required long exposures. Connor then developed the plates in the sunlight of the observatory's courtyard on printing-out paper, a process of a similar vintage as the plates themselves.

By spending time at the observatory, Connor immersed herself in the history of the place and of photography as a medium. She chose to reprint the whole glass plate, and each photograph explicitly displays its artifactual character. With age, photographic emulsion can separate from glass plates. In Connor's framing of the Milky Way, cracking, peeling emulsion runs along the lower edge, leading the viewer's eye to a fingerprint in the corner. Along the adjacent edge, Barnard has described (in a nearly illegible hand) what's depicted as well as given the celestial coordinates and date of the observation. Although he did not sign the photograph, the subject matter, a region of Sagittarius that Barnard frequently photographed and often referenced in print, and the observation date of 1892 guarantee that he made the photograph.[8] Such personal marks remind the viewer that the photograph was made by a person at a particular time and place and even argue against Connor's suggestion that astronomical photos lack an author.

Connor's interest in artifacts extends to the appropriation of a set of dropped and broken photographic plates that she found at Lick Observatory. She did not know when the plates were broken, but at least some had been published as unmarred images.[9] After carefully reassembling the shards, Connor redeveloped the images with the lines of fracture clearly visible. For her, the cracks "increased the artifact-ness of the sense of the image. It made marks, human-caused marks, on the sky, in the way we have always been putting human-imagined marks or constellations marks onto figures. It shattered the illusion of the picture that you were looking at the real thing and brings you back to 'Wait, what's happening here.'"[10] On the print, a web of jagged lines spread over the sky, framing the eclipsed moon at the center of the image (Figure 4). But the cracks do not simply lie on the surface. They record and convey the thickness of the glass plate. It almost appears as if one looks through the glass plate, an imperfect window to the heavens. In this way, the cracks remind us that we are not looking at the actual moon, but an artifact, one dependent on a set of technologies and an observer that together influenced its appearance.

In the case of the Milky Way, the technology had to be carefully employed to obtain the image Barnard desired. Whereas others had turned telescopes and cameras to the Milky Way and resolved the nebulous region into individual stars, Barnard was the first to produce a photograph that preserved its cloudy appearance. He explained that the difference between the visual characteristics of the eye and those of the photograph accounted for the difficulty in achieving such an image, writing "the eye is too feeble to pick out the individual stars of the Milky Way, or to separate them; it therefore perceives only a nebulous or clouded appearance, and is really impressed by a *quantity* of light which is made up altogether of individually invisible sources. The sensitive

plate is not thus deceived, for its action depends upon the *intensity* of the light, and it therefore picks out each individual point, if the lens is good." When photographing the Milky Way, Barnard wanted to retain the patterns perceived by the eye because he intended to study its morphology, the structure of what he called "one of the most beautiful and certainly most stupendous of the celestial features."[11] Unlike other astronomers during the period, he did not intend to count the stars, a task he believed too overwhelming in the case of Milky Way. Creating an image that fit his interests required Barnard to work against the inherent tendencies of the photographic medium.

Barnard's technological expertise helped him determine the best camera to capture the image he desired. He readily acknowledged that a successful image depended on the efforts of the observer, writing "the exposure must be very long, and the instrument must be watched and kept constantly fixed on some one star of the proposed picture every moment for several hours; and when all this is properly done, the plate requires the utmost delicacy of treatment in developing."[12] Rather than a completely objective view, the photograph records the heavens in a manner that allowed Barnard to highlight the nebulosity of the Milky Way and thereby understand it better.

Connor similarly uses the photos to see and understand in new ways. In exhibitions and publications, she typically juxtaposes astronomical photographs against those that reflect her global travels. The combinations establish formal relationships between the images and emphasize the aesthetic potential of the celestial scenes. Connor also sees the interplay between the images as a way to introduce another level of meaning. She explains, "I am drawn to sacred art of all forms. I am deeply interested in how to get photography, which so handily describes the facts of our world, to also move our spirits closer to the silent places where other realities and mysteries reside. This is one of the reasons I included the astronomical images." Connor does not reject the promise of objectivity that accompanies scientific images (and photography more generally). On the contrary, because the observations from Lick Observatory were made in the service of science and can lay claim to an even greater degree of facticity than other photographs, Connor uses them to encourage romantic reflections. She continues, "[The astronomical images] are a visual reminder of where we are—all the time that we keep thinking we are down here. Those images are so stunningly beautiful and sublime. They play with our notions of 'Heaven' and nature, fact and wonder."[13] Rather than seeing the photographs as a means to gain knowledge about the physical processes that govern the universe, Connor invites the viewer to reflect on the immensity of the cosmos and our relationship to it. The Milky Way becomes a means to recognize the potential to gain not only facts about the universe but also insights into the human condition.

Barnard and Connor shared a desire to transcend the limits proposed by instruments as well as an enthusiasm for nebulosity. Barnard manipulated the technology in order to return to a vision that was grounded in a phenomenological experience of the heavens. By studying the nebulous forms of the Milky Way, he hoped to understand the structure of the cosmos. For Connor the phenomenological experience of photographs and subsequent recognition of their artifactual nature is a means to go beyond vision. She intends her photographs to act as conduits to another realm of understanding, one defined by its nebulosity.

Thomas Ruff: Celestial Mapping

For Ruff, photography is the medium that shapes how we see the world. "My generation didn't grow up with painting, but with other media, with magazines, television, with a lot of sources of photographic depiction," Ruff explains. "Our image models are the images in the media. For that reason my images are not depictions of reality, but show a kind of second reality, the image of the image."[14] His interest in how an image represents an object, rather than the object itself, is a consistent theme throughout his career, and his series entitled *Stars* continues that focus on the formal aspects of images. Ruff states that "with the star photographs I had a particular idea of an image that I wanted to look at. It's always like that with me; I'm curious. I have an idea of an image, but I can't find the image because it doesn't exist yet. So I have to make it myself. With the stars, I imagined a more or less abstract image, a black surface with a lot of white dots."[15] Although such an image could be produced by other means, astronomical surveys of the heavens, the products of careful planning and advanced technologies that are intended to map the heavens as comprehensively as possible, produced images that matched Ruff's description.

Ruff purchased a complete set of the ESO/SRC Southern Sky Survey negatives, acquiring an astronomical artifact typically sold to university libraries and research institutions. In doing so, Ruff brought the archive into his studio. His action repeated the experience of astronomers who study copies of the negatives in offices and libraries, far from the telescope. After careful study, Ruff reprinted sections of selected images, dramatically enlarging them into 8.5 by 6 foot (2.6 by 1.8 m) photographs. In many ways, Ruff acknowledged and emulated the scientific origins of the negatives. The photographer spoke openly and frequently of his use of the survey negatives, and the insistent simplicity of the prints can be read as a nod to the astronomers' desire for objectivity. By appropriating images used by astronomers to map the cosmos, Ruff also recalls the merger of art and science in older celestial maps. However, even as he foregrounds the scientific content and objectivity, Ruff's approach disrupts the validity of the data contained within the artifacts by modifying the viewer's phenomenological experience of them.

The ESO/SRC Southern Sky Survey, the most comprehensive mapping of the southern skies, was the work of two observatories—the European Southern Observatory in La Silla, Chile, and the United Kingdom's Science Research Council in Siding Spring, Australia—that made the observations on glass plate negatives from 1973–1988. Extensive surveys such as this one require the commitment of a sustained amount of observing time and the support of a large number of astronomers to photograph and reproduce the plates. Atlases also, as Lorraine Daston and Peter Galison have argued, reveal and express notions of objectivity. In the case of photographic surveys, astronomers strive for mechanical objectivity, using instruments to eliminate the influence of any individual observer.[16] The process of observing is also systematized. In this survey each section of the sky was photographed using the same size plate, coated with the same type of emulsion, and exposed for an identical length of time.[17] Through this uniform technology, the survey designers attempted to record the southern sky comprehensively and objectively. After photographing each

region of the sky, astronomers examined the negative for any flaws or blemishes, rejecting and retaking those that did not meet their rigorous standards. They exercised the same care when making reproductions to ensure that each one was an exact copy of the original plate.

One set of glass plate negatives was sent to Uppsala Observatory, where astronomers used survey machines outfitted with zoom microscopes to catalog the heavens. Through their close and careful study of the plates, they identified more than 18,000 galaxies, star clusters, and nebulae, over sixty percent of these for the first time.[18] Astronomers also translated the celestial objects into numeric values, not only counting them but also locating them in space. The resulting catalog listed three different coordinate systems for each object: x and y coordinates for each plate; right ascension and declination, coordinates derived from the earth's poles and equator; and galactic coordinates, which are based on the center of the Milky Way.

In his appropriation of the photographs, Ruff underscores the scientific desire for objectivity by presenting the photographs as no more—and no less—than abstract patterns of black and white.[19] Unlike the older negatives from Lick Observatory, the ESO/SRC negatives are free of marks of authorship. The minimalism of the photographs resists description, and Ruff acknowledges as much by using coordinates for their titles: 02h 36m/–40°, 07h 48m/–70°, 20h 54m/–55°. Despite his emphasis on their objective view of the universe, Ruff recognizes that others may read his *Stars* series differently. "I didn't approach these images with a romantic idea, apart from the fact that I liked looking into the sky at night," he explains. "But it does happen that people begin to dream in front of my star pictures because it's a real experience of nature for them. You can only see that many stars with that brilliance 2,000 meters up in the Alps. Sometimes the viewers confuse my star pictures with that experience of nature."[20] Ruff attributes a romantic reading of the images to confusion about the relationship of photographs to the cosmos. Instead of recognizing them as artifacts, dependent on instruments that construct and shape the image (and before that on the humans who designed the instruments and observing protocols), the viewer mistakes the photographs for a direct, albeit elusive, and unmediated view of the heavens.

Ruff points to their status as artifacts by first presenting them as seemingly objective views and then disrupting that promise through the subjective choices he makes when reprinting the negatives. For each large-scale print, he frames a relatively small portion of the original survey negative. He does not attempt to replicate the completeness of the original set of negatives, reproducing only a limited number of views. In making his selections, Ruff adopts a classification scheme that groups the plates into six categories: pictures of stars in the foreground against a background of normal astral density, pictures of stars in the foreground against a background of greater astral density, pictures of stars in the foreground with other galaxies, pictures of more remote stars, pictures of stars with interstellar objects and gaseous nebulae, and pictures of the Milky Way with densely packed stars.[21] With these categories, Ruff acknowledges accepted astronomical notions of the universe but introduces idiosyncrasies that shift the focus to the appearance of the photographs and away from the numeric cataloging of data.

Ruff's choice to call attention to the visual attributes of the survey photographs positions his work within the long history of combining art and science in star atlases. For centuries, elaborately decorated maps showed the constellations in vivid forms and colors.[22] With the adoption of photography in the late nineteenth century, the ornate elements and imaginative characterizations disappeared from celestial atlases. However, the scientific value dramatically increased as photography made it possible for astronomers to observe more objects and with greater accuracy. Ruff's appropriation of the ESO/SRC Survey photographs honors this history.

However, his use of aesthetics as an organizing principle calls into questions our ability to navigate the universe scientifically. By printing the negatives as large-scale photographs, Ruff reverses the astronomers' mode of study. Rather than looking through a microscope, he enlarges the photographs. Although an enlarger and a microscope both magnify the image, Ruff's choice changes the phenomenological experience of the images from one of the cosmos made miniature to one that alludes to its immensity. Susan Stewart writes that "both the miniature and the gigantic may be described through metaphors of containment—the miniature as contained, the gigantic as container."[23] By studying the galaxies in miniature, astronomers could contain them within human instruments and systems of knowledge. The large-scale prints threaten to do the opposite. Their size envelops the viewer, who gets lost in an array of white dots on black. Ruff underlines the experience of dislocation by labeling his photographs according to the coordinates at the center of the original plate. Because he has cropped the original, often omitting that particular point, the coordinates no longer refer to what is depicted, which makes them less than helpful for wayfinding. Ruff transforms an artifact used to locate and catalog celestial objects precisely and produced as an aid for mapping the cosmos into an experience of getting lost.

Vija Celmins: Dark Matter

Unlike Connor and Ruff, Celmins has collected astronomical images from a range of different sources, and the connections between her work and the scientific content of the original can seem more attenuated. She has also not spoken in detail about where she finds most of the astronomical photographs she has redescribed. Despite this ambiguity about the exact source of the originals, her appropriations track the history of space exploration. Celmins made drawings based on photos taken by the Surveyor I moon mission in 1970–71, a drawing of Saturn one year after Voyager 2 made its flyby of the planet, and another in 1998 using the Hubble Space Telescope's Deep Field image as her model. But Celmins is best known for her drawings and paintings of star fields, and the originals used for these images are more uncertain. Unidentified and lacking in distinctive features, the scattering of white dots rarely gives any hint as to where they might be seen again; although based on photographs, they seem available only through Celmins's hand. Uncertainty takes another form in her recent work: a series of black slate tablets (Figure 5). Her careful reproduction in painted bronze of a mundane, if anachronistic, childhood object brings together her interest in the objects in her studio with her drawings of vastness and undefined fields. The blank, black surfaces of the tablets echo and expand the spaces between the stars.

5.
Vija Celmins, *Slate Tablet*, 2006–10. Bronze with acrylic, alkyd oil, pastel, string, and wood, 14 3/8 × 10 1/2 × 1 1/4 in (37 × 26.5 × 3 cm) . Copyright Vija Celmins. Courtesy of McKee Gallery, New York.

Celmins's pencil drawings of galaxies in Coma Berenices began her embrace of ambiguity (Figure 3). The composition centers on an overlapping pair of white, vaguely elliptical shapes with amorphous white shapes of various sizes spreading outward from it. Space and size are uncertain; the image gives few visual clues about the distance to these objects or the relationship between them. For astronomers, however, the cluster of galaxies that make up Coma Berenices has great significance. When studying this region, astronomers introduced the possibility of unseen mass, now known as dark matter. Celmins's drawings, albeit for different reasons, also function as a study in dark matter.

Celmins's interest, as with the other artists I have discussed, does not begin with the scientific content of the original photographs she carefully renders. Instead, she reflects on the

appearance of the images, saying "I generally start a painting after obsessing on an image, or the look of a printed image I've found somewhere in a book or remembered from somewhere. I fall for it, carry it around in my head, sort of fall in love with it."[24] Through the act of cutting the image from its source and incorporating it into her archive, Celmins divorces the photograph from its original context, transforming it into a pattern of black and white. It is a process that she has used for other images as well, appropriating newspaper photographs as well as copying photographs of ocean waves and rocky desert terrain. Beyond the appearance, the absence of clear marks of authorship also attracts Celmins. She says quite simply, "I like scientific images, they're so anonymous."[25] Despite the apparent anonymity of the images, the intentions of the creators do resurface in Celmins's appropriations.

Her emphasis on the appearance extends to her focus on the photographs as artifacts, and she describes a distinction between what is depicted in the photograph and the photograph itself. Of her work based on newspaper photographs, she says that "I began using the photograph as the subject . . . I was somewhere between painting the object as an object and painting the whole surface itself as a photograph, using the photograph as the subject. This is different than using the subject of the photograph."[26] To apply this description to the astronomical drawings, *Galaxy (Coma Berenices)* is less a picture of a galaxy and more a picture of a photograph, which happens to depict a galaxy. Despite her claim, the visual traces of the photographic original, of the artifact she appropriates, becomes increasingly more subtle through her career. As Cécile Whiting has argued, the lunar drawings "emphasize the partnership between the scientist and the machine that made the lunar surface visible" by including portions of the spacecraft within the frame and making apparent the seams between photographs that scientists mosaicked together to create a panoramic view.[27] The later star fields bear no visible sign of the telescope or camera. The drawings of Coma Berenices, however, occupy a position between these two points. The bright star at the center bottom has clear diffraction spikes, lines that appear to radiate from bright stars but are caused by the reflection of light within the telescope. Through their reproduction in graphite, Celmins reminds us that her subject is a photograph taken through a telescope, not an unmediated view of the heavens.

Celmins does not appropriate astronomical photographs in order to assert a new meaning. Instead, she speaks of an effort to drain the images of significance. She points to Ad Reinhardt's "Twelve Rules for a New Academy" as an influence on her work.[28] In the essay, which was published the year before Celmins began studying painting, Reinhardt endorsed art that eliminates the expressive and the personal in an effort to achieve purity. His rules prohibited texture, brushwork, color, space, scale, movement, and other elements that might reveal the artist or distract from the purity of the image.[29] Through her appropriation of astronomical photographs, Celmins found a method to achieve this. Instead of meaning, she shifts the viewer's attention to perceptual experience and to the status of the image as an artifact, something made by human hands. When describing her drawings of photographs of waves and desert floors, drawings that share with the astronomical examples an absence of color and an ambiguous depiction of size, space,

and scale, she says, "I'm not interested in showing how I feel on a certain day, or show[ing] how I feel about the desert or the ocean. I'm not that kind of artist. I'm not interested in symbolism or psychology or political issues in art. But I am interested in seeing and ordering things and structuring things, perception with nuances."[30] *Galaxy (Coma Berenices)* invites an intense experience of vision, one that replicates the artist's experience of redescribing the photograph and one that reminds the viewer of its status as a made object.

Because Celmins has not spoken about the original photograph she used for the galaxy series, it can be difficult to establish the source with certainty. However, the year that Celmins first made the series, *Sky and Telescope* published a photograph of Coma Berenices in celebration of the inaugural observations of the newly constructed 4 m telescope at Kitt Peak Observatory, the world's second largest telescope at the time of its construction.[31] It was released, in part, as an attractive picture to promote the new telescope and also because astronomers found it an intriguing region of the cosmos to study. In the 1930s, astrophysicist Fritz Zwicky calculated the mass of the Coma cluster and came up with an unexpectedly large number, given the amount of observable light. In order for the galaxies to exist in their present and stable arrangement, the cluster must contain additional and unseen mass, what astronomers today call dark matter. Zwicky's colleagues were reluctant to accept such a notion, and they debated its validity for the next several decades. When the photograph of the Coma cluster was published in *Sky and Telescope*, a team of astronomers at Kitt Peak was researching the region and addressing questions related to dark matter.[32]

For those aware of the missing mass problem, a photograph of Coma Berenices signified one of the great unsolved mysteries of the day. The answer, though, would not be found by studying the appearance of the photograph. After cataloging and counting the galaxies, a process that was done on the basis of survey photographs, astronomers then carried out a series of calculations to determine the mass and compare it to theoretical estimates. The mismatch between theory and observation led them to seek other explanations. Somewhere in the darkness between the galaxies unseen matter resides with the strength to prevent the galaxies from flying apart. It is the armature that in effect composes the galaxies.[33] Rather than an artifact of extended perception, the photograph documents the limits of human vision.

Celmins, inadvertently, but provocatively, repeats this interest in what lies in the spaces in between and the uncertainty that may arise when technologies of vision fail to enhance our sight, even as we may gain in understanding. Over a series of drawings, she renders the same cluster of galaxies using pencils of different degrees of hardness. Gray tones dominate the sky in *Galaxy #1 (Coma Berenices)*, and the white paper peeks through the marks of the pencil; in *Galaxy #3 (Coma Berenices)*, the blackness has become dense, obscuring all but the brightness of the galaxies.[34] Through her exploration of her medium, Celmins plays with darkness. The layers of graphite around the galaxies give shape to the galaxies, and as the background darkens through the series, the shapes of the glowing forms subtly shrink. It is as if the dark matter that surrounds them has occupied Celmins's attention so fully that she has chosen to ignore the light.

In the slate tablets completed more than thirty years later dark matter overtakes the stars. A blank board usually invites a person to write, but here Celmins only provides a piece of black chalk. No marks would show, but for Celmins, this is not a failure but a success, a complete immersion in the artifact, but one that also eliminates traces of its status as a made object. Her efforts are analogous to the actions of one of the characters in Italo Calvino's book of imaginative tales based on scientific theories, *Cosmicomics*, a girl who would "contemplate the blackness, and toy with the little grains of dust in tiny cascades" and seemed to dream "of a darkness a hundred times deeper and more various and velvety."[35]

Conclusion

For Ruff, Connor, and Celmins, the decision to appropriate astronomical photographs rests not only upon the appearance of those images but also upon the premise that scientific images are both objective and anonymous. Yet they also consider the images to be artifacts, engaging with questions about how photographs and telescopes shape our view and our experience of the cosmos. These artists do not appropriate images emptied of meaning, but rather borrow artifacts that carry their history and significance with them. Although not immediately apparent, each artist's use of astronomical photographs retains connections to specific ways that science has documented or represented the universe. Like Barnard, Connor embraces nebulosity, not to understand the structure of the physical realm, but as a vehicle for transcending it. Ruff imitates the cataloging methods of astronomers but undercuts their endeavor to map the universe. Celmins immerses herself in dark matter and the space between the objects she depicts, unintentionally echoing the concerns of astronomers. Excavating the history of these appropriated astronomical images reveals new complexities and demonstrates the artists engagement with scientific representations that operate simultaneously as aesthetic objects, measured data, and material artifacts.

Notes

1. For an introduction to Celmins, see Lane Relyea, Robert Gober, and Briony Fer, *Vija Celmins* (London: Phaidon, 2004), and "Vija Celmins, Andreas Gursky, Rirkrit Tiravanija," *Parkett* 44 (1995). On Conner, see Linda Connor, *Odyssey: The Photographs of Linda Connor*, featuring a conversation with Robert Adams, Emmet Gowin, and Linda Connor, essay by William L. Fox (San Francisco: Chronicle Books, 2008), and Lonnie Graham, "Interview: Linda Connor," *Exposure* 38, no. 1 (2005): 3–10. On Ruff, see Carolyn Christov-Bakargiev, *Thomas Ruff* (Milan: Castello di Rivoli Museo d'Arte Contemporanea, 2009).

2. W. Osborn and L. Robbins, "Census of Astronomical Photographic Plates in North America: Final Report" (Working Group on the Preservation of Astronomical Heritage, American Astronomical Society, Washington, DC, 2008; available at http://aas.org/files/CensusReport-Final.pdf, accessed 20 June 2010). The census was undertaken as the first step in establishing a national archive of astronomical plates and digitizing some plates.

3. HubbleSite, "Hubble Achieves Milestone: 100,000 Exposures," news release, July 18, 1996, http://hubblesite.org/newscenter/archive/releases/1996/25 (accessed 15 June 2010).

4. On tensions between images and data, see Peter Galison, *Image and Logic: A Material Culture of Microphysics* (Chicago: University of Chicago Press, 1997). On astronomical images made for public display, see Michael Lynch and Samuel Y. Edgerton Jr., "Aesthetics and Digital Image Processing: Representational Craft in Contemporary Astronomy," in *Picturing Power: Visual Depiction and Social Relations*, ed. Gordon Fyfe and John Law, Sociological Review Monograph 35 (London: Routledge, 1988), 184–221. See also James Elkins, *Six Stories from the End of Representation* (Stanford, CA: Stanford University Press, 2008).

5. "I like to say that I redescribe an existing image, not copy or reproduce it." From an interview with Celmins in Samantha Rippner, *The Prints of Vija Celmins* (New York: Metropolitan Museum of Art, 2002), 23.

6. Barnard's account of the history of astronomical photography is an excellent introduction. See E. E. Barnard, "The Development of Photography in Astronomy (I)," *Science* 8, no. 194 (September 16, 1898): 341–53; "The Development of Photography in Astronomy (II)," *Science* 8, no. 195 (September 23, 1898): 386–95. For a broader history of photography's adoption in

science, see Jennifer Tucker, *Nature Exposed: Photography as an Eye Witness in Victorian Science* (Baltimore: Johns Hopkins University Press, 2005). On Barnard's achievements, see William Sheehan, *The Immortal Fire Within: The Life and Work of Edward Emerson Barnard* (Cambridge: Cambridge University Press, 1995).

7. Linda Connor, interview by the author, January 2007.

8. See E. E. Barnard, "On the Photographs of the Milky Way Made at the Lick Observatory in 1889," *Publications of the Astronomical Society of the Pacific* 2, no. 10 (1890): 240–44; "On Some Celestial Photographs Made with a Large Portrait Lens at the Lick Observatory," *Monthly Notices of the Royal Astronomical Society* 50 (1890): 310–14.

9. The eclipse of the moon was published in E. E. Barnard, *Photographs of the Milky Way and Comets*, Publications of the Lick Observatory 11 (Sacramento: University of California, 1913).

10. Connor, interview.

11. Barnard, "On the Photographs of the Milky Way," 241.

12. Barnard, "The Development of Photography in Astronomy (II)," 386.

13. "Conversation," in Connor, *Odyssey*, n.p.

14. Thomas Wulffen, "Thomas Ruff: Reality So Real It's Unrecognizable," *Flash Art* 24, no. 168 (January/February 1993): 66.

15. Wulffen, "Thomas Ruff," 64–65.

16. Lorraine Daston and Peter Galison, *Objectivity* (New York: Zone Books, 2007).

17. For a summary of the process, see Richard W. West, "ESO Schmidt Photographs of the Southern Sky," *Sky and Telescope*, 48 (October 1974): 224–29.

18. Andris Lauberts, *The ESO/Uppsala Survey of the ESO(B)Atlas* (Garching bei München: European Southern Observatory, 1982).

19. Several critics have noted this emphasis on objectivity in Ruff's work. See Jody Zellen, "Thomas Ruff," *Arts Magazine* 65, no. 5 (January 1991): 87; Regis Durand, "The Secular Imagery of Thomas Ruff," in *Thomas Ruff* (Paris: Centre national de la photographie, 1997), 16.

20. Wulffen, "Thomas Ruff," 67.

21. Matthias Winzen, *Thomas Ruff: 1979 to the Present* (New York: Distributed Art Publishers, 2003), 193.

22. Deborah J. Warner, *The Sky Explored: Celestial Cartography, 1500–1800* (New York: Alan R. Liss, 1979).

23. Susan Stewart, *On Longing: Narratives of the Miniature, the Gigantic, the Souvenir, the Collection* (Durham, NC: Duke University Press, 1993), 71.

24. Robert Gober, "Interview," in Relyea, Gober, and Fer, *Vija Celmins*, 11.

25. Gober, "Interview," 11.

26. Susan Larsen, "A Conversation with Vija Celmins," *LAICA Journal*, October/November 1978:37.

27. Cécile Whiting, "'It's Only a Paper Moon': The Cyborg Eye of Vija Celmins," *American Art* 23, no. 1 (Spring 2009): 41.

28. Chuck Close, "Interview," in *Vija Celmins* (New York: Art Press, 1992), 8.

29. Ad Reinhardt, "Twelve Rules for a New Academy," in *Theories and Documents of Contemporary Art: A Sourcebook of Artists' Writing,* ed. Kristine Stiles and Peter Seltz (Berkeley: University of California Press, 1996), 86–90. Reinhardt's essay was written in 1953 and excerpted in *Art News* in 1957.

30. Larsen, "A Conversation with Vija Celmins," 39.

31. Scholars have suggested that Celmins obtained the photograph from CalTech or the Jet Propulsion Laboratory, both near her then home in Pasadena. See Whiting, "'It's Only a Paper Moon,'" and Vija Celmins, *Vija Celmins: Drawings* (Paris: Centre Pompidou, 2007). For images of Coma Berenices, see "First 4-Meter Photographs from Kitt Peak," *Sky and Telescope* 46 (July 1973): 10.

32. Andrea Bivano, "Our Best Friend, the Coma Cluster (a Historical Review)," in *A New Vision of an Old Cluster: Untangling Coma Berenices*, ed. A. Mazure et al., (World Scientific, Singapore, 1998; available at http://nedwww.ipac.caltech.edu/level5/Biviano/frames.html, accessed 1 June 2010). See also Herbert J. Rood, Thornton L. Page, and Eric C. Kintner, "The Structure of the Coma Cluster of Galaxies," *The Astrophyscial Journal* 175 (1 August 1972): 627–647.

33. For a basic introduction to dark matter and its role in composing galaxies, see NASA's Imagine the Universe, "Dark Matter," NASA Goddard Space Flight Center, http://imagine.gsfc.nasa.gov/docs/science/know_l1/dark_matter.html (accessed December 12, 2010).

34. Celmins, *Vija Celmins: Drawings*, 88–94.

35. Italo Calvino, *Cosmicomics*, trans. William Weaver (New York: Collier Books, 1970), 24.

Bibliography

Barnard, E. E. "On the Photographs of the Milky Way Made at the Lick Observatory in 1889." *Publications of the Astronomical Society of the Pacific* 2, no. 10 (1890): 240–44.

———. "On Some Celestial Photographs Made with a Large Portrait Lens at the Lick Observatory." *Monthly Notices of the Royal Astronomical Society* 50 (1890): 310–14.

———. "The Development of Photography in Astronomy (I)." *Science* 8, no. 194 (September 16, 1898): 341–53.

———. "The Development of Photography in Astronomy (II)." *Science* 8, no. 195 (September 23, 1898): 386–95.

———. *Photographs of the Milky Way and Comets*. Publications of the Lick Observatory 11. Sacramento: University of California, 1913.

Bivano, Andrea. "Our Best Friend, the Coma Cluster (a Historical Review)." In *A New Vision of an Old Cluster: Untangling Coma Berenices,* edited by A. Mazure, F. Casoli, F. Durret, and D. Gerbal. Singapore: World Scientific, 1998.

Calvino, Italo. *Cosmicomics.* Translated by William Weaver. New York: Collier Books, 1970.

Celmins, Vija. *Vija Celmins: Drawings.* Paris: Centre Pompidou, 2007.

Christov-Bakargiev, Carolyn. *Thomas Ruff.* Milan: Castello di Rivoli Museo d'Arte Contemporanea, 2009.

Close, Chuck. "Interview." In *Vija Celmins,* 5–54. New York: Art Press, 1992.

Connor, Linda. *Odyssey: The Photographs of Linda Connor.* Featuring a conversation with Robert Adams, Emmet Gowin, and Linda Connor. Essay by William L. Fox. San Francisco: Chronicle Books, 2008.

Daston, Lorraine, and Peter Galison. *Objectivity.* New York: Zone Books, 2007.

Durand, Regis. "The Secular Imagery of Thomas Ruff." In *Thomas Ruff,* 15–26. Paris: Centre national de la photographie, 1997.

Elkins, James. *Six Stories from the End of Representation.* Stanford, CA: Stanford University Press, 2008.

"First 4-Meter Photographs from Kitt Peak." *Sky and Telescope* 46 (July 1973): 10–13.

Galison, Peter. *Image and Logic: A Material Culture of Microphysics.* Chicago: University of Chicago Press, 1997.

Graham, Lonnie. "Interview: Linda Connor." *Exposure* 38, no. 1 (2005): 3–10.

Larsen, Susan. "A Conversation with Vija Celmins." *LAICA Journal,* October/November 1978:36–39.

Lauberts, Andris. *The ESO/Uppsala Survey of the ESO(B)Atlas.* Garching bei München: European Southern Observatory, 1982.

Lynch, Michael, and Samuel Y. Edgerton Jr. "Aesthetics and Digital Image Processing: Representational Craft in Contemporary Astronomy." In *Picturing Power: Visual Depiction and Social Relations,* edited by Gordon Fyfe and John Law, 184–221. London: Routledge, 1988.

Osborn ,W., and L. Robbins, "Census of Astronomical Photographic Plates in North America: Final Report." Working Group on the Preservation of Astronomical Heritage, American Astronomical Society, Washington, DC, 2008.

Reinhardt, Ad. "Twelve Rules for a New Academy." In *Theories and Documents of Contemporary Art: A Sourcebook of Artists' Writing,* edited by Kristine Stiles and Peter Seltz, 86–90. Berkeley: University of California Press, 1996.

Relyea, Lane, Robert Gober, and Briony Fer. *Vija Celmins* (London: Phaidon, 2004).

Rippner, Samantha. *The Prints of Vija Celmins.* New York: Metropolitan Museum of Art, 2002.

Rood, Herbert J., Thornton L. Page, and Eric C. Kintner. "The Structure of the Coma Cluster of Galaxies." *The Astrophyscial Journal* 175 (August 1, 1972): 627–47.

Sheehan, William. *The Immortal Fire Within: The Life and Work of Edward Emerson Barnard.* Cambridge: Cambridge University Press, 1995.

Stewart, Susan. *On Longing: Narratives of the Miniature, the Gigantic, the Souvenir, the Collection.* Durham, NC: Duke University Press, 1993.

Tucker, Jennifer. *Nature Exposed: Photography as an Eye Witness in Victorian Science.* Baltimore: Johns Hopkins University Press, 2005.

"Vija Celmins, Andreas Gursky, Rirkrit Tiravanija." *Parkett* 44 (1995).

Warner, Deborah J. *The Sky Explored: Celestial Cartography, 1500–1800.* New York: Alan R. Liss, 1979.

West, Richard W. "ESO Schmidt Photographs of the Southern Sky." *Sky and Telescope,* 48 (October 1974): 224–29.

Whiting, Cécile. "'It's Only a Paper Moon': The Cyborg Eye of Vija Celmins." *American Art* 23, no. 1 (Spring 2009): 36–55.

Winzen, Matthias. *Thomas Ruff: 1979 to the Present.* New York: Distributed Art Publishers, 2003.

Wulffen, Thomas. "Thomas Ruff: Reality So Real It's Unrecognizable." *Flash Art* 24, no. 168 (January/February 1993): 64–67.

Zellen, Jody. "Thomas Ruff." *Arts Magazine,* 65, no. 5 (January 1991): 87.

The Medium as Message
in Contemporary Portraiture

Anne Collins Goodyear

Associate Curator

Smithsonian Institution
National Portrait Gallery
Washington, D.C.

The medium is the message.[1]
—Marshall McLuhan, *Understanding Media:*
The Extensions of Man

What can be meant by "identity," then, and what
grounds the presumption that identities are self-
identical, persisting through time as the same,
unified, and internally coherent?[2]
—Judith Butler, *Gender Trouble:*
Feminism and the Subversion of Identity

"The medium is the message." Marshall McLuhan famously titled the first chapter of *Under-standing Media*, his legendary 1964 treatise on the transformational ramifications of new media of communication on human society. Yet, as McLuhan took pains to stress, it was not the content—or immediate informational value—of the message that most interested him. Indeed, as he explained, "the 'content' of any medium is always another medium. The content of writing is speech, just as the written word is the content of print, and print is the content of the telegraph." Instead, it was the deeper conceptual impact of new media upon the human condition that he made the focus of his study. To quote McLuhan once more, "what we are considering here . . . are the psychic and social consequences" of new media. "For the 'message' of any medium or technology is the change of scale or pace or pattern that it introduces into human affairs."[3] In this spirit, the present study seeks to describe the impact of a range of new materials and tools now

available for artistic practice, ranging from time-based (e.g., film and video) and digital media to the human genome, upon the reconceptualization—and experience—of the human subject. Looking at the examples provided by several artists who have recast the aims and potentials of portraiture, I seek to explore the role of new media upon the artistic and conceptual rendition of the portrait sitter. In putting forward these thoughts, I should clarify that in the context of the present study "portraiture" is not treated as a genre in and of itself, but rather as a mode of representing self and other. The artists under discussion here are not "portraitists" per se in the sense that they have developed practices geared toward depicting human likeness in a flattering fashion. Instead, each of these individuals has confronted the challenge of the depiction of the human subject in the wake of new technological and scientific developments that have profoundly impacted the way in which personal identity functions. As I shall argue, the very fluidity introduced by many new media has undermined the traditional assumption undergirding traditional portraiture that identity could be presumed to be stable and intact, a core to be uncovered or pinned down by the artist capturing a likeness. Instead, as the gender theorist Judith Butler has suggested, "identity" can no longer be presumed to be self-evident and unchanging. Instead, like the media now available to artists, the very identity of the portrayed individual becomes subject to ongoing negotiation and reconstitution.

During the course of the past half century, artists have witnessed the development and integration of numerous innovative technologies into their practice. Many of these, such as sixteen millimeter film, video, and the host of pictorial options introduced by the digital computer, have roots stretching back four, five, or even ten decades. Yet, as I shall argue here, their implications are now prompting pressing questions about the nature of personal identity. The issues raised by these electronically based art forms have important bearing upon those raised by the introduction of the human genome into the realm of the fine arts roughly a decade ago. It is the aim of this essay to explore the ramifications of these new tools and materials upon recent and current directions in portraiture, arguing that their introduction has contributed to a profound recasting and reframing of the self. Although theoretically informed, my approach will not be purely academic. Instead, I invoke the work of contemporary artists whose treatment and querying of personal identity have been demonstrably shaped by the use or lessons of film, video, the digitized image, or DNA. Such new media have, quite literally, transformed the subject of portraiture.

As an art historian concerned with the question of how artistic metaphors convey meaning, I have become increasingly intrigued by contemporary approaches to abstraction and figuration, indexicality and iconicity as a means to represent identity. Specific artistic choices both challenge and reflect long-standing concerns and assumptions about the "proper" aims, or even capabilities, of portrayal. Should a likeness capture indexical evidence of an ephemeral subject, thus preserving some "real" trace of that individual's physical presence in the world? Or should an "accurate" depiction aspire instead to reflect something of a sitter's subjectivity, reflecting the intangible forces that shape and define an individual? In attending to such questions, the implications of deeply rooted scientific discourses emerge in tandem with the ramifications of new

tools for picturing the self. At stake and in play are underlying questions about the very nature of identity today.

The Portrait as Index, from Photography to Genetics

For centuries western portraiture has reflected a desire to fix concrete, indexical evidence of human life. This aim takes shape in the origin myths of the genre, which stress links to the tracings of shadows—leading to the silhouette—and mirror reflections, ultimately suggesting the "scientific accuracy" of the pictorial rendition of physiognomic likeness.[4] The implied link between appearance and character, one functioning as a sign of the other, helped secure the assumption that pictorial likeness could perform as a viable representation of the portrait subject and his or her character. It was largely on this basis that photography, with its capacity to capture facial features mechanically through optics and chemistry, came to serve as a documentary tool par excellence, recording likeness not only for social purposes but, perhaps even more importantly, within carefully prescribed parameters, for documentary ones.[5] Indeed, it is worth noting that the very myths associated with the birth of portraiture characterize those of photography itself.[6]

An acute sensitivity to the pictorial conventions at play in photography and to the social coding of such images as real no doubt helped motivate Marcel Duchamp's iconoclastic *Wanted: $2,000 Reward* of 1923. Looking at the work closely, one notes that although photographs of Duchamp's face in profile and facing front are prominently displayed, his own name appears nowhere on the poster. Instead, the object invokes a succession of aliases, concluding with that of his female alter ego, Rrose Sélavy. Duchamp's coy undermining of the documentary authority of photography (not to mention his positioning of the artist as the agent of this exposure of its limitations) has an ongoing resonance clearly indicated by the broad range of appropriations it has inspired from the 1950s to the present.[7] Prefiguring the "death" of photography as a transparent marker of the real, Duchamp's *Wanted: $2,000 Reward* also posited the proliferation of personal "identities" associated with a single individual, announcing the destabilization of the model of the unified subject, a topic to be taken up at greater length later in this essay.[8]

Yet even in the wake of the death of photography, portraiture has betrayed an insistent impulse toward indexical representation. In 1989, the year of photography's sesquicentennial, which coincided with some of the earliest evidence of the medium's impending widespread digitization, art historian Richard Shiff observed, "at any moment in history the value of all representation depends upon the existence of some representation that can be regarded as transparent, realistic, or natural; . . . during the modern era photography has provided a kind of fabricated image that can successfully masquerade as a natural one."[9] Intriguingly, at just that moment, another medium, with an even more powerful claim to represent a natural, or indexical, connection to its subject was poised to make itself available: DNA. Wally Neibart's cartoon advertisement, *Portraits of Man*, published in the pages of *Science* magazine in the early 1990s, offers a prescient

example of the potential new function of genetics in portraiture.[10] Situated between well-known paintings by Picasso and Leonardo da Vinci, the sequence lauded by the knowledgeable connoisseur (or is he a scientist?) suggests the cultural power of DNA, given its privileged connection to nature itself.[11] As Neibart's cartoon indicates, in the genetic era, medium comes to be privileged over likeness in the quest to represent both self and other most "realistically."

As the theoretician C. S. Peirce reminds us, an indexical sign need "have no significant resemblance to their objects," but instead, "psychologically ... depends upon association by contiguity, and not upon association by resemblance."[12] The index's power, then, is not pictorial but substantive, conveying something about the real physical presence of a body, without necessarily conveying anything about its appearance. Intriguingly, at the same time Neibart playfully imaged the intersection of art museum and laboratory, the British artist Marc Quinn similarly embarked upon a series of portraits privileging genetically rich media over image. Perhaps best known is Quinn's *Self*, a series originated in 1991. Consisting of a sculptural representation of the artist's head, the work does not rely primarily upon iconic appearance to make a connection with its maker. Instead, the medium itself, alternately reported as consisting of eight or nine pints of the artist's blood—approximately the same amount in the human body—leaves the artist's mark upon the piece, registering not only his presence, but his very genetic makeup.[13] The indexical power of the object inheres in the medium used to produce it, implying a causal relationship between the art object and the individual pictured. Quinn puts it succinctly: "the material is life."[14] Although the blood that represents the artist's head is frozen in place—suggesting cryogenic permanence—the artist has committed himself to creating a new version every five years until his death, thus acknowledging the inevitable evolution of his body, his blood, and his features. His choice of medium also evokes the very specter of "tainted blood," that infected by disease, such as AIDS, suggesting the fragility and vulnerability of this "life force."[15]

The same year Quinn cast this work, he created a genetic self-portrait (Figure 1), using a technique developed in conjunction with the British scientist Sir John Sulston. Resembling a large laboratory slide, the work consists of a thick steel frame, enclosing glass through which one perceives small dots of Quinn's genes, cultured in bacteria, suspended in agar jelly. The highly polished frame reflects the presence of the viewer, much as a mirror, or Narcissus's pond, might, firmly linking the object to a long tradition of (self) portraiture, with its implicit allusion to mirrored reflections.[16] Insisting that these substances are not simply intended to shock, Quinn points instead to their metaphorical qualities: "I just think that if you use materials that have an ability to communicate directly, you open up a channel and you can work through that. So you are using the power of the materials."[17] Although one cannot discern the appearance of Quinn's features from the work, Quinn has arguably captured his physical essence, one of the most powerful and elusive claims and aspirations of portraiture. As Quinn has said of the similar genetic portrait he created of Sir John Sulston, who helped to decode the human genome, it is "the most realist portrait in the [British] National Portrait Gallery since it carries the actual instructions that led to the creation of John. It is a portrait of his parents, and every ancestor he ever had back to the beginning of Life in the universe."[18]

1.
Marc Quinn, *Cloned D.N.A. Self Portrait (2nd perspective)*, 2001. Stainless steel, polycarbonate agar jelly, bacteria colonies, cloned human DNA, $10^5/_{16} \times 8^1/_{16} \times 1^1/_{16}$ in. (26.2 × 20.5 × 2.7 cm). Photography by Steven White. Courtesy of White Cube, London.

Quinn traces his interest in freezing or suspending time to the fascination with Dutch art he developed as a graduate student in art history. According to the artist, "I was particularly struck by the idea of fixing natural images and representations of different periods or seasons on the canvas. It was like seeing the depiction of moments from different eras, frozen together. This led to my interest in time, which is not a real matrix, but rather a mental one."[19] If time thus functions metaphorically in portraiture, the artist playfully distends it in a slightly later self-portrait, an artificially manufactured diamond using carbon from his own hair.[20] Bringing instantly to mind the familiar slogan of diamond miner and seller De Beers, "a diamond is forever," Quinn's self-portrayal in this nonpictorial mode guarantees a representation that will never fail to represent

him accurately, drawing, as it does, not on the artist's physical features, but rather upon his unique chemical composition.

Like Marc Quinn, Tim Hawkinson similarly manipulates the indices we use to represent and classify ourselves. But if Quinn relies upon the physical characteristics of his materials to convey something about identity, Hawkinson challenges traditional pictorial representation through other means. To create *Self-Portrait (Height Determined by Weight)* in 1990, the artist poured, as he explains, "the equivalent of my weight in molten lead . . . into a mold of my body."[21] Reconstituted in this fashion, the artist's 6 foot (1.83 m) height shrinks to a mere 15½ inches (39.4 cm) while his weight remains constant. Playing with such variables, Hawkinson devised his *Hangman of My Circumferences* (1995), a woven sculpture made from a series of thrift store belts wrapped around the artist's body at 1 inch (2.5 cm) intervals and then reconstructed in the form of a cocoon.[22] If the fabric in its new form seems to provide a protective armor for the artist, it is precisely into such typically hidden areas Hawkinson proposes to peer with self-portrait constructions. *Pocket Self-Portrait* (1991) uses plaster casts of the interior pockets of a three-piece suit, supported by a vertical armature, to represent the artist.[23] Elsewhere, in *Blindspot (Fat Head)*, 1993, emulating Michelangelo's self-portrait in the Sistine Chapel, the artist symbolically flays himself, producing a synthetic hide made of polymer representing all the parts of the body typically invisible to the artist. One sees his face and neck, the top of his head, his shoulders, his back and his buttocks. This depiction of negative fields is further enhanced in Hawkinson's *The Fin Within* of 1995, consisting of a plaster mold of the space between his legs which has been carved to resemble a fish's tail. Thus, the very contours of the artist's body suggest the origin of fantasy and the attendant limits of self-portrayal.

"There are certain recurring interests in my work and ways of looking at things, maybe having to do with the way I get ideas and the way ideas are formed," Hawkinson has remarked about his work. "The first thing that I think of is the human form and using my own body as the reference point, ways of depicting and referring to that, and 're-looking' at that through different eyes."[24] Manipulating modes of presence and absence and recasting modes of perception through his self-portraiture, Hawkinson has represented himself not simply by recourse to the physical structure of his body but also through its activities. His 1993 mechanical sculpture, *Signature*, repeatedly produces facsimiles of the artist's signature. The artist's use of the combination desk-chair familiar to many of us immediately conjures up associations not only with the personal index of the signature but also with the social and cultural mark on this ostensibly personal gesture left by years of education.

Grappling still further with the intersection between the personal and the public, artist Jason Salavon has devised *Self-Portrait (The Jason Salavon Show)*, 1997 (Figure 2). The installation features a robotic sculpture that manipulates a remote control programmed to select the channels the artist himself would have selected "had [he] been watching twenty-four hours a day, seven days a week, for the length of the exhibition."[25] Although physically absent, the artist's presence is simulated, or indicated, through the activities of the software he has programmed. It

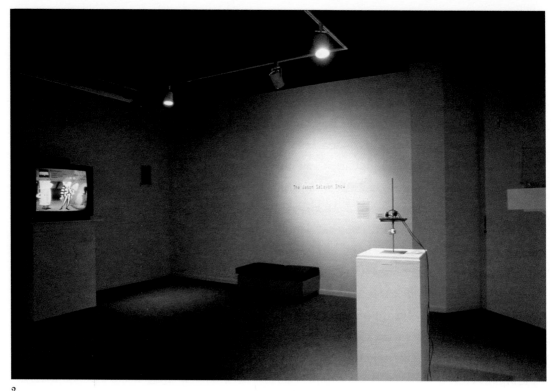

2.

Jason Salavon, *Self-Portrait (The Jason Salavon Show)*, 1997. Satellite hookup, custom hardware and software, variable dimensions. Courtesy of the artist and Ronald Feldman Fine Arts, New York.

is indeed arguable that such portrayal more accurately corresponds to the embodied experience of the self, which does not perceive oneself watching television, but instead simply consumes the programs. But in suggesting that personal identity can be gleaned from the habits with which one consumes popular culture, Salavon simultaneously points to the porous boundaries that distinguish self from others, the individual from cultural at large. Indeed, this is one of the artist's goals, as he has explained: "I was thinking about individuals within the whole, and how you define that whole. What are the common characteristics that make this a group, rather than one's individual identity within the group?"[26]

What is at stake in modes of portraiture that exploit an indexical connection to the sitter yet destroy the visual connection to appearance so long understood to be one of the goals of the genre? Intriguingly, such approaches to depiction accentuate the importance of the medium itself as a conduit for basic information.

In manipulating indexical attributes of the self (markers such as weight, body circumference, and personal behaviors), artists such as Quinn, Hawkinson, and Salavon suggest a powerful reorientation in the very function of identity in our culture. As a means to achieve some perspective on the nature of this shift, I turn to the gender theorist Judith Butler, who teases apart epistemological and performative models of the self, offering a valuable model for understanding a radical realignment of notions of selfhood and subjectivity in contemporary culture. As Butler argues,

to qualify as a substantive identity is an arduous task, for such appearances are rule-generated identities, ones which rely on the consistent and repeated invocation of rules that condition and restrict culturally intelligible practices of identity. Indeed, to understand identity as a practice, and as a signifying practice, is to understand culturally intelligible subjects as the resulting effects of a rule-bound discourse that inserts itself in the pervasive and mundane signifying acts of . . . life.[27]

In disrupting the equation between indexicality and physical resemblance that is so deeply engrained within the practice of western portraiture, Quinn, Hawkinson, and Salavon throw attention back upon "rule-bound discourses" that might otherwise remain invisible. Through their recourse to nonconventional indexical representation, these artists assert powerful questions about the way in which the self comes to identify him or herself in contemporary society. Familiar self-identical practices, such as the implied link between signifiers as basic as height and weight or the hand and the signature fail to signify "properly," detached as they are from their source of origin.

From Indexicality to Performativity

If the limits of indexical representation as an indicator of conventional appearance characterize the portraiture of Quinn, Hawkinson, and Salavon, it is appearance as a marker of socially constructed categories such as gender, age, and character that is explored by Douglas Gordon and several other artists engaged in more figurative work. Indeed, the problematization of iconic resemblance becomes a central concern of Douglas Gordon's 2004 *Proposition for a Posthumous Portrait*. Depicting a skull with a star carved into it, Gordon's work suggests powerful resonances with the self-representation of Marcel Duchamp. One quickly associates the work with Duchamp's photograph in a hinged mirror and photographs of Duchamp with an unconventional tonsure.[28] Although the latter image may well have contained a veiled reference to a note by Duchamp describing "a comet [with] its tail in front," or even the "milky way" of the Large Glass, Gordon's piece suggests another reading: Duchamp's assumption of star status in the wake of his death, in large part through his insistence on art's conceptual dimensions.[29] But if the work obviously alludes to Duchamp, Gordon's title provocatively leaves open the question of just who the image "really" represents. Indeed, titling the work a "proposition" for a posthumous portrait raises the inevitable question: might this piece just represent a proposal for the artist's own memorial?

Such deliberate blurring of the portrait's referent also animates Gordon's 1996 photographic *Self-Portrait as Kurt Cobain, as Andy Warhol, as Myra Hindley, as Marilyn Monroe*. Gordon accentuated the deliberate confusion of identity suggested by his self-portrait by providing the picture to the British press in 1996 upon being selected for the prestigious Turner Prize.[30] In representing himself through a photograph that deliberately constructs a fluctuating identity, Gordon references Duchamp. Duchamp, who dressed in drag in photographs by Man Ray to evoke Rrrose Sélavv, also depicted himself in his 1942 *Compensation Portrait* as a female tenant farmer, using a photograph appropriated—without permission—from Ben Shahn and later posing for Man Ray

wearing a woman's wig. Indeed, Man Ray's photograph has an uncanny resemblance to Douglas Gordon's later self-portrait. Gordon's image also brings to mind Andy Warhol's self-portraits in drag, created in the early 1980s.[31] With their performative implications, Gordon's photographs, although still, seem to reference the lessons of time-based art pioneered during the 1960s, and, indeed, Gordon himself, has produced numerous works that exploit the dimension of time.[32]

In the early 1960s, Andy Warhol, who famously claimed that "everybody should be a machine,"[33] revolutionized portraiture with his adoption of the 16mm movie camera in the summer of 1963. After experimenting with the development of films picturing everyday activities, such as sleeping and eating, Warhol began a series of short films in 1964 known as "Screen Tests." By the time he completed the series in 1966, he had recorded approximately 500 of these animated portraits.[34] As film historian Callie Angell has noted, the screen tests "provide a kind of filmed guest book for the Factory (as Warhol called his studio), including artists, film-makers, writers and critics, gallery owners, actors, dancers, socialites, pop music stars, poets, and, of course, Factory regulars and superstars."[35]

The parameters for the screen tests were carefully defined. Sitters were requested to remain as still as possible during the three minutes filming lasted, creating a look not unlike a picture from a photo booth—another format with which Warhol was simultaneously experimenting during the same two-year period.[36] Yet despite the restrictive rules imposed by Warhol, the artist felt film brought in, as he put it, "another whole dimension."[37] According to Warhol, "The great stars are the ones who are doing something you can watch every second, even if it's just a movement inside their eye."[38]

Aware of the "new dimension" in portraiture that his films represented, Warhol actually entertained the possibility of marketing his screen tests in the fall of 1964 as "Living Portrait Boxes." These boxes would contain small screens against which the film, transferred to an 8mm loop cartridge, would be projected.[39] Yet, although Warhol seems to have abandoned plans for using his screen tests in this fashion, both they and related projects reveal his sophisticated approach to the construction of time-based portraiture. His contemporary ninety-nine-minute film of curator and critic Henry Geldzahler cast the curator in a fashion strikingly similar to Picasso's 1906 portrait of Gertrude Stein, perhaps deliberately implying the revolution in art making that it promised.

Even more revolutionary was Warhol's 1965 double portrait of Edie Sedgwick, *Outer and Inner Space*, created with video, a brand-new medium, using a camera loaned to the artist by the Norelco Cooperation.[40] One of the critical advantages video offered over film was its comparative ease. Recorded on a magnetic tape, the video signal could be recorded in front of the eyes of the camera operator and could be played back virtually immediately. It was a revolutionary effect that Warhol immediately exploited. Using a split-screen effect, Warhol vividly captured the young woman's discomfort when confronted with her own videotaped image. The psychological tension captured by the piece reflects video's powerful implications for restructuring the experience of self, described by Rosalind Krauss in an early and groundbreaking account of the implications of video for art:

Video's real medium is a psychological situation, the very terms of which are to withdraw attention from an external object—the Other—and invest it in the Self . . . [T]he feedback coil of video seems to be the instrument of a double repression: for through it, consciousness of temporality and of separation between subject and object are simultaneously evacuated. The result of this repression is, for the maker and viewer of most video art, a kind of weightless fall through the suspended space of narcissism.[41]

The radical reorientation to notions of self and subjectivity demanded by the medium of video would play out still further in the work of Bill Viola, who recognized "the real raw material is not the camera and monitor, but time and experience itself."[42] Indeed, whereas Warhol would withdraw his films from circulation in 1972, Viola would pioneer the introduction of video into the gallery. Using himself as his most frequent subject, Viola has used the medium of video to record the natural rhythms of life as well as to take advantage of its duration to push his subjects and audiences into uncomfortable situations that explore their limits. As Viola explains,

> That's something that's in all my work—the act of seeing, experiencing, and its connection to the process of waking up. The wake-up call, the way the medium can echo something in us, engaging our own self-awareness. This is what happens when the process of recording reveals itself.[43]

Unlike Warhol, Viola incorporates sound into his portraits, bringing together a range of perceptual experiences.

An early 1972 self-portrait, *Tape I*, deliberately forces a confrontation between subject, object, and the video medium. In this work, which the artist describes as "an attempt to stare down the self," the artist watches himself in a mirror as his image is simultaneously recorded by a lens. The piece concludes when the artist can no longer endure the experience, screaming and turning off the tape. In a later project, *Reverse Television*, from 1983, Viola trained the camera on forty-four subjects in the Boston area, filming them for a period of ten minutes, with their eyes focused on the camera as though it were a television set. Thirty-second excerpts of the portraits were later aired, without comment, by Boston's public television station, WGBH, in coordination with the station's New Television Workshop designed to support and promote experimental video art.[44] Breaking the comfortable habit of spectatorship, Viola's portraits punctured a familiar experience for television viewers—forcing a confrontation with self. Although Viola would later pessimistically deny that a "television art" could be created in light of the current commercial control of the medium, it is notable that this particular project broke down the boundaries of the personal and public as well as forcing art out of the gallery into the personal space of the home.[45]

Bill Viola's self-portrait, *Nine Attempts to Achieve Immortality* (Figure 3), dating to 1996, similarly forces the viewer into an uncomfortable relationship with the portrait's subject, the artist. In the work, the artist faces a camera, holding his breath as long as possible, nine times consecutively. Although the contortions of the artist's face are captivating, it is sound which is

3.
Bill Viola, *Nine Attempts to Achieve Immortality*, 1996. 144 × 144 × 108 in (366 × 366 × 274 cm). One channel of black-and-white video projection onto a suspended screen, 50 × 69.5 cm, amplified sound. Performer: Bill Viola, 18:13 minutes. Photograph by Kira Perov, Bill Viola Studio, Long Beach, California.

perhaps even more powerful, confronting the viewer with the involuntary panting and gasping of a man who has denied himself oxygen. Not only video but also the human body becomes Viola's media for forcing us to confront our own human limits. Departing from the physical, Viola uses video as a means to court the metaphysical, asserting that the ultimate screen for his projections is not in the gallery, but in the human mind.[46]

If 16mm film and video transformed the portrait through its registration of time and its ability to provoke and capture the mounting psychological tension of one's consciousness of watching and being watched, the advent of the digitized and easily manipulated image, which transformed pictorial information into data (and bodies into bits), further heightened the notion of a self perpetually in transition. In the early 1980s, Nancy Burson, a pioneer in what would come to be known as "morphing," illustrated the ease with which an artist could manipulate digitized photographs.[47] Her aged pictorial renditions of movie stars and members of the British royal family and her *Warheads* series, consisting of composite "portraits" made from the facial features of world leaders, were combined in ratios reflecting the size of their nuclear arsenals. Such works demonstrated that the computer made possible a new range of flexibility in the production of pictures, allowing their almost instantaneous copying, rescaling, or "editing."

Although such manipulation of photographic images was not new in the history of art, having been famously exploited by the eugenicist Francis Galton and later by artists and designers, the ability to effect such transformations, almost instantaneously, through the ubiquitous platform of the computer radically changed the conceptual implications of such tools in the ongoing reinvention of portraiture.[48] The paradigm shift indicated in the digitization of images has been profoundly accelerated by the proliferation of disembodied communication through information networks made possible by the very computing devices that facilitate the easy manipulation of pictorial data.

As Katherine Hayles and others have argued, the disjunction between physical and virtual presence, with the latter's susceptibility to disruption, has profoundly altered our experience of self, transforming it from something unitary to something radically dispersed.[49] The question of how the immaterial, digitized, ever-changing, and easily manipulable image evoked through digital technology has the capacity to transform our conception of self is indeed intriguing. In his legendary 1980 meditation on the photographic image, *Camera Lucida*, the French literary theorist Roland Barthes noted, "'myself' never coincides with my image; for it is the image which is heavy, motionless, stubborn (which is why society sustains it), and 'myself' which is light, divided, dispersed."[50] Lincoln Schatz's 2008 portrait of LeBron James (Figure 4) arguably recasts the photographic portrait along lines similar to those described as a sort of fantasy by Barthes.[51] Working with his Cube, a 10×10 foot (3.05 × 3.05 m) translucent box of his own invention, embedded with

4.
Lincoln Schatz, *LeBron James, CUBE Portrait, Esquire's Portrait of the 21st Century*, 2008. Video still.

six cameras on each of its four vertical sides, Schatz invited the basketball star, like other sitters in the project, to engage in an activity of his own choosing—something that might be revealing of his interests and passions. Perhaps revealing a certain humor, as well as an affinity for competition, the athlete chose to have himself portrayed playing a video game—in this case simulating an NBA contest and featuring James's own avatar, of which he took charge. Schatz's Cube, with its twenty-four cameras, recorded the star at play for an hour, thus generating a total of twenty-four hours of footage. The resulting data files were then combined in varying degrees of transparency in ever-changing sequences to create something a cubistic depiction of James, who quite literally performs himself manipulating a depiction of himself. The *mise en abyme* becomes all the more fascinating when we learn that the basketball star was reluctant to leave the Cube, insistent upon completing the game, in which he generated his highest ever score.[52] He performed himself perfectly, collaborating in a portrayal that reinforces the notion of James as a figure in perpetual transformation, an ever-shifting embodiment of the fantasy of sport and achievement, a "player."

This conceptual transformation in the status of the self from a stable entity into a structure—a set of data, perhaps—that can be both radically dispersed and reconfigured at will characterizes Hasan Elahi's *Tracking Transience: The Orwell Project* (Figure 5). The Web-based project, first initiated in 2003 and ongoing at the time of this writing in January 2012, reflects the artist's frightening experience of being mistakenly identified as a terrorist in the wake of September 11.[53] Both through necessity and as a defense mechanism, the artist began meticulously documenting every aspect of his life, even tracking and filming his location. Yet, although the project provides

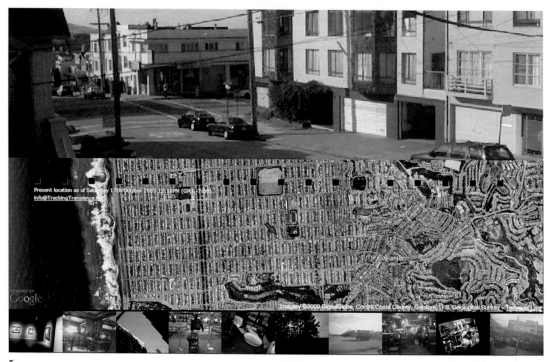

5.
Hasan Elahi, *Tracking Transience: The Orwell Project*, 2003 to present. Web-based work, trackingtransience.net/.

visual information about the setting in which the artist finds himself, the geographical location of that place, and even his meals, the artist himself is not pictured. Instead, it is the critical data that constitute his whereabouts, habits, and tastes.

Ironically, it is precisely in flooding the Internet and the FBI agents to whom he regularly reports with information that Elahi preserves his independence and, perhaps, even his privacy. Speaking to a turning point in his understanding of the work, Eahi notes,

> I started to share every single detail [of my life]. Food, beds I sleep in, toilets I used, etc. And the funny thing is that people started to get nervous, they were like 'we don't need to know all this!' :) That is where I realized I was living an amazingly anonymous life. That data overload was in fact recreating my privacy. As you cannot detach from Google search results, the only option you have is to flood the system, take power. You can not delete stuff, so bury it! My project - which started as an art experiment - turned at that point into an identity management mechanism.[54]

The radical presentness of Elahi's self-presentation, or representation, which demands an audience to decipher and make sense of it, calls to mind Roland Barthes's well-known essay, "The Death of the Author": "The modern scriptor is born simultaneously with the text, is in no way equipped with a being preceding or exceeding the writing, is not the subject with the [text] as predicate; there is no other time than that of the enunciation and every text is eternally written *here and now*," he famously argues.[55] If we accept the self-portrait as text, the inevitable conceptual challenge of self-representation presents itself. Is self-portrayal merely at the pleasure of the audience who seeks to understand it as such, as Elahi's *Tracking Transience* suggests?

As numerous scholars in a broad range of disciplines have concluded, the contemporary subject can no longer be conceived as a unitary, stable entity. New technologies, political resistance to institutional forces, and the recognition of the contingency of gender identification and sexual preference have destroyed the limiting, if reassuring, myth of an "essential" self. "Nothing will restore the concept of identity, of the centered, autonomous subject, immediately present to himself, that has served us for so many centuries," speculates Rosalind Krauss in her conclusion to an essay on contemporary subjectivity.[56] The transformation is fundamental for the art of portrayal that, for centuries, has sought precisely to distill those distinctive personal qualities with which we could identify the self.

But if portraiture's very underlying, ancient claims seem to be threatened by such a reconceptualization of the self, so too do these contemporary takes on portraiture open a new myriad of possibilities. As Maurice Blanchot has written, interpreting the legacy of Michel Foucault,

> The subject does not disappear; rather, its excessively determined unity is put in question, what arouses interest and inquiry is its disappearance (that is, the new manner of being which disappearance is), or rather its dispersal, which does not annihilate it but offers us, out of it, no more than a plurality of positions and a discontinuity of functions.[57]

If contemporary subjectivity, then, may be described as dynamic rather than rigid, unfixed rather than determinate, the inherent instability of physical perception and personal identity evoked in recent portraiture and self-portraiture suggests not a limit, but rather a potential to be mined. In closing I would like to point to what I see as the emergence of a new model, perhaps a new metaphor, for contemporary subjectivity born of the breakdown of traditional notions of authorship and cultural authority—signaled by portrait forms that deliberately disrupt the traditional function of indexical and iconic signification—in a world that is increasingly characterized by globalization. This is, quite simply, a self held in flux, a model of becoming rather than being, of openness to perpetual reinvention, identity as aperture rather than reflection.

Notes

1. Marshall McLuhan, *Understanding Media: The Extensions of Man*, originally published 1964 (Cambridge, MA: MIT Press 1994), 7ff.

2. Judith Butler, *Gender Trouble: Feminism and the Subversion of Identity*, originally published 1990 (New York: Routledge, 1999), 22.

3. All quotations in this paragraph are from McLuhan, *Understanding Media*, 8.

4. I address this topic in detail in my essay, "The Photograph, the Portrait, and the Index," in *Photography Theory*, ed. James Elkins, The Art Seminar 7 (New York: Routledge, 2007), 211–15, 385–88.

5. See Allan Sekula, "The Body and the Archive," *October* 39 (Winter 1986), 3–63; see also Richard Brilliant, *Portraiture* (Cambridge, MA: Harvard University Press, 1991), 40–43.

6. Goodyear, "The Photograph, the Portrait, and the Index," 211–15, 385–88.

7. See Anne Collins Goodyear and James W. McManus, *Inventing Marcel Duchamp: The Dynamics of Portraiture* (Washington, DC: National Portrait Gallery, Smithsonian Institution, 2009), 166–67, 208–9, 236–7, 248–49, 286–87, and 294–95.

8. The "death" of photography is commonly associated with the rise of photographic digitization. See, for example, William J. Mitchell, *The Reconfigured Eye: Visual Truth in the Post-Photographic Era* (Cambridge, MA: MIT Press, 1992); Hubertus von Amelunxen, Stefan Iglhaut, and Florian Rötzer, eds., *Photography after Photography: Memory and Representation in the Digital Age* (Munich: Overseas Publishers Association, 1996). A useful overview of theories of photography is provided by Sabine T. Kriebel, "Theories of Photography: A Short History," in *Photography Theory* (see note 4), 3–49.

9. Richard Shiff, "Phototropism (Figuring the Proper)," *Studies in the History of Art* 20 (1989): 161.

10. Donna Haraway discusses the portrait in "Deanimations: Maps and Portraits of Life Itself," in *Picturing Science, Producing Art*, ed. Caroline A. Jones and Peter Galison (New York: Routledge, 1998), 195–98.

11. On the cultural significance of the genome and for an insightful discussion of Neibart's cartoon as a parody of its fetishization, see Donna Haraway, "Deanimations," 181–207. On artists' use of genetics in contemporary art, see Suzanne Anker and Dorothy Nelkin, *The Molecular Gaze: Art in the Genetic Age* (Cold Spring Harbor, NY: Cold Spring Harbor Laboratory Press, 2004).

12. C. S. Peirce, "Logic as Semiotic: The Theory of Signs," in *Philosophical Writings of Peirce*, ed. Justus Bucher (New York: Dover 1940), 108.

13. Quinn's blood, collected over five months, was poured into a cast of his head and frozen. The work was inspired by a cast of the head of William Blake ("Marc Quinn," in Norman Rosenthal et al., *Sensation: Young British Artists from the Saatchi Collection* (London: Thames and Hudson in association with the Royal Academy of Arts, 1997), 205.

14. Simon Hattenstone, "Marc Quinn: Blood Brother," *The Guardian*, October 25, 1999.

15. I thank Michael Maizels for pointing out the powerful connection of the use of blood in the early 1990s with the threat of the AIDS virus.

16. For a succinct discussion of the emergence of self-portraiture and the concept of the modern self, see Joseph Leo Koerner, "Self-Portraiture: Direct and Oblique," in *Self Portrait: Renaissance to Contemporary*, ed. Anthony Bond and Joanna Woodall (London, National Portrait Gallery, 2005), 67–81. Joanna Woodall notes that in sixteenth-century Venice, the self-portrait was simply known a "portrait made in the mirror." She addresses both the ideal and narcissistic associations conjured up by the mirror; see Joanna Woodall, "'Every Painter Paints Himself': Self-Portraiture and Creativity," in *Self Portrait: Renaissance to Contemporary*, 19–20. Jean-Jacques Rousseau uses the figure of Narcissus to attack immature self-adulation, played out through a portrait, in *Narcissus, or the Self-Admirer: A Comedy*, in *The Miscellaneous Works of Mr. J. J. Rousseau*, vol. 2 (London: Printed for T. Becket and P. A. de Hondt, 1767). Rousseau's work and treatment of Narcissus is discussed briefly in T. J. Clark, "The Look of Self-Portraiture," in *Self Portrait: Renaissance to Contemporary*, 58.

17. Marc Quinn, quoted in Robert Preece, "Just a Load of Shock?: An Interview with Marc Quinn," *Sculpture* 19, no. 8 (October 2000): 16.

18. Marc Quinn, quoted in National Portrait Gallery, "Genomic Portrait," press release, September 18, 2001. Cited in Anker and Nelkin, *The Molecular Gaze*, 10.

19. Germano Celant, "Interview with Marc Quinn," in *Marc Quinn*, by Germano Celant, Darian Leader, and Marc Quinn, np. (Milan: Fondazione Prada, 2000).

20. There is, of course, a long history of the use of hair in portraiture. Robin Jaffee Frank notes that in addition to serving as an adornment or addition to miniatures in eighteenth- and nineteenth-century America, hair was actually "chopped up or dissolved to paint mourning miniatures, knotted in bracelets, plaited in lockets, or . . . displayed on the reverse of a portrait"; see Robin Jaffee Frank, *Love and Loss: American Portrait and Mourning Miniatures* (New Haven, CT: Yale University Press, 2000), 10.

21. Tim Hawkinson, quoted in "Selected Works and Descriptions," in *Tim Hawkinson*, by Lawrence Rinder (New York: Whitney Museum of Modern Art, 2004), 180.

22. Rinder, *Tim Hawkinson*, 190.

23. Rinder, *Tim Hawkinson*, 182.

24. "Artists Speak: Tim Hawkinson," *School Arts*, February 1, 2004, http://www.questia.com/library/1G1-112985854/artists-speak -tim-hawkinson (accessed December 4, 2012).

25. Artist's commentary on *Self-Portrait (The Jason Salavon Show)* 1997, http://salavon.com/JSshow/jsShow.shtml (accessed April 24, 2012).

26. Jason Salavon, quoted in Ann Wiems, "The Message is the Medium," *City Art* (April 2001), 219, cited in *Only Skin Deep: Changing Visions of an American Self*, ed. Coco Fusco and Brian Wallis (New York, International Center for Photography in association with Harry N. Abrams), 330.

27. Judith Butler, *Gender Trouble*, 184.

28. These works are discussed in Goodyear and McManus, *Inventing Marcel Duchamp*, 136–37, 142, 154–59.

29. A discussion of Douglas Gordon's Proposition for a Posthumous Portrait is included in Goodyear and McManus, *Inventing Marcel Duchamp*, 293. Marcel Duchamp, "1912" note from *The Green Box*, *The Writings of Marcel Duchamp*, edited by Michel Sanouillet and Elmer Peterson (New York: Da Capo Press, 1973), 26. On the relationship of the 1921 photograph of Duchamp with the star tonsure to this note, see Arturo Schwarz, *The Complete Works of Marcel Duchamp*, vol. 2, 3rd ed. (New York: Delano Greenidge Editions, 1997), 673.

30. Nancy Spector, "a.k.a.," in *Douglas Gordon*, ed. Russell Ferguson (Los Angeles: The Museum of Contemporary Art, 2001), 126.

31. On Man Ray's photograph of Duchamp wearing a wig, see Goodyear and McManus, *Inventing Marcel Duchamp*, 218–19; on Warhol's self-portraits in a wig and makeup, on which he collaborated with Christopher Makos, see Christopher Makos, *Andy* (New York: Assouline, 2001); and Vincent Fremont and Andy Grundberg, *Andy Warhol: Polaroids, 1971–1986* (New York: Pace/MacGill, 1992), 100–111, where a number of these works are reproduced, although without reference to Makos's role in their creation.

32. A good overview of Gordon's work is provided by Russell Ferguson, ed., *Douglas Gordon* (see note 30).

33. Andy Warhol, in Gene Swenson, "What is Pop Art?: Answers from 8 Painters, Part I," *Art News* 62, no. 7 (November 1963), 26.

34. These are sometimes conflated with a similar series of "portrait films" in which Warhol allowed his subjects to show off their talents; see Callie Angell, "Andy Warhol, Filmmaker," in *The Andy Warhol Museum* (New York: Distributed Art Publishers, 1994), 128, 143, n. 23. The most comprehensive source on Warhol's Screen Tests is Callie Angell, *Andy Warhol Screen Tests: The Films of Andy Warhol Catalogue Raisonne*, vol. 1 (New York: Abrams in Association with Whitney Museum of American Art, 2006).

35. Angell, "Andy Warhol, Filmmaker," 128.

36. Angell, "Andy Warhol, Filmmaker," 128. Note that the silent 16mm Bolex camera that Warhol shot only was capable of shooting four minute lengths of film (Angell, "Andy Warhol, Filmmaker," 125).

37. From Andy Warhol, *The Philosophy of Andy Warhol* (New York: Harcourt Brace Jovanovich, 1975), 63, quoted in Callie Angell, *Something Secret: Portraiture in Warhol's Films* (Sydney: Museum of Contemporary Art, 1994), 2.

38. Andy Warhol and Pat Hackett, *Popism: The Warhol '60s* (New York: Harcourt Brace Jovanovich, 1980), 109, quoted in Callie Angell, *Something Secret*, 3.

39. Angell, "Andy Warhol, Filmmaker," 128.

40. Angell, "Andy Warhol, Filmmaker," 140.

41. Rosalind E. Krauss, "Video: The Aesthetics of Narcissism," in *Perpetual Inventory* (Cambridge, MA: MIT Press, 2010), 11, 13, reprinted from *October*, no. 1 (Spring 1976).

42. Bill Viola, "In Response to Questions from Jörg Zutter," in *Reasons for Knocking at an Empty House, Writings 1973–1994* (Cambridge, MA: MIT Press, 1995), 252.

43. Bill Viola in Bill Viola and Lewis Hyde, "Conversation," Part 2, March 10, 1997, in *Bill Viola*, ed. David Ross (New York: Whitney Museum of American Art, 1998), 165.

44. For more information on Bill Viola's "Reverse Television" and WGBH's involvement in it, see Bill Viola's "Reverse Television," Open Vault, WGBH Media Library and Archives, http://openvault.wgbh.org/catalog/ntw-mla000230-bill-viola-s-reverse-television (accessed August 7, 2011).

45. See Bill Viola, "Statement, 1992," in *Reasons for Knocking at an Empty House* (see note 42), 211–12. Although not explicitly concerned with the work of Bill Viola, David Joselit offers an insightful account of television's relationship to art (and commerce) from the 1960s to the present in his *Feedback: Television Against Democracy* (Cambridge, MA: MIT Press, 2007).

46. As Viola has remarked, "The real raw material is not the camera and monitor, but time and experience itself, and that the real place the work exists is not on the screen or within the walls of the room, but in the mind and heart of the person who has seen it. This is where all images live." Viola, "In Response to Questions from Jörg Zutter," 252.

47. The work of Nancy Burson is discussed in Anne Collins Goodyear "Digitization, Genetics, and the Defacement of Portraiture," *American Art* 23, no. 2 (Summer 2009), 28–31.

48. One of the most notable precedents to Burson's computerized portrait composites is the work of anthropologist and eugenicist Francis Galton, which is discussed in detail by Allan Sekula, "The Body and the Archive," 40–55. A more playful approach to pictorial composites, creating "ideal" types, appeared in "Male and Female," *Vanity Fair*, 1934, reprinted in *Vanity Fair: A*

Cavalcade of the 1920s and 1930s, ed. Cleveland Amory and Frederic Bradlee (New York: Viking Press, 1960), 266–67; William Wegman also experimented with pictorial composites in *Family Combination* (1972), discussed in Carla Gottlieb, "Self-Portraiture in Modern Art," in *Sonderdruck aus dem Wallraf-Richartz Jahrbuch*, ed. Walter Boeckelmann (Cologne: Dumant Buchverlag, 1981), 294–96. Nancy Burson worked with a number of computer scientists on the development of computer software in the late 1970s and early 1980s that enabled the artist to "morph" images digitally. Burson received a patent in 1981 for "The Method and Apparatus for Producing an Image of a Person's Face at a Different Age." Lynn M. Herbert, "Faces: Nancy Burson," in *Faces: Nancy Burson* (Houston: Contemporary Art Museum, 1992), 8.

49. See Katherine Hayles, *How We Became Posthuman: Virtual Bodies in Cybernetics, Literature, and Informatics* (Chicago: University of Chicago Press, 1999); Anna Munster, *Materializing New Media: Embodiment in Information Aesthetics* (Hanover: Dartmouth College Press, 2006).

50. Roland Barthes, *Camera Lucida*, trans. Richard Howard, originally published in French in 1980 (New York: Hill and Wang, 1981), 12.

51. Schatz's portrait of LeBron James is one of nineteen portraits of contemporary leaders in a broad range of fields comprising his larger project, commissioned by *Esquire* magazine, *Esquire's Portrait of the Twenty-First Century*, 2008. The project is detailed in David Granger, "The 21st Century Begins Now," *Esquire,* October 2008:3–8. It has also been collected by the National Portrait Gallery, Smithsonian Institution. A clip of the time-based portrait can be accessed at http://vimeo.com/14860950 (accessed January 16, 2012).

52. Lincoln Schatz, in conversation with the author, August 2010.

53. *Tracking Transience* can be viewed at http://trackingtransience.net/ (last accessed January 16, 2012). The Bangladeshi-born artist is an American citizen.

54. Laurent Haug, "Lift11 Talk: Hasan Elahi on Disclosing Your Whole Life Online to Escape the US Terrorists List," Lift, http://lift conference.com/news/lift11-talk-hasan-elahi-disclosing-your-whole-life-online-escape-us-terrorists-list (accessed January 16, 2012).

55. Roland Barthes, "The Death of the Author," in *Image, Music, Text*, ed. and trans. Stephen Heath (New York: Hill and Wang, 1977), 145. The emphasis is Barthes's.

56. Krauss, "Who Comes after the Subject," in *Perpetual Inventory* (see note 41), 263.

57. Maurice Blanchot, "Michel Foucault as I Imagine Him," in *Foucault/Blanchot*, trans. Jeffrey Mehlman (New York: Zone Books, 1987), 76–77.

Bibliography

Amory, Cleveland, and Frederic Bradlee, eds. *Vanity Fair: A Cavalcade of the 1920s and 1930s*. New York: Viking Press, 1960.

Angell, Callie. "Andy Warhol, Filmmaker." In *The Andy Warhol Museum*, 121–45. New York: Distributed Art Publishers, 1994.

———. *Something Secret: Portraiture in Warhol's Films*. Sydney: Museum of Contemporary Art, 1994.

———. *Andy Warhol Screen Tests: The Films of Andy Warhol Catalogue Raisonne*. Vol. 1. New York: Abrams in Association with Whitney Museum of American Art, 2006.

Anker, Suzanne, and Dorothy Nelkin. *The Molecular Gaze: Art in the Genetic Age*. Cold Spring Harbor, NY: Cold Spring Harbor Laboratory Press, 2004.

Barthes, Roland. "The Death of the Author." In *Image, Music, Text*, edited and translated by Stephen Heath, 142–48. New York: Hill and Wang, 1977.

———. *Camera Lucida*. Translated by Richard Howard. New York: Hill and Wang, 1981 [1980].

Blanchot, Maurice. "Michel Foucault as I Imagine Him." In *Foucault/Blanchot*, translated by Jeffrey Mehlman, 61–109. New York: Zone Books, 1987.

Brilliant, Richard. *Portraiture*. Cambridge, MA: Harvard University Press, 1991.

Butler, Judith. *Gender Trouble: Feminism and the Subversion of Identity*. 1990. Reprint, New York: Routledge, 1999.

Celant, Germano, Darian Leader, and Marc Quinn. *Marc Quinn*. Milan: Fondazione Prada, 2000.

Clark, T. J. "The Look of Self-Portraiture." In *Self Portrait: Renaissance to Contemporary*, edited by Anthony Bond and Joanna Woodall, 57–65. London: National Portrait Gallery, 2005.

Ferguson, Russell, ed. *Douglas Gordon*. Los Angeles: The Museum of Contemporary Art, 2001.

Frank, Robin Jaffee. *Love and Loss: American Portrait and Mourning Miniatures*. New Haven, CT: Yale University Press, 2000.

Fremont, Vincent, and Andy Grundberg. *Andy Warhol: Polaroids, 1971–1986*. New York: Pace/MacGill, 1992.

Fusco, Coco, and Brian Wallis, eds. *Only Skin Deep: Changing Visions of an American Self*. New York: International Center for Photography in association with Harry N. Abrams, 2003

Goodyear, Anne Collins. "The Photograph, the Portrait, and the Index." In *Photography Theory*, edited by James Elkins, 211–15. The Art Seminar 7. New York: Routledge, 2007.

———. "Digitization, Genetics, and the Defacement of Portraiture." *American Art* 23, no. 2 (Summer 2009), 28–31.

———. and James W. McManus. *Inventing Marcel Duchamp: The Dynamics of Portraiture*. Washington, DC: National Portrait Gallery, Smithsonian Institution, 2009.

Gottlieb, Carla, "Self-Portraiture in Modern Art." In *Sonderdruck aus dem Wallraf-Richartz Jahrbuch*, edited by Walter Boeckelmann, 294–96. Cologne: Dumant Buchverlag, 1981.

Granger, David. "The 21st Century Begins Now." *Esquire*, October 2008:3–8.

Haraway, Donna. "Deanimations: Maps and Portraits of Life Itself." In *Picturing Science, Producing Art*, edited by Caroline A. Jones and Peter Galison, 181–207. New York: Routledge, 1998.

Hayles, Katherine. *How We Became Posthuman: Virtual Bodies in Cybernetics, Literature, and Informatics*. Chicago: University of Chicago Press, 1999.

Herbert, Lynn M. *Faces: Nancy Burson*. Houston: Contemporary Art Museum, 1992.

Joselit, David. *Feedback: Television Against Democracy*. Cambridge, MA: MIT Press, 2007.

Koerner, Joseph Leo. "Self-Portraiture: Direct and Oblique." *Self Portrait: Renaissance to Contemporary*, edited by Anthony Bond and Joanna Woodall, 67–81. London: National Portrait Gallery, 2005.

Krauss, Rosalind E. "Video: The Aesthetics of Narcissism." In *Perpetual Inventory*, 3–8, 271–72. Cambridge, MA: MIT Press, 2010. Reprinted from *October*, no. 1 (Spring 1976).

———. "Who Comes after the Subject." In *Perpetual Inventory*, 257–69, 296–97. Cambridge, MA: MIT Press, 2010.

Kriebel, Sabine T. "Theories of Photography: A Short History." In *Photography Theory*, edited by James Elkins, 3–49. The Art Seminar 7. New York: Routledge, 2007.

Makos, Christopher. *Andy*. New York: Assouline, 2001.

McLuhan, Marshal. *Understanding Media: The Extensions of Man*. 1694. Reprint, Cambridge, MA: MIT Press, 1994.

Mitchell, William J. *The Reconfigured Eye: Visual Truth in the Post-Photographic Era*. Cambridge, MA: MIT Press, 1992.

Munster, Anna. *Materializing New Media: Embodiment in Information Aesthetics*. Hanover: Dartmouth College Press, 2006.

Peirce, C. S. "Logic as Semiotic: The Theory of Signs." In *Philosophical Writings of Peirce*, edited by Justus Bucher, 98–119. New York: Dover, 1940.

Preece, Robert. "Just a Load of Shock? An Interview with Mark Quinn." *Sculpture* 19, no. 8 (October 2000): 14–19.

Rinder, Lawrence. *Tim Hawkinson*. New York: Whitney Museum of Modern Art, 2004.

Rosenthal, Norman, Brooks Adams, Lisa Jardine, Martin Maloney, Norman Rosenthal, and Richard Shone. *Sensation: Young British Artists from the Saatchi Collection*. London: Thames and Hudson in association with the Royal Academy of Arts, 1997.

Sanouillet, Michel, and Elmer Peterson. *The Writings of Marcel Duchamp*. New York: Da Capo Press, 1973.

Schwarz, Arturo. *The Complete Works of Marcel Duchamp*. Vol. 2. 3rd ed. New York: Delano Greenidge Editions, 1997.

Sekula, Allan. "The Body and the Archive." *October* 39 (Winter 1986): 3–63.

Shiff, Richard. "Phototropism (Figuring the Proper)." *Studies in the History of Art* 20 (1989): 161–79.

Spector, Nancy. "a.k.a." In *Douglas Gordon*, edited by Russell Ferguson, 112–149. Los Angeles: The Museum of Contemporary Art, 2001.

Swenson, Gene. "What is Pop Art?: Answers from 8 Painters, Part I." *Art News* 62, no. 7 (November 1963): 24–27, 60–63.

Viola, Bill. *Reasons for Knocking at an Empty House, Writings 1973–1994*. Cambridge, MA: MIT Press, 1995.

Viola, Bill, and Lewis Hyde. "Conversation." In *Bill Viola*, edited by David Ross, 143–65. New York: Whitney Museum of American Art, 1998.

von Amelunxen, Hubertus, Stefan Iglhaut, and Florian Rötzer, eds. *Photography after Photography: Memory and Representation in the Digital Age*. Munich: Overseas Publishers Association, 1996.

Warhol, Andy. *The Philosophy of Andy Warhol*. New York: Harcourt Brace Jovanovich, 1975.

———. and Pat Hackett. *Popism: The Warhol '60s*. New York: Harcourt Brace Jovanovich, 1980.

Woodall, Joanna. "'Every Painter Paints Himself': Self-Portraiture and Creativity." In *Self Portrait: Renaissance to Contemporary*, edited by Anthony Bond and Joanna Woodall, 17–29. London: National Portrait Gallery, 2005.

Collaboration in Action: Three Perspectives on the Smithsonian Artist Research Fellowship Program

Contemporary Art Informed by Science
The Smithsonian Artist Research Fellowship

Jane Milosch
Director

Smithsonian Institution
Provenance Research Initiative
Washington, D.C.

It is no secret that both artists and scientists are drawn to inquiry and discovery, yet how can museums capitalize on this excitement and their interdisciplinary work? The Smithsonian Artist Research Fellowship (SARF) is a path-breaking program that encourages them to interact at a creative and empirical level that involves logic and play, observation and analysis, and time to examine and discuss data and discoveries. Although artists and scientists may or may not work in different settings and may or may not use similar materials and methods, they share a passion for their subject. Some are fascinated by a rare object or animal, inspired by a place or events, or attracted to explain the unexplainable; others are intrigued by the random order of things and some by the orderly nature of things. This curiosity enables artists and scientists to do their work and to take risks in order to make discoveries, and it requires tenacity to dig deeper, to probe further, and to try things that might seem nonsensical to most. The SARF program builds on a history of discovery through the cross fertilization of the arts and sciences.

About the Program

Since its inception in 2007, SARF stipends have been awarded to forty contemporary visual artists who take an interdisciplinary approach to subject matter, work in a variety of material

and methods, and enjoy research and collegial exchange.[1] The SARF provides for a two- to three-month residency for artists among the scientific, historical, and cultural resources of the Smithsonian Institution, among its diverse collections, as well as matches them with experts on the Smithsonian staff. This combination provides artists with a highly focused period of time to closely investigate objects, events, or scientific phenomena that inspire their creative work. Unlike other artist residency programs, which provide studios where artists can produce work, this fellowship provides an environment of discovery and contemplation. The SARF recipients work in a variety of settings alongside experts in a wide range of disciplines—anthropologists, astrophysicists, botanists, cartographers, conservators, ethnographers, ichthyologists, historians.

The SARF recipients study not only what is on view in the museums' galleries but also the vast collections maintained behind the scenes—from laboratories to field sites abroad and from special exhibitions to storage facilities. These diverse collections and settings permit artists to study both living and preserved examples, including diverse environments and types of species, such as butterflies, plants, fish, and mammals. The 2009 SARF recipient Sam Durant described the fellowship as a transformative experience that ignites creative breakthroughs and "creative thinking without pressure to produce art."[2]

The selection and review process for SARF continues to evolve. In 2009, a panel of fourteen curators and scholars from across the Smithsonian selected nine SARF recipients from more than sixty-four applications. Artist applicants had been nominated by national and international art curators and art experts as well as by former SARF recipients. Although the application process does allow for artists to self-nominate, self-nominations have been few. Artists interested in being nominated are encouraged to contact Smithsonian curators who might be familiar with their work or have expertise in the primary genre or medium in which the artist works, such as craft, design, photography, or video. Whereas the art curators assess the artists' work, their level of accomplishment, and whether they had enough experience and skill to carry out the proposed research project, other Smithsonian curators and experts assess the application for its feasibility within the purview of their respective disciplines and the museum, comment on the validity and merits of the proposed research topic, and recommend scholars or scientists whose interests aligned with those of the artist. This process ensures that only exceptionally accomplished artists are selected and that the proposed research project could be carried out at the different venues and be supported by Smithsonian staff. The fellowship includes a modest financial award, which enables the artists to travel and work at one or more Smithsonian sites during their two- to three-month residencies, which can be sequential or spread out over a period of a year.

Unlike traditional research fellowships, SARF does not require artists to record or transfer their findings into written documents, charts, or diagrams, though some do. Their observations and discoveries are recorded in a variety of ways, and their different projects involve a range

of interdisciplinary areas and result in new art work in a variety of media. For example, the research of New York–based artist Douglas Ross, a 2008 SARF recipient, focused on the historical representations, definitions, and delineations of territory in American history. He met with art curators, mathematicians, and cartographers to better understand and compare diverse concepts of territory. While he examining Japanese folding screens at the Freer and Sackler Galleries, Ross was also looking at aerial and aerospace photographs at the National Air and Space Museum (NASM). During his residency, Ross met with more than twenty experts in a range of fields and noted, "I most appreciated and benefited from the periods of direct access to actual objects and artifacts, and definitely the conversations with those specialists and curators, who were excited to provide and exchange information that was pertinent not only to my own interests but their interests as well . . . The direct exposure provided some glimpses and flashes of larger interconnections, correspondences, and narratives that were completely unforeseeable."[3]

Matching Artists with Experts and Collections

Probably the most unique feature of the SARF program is that it matches artists with experts, from scholars to all types of museum professionals, who share the artist's research interests. The world's largest museum and research complex, the Smithsonian Institution comprises nineteen museums and galleries, nine research centers, and the National Zoo: the specimens, artifacts, and artworks in the Smithsonian collections are currently estimated at 140 million, the libraries have holdings of over 1.5 million items, and the archives have approximately 83,000 cubic feet (2350.3 m³) of material. This diversity allows the artists to study an object or topics from a multitude of perspectives and with different questions and results in mind. Furthermore, because the Smithsonian has many institutional partnerships with other cultural, educational, and scientific research programs and initiatives around the world, in such places as Antarctica, Moorea, Panama, and Guiana Shield, the locations for the SARF residencies extend well beyond the borders of Washington, DC. These satellite centers offer a rare opportunity for artists to work on site with scientists and other experts in a variety of countries.

Since most SARF recipients are rarely affiliated with an academic institution, their research methods are more investigative and fluid than those of traditional academic researchers. The SARF research topics and themes are often much broader than the topics of academic scholars or scientists, and it is precisely because the artists' research is rarely connected to a specific hypothesis or theory to test that they have the flexibility to shift their focus if something else piques their interest. Although the SARF program provides opportunities to participants in a broad range of areas, partnerships between artists and scientists have been particularly fruitful in generating new insights for collaborators from disparate fields.

The following essays by Shih Chieh Huang and Lynne Parenti testify to the dynamic col-laboration SARF has engendered, but there are many stories. Shih Chieh Huang, a 2007 SARF recipient, is a Taiwanese-American installation artist who currently lives and works in New York City and was one of the first eight artists to participate in SARF. His research project involved the study of "how organisms use bioluminescence and the evolutionary story behind its devel-opment." During his two-month residency in Washington, DC, Huang worked with a number of scientists but most closely with Lynne Parenti, Curator of Fishes and Research Scientist, at the National Museum of Natural History. While Huang worked in Washington, DC, another 2007 SARF recipient, Björn Dahlem, a German sculptor and installation artist based in Berlin, researched new global images, cosmological models, and the phenomena of black holes during his residency. He benefited from his work with astrophysicists and scientists at the Smithso-nian's Astronomical Observatory at Harvard University, Cambridge, Massachusetts, which is the world's largest and most diverse center for the study of the universe. A year later, in 2008, Rachel Berwick, a Connecticut-based multimedia artist, was awarded a SARF to work with Ed Broni-kowski, Senior Curator for Animal Programs at the National Zoo, as well as to study ornithologi-cal specimens, the writings of seventeenth- to nineteenth-century explorers and naturalists, and the migration patterns of birds and people at the National Museum of Natural History. Part of Berwick's research project, "The Migration of Bird and Man," involved collaborating with Bron-ikowski to help design of the zoo's new migratory bird facility.

In 2008–09, two artist fellows worked closely with anthropologists. Samuel Durant, a California-based artist who works in a variety of materials, visited the Smithsonian's Tropical Re-search Institute in Panama for the major part of his two-month residency. His research focused on the San Blas Kuna Indians and how their relationship to anthropologists has been represented in Kuna culture. Aside from his work with scientists in Panama, he worked with curators and an-thropologists at the National Museum of the American Indian, National Museum of Natural His-tory, and the Hirshhorn Museum and Sculpture Garden. In contrast to Durant's work, Nigerian artist Marcia Kure investigated the political, social, and cultural context of the Lakota Winters Count collection in the Department of Anthropology at the National Museum of Natural History while she studied and compared her findings with textile collections, drawings, and prints at the National Museum of African Art and the Cooper-Hewitt National Design Museum in New York. Kure found the SARF program "an atmosphere of enthusiasm, adventure, and intellectual curiosity" and the experience of "handling objects with experts and having conversations with experts in a variety of disciplines" inspiring.[4] Since her residency, Kure has produced a series of watercolors and a video that capture some of her discoveries.

In 2010, SARF recipient Jocelyn Chateauvert, a South Carolina–based hand papermaking artist, traveled to a Smithsonian research center in South America. Her research involved the study of plant life from macro- and microperspectives (she uses a variety of plant fibers to make her handmade paper) and the art of botanical illustrations. She studied drawings and specimens

with scientific illustrator Alice Tangerini at the National Museum of Natural History (NMNH) and, under the guidance of botanist and curator Vicki Funk, conducted field work at NMNH's Biological Diversity of the Guiana Shield program in Venezuela. Following her first trip to the Guiana Shield, she remarked, "My experience there [Guiana] and at the Smithsonian thus far is leading me in an unexpected but passionate direction. Sitting in a benab viewing the mountain-scape of Surama . . . interweaves the historical figure Maria S. Merian, the botanical illustrator whose work I studied during my initial research in DC . . . This has already led to some 1500 images, a video, as well as 14 hours of sound recordings."[5]

The National Museum of American History (NMAH) has also hosted a number of artists. Richard Chartier, a 2011 SARF recipient and installation and performance artist based in Washington, DC, created a blog to document the progress of his sound-based research project at NMAH. Under the guidance of curator Steve Turner, he recorded the sounds of nineteenth-century acoustic apparatuses, including a unique Tonometer comprising 670 tuning forks, in an effort to develop new sources and sounds for his installations and performances. At the end of one of his blog entries, Chartier summarized the unique experience that SARF offers when he noted, "Steven Turner told me of his trip to Ohio last week to collect some additional pieces for the collection. I am very excited to see them when they are unpacked. He was even interviewed on TV about these 171 additions to the collection . . . We discussed some experimental recordings that I would like to do after the Grand Tonometer raw recordings are completed . . . Today was quite productive with another 100 more raw recordings of the tiny tuning forks. Note to self: do not wear a shirt that crinkles when I move. Three more rows and 150 tuning forks to go."[6]

Some of the artists' research projects have been preceded by or led to an acquisition or exhibition at Smithsonian museums. The works of several SARF recipients have been featured in group or solo exhibitions at the Hirshhorn Museum and Sculpture Garden (HMSG). For example, a sculpture by Dan Steinhilber, a sculptor and installation artist based in Washington, DC, was acquired by the HMSG in 2004, and because of his experience with the museum, he was nominated to apply for a SARF fellowship in 2008. His research topic, which involved different concepts of buoyancy and gravity, led him to study aquatic and aerospace collections at the NMNH and NASM. In 2008, HMSG curator Anne Ellegood invited Terence Gower, a New York–based multimedia artist, to return to Washington, DC, to exhibit a series of new work directly inspired by his 2007 SARF residency. Gower's exhibition *Public Spirit* tells the story of the original proposal for the Hirshhorn Museum, which founder Joseph Hirshhorn envisioned as the centerpiece of a utopian "town culture" planned for the wilderness of western Ontario, Canada.[7] In 2009, Brian Jungen, a Canadian artist who works in a variety of materials, applied for a SARF fellowship in anticipation of his exhibition at the National Museum of the American Indian (NMAI). He investigated the connections between the scientific study of air and space and Native American beliefs regarding the same, and he was able to carry out parts of his residency while his exhibition was on view at NMAI.[8] In 2010, Henrique Oliveira, a Brazilian artist who

works in a variety of media, received a SARF fellowship just prior to his exhibition *Artists in Dialogue 2*, which opened in 2011 at the National Museum of African Art and included a site-specific installation for the museum.[9] Inspired by the interactions of SARF artists with scientists and staff at NMNH, Barbara Stauffer, Chief of Temporary Exhibitions, formed a Contemporary Art and Science Advisory Committee at NMNH to consider exhibitions and programs that included contemporary art. Most recently, in 2010, the first contemporary art-science exhibition, *The Hyperbolic Crochet Coral Reef*, opened at NMNH.[10] In 2011, an exhibit of Shih Chieh Huang's work inspired by his residency at NMNH opened at the NMNH.

Increase and Diffusion of Knowledge

The SARF program accentuates the intellectual and creative core of the Smithsonian, with its core mission to promote the "increase and diffusion of knowledge." No other artist residency program in the United States, and possibly the world, offers artists access to such a range of interdisciplinary collections and depth of expertise. The artist fellows benefit from their interactions with Smithsonian experts and with other fellows in residency at the same time, creating many avenues for exchange. Just as importantly, SARF creates an opportunity for Smithsonian curators and scholars to discover the work of new artists from around the world and thereby possible new acquisitions, exhibitions, programs, and special projects, as well as new collectors and potential donors.

One of the challenges with this relatively new program has been to expand awareness about the program within and outside of the institution. During their SARF residencies, the artists give a public talk about their work and research project, and these take place across the institution. In the spring of 2009, the Smithsonian's Material Culture Forum (MCF) organized an event, Intersections: Interdisciplinary Perspectives, at the HMSG to highlight the SARF program and demonstrate how the work of these artists was impacting the research of Smithsonian scholars.[11] The program included four SARF recipients, Rachel Berwick, Shih Chieh Huang, Marcia Kure, and Douglas Ross, who discussed their research projects and how these projects were impacting their art, and eight Smithsonian curators and scholars from different disciplines, who commented on their experience of working with the artist fellows. Jim Ulak, Curator of Japanese Art at the Freer and Sackler Galleries, summarized his experience of working with Douglas Ross as "a wonderful give-and-take relationship" and noted that the SARF program draws the Smithsonian community together, "mixes us together," and that the artists are like bees, "pollinating and bringing together the some six thousand of us into ways of thinking that we had not previously considered."[12]

Conclusion: Leading into the Future

Since 2007, SARF artists have come from more than twenty countries and studied with hundreds of Smithsonian staff in locations ranging from the Museum Support Center in Suitland, Maryland, to the Guiana Shield, Venezuela. The artists' research topics have ranged from migratory

birds and bioluminescence of deep-sea life to buoyancy and tuning forks, and their discoveries are leading to new work in a variety of media, from bird shelters to animation films, videos, installations, and performance. The SARF program benefits artists, the Smithsonian, and the museum visitor by expanding our understanding of how "artists make art, and how scientists make science," challenging contemporary perceptions about science and art, and reminding us of the objective aspects of art and the subjective aspects of science.

Although the program has yielded great results, like all programs in their infancy, the future direction is still in a vulnerable and formative position, especially in terms of dwindling resources. Shih Chieh Huang's and Parenti's experiences testify to the inspirational exchange SARF has engendered between artists and scientists, and hopefully, their stories will attract greater financial and institutional support for SARF. Since the spring of 2009, because of budget and staff reductions, the program no longer has a director or a program assistant; instead, a committee of Smithsonian art curators administers the SARF program, with assistance from the Office of the Under Secretary for History, Art, and Culture and the Office of Fellowships.[13] A long-term plan for administering and funding the program needs to be developed, ideally with the goal to establish a named endowment in support of SARF.

Notes

1. Since 2007, the following forty artists have received SARF awards: Ghada Amer, Carlos Amorales, Kader Attia, Rachel Berwick, Sandow Birk, Joann Brennan, Richard Chartier, Jocelyn Chateauvert, Sonya Clark, Peter Coffin, Abraham Cruz Villegas, Jamal Cyrus, Björn Dahlem, Samuel Durant, Mary Evans, Nancy Friedman-Sanchez, Joseph Gerhardt, Terence Gower, Emmet Gowin, Tracy Hicks, Shih Chieh Huang, Elizabeth Huey, Nene Humphrey, Runa Islam, Ruth Jarman, Brian Jungen, Marcia Kure, Candace Lin, Rodney McMillian, Linn Meyers, Maggie Michael, Henrique Oliveira, Sergio Palleroni, Richard Pell, Morgan Puett, Douglas Ross, Dan Steinhilber, Alison Taylor, Sue Williamson, and Clive van den Berg. For a complete listing of former and current fellows, visit http://www.si.edu/sarf/fellows.

2. Sam Durant, in conversation with the author, July 2009.

3. Douglas Ross, 2008 SARF questionnaire.

4. MCF-SARF program Webcast, March 17, 2009, mms://media1.smithsonian.museum/MaterialCulture/2009-03-17_Material_Culture_Forum.wmv (accessed December 5, 2012). Author wishes to acknowledge James Hayes, Iowa City, for his financial support, which made this program possible.

5. Jocelyn Chateauvert, e-mail to author, September 2010.

6. From a July 21, 2010, post on Richard Chartier's blog, "A Final Fork and a Memory," http://www.3particles.com/grandtonometer/ (accessed October 9, 2012).

7. For more about Terence Gower's exhibition, see the Hirshhorn Museum and Sculpture Garden Web site, http://www.hirshhorn.si.edu/collection/home/#collection=current-exhibitions&detail=http%3A//www.hirshhorn.si.edu/bio/directions-terence-gower-public-spirit/&title=Directions%3A+Terence+Gower%3A+Public+Spirit (accessed October 9, 2012).

8. For more about Brian Jungen's exhibition, see the National Museum of the American Indian Web site, http://www.americanindian.si.edu/exhibitions/jungen/ (accessed October 9, 2012).

9. For more about Henrique Oliveira's exhibition, see the National Museum of African Art Web site, http://africa.si.edu/exhibits/dialogue2/oliveira.html (accessed October 9, 2012).

10. For more information about the Hyperbolic Crochet Coral Reef exhibition and community project, see the National Museum of Natural History Web site, http://www.mnh.si.edu/exhibits/hreef/ (accessed October 9, 2012).

11. Stephanie Hornbeck, former conservator at the National Museum for African Art and chair of the Smithsonian's Material Culture Forum, initiated the Intersections: Interdisciplinary Perspectives program together with Milena Kalinovska, Director of Programs, Hirshhorn Museum and Sculpture Garden, to better introduce SARF to the Smithsonian community.

12. Jim Ulak, in conversation with the author, March 2009.

13. Edwin (Ned) Rifkin, former Under Secretary for Art, Smithsonian Institution, conceived of the idea for a program to host "artist fellows" at the Smithsonian and Susan Talbott, former Director of Smithsonian Arts, initially directed the program. Since April of 2008, the Office of the Under Secretary for History, Art, and Culture, in collaboration with the Office of Fellowships, oversees the Smithsonian Artist Research Fellowship at the Smithsonian. From 2008 to 2009, I directed the SARF

program as well as other paninstitutional art initiatives while serving as the senior program officer for art. I recruited Veronica Conkling as a program assistant to help administer the SARF program, and she organized orientation sessions, tours of SI facilities, and events, which created a strong sense of a community between the artist fellows and Smithsonian staff. Bruce (Will) Morrison in the Office of Fellowships worked closely with us to continue to develop the parameters of the program. Richard Kurin, Under Secretary for History, Art, and Culture, continues to support the program along with many Smithsonian colleagues. See www.si.edu/sarf.

The Influence and Inspiration from Taking Part in the Smithsonian Artist Research Fellowship Program

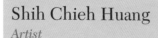

Shih Chieh Huang

Artist

Taipei, Taiwan

Introduction

My artwork explores the unusual evolutionary adaptations undertaken by creatures that reside in inhospitable conditions for humans. I create comparable ecosystems building an installation populated with living sculptures made from common, everyday objects. These artificial living creatures are constructed from synthetic materials cannibalized from mundane objects that define our modern world: household appliances, zip ties, water tubes, lights, computer parts, cheap motorized toys and the like. The objects are dissected and disassembled as needed and reconstructed into experimental primitive organisms that when electrified become animated and begin to take life. This animation displays patterns that are as alien and familiar as unusual underwater creatures – life existing on the fringes of evolutionary transformation. The artwork is often compared to these life forms when the viewer understands how the sculptures "come alive": computer cooling fans are re-purposed for loco-motion, translucent Tupperware™ serves as a skeletal framework, guitar tuner rewired to detect sound, and automatic night lights become a sensory input.

—Huang Shih Chieh, Artist Statement

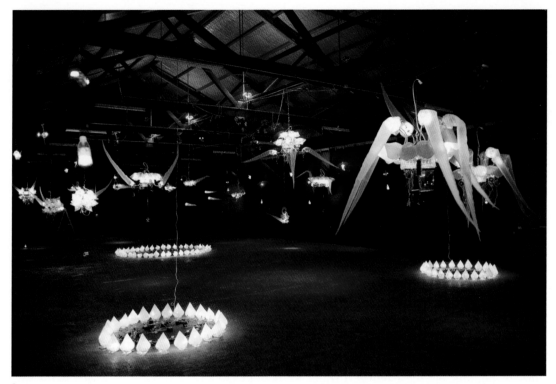

1.
Arc Biennial 2009, Brisbane Australia. Installation view 7,000 square feet (650.3 m²). Modified household materials, plastic containers, garbage bags, computer cooling fans, microcontrollers, and LED lights. Courtesy of the author.

As one of the first participants in the Smithsonian Artist Research Fellowship (SARF) program, I lived and worked in Washington, DC, for two months in the late summer of 2007 (Figure 1). My time as a fall 2007 Smithsonian artist research fellow was exciting and inspiring. Through great efforts came great rewards, free of restrictions and guidelines—I was part of the first team of participants. A sense of freshness came from this new group that led me to take steps into the world of the Smithsonian and discover what it was that I wanted to accomplish. Initially, my goal was to learn more about bioluminescent organisms, but upon completion of the program I left with insights and understandings that were much broader than I could have possibly imagined. This was my first chance to meet and work with scientists, and this collaboration may very well have been these scientists' first chance at working with a conceptual artist. Sharing our interests, research, and findings was the beginning of forming a dialogue and perspective that continues to have great influence on my artwork.

The Scientists

I met and worked with many scientists at the Smithsonian and found my interactions with them all to be great and rewarding experiences. Each of the scientists helped me to see and hear anew,

informed perspective about my interests in bioluminescent animals, and raised unimaginably interesting anecdotes and tangents from these dialogues. Meeting for informal interviews with the scientists in their offices gave us a chance to talk about and listen to what each of us did. We shared what we knew about my topics of interest, which helped me to know more about these animals as well as the humans who study them.

The richest dialogue and direction came from my mentor, Lynne Parenti. Her sense of humor and fresh perspective still resonate well with the way I look at the world. I will never forget when, during one of our first meetings, she drew a quick squiggly line on the blank paper on her desk, free of intention or meaning. "If we search the ocean long enough we could probably find a life form that looks like this," she said. She gave me great insights into deep-sea creatures while reminding me that our knowledge comes from the limits of the human perspective. She was ready to point out what may be flaws in the viewpoint that we are used to understanding, telling me that these weird-looking fish are not weird, that they probably think we are weird, and how fish that live in inhospitable conditions are only in conditions inhospitable to humans, that these volcanic environments are perfect for these fish. She expressed an opinion of evolution that seemed less Darwinian and more happenstance, where the chance of survival is also dependent on being in the right place at the right time or, more importantly, not being in the wrong place at the wrong time. By pointing out these quirks, I could see how Lynne takes a broader approach to the way life exists. Arming me with this knowledge, she pointed me in the right direction to find what I was interested in. She gave me the Latin names for many of the creatures I told her about and also helped me to connect with other scientists at the Smithsonian who might have more information.

Dave Johnson, curator in the Department of Vertebrate Zoology, was one of the scientists that Lynne Parenti directed me to. We met in his office, where I saw his incredible motorized microscope. I saw how fast and easy it was for him to take a digital image of a specimen and e-mail it to his colleagues. It is great to see the power of quickly and easily sharing information. I could see how this could help research rapidly evolve within this community. We continued to talk about our work. Dave showed me a remarkable PowerPoint presentation that illustrated a breakthrough in his work. He discovered that what was once considered two species were actually the same species, but the female and male looked very different in the adult stage. The images in his presentation show the dramatic transformation from larvae to adult. He described the importance of looking at nature with a larger perspective. When you look at a small section of nature, your chances of making a conclusion are likely to be wrong. It is best to take father steps back before you make any assumptions. In his case, no one ever saw the female of one species, and no one ever saw the male of the other. Dave went back and then farther back to discover strong similarities at the larvae stage. He described how important it is to look at nature with a larger perspective.

Lynne Parenti also put me in contact with a scientist who works directly with bioluminescent creatures. Louis Kornicker is a taxonomist. Taxonomy is a specialized field of biology that works to further our classification system of living organisms. Given that this was my first time meeting

a taxonomist, I learned that Louis' work as a taxonomist is done by dissecting and identifying each and every body part of the animal he is studying. Using comparisons and identification, Louis can categorize and group different species into new subcategories. Prior to meeting Louis, I had no idea that such a specialty existed. Louis was able to show me details of ostracods and copepods and pointed out where bioluminescent parts were and showed me how they moved and integrated with the animal. He showed me one of his colleague's PowerPoint presentations that was full of information about the chemical structure of organisms that had bioluminescence and also covered in depth the ostracod's bioluminescent mating light pattern. Speaking to Louis opened my eyes to see new parts of an animal, such their legs, segments, and protrusions, that I had never seen or understood. I feel that becoming aware of this practice has given rise to different underlying layers in my own work that may not be easily noticed to the untrained eye (Figure 2).

2.
LT-08. Plastic container, water bottle, computer cooling fans, microcontroller, magnifying sheet, cable ties, and LED lights. Courtesy of the author.

For example, consider how my work often uses kinetic movement. Different bodies of my work move by different methods, be it by fans, motors, gravity, or electric pumps. The characteristics of movement produced by these means are chosen very carefully when I am creating an installation. I examine the way air fills a bag and the way the air from a bottle hanging from a string with a fan attached moves. Qualities like these are what helps to create a whole installation and establish an encompassing theme or feeling. I see it as a kind of ecosystem where things fit with each other because they all move and respond with a similar movement. Various delays in motion can relate or contrast with other works. Because I can identify and categorize which device will produce what kind of movement, I can complete the visual unification that is necessary in my installations. When this unification is successful, the viewers may comprehend a similar sense of understanding if they are able to make their own assumptions by putting works into categories of their own that they can see. I relate this closely with the work of taxonomists—creating order in chaos.

The Laboratory

Meeting with several specialists and scientists who knew about bioluminescent creatures laid the foundation for the most exciting part of my time in the SARF program, which was visiting the new specimen laboratory in Maryland (Figure 3). It is an incredible facility with an awesome collection. Anything I wanted to see was available. And what I wanted to see was examples of creatures with characteristics that I find strange and interesting that live thousands of feet beneath the surface of the ocean. Each fish that I had in mind was available at the laboratory. I had seen so many pictures and videos of them, but they could not compare to seeing the actual fish, even though the specimens were not alive. The facility was so well equipped that I could place parts of the fish under the microscope for closer inspection, I could use the probing tools to study the texture of their bodies, I could feel how some were slimy and some were bony, and I could look at any detail I wished. The most fun aspect was probably that I did not know what I was looking for. All I knew was that I wanted to see them and understand them as best as I could.

My time at the laboratory allowed me to research anglerfish, gulper eels, dinoflagellates, bobtail squid, vampire squid, and so many others. In the laboratory, I felt most like a scientist myself. I learned in my own way how to study these creatures. I used unfamiliar tools, from strange tweezers to vacuums, microscopes, and light wands, which all gave me insights and information that I could not have learned otherwise. I learned by experiencing each creature's shape, size, and smell. The most interesting part of this shift from operating as artist to functioning as scientist was that I found my "new" way of working within the laboratory setting offered at the Smithsonian was not so different from my approach to making artwork in the studio. In both practices, I create my own methods and practices for accomplishing what I'm working on, such as gathering whatever information I can find by speaking to people who may know more about certain parts of what I am working on, using whatever tools I may find, and often feeling that I'm not sure what it is I'm trying to do.

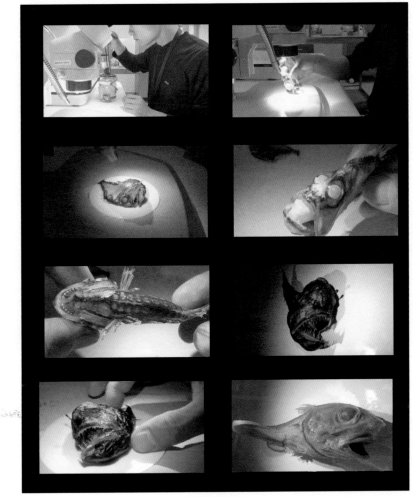

3.
Video stills, observing anglerfish and hatchet fish under the microscope at the Smithsonian Laboratory. Courtesy of the author.

Discoveries from the SARF Program and Their Impact on My Work

The ocean depths are truly filled with intriguing creatures (Figures 4 and 5). The creatures that researchers have been fortunate to discover are not only scientifically significant but also elicit an emotional response. I find that these animals have a peaceful appearance, with slow and graceful movements. This quality of tranquility carries into my artwork. In general, we can assume that the behavior patterns and body shapes of these creatures are a product of their relationship to their environment. They are shaped the way they are as a result of what their environment requires for survival. For example, the gulper eel has a giant stomach to store what scarce food is available, and the male anglerfish is able to grab and hold on to a female. The male's body

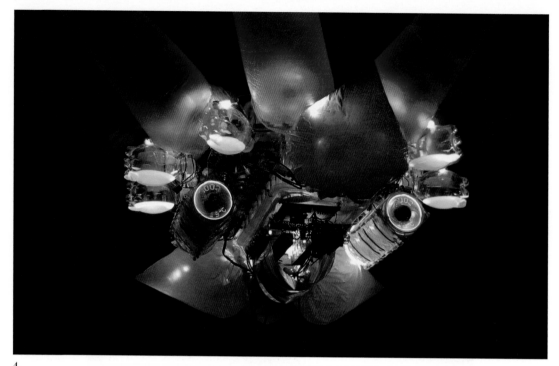

4.
ES-C-07. Plastic container, water bottles, highlighter juice, garbage bags, computer cooling fans, LED lights, and micro-controller. Courtesy of the author.

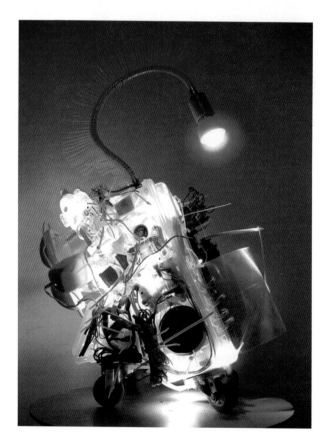

5.
RTI-#9. Plastic container, cable ties, LED lights, measuring cup, computer speakers, magnifying sheet, and microcontroller. Courtesy of the author.

eventually atrophies, appearing to shrivel and dry up, but the female keeps the sperm alive until she is ready for reproduction.

In effect, this is how I see my own work, especially considering the relationships between bodies of works and developing process. My works develop certain physical protrusions to hold enough relays and computer cooling fans so that there will be enough force for it to move. They take shape from the way they must hang in a room so that they can gracefully spin. It is difficult to describe, but I sense a subtle symbiotic relationship that is elusive and mysterious and beyond my own comprehension. But I see the artwork forming and evolving in relationship to its environment so that it can "thrive" and "live" on. This is mirrored in the way life exists for these deep-sea creatures. My connection to these elusive mysteries is where the seed of inspiration comes from in my work. This connection is what I am exploring and expressing.

In addition to a deeper understanding of my own artistic practices, I find that the documentation process that I saw at the Smithsonian has influenced me as well. The taxonomists at the Smithsonian were rigorous in logging every detail they see. They identify and make records of each component that makes up the animal they are studying. Seeing this process made a big impression on me because I find myself documenting my own process more and more. I found that setting up a camera with time-lapse video to film myself working helps me to look at the process of the way things happen in my studio or during an installation. The videos give me the ability to gain foresight into how many days an installation will take and what tools and materials may be needed (Figure 6).

The video stills in Figure 6 show certain steps in creating *EX-C-F*. Reviewing these videos has been an important step in my evolutionary process of art making. Before going on to make a series of works that may consist of several variations of the same piece I must review these videos to gain a perspective on the work I could not obtain otherwise. Through this process I have learned where the mechanical function as well as production of the work can be streamlined and made more efficient. Further spatial understanding is also gained on seeing the connection between parts and controllers. This understanding helps with the wiring process, inspiring ideas for the most efficient way to run the wire and how long to make the wire pieces I need. Ultimately, the decisions made from these videos affect the final aesthetics of the work. This type of logging has been a direct benefit from my participation in the SARF program.

My time in the SARF program has inspired me not only in the ways listed above but also on a less conscious and broader scale. Every day, I am reminded of my time at the Smithsonian, be it when I am tightening a small screw under a magnifying glass or using a laser beam to highlight a small protrusion of acrylic. I have moments when I strongly remember myself as the "amateur scientist" that I became during my residency. It is clear that this scientist will always be a part of me. This scientist is fostered by the treasured relationships I made with the other scientists at the Smithsonian. In a sense, I feel that I am now an adjunct part of this scientific community. I feel that my dialogue and understanding of the deep-sea world and its relation to our own will continue to grow and evolve to new unexpected depths that I am very excited to experience (Figure 7).

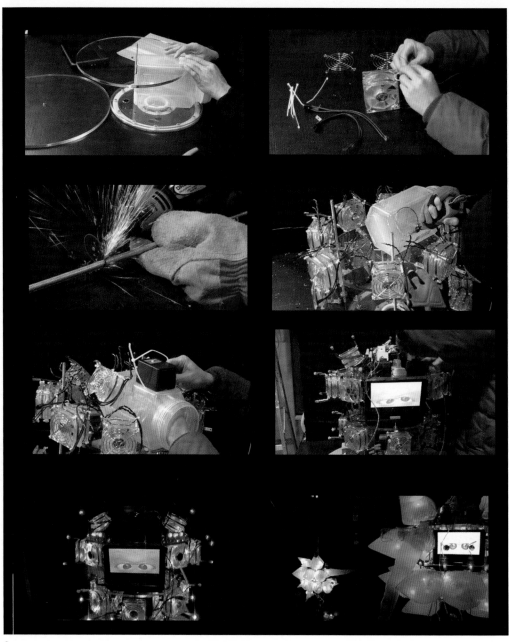

6.
Video stills, construction of artwork *EX-C-F*. Modification of plastic cookie jar, computer cooling fans, and garbage bags. Courtesy of the author.

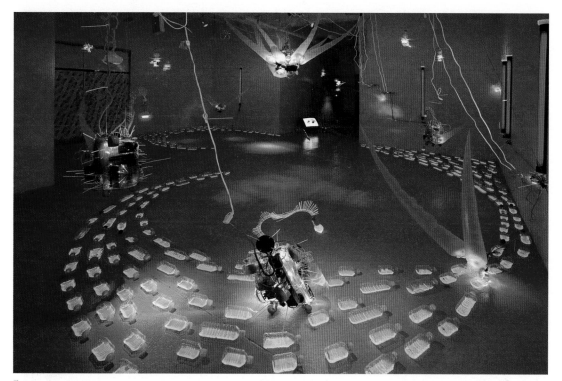

7.
Installation view, Virgil de Voldere Gallery. Modified household materials, plastic containers, garbage bags, computer cooling fans, microcontrollers, and LED lights. Courtesy of the author.

Acknowledgments

I thank Lynne Parenti for all the help and support during and after my research. I also thank Dave Johnson, Rafael Lemaitre, Louis Kornicker, Michael Vecchione, Jeff Clayton, and everyone at the Smithsonian for allowing me to peep into their world. I give special thanks to my friend O. M.

Light at the Museum

Lynne R. Parenti

Curator of Fishes and Research Scientist

Smithsonian Institution
National Museum of Natural History
Washington, D.C.

When asked by a colleague for my thoughts on Huang Shih Chieh (CJ) for a public forum on the Smithsonian Artist Research Fellowship program, I wrote

> [CJ] is simply one of the most creative people I have ever met. His investigation of the creation of light by living things knew no bounds—he manipulated fixed specimens to see just where their light organs were and how they worked as readily as he reconfigured commercial light sensors. He crossed the boundary between science and art by denying its existence. I feel privileged to have met Mr. Huang and to have experienced his art.

Such is the impression a young artist left on me after an all-too-brief time in the Division of Fishes, National Museum of Natural History, in 2007. CJ came to investigate one of the most fascinating and complex biological phenomena, bioluminescence—light production by living organisms—by studying dead animals. That may seem odd to some, yet it was perfectly natural to me and my natural history museum colleagues who study biological diversity and comparative morphology largely by examining dead (we generally use the less-loaded word "preserved") animal and plant specimens that we and our predecessors collected worldwide and that are maintained as one part of the vast research and educational resources of the Smithsonian Institution.

The collections are public property, of course, developed over one and a half centuries and maintained in perpetuity as a national, and international, treasure.[1] Because of their singularity, fragility, and inestimable value, permission to study biological specimens and other objects in the collections, hands-on, is granted only to bona fide scholars. In his essay, CJ describes one of our initial, cordial meetings. Maybe he caught on, maybe not, that through these early conversations I was trying to gauge not only what he wanted to learn from the specimens but, of equal importance, how he would treat them. The words he used to describe animals from the depths –peaceful, graceful, terrific, mysterious, even strange—conveyed his positive, respectful, and emotional response to them. He said all the right things and was allowed all the time he needed with the specimens.

CJ emphasizes that he learns by doing, that he does not know what he is looking for, that he just looks, pokes and probes at the specimens, turns them upside down, and touches their skin. He reminds us, through his actions, that we should all think that way, scientist and artist alike. Such unstructured exploration can result in the best, most creative art and, in my opinion, also the best and most creative science.

Above all, CJ demonstrates that he grasped the importance of museums in the study of science—as well as history, art and culture—when he writes in his essay in this volume of how specimens, the objects, are primary: "I had seen so many pictures and videos of [the fishes], but they could not compare to seeing the actual fish [specimen], even though the specimens were not alive." CJ got it: a video or other visual representation could not compare to the real thing, even if the real thing were not alive. For this respect and understanding, the specimens repaid him in kind as they served as catalysts for his imagination and creativity. His constructions are not *re*constructions or biological models, but proxies for light-emitting marine organisms, full of warmth and whimsy and the genius of Huang Shih Chieh.

Note

1. P. M. Henson, "A National Science and a National Museum," *Proceedings of the California Academy of Sciences* 55, Suppl. I, no. 3, (2004): 34–57.

About the Contributors

David Bjelajac, Professor of Art and American Studies at The George Washington University, is the author of *American Art: A Cultural History* (Prentice Hall, 2000; 2nd ed., 2005). Professor Bjelajac also has published books and articles on nineteenth-century American painting in relation to the history of religion, science, freemasonry, and hermetic, esoteric traditions. His current plans include a book on Copley's *Watson and the Shark* and another book project on chemistry, color, and American painting.

Dirk Bühler studies and has a PhD in architecture (RWTH [Rheinisch-Westfaelische Technische Hochschule] Aachen, Aachen, Germany). From 1979 to 1992 he was researching and teaching history of Latin American architecture in Mexico City and Puebla, Mexico. Since 1993, he has been a senior curator and director of the architectural and construction collection and management of temporary expositions at the Deutsches Museum in Munich, Germany. In 1998 he curated bridge-building and hydraulic engineering expositions at the Deutsches Museum. He has publications on the history of construction and studies civil architecture and engineering in Latin America.

Tom D. Crouch, a Smithsonian employee since 1974, has served both the National Air and Space Museum and the National Museum of American History in a variety of posts. At present, he is employed as Senior Curator with the Aeronautics Division of the National Air and Space Museum. Crouch holds a PhD in history from Ohio State University. He is the author or editor of fifteen books and many articles.

Bryan Dewalt is the Curator of Communications at the Canada Science and Technology Museum in Ottawa. He is responsible for the development, documentation, and interpretation of all aspects of the communications collection. He has published on the history of printing technology, dictation machines, and digital networks.

Martha Fleming has created science-related exhibitions at the Science Museum, London and with the Medical Museion of the University of Copenhagen, which developed out of an extensive career as a professional artist exhibiting large-scale installations in Montreal, New York, Toronto, London, Madrid, Sao Paulo, and elsewhere. She has acted as a consultant to Public Programmes

at the Wellcome Trust as well as Development Manager at the Royal Society. Martha Fleming has been a Visiting Research Fellow at the Max Planck Institute for the History of Science (Berlin), at the Materials Library of King's College London, and at the School of Art, Architecture and Design of Leeds Metropolitan University. She is currently assisting in the development of the Centre for Arts and Humanities Research at the Natural History Museum (London).

Ellery Foutch, a Mellon Postdoctoral Fellow at the University of Wisconsin–Madison, received her PhD from the University of Pennsylvania with a dissertation entitled "Arresting Beauty: The Perfectionist Impulse of Peale's Butterflies, Heade's Hummingbirds, Blaschka's Flowers, and Sandow's Body." Her research has been supported by the ACLS/Mellon Dissertation Completion Fellowship, the Wyeth Foundation Predoctoral Fellowship at the Smithsonian American Art Museum, the Terra Foundation for American Art, and the Philadelphia Area Center for the History of Science.

Anne Collins Goodyear, PhD, is Associate Curator of Prints and Drawings at the National Portrait Gallery, Smithsonian Institution, and Professorial Lecturer in Art and Art History at George Washington University. She is coeditor, with James W. McManus, of *Inventing Marcel Duchamp: The Dynamics of Portraiture* (Washington, DC: National Portrait Gallery, 2009) and has published numerous essays exploring the intersections of modern and contemporary art and portraiture with science and technology.

Shih Chieh Huang, born in Taiwan, has exhibited his sculptures and installations at the Busan Biennial, Aichi Triennial, 52nd Venice Biennial, Biennial Zero1 San Jose, Biennial Cuvée in Austria, the ARC Biennial Australia, the New Museum of Contemporary Art in New York, and MOCA (Museum of Contemporary Art) Shanghai. His solo exhibitions have been held at the Smithsonian Institution's National Museum of Natural History, the RISD (Rhode Island School of Design) Museum of Art, the Beall Center for Art and Technology, and MOCA Taipei.

Elizabeth A. Kessler is Assistant Professor of Art History and Liberal Studies at Ursinus College. She has published essays in *Studies in the History and Philosophy of Science*, *Hubble: Imagining Space and Time* (National Geographic), and *Beyond the Finite: The Sublime in Art and Science* (Oxford University Press). Her first book, *Picturing the Cosmos: The Hubble Space Telescope Images and the Astronomical Sublime*, will be published by the University of Minnesota Press in November 2012.

Peggy Aldrich Kidwell is Curator of Mathematics at the Smithsonian's National Museum of American History. Her BA is from Grinnell College; her PhD is from Yale University. Kidwell's research interests include the history of astrophysics, women in science, and mathematical instruments. Her most recent book, coauthored by Amy Ackerberg-Hastings and David Lindsay

Roberts, is *Tools of American Mathematics Teaching, 1800–2000* (2008). She is now studying the history of mathematical recreations in the United States.

Christine Mullen Kreamer, PhD, is Deputy Director and Chief Curator at the National Museum of African Art, Smithsonian Institution. Her numerous exhibitions and publications explore art and ritual, gender, African systems of knowledge, and museum practice. They bridge both traditional and contemporary arts and the disciplines of art history, anthropology, and museum studies. Her coauthored publications include *African Vision: The Walt Disney–Tishman African Art Collection* (2007) and *Inscribing Meaning: Writing and Graphic Systems in African Art* (2007).

Erin McLeary is an exhibit developer and independent scholar in Philadelphia, Pennsylvania.

Bernard Mergen specializes in nineteenth- and twentieth-century cultural and environmental history. Among his professional publications are *Snow in America* (Smithsonian Institution Press, 1997), which won the Ullr Award from the International Skiing History Association, and *Weather Matters: An American Cultural History Since 1900* (University Press of Kansas, 2008), which won the Louis J. Battan Author's Award from the American Meteorological Society. He is currently completing a history of Pyramid Lake, Nevada.

Jane Milosch directs the Provenance Research Initiative, Office of the Under Secretary for History, Art, and Culture, Smithsonian Institution, and was previously Senior Program Officer for Art, directing paninstitutional art programs and new interdisciplinary initiatives. She was also a curator at the Renwick Gallery, Smithsonian American Art Museum, and at the Cedar Rapids Museum of Art in Iowa. A former Fulbright Scholar to Germany, her research interests include modern and contemporary art, craft, and design, as well as interdisciplinary studies.

Katherine Ott, PhD, is a medical history curator at the Smithsonian's National Museum of American History. Her exhibition subjects have included polio, acupuncture, medical devices for altering the human body, and HIV and AIDS. She is the author of *Fevered Lives: Tuberculosis in American Culture Since 1870* and is coeditor of *Artificial Parts and Practical Lives: The Modern History of Prosthetics* and *Scrapbooks in American Life*. Ott also teaches at The George Washington University.

Lynne R. Parenti joined the National Museum of Natural History in 1990 as a Curator of Fishes and Research Scientist. She received her BS in 1975 from Stony Brook University and her PhD in 1980 from the City University of New York. Her current research focuses on the systematics and biogeography of Southeast Asian freshwater fishes, use of reproductive morphology in the study of bony fish phylogeny, and the theory and methods of historical biogeography.

J. D. Talasek is the director of Cultural Programs of the National Academy of Sciences, Washington, DC. He was the creator and organizer of two international online symposia hosted by the academy: "Visual Culture and Bioscience" (2008), coeditor of the published transcripts (2009), and "Visual Culture and Evolution" (2010), coeditor of the published transcripts (2012). Talasek has curated several exhibitions at the National Academy of Sciences, including Visionary Anatomies (toured through the Smithsonian Institution, 2004–06) and Absorption + Transmission: Work by Mike and Doug Starn. He is the art advisor for *Issues in Science and Technology* magazine, published by the University of Texas at Dallas and the National Academies. Talasek holds an MFA in studio arts from the University of Delaware, an MA in museum studies from the University of Leicester, and a BS in photography from East Texas State University. He is currently on the faculty at Johns Hopkins University in the Masters of Museum Studies Program.

Alison Taubman is Principal Curator, Communications at National Museums Scotland, a post endowed by BT (British Telecommunications plc) in 2002. She has worked with a range of technology collections for over 20 years, focusing on their social impact within gallery displays. She was also Project Curator for the Transatlantic Slavery Gallery, which opened in 1994 at the Merseyside Maritime Museum, part of National Museums Liverpool.

Margaret A. Weitekamp, PhD, is a curator in the Space History Division at the Smithsonian's National Air and Space Museum, where she oversees over 4,000 pieces of space memorabilia and space science fiction objects. She wrote *Right Stuff, Wrong Sex: America's First Women in Space Program* (2004), winner of the Eugene M. Emme Award for Astronautical Literature from the American Astronautical Society. She earned her BA at the University of Pittsburgh and her PhD at Cornell University.

Index

Numbers in *italic* indicate pages with illustrations

Absorption + Transmission exhibition, 217
acupuncture models, 3, 4, 10–13, *11*
Aerial Navigation Company, 174
Aeroport (Porter airship), 174–75
aesthetics
 affection and aesthetic qualities, 88
 of architectural space, 59, 63–68, *65, 66*
 assessments of, 75
 collaboration and intersection between art, aesthetics, science, and technology, vi–viii, x–xii, 132–33, 143, 216–19
 concept of, x
 exhibitions, aesthetic value of, 72
 models as aesthetic objects, x, 1, 3–5, 33
 natural history museum objects and exhibits and, 33, 36n65
 neutrality, aesthetics of, 4, 5
 representation and the real, line between, 22–27, *24*, 32–33, 106, 108–9
 standardization, aesthetics of, 4
 of technology, x, 122–130
 technology and development of, 77
 truthfulness, aesthetics of, 1, 4
affection and aesthetics
 anthropomorphization of zoo animals, space shuttles, and, 98–100, 101–2
 neoteny, juvenile characteristics, and affection, 89, 95–99, *96, 98*, 101–2
 qualities that invoke affection, 88
Africa
 agricultural practices and lunar calendar use, 188
 contributions to science and practice of astronomy, 186
 cultural astronomy, contributions to, 187–90, 192–95, 196n8
 Milky Way, African myth about creation of, *187*, 194
 misperceptions and popular beliefs about, 186, 195n1
 moon representations in African art, 192, *193*
 solar representations in Africa art, 190, 192, *192*
African Cosmos exhibition, 186–197
 focus and scope of exhibition, 186–87, 194–95
 publication about exhibition, 188, 196n4
 South African artists, 193–94, *195*
 works included in exhibition, 187–94, *187, 190, 191, 192, 193*
Agassiz, Elizabeth, 28–29
Agassiz, Louis, 28
agricultural practices and lunar calendar use, 188
AIDS, 243, 254n15
aircraft and airships
 airplanes, invention of, 177
 Brodbeck flying machine, 175–176
 Burton safe airship, 178, 184n28
 Cannon flying machine, 176
 Custead ornithopter, 176
 Dellschau airship and aeronautic information scrapbooks and paintings, 168–69, 170–73, *171, 172*, 178–83, *179, 181*, 183n10
 Giffard airship, 175
 Goosey construction and flight, 170, *171*, 173, 178, 183n7
 introduced through toys, 92
 mysterious airship and flying saucer hoax, 176–77, 182–83, 184n38
 Porter and Aerial Navigation Company, 174–75
 Zeppelin airship, 177
Aitken, Doug, vii
Ajay, Abe, 200, 202
Albers, Josef, 199
alchemy, 144, 147–48, 151–156, 159
Altshiller-Court, Nathan, 204
American Museum of Natural History (AMNH), 26–27, 35–36n41
American Wilderness Experience, 109
Ames, Oakes, 22, 25–26
Analysis of Beauty (Hogarth), 155
Anatsui, El, 193
animals
 anthropomorphization of zoo animals, 87, 96–98, 99–100
 charismatic animals, 87
 human-animal encounter in *Split + Splice* exhibition, 138, *138*

animals (*continued*)

 neoteny, juvenile characteristics, and affection, 93–95, *94*, *96*

Ann Arbor (Michigan) cell phone tower, 116

Ansco Universal view cameras, 82, 86

Anuszkiewicz, Richard, 199

Apache culture, 12

Apollo Program, 99

appearance and character, link between, 242

archaeoastronomy (ethnoastronomy/cultural astronomy), 187–90, 192–95

architecture and engineering models

 as aesthetic objects, 72

 as assembled realities, 57, 71–72

 collections of, 57–58

 construction of, 58

 Dessau public baths model, 57, 68–71, *68*, *70*, 73nn36–37, 73n39

 Deutsches Museum collection and exhibits, 56–75

 documentation and representation of construction methods and processes through, 59, 73n10, 73n13

 façade (skin), 59, 60–63, *61*, 73n18, 73n21

 function of a building and, 59, 68–71, *68*, *70*

 functions of, 57–60, 67–68, 71–72, 72–73nn9–14

 historical documentation role, 58–59, 72n9

 history of, 57

 Japanese house models, 56–57, 63–68, *65*, *66*

 Kammerzell House, 56, 60–63, *61*, 73n15, 73n18, 73n21

 public instruction role of, 59, 69–71, 73n11

 reality, representation of and perception of, 71–72

 scale of, 57, 72n1

 space, aesthetics of, 59, 63–68, *65*, *66*

 as works of art, 59, 73n14

art

 collaboration and intersection between art, aesthetics, science, and technology, vi–viii, x–xii, 132–33, 143, 216–19

 creative inquiry and engagement through objects that bring together art, science, and technology, vii–viii

 genetics, 213, 242–45, *244*, 254n13, 254n15

 individual and culture, recording elements of both, 213

 museums and collaboration between arts and sciences, xi

 placement of and shift in interpretation of, 213–14, 220n10

 purity of art, 234

 science-related art, 144–159, 168–183, 186–195, 198–208, 212–220, 220n4, 220n7, 222–236, 240–254

 "Twelve Rules for a New Academy" (Reinhardt), 234

 See also portraits/portraiture

Art and the Power of Placement (Newhouse), 213–14

Artefacts, v, x–xi, 133

artifacts and objects

 aesthetics of natural history museum objects and exhibits, 33, 36n65

 creative inquiry and engagement through objects that bring together art, science, and technology, vii–viii

 enclaved objects, 3

 life cycle of, 3

 photography of, 22–25, *23*, *24*, 33, 35n25, 35n30, 36n65

 relationship between people and, 14

Art of Video Games exhibition, viii

astronomy and astronomical artifacts

 African contributions to cultural astronomy (archaeoastronomy/ethnoastronomy), 187–95, 196n8

 artistic depictions of stars, vi, xi

 Asante *adinkra* cloths and celestial design motifs, 192–93

 Celmins drawings and paintings, 222–23, 224, 226, *227*, 232–236, 236n5, 237n31

 Connor photographs, 222–23, 224, *224*, 225, 226–29, 236

 dark matter, 235

 ESO/SRC Southern Sky Survey, 230–32

 lunar eclipse, *225*, 228

 Milky Way, African myth about creation of, *187*, 194

 Milky Way, photographs of, 224, *224*, 226–29

 number of and distribution of imagines, 223–24

 observation and instruments of vision to study astronomy, 223, 229

 photographs of stars, vi, 222–239

 Ruff photographs, 222–23, 224, 226, *226*, 230–32, 236

 Southern African Large Telescope (SALT) complex, 193–94

Atlantis space shuttle, 89

atomic weights, 42

Auzoux, L. T. J., 20

Baker-White, Tracy, 173

Bak-Jensen, Søren, 133, 142n6

balloon flights, 173

balm of Gilead, 151–52

Bamana people and Chi Wara, 190, *192*

Barnaby (Johnson comic strip), 200, 201, 206

Barnard, E. E., 227–29, 236

Barthes, Roland, 251, 253

Bath Machines Shuttle Tub Toys, 100, *100*

Bauer, Susanne, 133, 142n6

Bean, Alan, vi

Beardsley, John, 170

Bell, Alexander Graham, 123
Berkeley, George
 Essay Towards a New Theory of Vision, 146–47
 Hermetica, interpretation of, 147
 Siris, 151, 155, 157
Berwick, Rachel, 263, 265
bioluminescent organisms, 263, 269–279
bird's-eye views, 13, 14
Blanchot, Maurice, 253
Blaschka, Leopold, 18, 20–22, 26–27, 29–33, 34n13
Blaschka, Rudolf, 18, 20–22, 26–27, 29–33, 34n13
Bleriot, Louis, 178
Blindspot (Fat Head) (Hawkinson), 245
blood and self-portraits, 243, 254n13, 254n15
Boerhaave, Hermann, 156
Boghossian, Alexander "Skunder," 193
Börner & Herzberg, 69
Boshoff, Willem, 193
botany
 botanical art collection, vii
 classification scheme for flowers, 29
 colors and names of colors, relationship between,
 41–42
 documentation and classification of plant life, vii
 dried and pressed specimens, 19, *19*
 Glass Flowers, 18–39
 glass models from Blaschka studio, 20–22
 museum collections, *19*
 natural versus artificial specimens, 19–21, 34n6,
 34n8
 wax models, 20, 26–27, 34n6, 35–36n41
Bradley, Milton, 41–42, 52n7
Brawer, Catherine, 215–216
Brendel, Reinhold, 20, 34n8
Brendel, Robert, 20, 34n8
Brio space shuttle toy, 94
Brodbeck, Jacob Friedrich, 175–176
Bronikowski, Ed, 263
Buran program, 93
Burger, Hillel, 23–25, *24*, 33, 35n30
Burson, Nancy, 250, 255–256n48
Burton, W., 178, 184n28
Butler, Judith, 241, 246–47

Calder, Alexander, vi, 199
California gold rush and mining camps, 168–69, 170,
 173, 174
Calumet 8 × 10 cameras, 77, 79–82, *83*, *86*
Calvino, Italo, 236
Canada Science and Technology Museum and *Karsh:
 Image Maker* exhibition, 75, 76–87
Cannon, Burrell, 176
Cardinal, Roger, 170, 180
Carlson, Ferdinand A., 53n15

Cartier-Bresson, Henri, 81
cell phone towers
 concealment and camouflage of, 104–21
 cost of disguised towers, 106, 108
 cost of towers, 108
 design of, 75
 in national parks and forests, 114–15, 117
 number of disguised towers, 105
 number of towers, 105
 palms and cacti, camouflage as, 105–6, 108, 109,
 111, 112, 116
 site selection and placement of, 104, 107, 108, 109,
 114–15
 technological picturesque, 107–12
 technological sublime, 106, 107
 technology to disguise, 104
 trees, camouflage as, 104–7, 108–09, *110*, *111*,
 115–118
 types of, 104, *105*
Celmins, Vija, 222–23, 224, 226, 232–236, 236n5
 Galaxy (Coma Berenices), *227*, 233, 234, 235,
 237n31
 Slate Tablet, 232, 233, 236
Center for Advanced Visual Studies, 201
Center for Art + Environment, 220n4
Challenger space shuttle, 89
Chandra X-ray Center, vi
Chanute, Octave, 177, 178
character and appearance, link between, 242
Chartier, Richard, 264
Chateauvert, Jocelyn, 263–64
Chi Wara and Bamana people, 190, *192*
Christ and the Miraculous Draught of Fishes
 (Raphael), 149
Churchill, Winston, 77, 79
Clair, Jean, 133
Cleveland, Alice S., 9
Cloned D.N.A. Self-Portrait (Quinn), 243, *244*
Clovis points, viii
coal and steel industry, 125
Cohen, Michael P., 118
collections, principle of sameness in difference and
 building a collection, 9–10
College Geometry (Altshiller-Court), 204
Colonna, Fabio, 29
color
 alchemy and light and color effects, 146–47, 148,
 154–156
 challenges of reproducing color, 45, 49, 51, 53n15
 education about, 42–45, *43*, 53n12
 Maxwell discs, 48, 52n7
 Munsell color system development, 40–55
 Munsell instruments and standards, 45–49, *45*, *47*,
 51–52, 53n19

color (*continued*)
 names for, 41, 52n3
 organization of Munsell system, 42, 52n7
 Ridgway system, 49–52, *50*
 as scientific tool, 41–42, 46–52, *47*, 53n19, 54n33
 standardization of names and systems for, 41–42, 52n7
 subjectivity of work with, 49, 51
Columbia space shuttle, 89
Coma Berenices, *227*, 233, 234, 235, 237n31
Compensation Portrait (Duchamp), 247–48
Conkling, Veronica, 266–67n13
Connor, Linda, 222–23, 224, *224*, *225*, 226–29, 236
Coolidge, Calvin, 220n1
Cooper-Hewitt National Design Museum, 263
Copley, John Singleton
 alchemy interests of, 144, 147–48, 151–156, 159
 color and light, understanding of and use by, 146–47, 148, 154–156
 Freemasonry connections of, 147, 159
 home of, hospital history of, 147
 oil varnish recipe, 144, 151–52, 161n28
 Watson, relationship with, 145
 Watson and the Shark, 141, 144–159, *145*, 160n1
coral reefs, artistic renderings of, vii, xi, 265
Corning Museum of Glass, 35n30
Cosmic Evolution Survey (COSMOS), 194
cotton grading, 47–48, *47*
Courant, Richard, 202
Coxeter, H. S. M., 202, 206
creativity, intersection between art, science, and technology and, vii–viii
Cube portraits, 251–52, *251*
cultural astronomy (archaeoastronomy/ethnoastronomy), 187–90, 192–95
culture, disciplining the wildness of, 14
Currier, Nathaniel, 174–75
Curtiss, Glenn, 178
Custead, W. D., 176
Custis, Marvin A., 5

Dahlem, Björn, 263
Danforth, Samuel, 147, 154
Darger, Henry, 181–82
dark matter, 233, 235
Darwin, Charles, 218, 220–21nn18–19
David (Michelangelo), 214, 216, 220n10
Davies, Douglas, 114
da Vinci, Leonardo, viii
Deane, Walter, 26, 27
Dellschau, Charles August Albert, 183n3
 aircraft propulsion interest of, 178
 airship and aeronautic information scrapbooks and paintings, 168–69, 170–73, *171*, *172*, 178–83, *179*, *181*, 183n10

airship shape and material choices, 177
aviation interests of and inspiration for drawings, 173–180, 182–83
birth and early years of, 169
collections of works by, 182
death of, 182
discovery of work by, 182
employment of, 168, 169, 173
Goosey construction and flight, 170, *171*, 173, 178, 183n7
marriage and family of, 169, 181–82
mental health of, 181–82
outsider artist designation, 169, 170, 180–82, 183
photo of, *169*
press blooms, *172*, *172*, 173, 178–80, *179*, 182, 184n30
Recolections Reall and Speculative Works on Ideas of Friends and Higher Aims, Long Gone, 170, 183n3
Reminiscences of Years Past of Time and a Way of Life Written and Illustrated in Idle Hours, 169–70, 173, 177, 183n3
Sonora Aero Club narrative, 168, 170, 173, 175, 182–83
tragedy in life of, 169–70
World War I and topics of press blooms, 180
Democratic Republic of the Congo, Sungu-Tetela people, 192, *193*
Dendera, Egypt, 189
dermatology
 atlases of skin diseases, 5–6
 journal about, 6, 15n9
 medical moulage and wax models, 15n9
 skin diseases, stereographic set for diagnosis of, 3, 4, 5–8, *6*, *7*, 13, 14
Dessau public baths (Stadtschwimmhalle) model, 57, 68–71, *68*, *70*, 73nn36–37, 73n39
Deutsches Museum
 architecture and engineering model collection and exhibits, 56–75
 conference on exhibition development, 133
 founder of, 69–70
 public instruction exhibits at, 57, 59, 69–71
 reputation of, 58
 Wunderkammer Museum exhibition, 33, 36n65
Discovery space shuttle, vi, 88, 89
Disney World, Disneyland, and Walt Disney, 97, 108, 117
DNA, 242–43
Dogon people, Mali, 188, 189, *190*
Dog Star (Sirius), 188, 189
Domino's Farm, Ann Arbor, 116
Dubuffet, Jean, 169
Duchamp, Marcel, 199, 242, 247–48

Duché, Jacob, 147
Durant, Samuel "Sam," 261, 263

Egyptian stone circles and megaliths, 188–89
Einstein, Albert, viii
Ektar lenses, 81
Elahi, Hasan, 252–53, *252*
electronics and microelectronics industry, 125, 127,
 129, *130*
Ellegood, Anne, 264
Emerson, Ralph Waldo, 112
Endeavour space shuttle, 89
energy production, 127, *128*
engineering
 art based on, 201
 engineering mathematics, 198
Enterprise space shuttle, 102n2
ES-C-07 (Huang), *274*
Essay Towards a New Theory of Vision (Berkeley),
 146–47
Ethiopia
 agricultural practices and lunar calendar use, 188
 Watson and the Shark (Copley), Ethiopia, and
 Ethiopian sailors, 154–55, 157, 158, 159
ethnoastronomy (cultural astronomy/
 archaeoastronomy), 187–90, 192–95
European Southern Observatory (ESO), 226, 230–32
EX-C-F (Huang), *275, 276*
exhibitions
 aesthetics of natural history museum objects and
 exhibits, 33, 36n65
 aesthetic value of, 72
 collaboration between museum professionals and
 historians, 132–33
 conference on exhibition development, 133
 cultural and historical constructs and exhibition
 design, 128–29, *130*
 design and development of, xii
 Karsh exhibition development and design, 75,
 76–87, *80, 83, 84, 86*
 navigation through, 137
 pouring book learning into glass cases, 132
 Scottish science and technology exhibition design,
 123–130, *126, 128, 130*
Experiments in Art and Technology, 201
eye, schematic, 3, 4, 8–10, *8*, 13, 14
Ezekiel Flying Machine, 176

façade (skin), 59, 60–63, *61*, 73n18, 73n21
Fayetteville cell phone tower, 116, *117*
Festival Karsh, 77
film and video, 248–50, 255n34, 255n36, 255n46
The Fin Within (Hawkinson), 245
Fisher, William Albert, 3, 8–10

Fisher-Price Little People Space Shuttle, 97, *98*
Flanders, Harley, 206, 207
Fleming, Alexander, 123
Ford, Worthington, 42
Forth Bridge, 129
Freemasonry and *Watson and the Shark* (Copley), 144,
 147, 148, 156, 159
Freer and Sackler Galleries, 262, 265
"From Earth to the Universe" project, vi

Galaxy (Coma Berenices) series (Celmins), 227, 233,
 234, 235, 237n31
Galison, Peter, 57, 132, 230
Galton, Francis, 251, 255–256n48
Gardiner, Sylvester, 147, 157, 207
Gardner, Martin, 206
Gates, Joseph "Ready," 173
Geldzahler, Henry, 248
Gemini program, 101
genetic artists, 213
genetics and portraiture, 242–45, *244*, 254n13, 254n15
geometry
 art theory and, 199
 Johnson paintings, 198, 199, 207
 See also mathematics
Gesner, Conrad, 29
Ghana
 Asante *adinkra* cloths and celestial design motifs,
 192–93
 conference during total solar eclipse, 196n8
Giambologna, *150*, 151
giant pandas, 88, 99–100
Giffard, Henri, 175
Glass Flowers, 18–39
 accuracy of, 18, 22, 27
 aesthetic qualities of, 25–27
 display of and popularity of, 18, 21–22, 25–27,
 34n14
 exclusive, binding contract to make, 21
 natural versus artificial specimens, 19–21, 34n6,
 34n8
 original exhibition design and educational value of
 models, 27–32, *28, 30, 32*
 packing material for transport of, 31–32
 publications about and photographs of, 22–25, *23,
 24*, 33, 35n25, 35n30
 representation and the real, slippage between,
 22–27, *24*, 32–33
 size of, 27–28, 30–31, *30*
 technique and tools for making, 21, 26, 32, 34n13
Go-Bot toys, 95
Goodale, George Lincoln, 19–21, 25–26, 27, 28, 29,
 34n8
Goodhue, Bertram Grosvenor, 212

Gopnik, Blake, 115
Gordon, Douglas, 247–58
Goree, "Doc," 171
Gould, Stephen Jay, 97
Gower, Terence, 264
Graft (Paine), 115
Gray, Asa, 19
Gris, Juan, 199
Grubb, Tom, 116, *117*

Hale, George Ellery, 212, 213
Hale Telescope, 212
Hallock, William, 42
Hamly, D. H., 50
Hangman of My Circumferences (Hawkinson), 249
Hardy, G. H., 202
Harold and the Purple Crayon (Johnson), 200
Harold's ABC (Johnson), 201
Harold's Trip to the Sky (Johnson), 201
Harpers Ferry church spire cell phone tower, 116
Harvard University
 Arnold Arboretum, 19
 Botanical Museum, 19, 21, 22, 25
 Botanic Garden, 19
 Herbaria, 25
 Museum of Comparative Zoology, 21
 Museum of Natural History, 33
 Museum of Vegetable Products, 19
Hassinger, Maren, 115
Hathor, 189
Havana, Cuba, 144–45, *145*, 148, 149, 157, 158–59
Hawkinson, Tim, 245, 246–47
Hazoumè, Romuald, 193
Heiferman, Marvin, 213
Henderson, Linda Dalyrymple, 199
Hermes (Mercury), 147, 150, *150*, 152, 157, 158
Hermes Trismegistus, 147, 148, 151
Hermetica, 147
Herter, Albert, 212
Heydon, S. E., 177
Hirshhorn, Joseph, 264
Hirshhorn Museum and Sculpture Garden (HMSG)
 Intersections: Interdisciplinary Perspectives event, 265
 SARF (Smithsonian Artist Research Fellowship) program artists and exhibits, 263, 264
 types of exhibits at, vii
history of science, technology, and medicine (HSTM), 132–33, 141
Hoen, A. B., 51
Hogarth, William, 155
Homberg, Wilhelm, 152
HSTM (history of science, technology, and medicine), 132–33, 141

Huang, Shih Chieh
 Arc Biennial 2009, *269*
 ES-C-07, *274*
 EX-C-F, 275, *276*
 LT-08, *271*
 RTI-#9, *275*
 SARF (Smithsonian Artist Research Fellowship) program, 263, 265, 268–279
Hubble Space Telescope, 223–24, 232
Humphrey, Ozias, 161n28
Hurd, Nathaniel, 147
Hyperbolic Crochet Coral Reef project, vii, xi, 265

Iconoclash, 132
identity
 character and appearance, link between, 242
 destabilization of model of unified subject, 242, 246–47, 253–54
 portraiture and, 241, 247–48
Illman, William, 50
Impressionist paintings, 4
Industrial Museum of Scotland, 122–23. *See also* National Museum of Scotland
Inscribing Meaning (Kreamer), 195n1
Institute for Figuring (IFF), xi
instruments, scientific medicine and, 4, 9
Intersections: Interdisciplinary Perspectives event, 265
Ivins, William M., Jr., 204

James, LeBron, 251–52, *251*, 256n51
Jantjes, Gavin, *187*, 193–94
Japanese house models, 56–57, 63–68, *65*, *66*
Jensen, Alfred, 199
Jobs, Steve, viii
Johnson, Crockett
 Abstractions of Abstractions show, 209n34
 amateur status as painter and mathematician, 199, 207
 Barnaby, 200, 201, 206
 birth name and early life of, 199–200
 children's books by, 200–1
 Cold War publications, 204–7
 comic art, 200, 201
 early mathematical paintings, 201–4, *203*
 focus of paintings, 199
 geometric paintings, 198, 199, 207
 graphic arts career of, 199–201
 Harold and the Purple Crayon, 200
 Harold's ABC, 201
 Harold's Trip to the Sky, 201
 heptagon paintings, 206–7
 influence of, 207–8
 materials for painting, 202, 207

mathematical paintings, 198–208, *203*, *205*, *206*
 Parabolic Triangles (Archimedes), 205
 Proof of the Pythagorean Theorem, 203–4, *203*
 Squared Circle, 206, *206*
 Squared Lunes, 205, *205*
 technical details of painting, interest in, 202
Johnson, Dave, 270
Joyce Kilmer Memorial Forest, 117
Jungen, Brian, 264

Kammerzell House, 56, 60–63, *61*, 73n15, 73n18, 73n21
Karsh: Image Maker exhibition, 75, 76–87
Karsh, Yousuf
 cameras and equipment used by, 77, 79–86, *83*, *84*, *86*
 character of, 80–81
 early life of, 77
 exhibition development and design, 75, 76–87, *80*, *83*, *84*, *86*
 photography style of, 78, 80–1, 82–84, *83*, *84*
 portrait photography of, 76, 77, 78, *79*
 reputation of, 77
 self-portrait, 82, *84*
 success of exhibition about, 86–87
 technical detail and attention to product and process, 78–79, 80–82, 86
Kasner, Edward, 202
Kennedy Space Center (NASA), 101
Kentridge, William, 193
Kepes, Gyorgy, 201
Kilmer complex, 75, 104–19
Kilmer, Joyce, 104, 117
Kitt Peak Observatory, 235
Klüver, Billy, 201
Koch, Hans-Jürgen, 33
Koch, Heidi, 33
Kodak Ektar lenses, 81
Kornicker, Louis, 270–71
K.O.S. (Kids of Survival) + Tim Rollins, 216–18, *219*, 220n17, 221n19
Krauss, Rosalind, 248, 253
Krauss, Ruth, 200
Kredel, Fritz, 22, 35n25
Krieger, Martin, 117
Kure, Marcia, 263, 265
Kurin, Richard, 266–67n13

L'âme au Corps, 132–33
lampworking technique, 21, 26, 32, 34n13
landscapes
 aesthetics and, 108–10, 112–16
 highways and highway beautification programs, 106, 107

national parks and forests, cell phone towers in, 114–15, 117
national parks and road design, 106, 118n6
picturesque, technological, 107–12
sublime, technological, 106, 107
transformation of through technology, 106, 109, 114–118
urban civilization and forested wilderness, balance between, 112–13
See also trees and forests
Langley, Samuel Pierpont, 177
lantern slides, 36n48
Larson Camouflage, 106, 107–8, 109, *110*, 115, 117
Latour, Bruno, 132
Lauri puzzles, 95
Lawry, Lee, 212
Lick Observatory, 224, 226–27, 231
light
 alchemy and light and color effects, 146–47, 148, 154–56
 prismatic light, 148
 solar and divine light, linking of, 151
 tar-water, light-activated, 151, 152, 155
 white light, 148
Lilienthal, Otto, 177
Lindemann, Carl Louis Ferdinand von, 206
"Living Portrait Boxes" (Warhol), 248–49
Lloyd, John, 127
Lorenz, Konrad, 89, 95–97
LT-08 (Huang), *271*
lunar calendars, 188

machines, desemantification-resemantification process and, 122
Making the Modern World, 133
Mali
 Bamana people and Chi Wara, 190, *192*
 Dogon people, 188, 189
 Dogon stool, 188, *190*
 Timbuktu manuscripts, 189
Mapplethorpe, Robert, 24
marine invertebrate models, 20–21, 33
Marsh, George Perkins, 112
martlets, 149, *149*, 150, *151*, 155
Maryland Historical Society, *Mining the Museum* exhibition, 33
material culture and materiality
 models and, xi, 1
 perception and independent existence of, 146–47
 science and technology and, x, xi, xii, 129–30, 141
Material Culture Forum (MCF), 265
mathematics
 geometric paintings, 198, 199, 207
 geometry and art theories, 199

mathematics (*continued*)
 Johnson paintings, 199–208, *203, 205, 206,* 208n4, 209n34
 popular interest in, 198–99, 201, 202–3, 208
 space age and mathematics training, 201
 teaching of, 198, 204–5
 visual representation of mathematical ideas, 198
Mathematics and the Imagination (Newman and Kasner), 202
Max Planck Institute for the History of Science, 133
McCarthy, Ryan, 108
McLeod, D. Gordon, 85, *85*
McLuhan, Marshall, 240
Medical Museion, University of Copenhagen, 133–141, 142n5
medical teaching
 accuracy of models, 4
 acupuncture models, 3, 4, 10–13, *11*
 attributes of modernity and models, 13–14
 drawings and sketching ability of physicians, 10, 15n21
 embodiment and counterembodiment, 4–5
 functions of models, 2–3, 13–14
 marketing of models, 5, 9, 13
 medical moulage and wax models, 15n9
 models for, 2–17
 objectivity and scientific artifacts, 4
 photographs and, 8
 schematic eye, 3, 4, 8–10, *8,* 13, 14
 skin diseases, stereographic set for diagnosis of, 3, 4, 5–8, *6, 7,* 13, 14
 standardization of medicine and normalizing of judgement, 14
 theatrical function of models, 6, 13
medicine
 biomedicine and *Split + Splice* exhibition, 132–141, *138, 139, 140*
 color charts for use by physicians, 46, 53n19
 embodiment and counterembodiment, 4–5
 narrative as data, 12
 objectivity and scientific artifacts, 4
 poison antidote, 157
 scientific medicine and medical instruments, 4, 9
 specialization and subspecialties, 10
 standardization of medicine and normalizing of judgement, 14
 subjective information and precision of science, 12–13
medium as message, 240–41
Mehretu, Julie, 193
Meière, Hildreth, 212, 215–216, *215*
Menil, Dominique de, 182
Mennis, Peter, 170, 171, *171,* 173
Mercury (Giambologna), *150,* 151

Mercury (Hermes), 147, 150, *150,* 152, 157, 158
Mercury program, 101
Merian, Maria S., 264
Metallballon (Schwartz airship), 177–78
Metzing, Jean, 199
Michelangelo, 214, 216, 220n10
Mickey Mouse, 97
Milky Way
 African myth about creation of, *187,* 194
 photographs of, 224, *224,* 226–29
Miller, Oskar von, 69–70, 71
Milton, John, 155
models
 accuracy of, 4, 18
 as aesthetic objects, x, 1, 3–5, 33, 72
 architecture and engineering models, 56–75
 characteristics of, 57
 collection and exhibition of, 1, 3
 creation and production of, 4
 explanation of complex ideas through, xi, 1
 functions of, xi, 1, 2–3, 4, 5, 13–14, 57–60, 71–72
 Glass Flowers, 18–39
 material culture and, xi, 1
 medical teaching models, 2–17
 Munsell color system, 40–55
 scale of, 57, 72n1
 wax models, 15n9, 20, 26–27, 34n6, 35–36n41
Mondrian, Piet, 199
moon
 African art, representations in, 192
 Asante *adinkra* cloths and celestial design motifs, 192–93
 lunar eclipse, *225,* 228
 Sungu-Tetela people and moon design motif mask, 192, *193*
Morrison, Bruce "Will," 266–67n13
Morton, Julius Sterling, 113
Mount Vernon, 109, *110*
Muir, John, 113
Munsell, Albert H.
 color education philosophy, 42–45, *43,* 53n12
 color system development, 40–55
 interest in color, 40
 middle and muted values, preference for, 44, 53n12, 53n14
 organization of color system, 42, 52n7
Munsell Color Company
 color instruments and standards, 45–49, *45, 47,* 51–52, 53n19
 employees of, 46–48, *47,* 53n15
 sale and acquisition of, 54n33
Museum of Science and Art, 123. *See also* National Museum of Scotland

Museum of Scotland, 123. *See also* National Museum of Scotland
Mütter Museum, 33

Nabta Playa, Egypt, 188–89
Nadkarni, Nalini, 114
Nantahala National Forest, 117
Narcissus and self-portraiture, 243, 254n16
NASA (National Aeronautics and Space Administration), 201
 Chandra X-ray Center, vi
 science and technology education goals, 101
 See also space shuttles
National Academy of Sciences (NAS)
 art exhibition program, 213, 214–15, 216–20, *216*, *217*, *219*
 building design and construction, 212–13
 chartering of, 212
 dome ceiling of the Great Hall, 212, 215–216, *215*
 temple of science reference, 213, 220n1
National Air and Space Museum (NASM)
 SARF (Smithsonian Artist Research Fellowship) program artists and exhibits, 262, 264
 Steven F. Udvar-Hazy Center, vi
National Arbor Day campaign, 113
National Gallery of Art Sculpture Garden, 115
National Museum of African Art, 263, 265
National Museum of American History (NMAH)
 Johnson paintings in, 199, 202, 203
 medical sciences collection, 2
 SARF (Smithsonian Artist Research Fellowship) program artists and exhibits, 268
National Museum of Natural History (NMNH)
 Contemporary Art and Science Advisory Committee, 265
 Hyperbolic Crochet Coral Reef project, vii, xi, 265
 SARF (Smithsonian Artist Research Fellowship) program artists and exhibits, 263, 264, 265
 X-Ray Vision: Fish Inside Out exhibition, vii
National Museum of Scotland
 cultural and historical constructs and exhibition design, 128–29
 original museum and name changes, 122–23
 Riverside Museum, 123
 Scotland: A Changing Nation gallery, 123–130, *126*, *128*, *130*
 Victorian building, 123
National Museum of the American Indian (NMAI), 263, 264
National Zoo, vii, 262, 263
nature, pictorial representation and imitation, 4
NatureMaker, 109, 111
Navarro, Peter, 182

Neal, Valerie, 90
Neibart, Wally, 242–43
Nel, Karel, 193, 194, *195*
Nel, Phil, 200
neoteny, juvenile characteristics, and affection, 89, 93–97, *94*, *96*, 99–100
Neustetter, Marcus, 193
neutrality, aesthetics of, 4, 5
Nevada Museum of Art, 220n4
Newhouse, Victoria, 213–14
Newman, James R., 202, 204
New Masses, 200
Newton, Isaac, 147–48, 156
Nexø, Sniff Andersen, 133, 142n6
Nickerson, Dorothy, 46–49, 51
Nigeria, Shango and Shango dance staff, 189–90, *191*
Nine Attempts to Achieve Immortality (Viola), 249–50, *250*
nonart images, 3–4
Novo Nordisk Foundation, 133, 142n5
The Number of Things (Valens), 204–5

oil and gas industry, 127, *128*
Oliveira, Henrique, 264–65
Olsén, Jan Eric, 133, 142n6
ophthalmoscope and the schematic eye, 8–10, *8*, 13, 14
On the Origin of Species (After Darwin) (Rollins + K.O.S.), 218, *219*, 221n19
On the Origin of Species (Darwin), 218, 220–21n18
Outer and Inner Space (Warhol), 248
outsider artists, 169, 170, 180–82, 185

Paik, Nam June, vi
Paine, Roxy, 115
Paleoindian people, viii
Paludan, Jonas, 134
pandas, 88, 99–100
Parabolic Triangles (Archimedes) (Johnson), 205
Paradise Lost (Milton), 155
Paradise Now exhibition, 213, *216–17*
Parenti, Lynne, 263, 270
Paul, Saint, 157
Paulhan, Louis, 178–79
Peirce, C. S., 243
Pelham, Charles, 147
Pelham, Peter, 147
photographs and photography
 death of photography, 242, 254n8
 as documentary tool, 242
 medical teaching and, 8
 truthful evidence expressed through, 8
Pickert, Susanne, 133
picturesque, technological, 107–12

Pilcher, Percy, 177
Pillsbury, J. H., 41–42, 49, 52n7
Pioneer (Porter airship), 175
Pioneers of Science gallery, Scottish National Portrait
 Gallery, 123
Piper Alpha rig, 127
plants. *See* botany
Pocket Self-Portrait (Hawkinson), 245
Porta Hedge (*Mobile Observation Lab*) (Shull), 115
Porter, Rufus, 174–75, 178
Portrait Gallery of Canada and *Karsh: Image Maker*
 exhibition, 77, 78–89
Portraits of Man (Neibart), 242–43
portraits/portraiture
 aims and potentials of, 241
 character and appearance, link between, 242
 destabilization of model of unified subject, 242,
 246–47, 253–54
 digitized images, 250–53, *251*
 film and video, 248–50, 255n34, 255n36, 255n46
 genetics and, 242–45, *244*, 254n13, 254n15
 Gordon works, 247–48
 hair, use of in, 244, 255n20
 Hawkinson works, 245, 246–47
 identity and, 241, 247–48
 indexical evidence of human life, 241, 242–247, 254
 Karsh portrait photography, 78, 79, 80, 81
 Karsh self-portrait, 84, *86*
 Narcissus and self-portraiture, 243, 254n16
 pathology depictions through stereographic images,
 7–8, *7*
 Quinn self-portraits, 243–45, *244*, 246–47, 254n13
 Salavon installation, *245*, 245–247
 Schatz works, 251–52, *251*, 256n51
 self-portraits, 254n16
 subject of, transformation of, 241
 technologies for, development and integration of
 innovative, 240–42
 Warhol works, 248–49, 255n34, 255n36
 Web-based project, 252–53, *252*
Prang, Louis, 42
Proof of the Pythagorean Theorem (Johnson), 203–4, *203*
Proposition for a Posthumous Portrait (Gordon), 247

Quinn, Marc, 243–45, *244*, 246–47, 254n13

Rainforth, Harry, 5, 6
Rainforth, Selden Irwin, 3, 5–8
Rauschenberg, Robert, vi
The Real Projective Plane (Coxeter), 206
*Recolections Reall and Speculative Works on Ideas
 of Friends and Higher Aims, Long Gone*
 (Dellschau), 170, 183n3
Reinhardt, Ad, 199, 201–2, 209n32, 234

*Reminiscences of Years Past of Time and a Way of Life
 Written and Illustrated in Idle Hours* (Dellschau),
 169–70, 173, 177, 183n3
Reston, James, 10
Reverse Television (Viola), 249
Richardson, George, 149
Ridgway, Robert, 49, 51–52
Riess, Franz, 69
Rifkin, Edwin "Ned," 266–67n13
roads and highways
 highway beautification programs, 106, 107
 national parks and road design, 106, 118n6
Rockwell, Norman, vi
Rollins, Tim, + K.O.S., 216–18, *219*, 220n17, 221n19
Rolston, Holmes, III, 114
Rombout, Melissa, 78
Ross, Douglas, 262, 265
Royal Botanic Gardens, Kew, 19, 34n6
Royal Scottish Museum, 123. *See also* National
 Museum of Scotland
RTI-#9 (Huang), 275
Ruff, Thomas, 222–23, *224*, 226, *226*, 230–32, 236

Sackler and Freer Galleries, 262, 265
Sadler's Wells, 145
Salavon, Jason, *244*, 245–247
Santos-Dumont, Alberto, 177
SARF, *see* Smithsonian Artist Research Fellowship
Saturn (god), 153, 154, 156
Saturn (planet), 232
Schatz, Lincoln, 251–52, *251*, 256n51
Schultz, Daniel, 69, 73n39
Schwartz, David, 177
science and technology
 aesthetics, technology and development of, 77
 aesthetics of technology, x, 122–130
 art, science-related, 213–220, 220n4, 220n7
 artistic interpretations of, x
 art placement in context of and shift in interpreta-
 tion, 213–14, 220n10
 collaboration and intersection between art,
 aesthetics, science, and technology, vi–viii, x–xii,
 132–33, 141, 216–17
 color as scientific tool, 41–42, 46–52, *47*, 53n19,
 54n33
 creative inquiry and engagement through objects
 that bring together art, science, and technology,
 vii–viii
 cultural impacts of, 213
 education about, 101
 human acceptance of, 106
 influence of, v
 landscape transformation through, acceptance of,
 106

machines and technology, value of, 122, 130

materiality, material culture, and, x, xi, xii, 129–30, 143

museums and collaboration between arts and sciences, xi

objectivity and scientific artifacts, 4

Scottish museum exhibition design, 123–130, *126, 128, 130*

utilitarian art, technology as, 123

Science Research Council (SRC), 230–32

Scientific American, 174, 178

Scottish National Portrait Gallery, Pioneers of Science gallery, 123

Screen Tests (Warhol), 248, 255n34, 255n36

Sedgewick, Edie, 248

Self (Quinn), 243

Self-Portrait (Height Determined by Weight) (Hawkinson), 245

Self-Portrait (The Jason Salavon Show) (Salavon), *244,* 245–247

Self-Portrait as Kurt Cobain, as Andy Warhol, as Myra Hindley, as Marilyn Monroe (Gordon), 247

Semper, Emanuel, 69

Serra, Richard, 125

7,000 Evergreens (Shull), 115

Sewall, Joseph, 159

Shango and Shango dance staff, 189–90, *191*

sharks. See *Watson and the Shark* (Copley)

Sheen, Annabelle, 108

shipbuilding, 125, *126,* 129

Shonibare, Yinka, 193

Shull, Justin, 115

Sichau, Christian, 133

Sierra Club, 113

Signature (Hawkinson), 245

Siris (Berkeley), 151, 155, 157

Sirius (Dog Star), 188, 189

Sir William Arrol & Co Ltd, 129

skin diseases, stereographic set for diagnosis of, 3, 4, 5–8, *6, 7,* 13, 14

Slate Tablet (Celmins), 232, *233,* 236

Sloan, Mark, 33, 36n65

Smithsonian American Art Museum, vii, viii

Smithsonian Artist Research Fellowship (SARF) program, x, 260–279

administration of, 266, 266–67n13

application, selection, and review process, 261

artists awarded SARF stipends, 260–61, 266n1

awareness of program, 265

benefits of, 265, 266, 274–75, 277

collaboration between artists and experts, 262–65, 269–72

collections, access to, 262–65, 270–72, *273,* 278–79

experiences of artists, 263–64, 265, 268–277

experiences of curators and other experts, 265, 278–79

findings and project outcomes, 261–62

funding for, 266

future direction of, 266

locations for residencies, 262, 265

purpose and scope of program, 143, 260–62

research methodology, 262, 279

research topics and themes, 262–266

Smithsonian Astronomical Observatory, vi, 263

Smithsonian Institution

core mission of, 265

diversity and scope of museums, galleries, and centers, vi–vii, 262

institutional partnerships, 262

Smithsonian Oral and Video Histories project, viii

Smithsonian Tropical Research Institute, 263

Smolinski, Joseph, 115–16

snakestones (shark teeth), 156–57

soil color scale, 49, 51

Sommer, Robert, 114

Song 1 (Aitken), vii

Sonora Aero Club, 168, 170, 173, 175, 182–83

South African artists, 193–94, *195*

Southern African Large Telescope (SALT) complex, 193–94

Southern Sky Survey (ESO/SRC), 230–32

Soviet Buran program, 93

space

artistic depictions of, vi

dark matter, 235

photographs of, vi, 222

See also astronomy and astronomical artifacts

space age and space exploration

artists to record achievements in space, 201

Johnson children's book about, 201

mathematics education and, 201

space shuttles

disasters with, 87, 100

anthropomorphization of, 99–100, *100,* 101–2

astronauts and public face of program, 93

design of, vi, 88, 89, 91–93, 99–100, 101–2

face of, 88, 97, 99

focus of studies about, 89

pandas, comparison to, 99–100

public image of, 100

reusability of, 91–93

safety and reliability of, 75, 101–2

success of program, 102

space shuttle toys

aesthetic adaptations and design of, 88–9, 94–101

anthropomorphization and design of, 100, *100,* 101–2

astronauts as part of, 93, 100, *100*

space shuttle toys (*continued*)
 donation of collection of, 90
 familiarization and instructional function of, 91–94,
 92, *93*, 100, 101–2
 flag or NASA symbol on, 91, *92*, *93*, 101
 neoteny, juvenile characteristics, and affection, 89,
 95–99, *96*, *98*, 101–2
 older children, designs for, 89, 94–95
 plush toys, 101
 reasons for making, 90, 101–2
 technological accuracy of, 90, 91–94, *92*, *93*
 young children, designs for, 89, *92*, 94–95, 97, *98*
spectroheliograph, 212
Splash Pieces (Serra), 125
Split + Splice exhibition
 aesthetics and exhibition design, 75, 132, 134, 141
 audiovisual components, 140
 collaboration between museum professionals and
 historians, 132–33
 design of, 133–141, *138*, *139*, *140*
 focus of and research project as basis for, 133–35,
 142n6
 funding for, 133, 142n5
 human-animal encounter, 138, *138*
 instruments and objects, display of, 139–40, *139*
 User Manual, 137
Sprint Voyager (Grubb), 116, *117*
Squared Circle (Johnson), 206, *206*
Squared Lunes (Johnson), 205, *205*
Square Kilometre Array radio telescope, 193–94
Stadtschwimmhalle, Dessau, model, 57, 68–71, *68*,
 70, 73nn36–37, 73n39
Stahl, Georg, 152, 156
standardization, aesthetics of, 4
Starn, Doug, 216–7, *216–7*
Starn, Mike, 216–7, *216–7*
stars. See astronomy and astronomical artifacts
Stauffer, Barbara, 265
Stealth Concealment Solutions, Inc., 106, 107–8, 109
STEAM (science, technology, engineering, art, and
 mathematics), xii
Steichen, Edward, 81
Stein, Gertrude, 248
Steinhilber, Dan, 264
STEM (science, technology, engineering, and
 mathematics), xii
stereographs
 creation of images for, 6–7
 introduction of, 6
 popularity of, 6, 13
 skin diseases, stereographic set for diagnosis of, 3,
 4, 5–8, *6*, 7, 13, 14
 viewers, 5, 6, *6*

Steven F. Udvar-Hazy Center, National Air and Space
 Museum, vi
stork characteristics and imagery, 149–51, 152,
 161n29
stork vessel, 152, *153*
Straight Edge, Inc., Inside/Outside Space Shuttle
 Puzzle, 97–99
Structure of Thought #13 (Starn and Starn), *216–17*
sublime, 106, 107
Sulston, John, 243
sun
 Africa art, solar representations in, 190, 192, *192*
 Asante *adinkra* cloths and celestial design motifs,
 192–93
 importance of to Africa people, 190
Sungu-Tetela people, Democratic Republic of the
 Congo, 192, *193*
Super Go-Bot toys, 95
Surveyor I moon mission, 232

Taimina, Daina, xi
Talbott, Susan, 266–67n13
Tangerini, Alice, 264
Tape I (Viola), 249
tar-water and tar-based elixirs and lotions, 151–52,
 155
Taut, Bruno, 64
taxonomy, 270–71
Thoreau, Henry David, 112
Timbuktu, Mali, 189
toys
 familiarization and instructional function of, 90, 91
 histories of, 89–90
 naturalizing technology through, 75
 space-ship toys, popularity of, 89–90
 See also space shuttle toys
Tracking Transience (Elahi), 252–53, *252*
Tree City USA designation, 113
trees and forests
 accessibility to forests, 113
 aesthetic appeal of, 112–16
 cell phone towers camouflaged as, 104–5, 108–9,
 110, *111*, 115–118
 destruction of, 112
 land coverage in forests, 112
 landscape preferences of people and, 106
 national parks and forests, cell phone towers in,
 114–15, *117*
 natural and artificial, line between, 104, 106–7,
 108–9, 111–12, 115–118
 preferences for, assessment of, 113–14
 preservation of, 113
 tree planting campaigns and initiatives, 113

urban civilization and forested wilderness, balance
between, 112–13
See also landscapes
Trischler, Helmuth, 133
truthfulness, aesthetics of, 1, 4
Turnbull, Herbert W., 203
Turner, Steven, 264
"Twelve Rules for a New Academy" (Reinhardt), 234

Udvar-Hazy Center, National Air and Space
Museum, vi
Ulak, Jim, 265
United State Forest Service, 113
United States Food and Drug Administration, 12
University of Copenhagen, Medical Museion, 133–
141, 142n5
Uppsala Observatory, 231
utilitarian art, technology as, 123

Valens, Evans G., 204–5, 206
vermillion, 155
Victor, Mary Jane, 182
video and film, 248–50, 255n34, 255n36, 255n46
Viola, Bill, 249–50, *250*, 255n46
visual arts and nonart images, 3–4
Voit, Robert, 116
Voyager 2 mission, 232

Walls Speak exhibition, 215–216
Wanted: $2,000 Reward (Duchamp), 242
Ware, Charles Eliot, 21
Warheads series (Burson), 250
Warhol, Andy, 248–49, 255n34, 255n36
Washington, George, 109
Watson, Brook
coat of arms, *149*, 150, *151*
Copley, relationship with, 145
crossing-the-line initiation, 148–49
Freemasonry association of, 147, 159
injury of, 144–45
leg amputation and recovery, 144, 147, 159
mayoral election, 159
Wheatley, relationship with, 155
Watson and the Shark (Copley), 141, 144–167, *145*
alchemy and, 144, 147–48, 151–156, 159
astrological/zodiacal associations, 144, 146, 154–
158, 159
Christ's Hospital, bequeath to, 159
color and light effects, 146–47, 148, 154–156

critics comments on, 145–146, 158–59
crossing-the-line initiations and baptismal
depiction, 148–49, 152–55, 157, 159
Freemasonry and, 144, 146, 148, 156, 157
healing theme of, 145, 146
moon and crescent moon imagery, 157–58
narrative depicted in, 144–45
original title of, 144–45
reinterpretations of, 146
shark attack, 144–45, *145*
shark characteristics and imagery, 146, 148, 152,
156–57, 161n29
snakestones (shark teeth), 156–57
stork characteristics and imagery, 149–51
versions of, 160n1
Web-based portrait project: Tracking Transience
(Elahi), 252–53, *252*
Wegman, William, 256–257n48
Wellcome Institute, 33
Wertheim, Christine, xi
Wertheim, Margaret, xi
Wessels, Tom, 114
West, Benjamin, 157
Wheatley, Phillis, 155–156
Whitehead, Gustave, 176
Wikle, Thomas, 106
Williams, Kate, 127
Williams, Michael, 112
Wilsenach, Berco, 193
Wilson, Fred, 33
Wilson, George, 122–23, 128
Wilson, Samuel, 173
Winthrop, John, 147, 155
Winthrop, John, Jr., 147
Wölfli, Adolf, 180–82
World Health Organization, 12
The World of Mathematics (Newman), 202–3, 204
Wright, Orville, 168, 178, 179
Wright, Wilbur, 168, 178, 179
Wunderkammer Museum exhibition, Deutsches
Museum, 33, 36n65

X-Ray Vision: Fish Inside Out exhibition, vii

Zeppelin airship, 177
Zulu, Sandile, 193
Zulu series (Jantjes), *187*, 194
Zwicky, Fritz, 235